Goya Sarah Symmons

ART&IDEAS

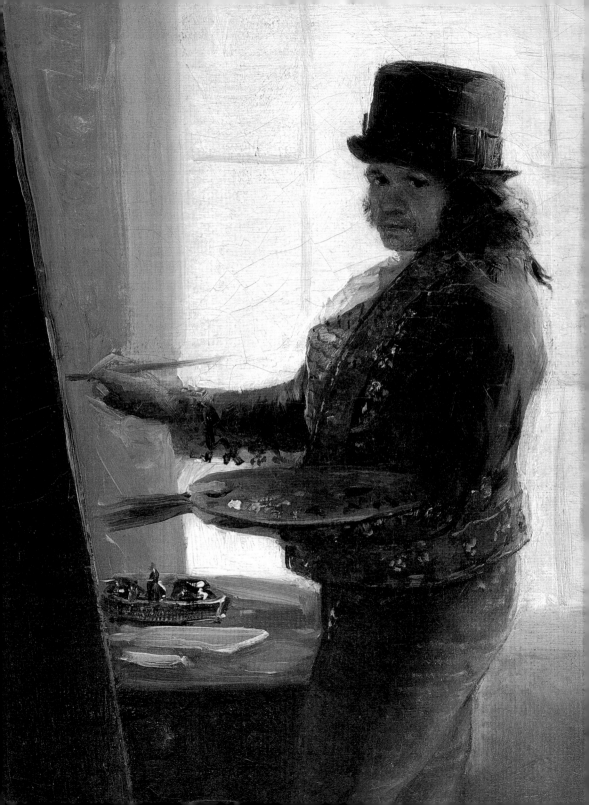

Goya Sarah Symmons

Opposite
Self-Portrait in the Studio (detail of 82), *c.*1791–2. Oil on canvas; 42 × 28 cm, 16 ½ × 11 in. Royal Academy of San Fernando, Madrid

Introduction

The art of Francisco Goya (1746–1828) often appears disconcertingly realistic, even brutal, beside the art of his contemporaries. As one of Spain's greatest artists he is now ranked with the world's most formidable painters and engravers. Yet compared with his contemporaries, he demonstrates a strange gift for creating works which both attract and repel the spectator. And an easy (although dubious) explanation for the darker side of Goya's inspiration is suggested by the circumstances of his life.

A talented young provincial, Goya rose to become chief painter at the Spanish court, with an unusually wide repertoire of work: murals, frescos, tapestry designs, portraits and engravings. At the age of forty-six he was struck by a severe illness which left him profoundly and permanently deaf. A simple 'before and after' myth is appealing: the ambitious, optimistic creator of beautiful images is transformed by illness into the isolated, anguished painter of disturbing fantasies. The truth of Goya's life and work, however, appears to be far more complicated, and a careful study of his paintings shows few abrupt changes in subject matter, style or personal vision. A lifelong preoccupation with the depiction of the erotic and horrific, already evident in some of his earliest work, was combined with the continuing struggle to find technical methods suitable to convey his passionate and realistic view of human behaviour. The difficulty in coming to grips with such an artist lies in abandoning the myth and reconciling the contradictions of his life and work. In fact, these contradictions have a story-book quality: poverty and wealth; delicate beauty and the extremes of horror; ambitions for a career at court and a taste for biting social satire.

This study of Goya will explore what can be deduced about the personality of the artist from his works and the documentary evidence available. It will situate his art within the context of

the Spain in which he lived and examine to what extent political, economic or social issues impinged upon or sharpened his vision. And it will show how an interplay between the artist's personal inclinations and the interests of a number of enlightened patrons enabled a powerful creativity to flourish and develop beyond the boundaries set by Spanish ecclesiastical and secular artistic traditions.

The Spain which appears in Goya's art was a country divided by war and bedevilled by economic depression, but which nevertheless could look back on a past of international power and influence. The Spanish empire had reached its greatest glory under the rule of the Habsburg monarch, Philip II (r.1556–98), although it was also during Philip's reign that Spain's decline began, with economic depletion brought about by the heavy costs of naval and military campaigns. Throughout the seventeenth century this weakened Spain was often at war with her European neighbours, particularly France. In order to stop these potentially catastrophic skirmishes, Charles II of Spain (r.1665–1700), who had no heir, agreed to name a French duke, Philip of Anjou (grandson of King Louis XIV and a member of the Bourbon dynasty), as heir to the Spanish throne. As a result, some forty years before Goya's birth, the country was plunged into the War of Spanish Succession (1701–14), one of the longest and bitterest conflicts in its history. Philip's claim to the throne (supported by France) was challenged by the Habsburg Archduke Charles (who was supported by England, Austria and the Low Countries), and in the ensuing conflict Spain lost dependencies in Italy and Holland, and the country was economically ruined. In 1714 Philip eventually triumphed, but the country had shrunk to a nation whose international influence was set on a path of irreversible decline.

The war had an impact on all sections of Spanish society and its effects were felt throughout the eighteenth century. Philip V (r.1700–46) initiated a period of retrenchment and reparation, when domestic concerns largely replaced the Spanish imperialistic ambitions of previous centuries. In some ways, such change was beneficial, prompting new economic growth and prosperity, and the Spain of Goya's youth was a place of widespread improvement: from

agriculture and commerce to education. Nevertheless, progressive political development in Spain during the eighteenth century reads as a complex series of contradictions and uncertainties. By the time Goya died in 1828, the country had been riven by invasion, revolution and civil war. As Goya became a front-rank artist, he depicted in paintings and prints Spain's process of modernization but also, as the situation deteriorated (especially following the French invasion of 1808), he recorded more of the darker side of society. The *Caprichos*, the *Second of May*, the *Disasters of War* and the *Disparates* (1) reflect the economic plight of his country, the sufferings of the poor and dispossessed, the growth of crime, the violence of public executions, the corruption of the Church and the impact of war on the lives of ordinary Spaniards.

Foreign commentators on Spain in the eighteenth century shared with enlightened native writers a view of the nation as a closed society, dominated by a repressive Church, ruthless despots and a pool of idle aristocrats. Accounts by travellers in Spain during Goya's lifetime give vivid details of the alien savagery of Spanish life and the exotic quality of native customs. Often the country was written off as irredeemably barbaric, although curiosity and a desire to explore the countryside and visit centres of architectural beauty, such as the cathedrals of Toledo and Seville, did attract foreign visitors.

The unpopularity of the Church and the oppression of the state formed the main issues of internal controversy in Spain during the eighteenth century. Political reformers drew strength from the writings of Enlightenment philosophers in England and France, such as Jean-Jacques Rousseau and Voltaire, despite the fact that their books were banned in Spain. The emphasis on reason, and on intellectual and personal freedom that characterized the new spirit of the European Enlightenment, began to penetrate all aspects of Spanish life. Such a change in attitude was bound to weaken the power of organized religion, and there were violent anticlerical demonstrations.

Having lived through this period of turbulent change in Europe, culminating in the French Revolution, the Napoleonic invasion of Spain and the 1808–14 Peninsular War (which Spaniards refer to as

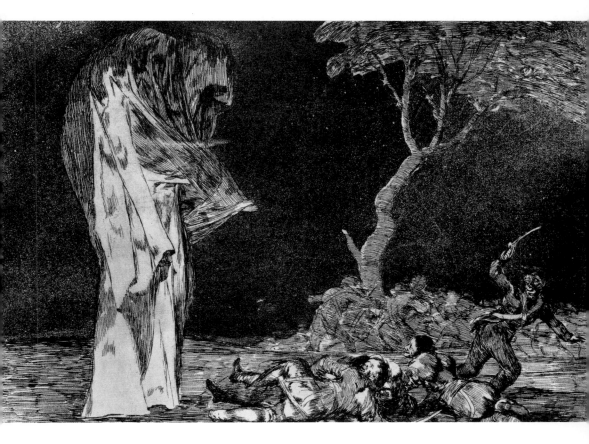

1
Fearful folly,
c.1817–20.
Disparates,
c.1816–23.
Drypoint,
aquatint and
etching;
24·5 × 35·7 cm,
9⅝ × 14 in

the War of Independence), Goya came to reflect in his art national catastrophes and political transitions, as well as the enjoyments of court life and the beauties of Spanish women. So many of the vicissitudes of his own society are mirrored in Goya's radical depictions that it can be easily assumed that, as an artist, he was obsessed with the political controversies of his time. In fact, there is little evidence to support the view that Goya nurtured a strong sense of political identity. In his mature years he occupied an almost unassailable position as chief painter to the court of Spain, and, throughout his career, while personally inclined to depict the effects of oppression on ordinary people, he nevertheless profited from the patronage of both Church and state. His popularity among Spanish intellectuals, the aristocracy and the monarchy, was proof of his artistic agility at surviving undaunted in the most unpromising of situations. Essentially his political position centred on the attainment of professional status and the supreme importance of artistic freedom, and his mature work bears the unmistakable imprint of his powerful personality and individual preoccupations. In the play of these complex inner and outer worlds lies the secret of his most unlikely success story.

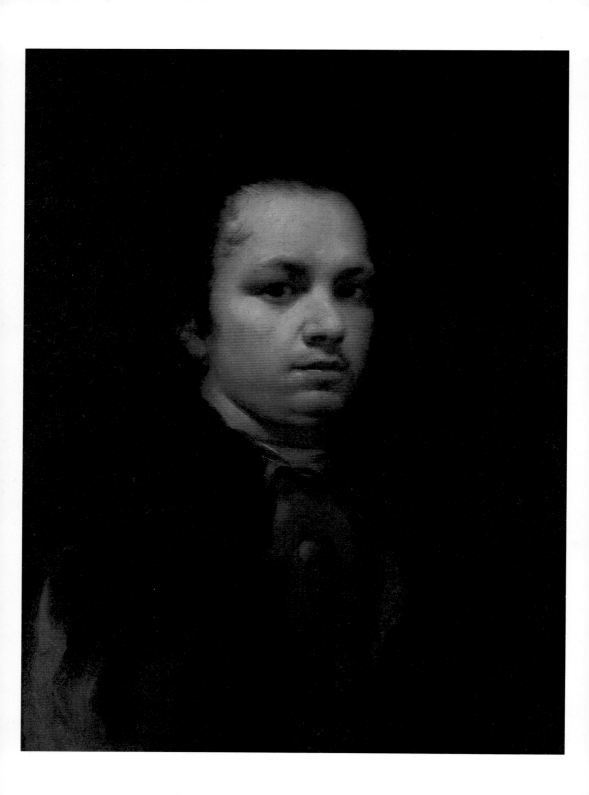

Francisco Goya was born in 1746 in the village of Fuendetodos
in Aragon (3). This large Spanish region consists of a bleak plain,
bounded by the Pyrenees in the north, and by the provinces of
Catalonia and Valencia in the east, and Castile and Navarre in the
west. Formerly an independent kingdom, Aragon suffered particu-
larly after the War of Spanish Succession, when it had supported the
Habsburg candidate for the Spanish throne. Before and during Goya's
lifetime the region retained a strong sense of individual nationalism.

Goya himself was to achieve the type of success which few of humble
background in eighteenth-century Spain could have dreamed of, and
this tough determination was part of his inheritance from particularly
dogged forebears. The name 'Goya' originated in the Basque provinces
of northeastern Spain from where the artist's ancestors probably
migrated into Aragon to find work. Goya's father was an artisan;
a gilder who practised the ancient craft of applying gold to picture
frames, cabinets and wooden mouldings. Although a highly skilled
job, it was poorly rewarded, and when Goya Senior died in 1781 he
left no property. Nevertheless, the family could boast of aristocratic
connections. Goya's father's low status as an artisan did not prevent
him from marrying Gracia Lucientes, the daughter of provincial
hidalgos, that is, minor impoverished aristocracy. Of their six chil-
dren, only Francisco, the artist, and his younger brother Camilo, who
became a priest, are remembered. These professions – the fine arts
and the Church – were vocations which cut across the class hierar-
chies of Spanish society.

Eighteenth-century Aragon witnessed many social transitions. There,
as in other parts of Spain, hidebound traditionalists and those with
a more tolerant, modern outlook were to create the ebb and flow of
Spanish political life in the age of Enlightenment. Goya's youthful
education in the Aragonese countryside and later in Saragossa (the

2
Self-Portrait,
*c.*1771–5.
Oil on canvas;
58 × 44 cm,
22 ⁷⁸ × 17 ³⁸ in.
Private
collection

region's capital city), was fostered by the provincial Church and nobility. His move to Saragossa as a teenager would have introduced him to changes within his own society, as well as within his chosen profession.

The wealth and influence of the many religious orders of Saragossa were legendary. 'The inhabitants of Saragossa used to remark to me that their city was but a gloomy place', recorded one English visitor to Aragon, Charles Vaughan. 'The inhabitants seem not to have been fond of public amusements – it was very seldom that a theatre was opened amongst them and their strong religious impressions are said to have cast a gloom over the manners of the place.' A multi-volume guidebook to the beauties of Spain, published in France between 1806

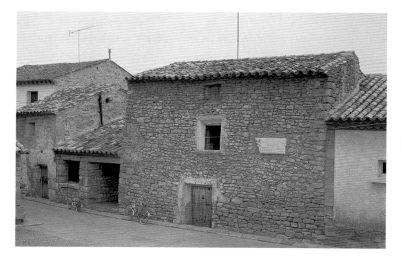

3
Goya's
birthplace in
Fuendetodos

and 1820, shows the city (4) overshadowed by the towers of the great Cathedral of Our Lady of the Pillar ('El Pilar'). The hint of provincial torpor which colours this French view of Saragossa gives no indication that this was the capital of a region coming to terms with the Industrial Revolution and the modern world.

Goya's early life was dominated by the Catholic Church. His first public work, a reliquary for his local village church in Fuendetodos (destroyed in 1936 during the Spanish Civil War) exemplified the benefits of local Catholic patronage. The artist would have been just sixteen or seventeen when he painted this reliquary; surviving,

prewar photographs show that the work consisted of separate panels depicting scenes from the lives of St Francis and St James and the image of the Virgin of the Pillar on the doors. These saints were especially revered in Aragon, and the figure of the Virgin of the Pillar had inspired the building of the great cathedral in Saragossa. According to legend, St James, while travelling through Spain as a missionary, met the Virgin Mary who gave him a statuette of herself on a column of jasper and instructed him to build a church to house this holy object. A relic of the original column is preserved in a shrine in the cathedral at Saragossa, which stands on the site of the saint's vision; this miraculous event became the focus of religious activity in the region, where many social functions and benefits were performed by

4
Drawing of the Cathedral of Our Lady of the Pillar, Saragossa, reproduced in Alexandre de Laborde's *Voyage Pittoresque et historique de l'Espagne,* 1806–20

monastic orders. Goya was educated by a Roman Catholic teaching order primarily devoted to educating the poor; subsequent to this he was apprenticed to José Luzán y Martínez (1710–85), a religious painter in Saragossa who worked as an artistic censor for the Inquisition. When one looks at Goya's reliquary and at other attributable paintings from this period, it is clear that the restrictions of provincial religious painting hampered the growth of the artist's independent style. Much of his early work is dull and derivative.

Goya's training in provincial Aragon was probably based on a mixture of workshop and apprenticeship traditions. José Luzán's teaching method relied on encouraging students to copy engravings, a training

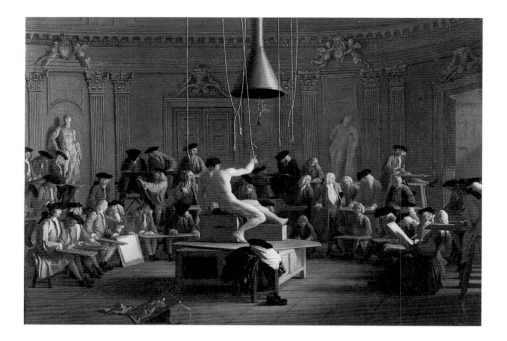

device favoured by minor academies which might or might not employ a live model. Michel-Ange Houasse (1680–1730), a Parisian painter who worked in Spain from 1715 to 1730, recorded the scene inside a drawing academy around 1725 (5). The students are assembled around the model while in the background stand casts of famous classical sculptures (the 'Farnese Hercules' is recognizable on the far wall). A much later painting by one of Goya's contemporaries, José del Castillo (1737–93), shows the studio of a country painter (6). Three young students are playing with a cat. One boy has been copying a print of a nude hanging on the wall; to the right stands a classical-style bust.

In old age Goya was to write a short memoir recalling this early period of his life. He records that he spent four years with Luzán, 'who taught him the principles of drawing by giving him the best prints in his collection to copy', and it may have been in Luzán's studio that the young artist first discovered his passion for engraving and printmaking. Having completed his training with Luzán, Goya pursued his own ambitions at a time when the status of Aragonese artists was increasing.

5
Michel-Ange Houasse,
The Drawing Academy,
c.1725.
Oil on canvas;
52 × 72·5 cm,
20 ½ × 28 ½ in.
Royal Palace,
Madrid

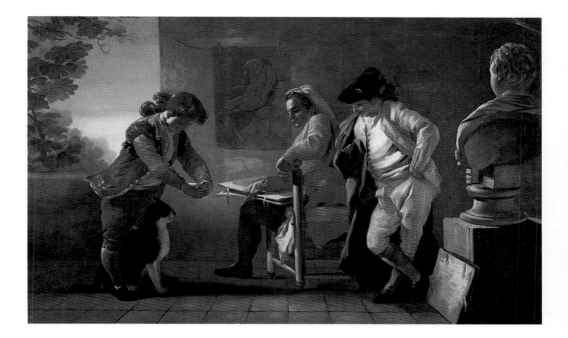

6
José del
Castillo,
*A Painter's
Studio*,
1780.
Oil on canvas;
10·5 × 16 cm,
4 ⅛ × 6 ¼ in.
Theatre Royale,
Madrid

The growth of provincial art schools in Spain during the eighteenth century was one symptom of the regionalized political scene. The previous century had seen artists migrating to large cities to find work, but in Goya's day painters and sculptors could survive professionally in the provinces. In Saragossa Church patronage was so extensive that rural congregations developed a voracious appetite for painted images of the Virgin Mary, popular local saints and the lavish embellishments of sacred objects. This meant that any reasonably talented young man could establish a prosperous artistic career in his home region. In Aragon most connoisseurs and established masters were still smarting from the refusal in 1747 by the Spanish king Ferdinand VI (r.1746–59) to grant full academic status to the drawing academy in Saragossa (the city did not receive its royal charter for a full Academy until 1778), but despite this setback artistic activity in the city flourished.

During Goya's apprenticeship in Luzán's studio three outstandingly talented boys from a local aristocratic family, Francisco (1734–95), Manuel (1740–1809) and Ramón Bayeu (1746–93), became the star pupils. Like Goya these students had received their first instruction from local

art teachers, and religious art was also the staple subject matter of their youthful work. The eldest, Francisco, won widespread respect; his local church commissions are elegant and decorative, quite different from Goya's early work. A sketch of the legend of St James which inspired the founding of the Cathedral of El Pilar in Saragossa (7) demonstrates Bayeu's fluid handling of paint and the delicate gestures with which he endowed his figures. In 1758 he achieved recognition outside his home region by winning a history painting scholarship at the Royal Academy of San Fernando in Madrid, a goal that Goya was later to pursue.

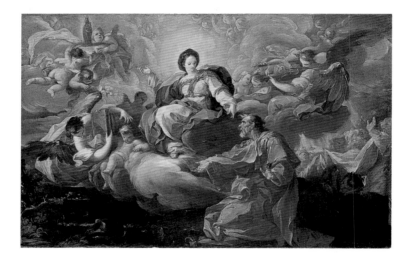

This Academy, the first of its kind in Spain, had received its royal charter in 1752 from Ferdinand VI and established Madrid as the undisputed academic centre of artistic activity in Spain; it also symbolized an increasing sense of artistic nationalism. From the end of the seventeenth century, Spanish court art had been dominated by painters from France, Italy and northern Europe who found lucrative employment in the Spanish capital. The foundation of the Academy had the effect of producing native masters with an increased sense of national identity.

At the Academy art students were obliged to follow a strict training programme, and talented students from all backgrounds were encouraged, through scholarships, to further their careers and make study visits to France and Italy. Prominent figures from the worlds of schol-

arship, politics and the court were invited to address the students and become lay members of the institution. The eventual foundation of more academies in provincial Spanish cities was also designed to improve both the status and the achievement of young Spanish artists. However, painters whose work did not suit the elevated principles of the Spanish academicians, or who offended the powerful lay members of the governing boards, could be professionally ruined.

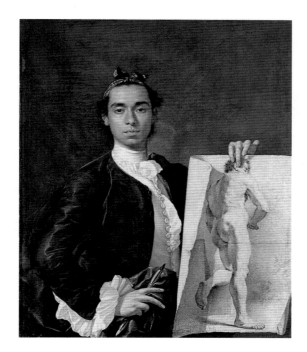

7
Francisco Bayeu,
St James Being Visited by the Virgin with a Statue of the Madonna of the Pillar,
1760.
Oil on canvas;
53 × 84 cm,
20 ⁷⁸ × 33 ¹⁸ in.
National Gallery, London

8
Luis Meléndez,
Self-Portrait,
1746.
Oil on canvas;
99·5 × 82 cm,
39 ¹⁴ × 32 ¹⁴ in.
Musée du Louvre, Paris

One of the most promising young artists of the generation preceding Goya, Luis Meléndez (1716–80), was professionally marginalized for many years after his father quarrelled with the ruling council set up to advise on the formation of the Academy. In his *Self-Portrait* of 1746 (8), Meléndez holds up his prizewinning anatomical sketch to display his talent at life drawing. Such flamboyance did him no good, however, in the stringent political climate of the 1750s.

A sketch of the studio in the Royal Academy of San Fernando (9) shows an imposing and formal setting for youthful ambitions: no windows, a central chandelier providing a source of artificial light, and a large collection of plaster casts after classical sculptures. The teaching

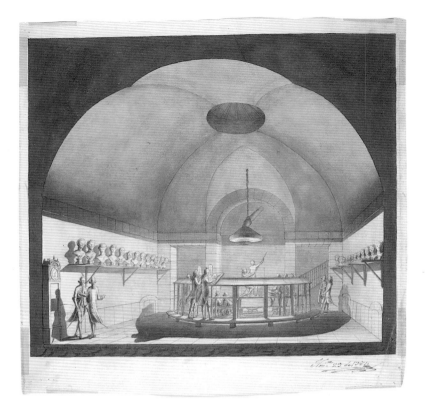

programme was derived from the example of the French Academy,
which had been founded by Louis XIV in 1648. By the 1760s, however,
the Academy in Madrid had already been subjected to reforms which
distracted it from its seventeenth-century model. An important influ-
ence in this was the Bohemian-born painter Anton Raphael Mengs
(1728–79), who arrived in Madrid in 1761 after winning particular
renown in Italy as one of the first artists to establish the Neoclassical
style of painting in Europe (10). Mengs came from Rome at the invita-
tion of the Spanish king, Charles III (r.1759–88), and during his two
terms of office as a court painter in Spain (1761–9 and 1773–6) he
reformed the academic system and changed the direction of Spanish
painting, giving it a more secular emphasis based on classical forms
and principles. The Academy had already set up a library for its
students (11), and under the influence of Mengs this was filled with
classical texts, prints of classical buildings and casts after classical
statues. The changes parallel similar reforms that were carried out

in Spanish universities in the same decade. The growing obsession throughout Europe for redesigning educational systems for all classes of society was particularly strong in Spain, where the religious orders had traditionally dominated academic teaching. A secular institution such as the Royal Academy of San Fernando needed to prove its worth by becoming rigorous in its methods.

As well as specialized technical training, the students received a broad liberal education and were encouraged to study classical sources with regard to subject matter and style, and generally follow a teaching programme devoted to classical learning. By the late eighteenth century their studies were extended to include mathematics and geometry as well as history.

When the Academy of San Fernando received its royal charter, it was on the understanding that serious painters, sculptors, architects and engravers would require proper assessment and accredited qualification before they could be given membership. Membership of the Academy was a crucial constituent of an artist's career. As an academician (*académico de mérito*), the artist could assume the rank of an aristocrat, and supervise large public building projects or decorative schemes. The first step towards obtaining such status was to achieve a first-, second- or third-class grading in a student competition. Francisco Bayeu achieved success in one such competition in 1758 with a sketched subject from Spanish history.

In the eighteenth century history painting was the most prestigious artistic genre, and the Academy's history painting competition the most highly-rated and difficult of the range of competitions held each year. Candidates underwent two drawing tests: they were set subjects from classical and Spanish history, or from the Bible, which they could prepare over a given time; then, having presented these drawings to the judges, they were shut up in a studio with another, similar subject, which they had to draw within a couple of hours. The judges, consisting of the academic professors, cast votes for the best work. The student to gain the most votes won the first prize and qualified for a scholarship, although runners-up might also be considered for lesser prizes.

9
Gómez de Navia,
The Academy Drawing Studio at the Royal Academy of San Fernando in Madrid,
1781.
Pen, chalk and grey wash;
41·1 × 41·6 cm,
16 ¹⁄₈ × 16 ³⁄₈ in.
Royal Academy of San Fernando, Madrid

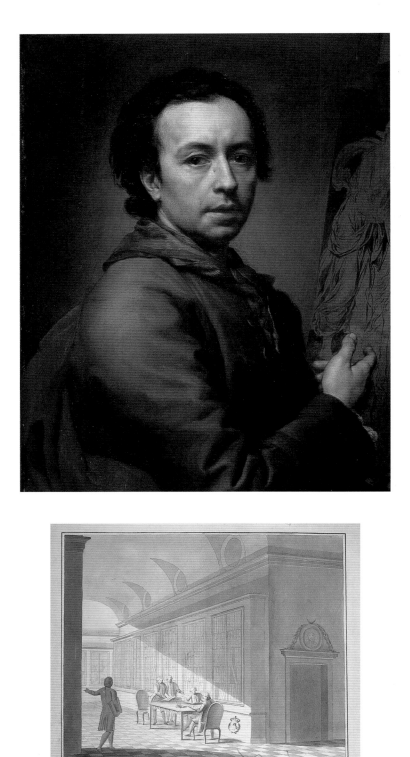

In the early 1760s student competitions became more harshly evaluated as the teaching system was reformed. Students were encouraged to copy classical and Renaissance works, and the type of formal training introduced into the Madrid Academy after the arrival of Mengs made it more difficult for a young artist to achieve the necessary academic qualification. Despite the fact that Goya's experience as a provincial art student was probably insufficient to prepare him for the professional demands of such a system, in 1763, at the age of seventeen, he travelled to Madrid to take part in his first student competition. It is not known how long he remained in the capital, but he may have lodged with Francisco Bayeu, who was already establishing himself there as an up-and-coming painter. Disappointingly, Goya received no votes at all from the professors who judged the submitted works, and when three years later he took part in another competition, the result was identical.

In that year two of Goya's colleagues, Francisco Bayeu's youngest brother, Ramón, and a young native of Madrid, Luis Paret y Alcázar (1746–99), won prizes. Both were adept at producing the type of classical drawing required by the Academy and were later to become major Spanish painters. The sketch that won a second-class historical prize for Luis Paret, a subject from the history of ancient Rome, *Hannibal Sacrificing at the Temple of Hercules* (12), exhibits a brilliantly sensitive drawing technique. Elegant figures dressed in antique armour appear strikingly energetic. Every detail has been studied from contemporary historical research and is archaeologically accurate. This is one of the earliest examples of successful Neoclassical drawing at the Madrid Academy and symbolizes the political importance which Neoclassical art exercised at this time.

The subject of Hannibal assumed particular significance in Spain, where the great Carthaginian general had lived and conquered in the third century BC (when southern Spain was part of Carthaginian territory), before turning his attention to the defeat of Rome. He consequently became identified with Spanish history: a heroic figure whose military prowess was seen as a parallel to the military exploits of the Bourbons. Evoking a historical personality central to the

10
Anton Raphael Mengs,
Self-Portrait,
1774.
Oil on panel;
73·5 × 56·2 cm,
29 × 22 ⅛ in.
Walker Art Gallery,
Liverpool

11
Manuel Alegre,
The Library,
1784.
Chalk, ink and wash;
49 × 60 cm,
19 ¼ × 23 ⅝ in.
Royal Academy of San Fernando,
Madrid

Spanish view of the classical world, the story of Hannibal was avidly read by Spanish scholars in the eighteenth century. He, like Roman heroes such as Horatius, Brutus, Romulus, Scipio and Cincinnatus, offered a notion of classical virtue which was seen as a model of human behaviour and was to dominate European exhibitions of history paintings.

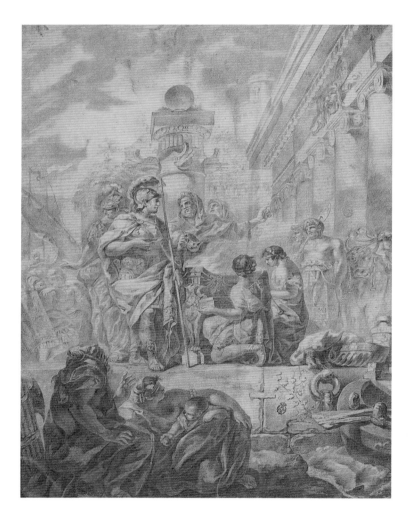

The eighteenth-century rediscovery of ancient Greek and Roman civilizations initiated the Neoclassical movement in art and archi-tecture, something that had been pioneered by Mengs's close friend, the German art historian, Johann Joachim Winckelmann. However, it was not a purely theoretical and intellectual phenome-

non. Archaeological discoveries at Herculaneum and Pompeii in Italy, two Roman towns destroyed by the eruption of Mount Vesuvius in 79 AD, had sparked off an enormous burst of excitement throughout Europe. The realities of a remote civilization and culture seemed to be coming ever nearer to people in the modern world, and an enthusiasm for antiquity was combined with a new passion for classically inspired designs in furniture, interior decoration and domestic implements. The ideals of classical philosophy also played a large part in political as well as cultural developments within European society, and the two great revolutions of the second half of the eighteenth century, the American War of Independence (1775–83) and the French Revolution (1789), drew images and ideas from classical antiquity. While George Washington was occasionally portrayed in the guise of the virtuous Roman general Cincinnatus, French revolutionaries employed artists to stage political festivals with antique trappings and costumes. In 1791 the body of the philosopher Voltaire was drawn to the Panthéon in Paris – a large Neoclassical building designed by Jacques-Germain Soufflot (1713–80) as a kind of secular cathedral – on a bier designed as a Roman sarcophagus. In Spain a passion for the antique was demonstrated not only through the subjects taught in the universities and at the academies, and by the literary developments of the period, but also in new building programmes and the use of historical parallels to show off the grandeur and achievement of the Bourbons.

The new Royal Palace in Madrid (13), in particular, was designed to memorialize the power, benevolence and taste of the Spanish Bourbon monarchy. Following his earlier triumph in the War of Spanish Succession, Philip V, with the help of his younger son, Charles, retook the kingdom of Naples and Sicily in 1734, of which Charles became king. In the same year one of the most ancient of the royal palaces in Madrid, the Alcázar, was destroyed by fire. Work began almost immediately on a new lavish building made of granite, with doors and windows in 'piedra de Colmenar', a white Spanish marble. Designed originally by Filippo Juvarra (1678–1736) and erected between 1738 and 1764 by Giovanni Battista Sacchetti (1690–1764), this building, a hybrid mixture of Baroque, Rococo and classical archi-

12
Luis Paret y Alcázar,
Hannibal Sacrificing at the Temple of Hercules,
1766.
Red chalk;
6·5 × 4·7 cm,
2 ½ × 1 ⅞ in.
Royal Academy of San Fernando, Madrid

tectural motifs, remains one of the most individual palaces ever built in Spain. Although not completed until 1808, on the eve of the French invasion, the Royal Palace has always been viewed in Madrid as the supreme architectural achievement of the eighteenth-century Bourbon monarchy. Prestigious foreign artists such as Giambattista Tiepolo (1696–1770) from Venice and Mengs from Rome were invited to Madrid to supervise the decorations. The throne room's supreme decorative feature was Tiepolo's great ceiling fresco *The World Pays Homage to Spain* (14).

Mengs's grave Neoclassical works, with their limited colours, figures based on classical statues, and elevated ideas, appealed particularly to the austere taste of mid-eighteenth-century Madrid. While Goya's background as a painter of rural altarpieces in Aragon had not prepared him for the intellectual, international Neoclassical style established in the capital in the 1760s, Francisco Bayeu had been called to Madrid by Mengs to help with the extensive decorations inside the Royal Palace. This honour established Bayeu as one of the most promising young artists in Spain and represented a considerable boost to Aragonese art. Goya, by contrast, must at this time have seemed an unlikely candidate for public success.

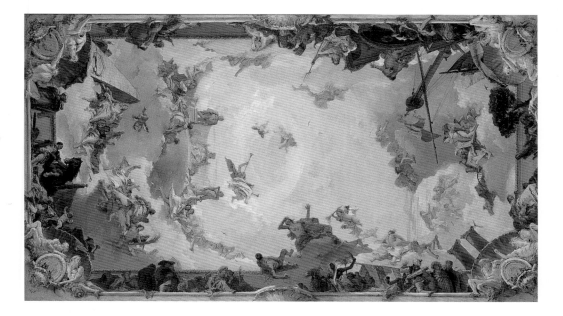

Despite his second failure at the Academy in Madrid at the age of twenty, Goya continued to paint after his return to Aragon. A series of murals by him are recorded in the Sobradiel palace in Saragossa, his only notable commission in the period from 1767 to 1770. He continued working and cultivated his acquaintance with the Bayeus, who were continuing their rise to professional eminence in academic and public life. The obscurity of Goya's early life and the comparative lack of precise documentation makes it hard for us to know if he ever considered settling for a quiet life in the provinces as a minor painter, patronized by local nobility and religious orders. Whatever the situation, his need to gain academic qualification and wider knowledge of classical antiquity and the Old Masters remained vital professional requirements. Thus, in 1770, he undertook a journey to Italy.

The few records of Goya's Italian visit demonstrate his independence and determination as well as a profound change in artistic outlook. He travelled to Rome, a city then flooded with art students from all over Europe, trying to establish their artistic credentials as experienced copyists of the classical and Renaissance masterpieces to be found in the city's collections, and of the architectural remains of its classical past.

Rome lay at the heart of the eighteenth-century artist's search for fame. Without any government scholarship, Goya would have been freer than many other art students and was at liberty to pursue his own tastes unhampered by a set programme, or the obligation to send work back to a home academy in order to demonstrate that his progress was in line with academic requirements. Rome offered artistic and social prospects far beyond provincial Saragossa, and the lives of foreign art students there during the eighteenth century could be exciting and rich. The French painter Jean-Honoré Fragonard (1732–1806), who studied in Rome from 1756 to 1761, deliberately rebelled against his academic teachers and turned from painting copies after grand art to portraying life in the Italian countryside around the city. The English sculptor John Flaxman (1755–1826), who spent several years in Rome between 1787 and 1794, recorded his disgust at the loose life of the foreign art students, their fights in coffee houses, their internal rivalries when competing for the attention of wealthy connoisseurs. A large number of art dealers who sold both modern and classical art also lived in Rome, as did numerous wealthy collectors.

Goya seems to have shunned art student circles while in Italy, although he is thought to have lodged with a Polish artist, Tadeusz Kuntze (1733–93). Comparatively few Roman works by him survive, but a notebook dating from this period, recently acquired by the Museo del Prado in Madrid, has, however, come as a revelation to scholars. It forms the sole reliable record of his Italian visit and contains many interesting drawings. It was not completed in Italy but seems to have become a synthesis of notebook, sketchbook and diary, which the artist continued to use for many years after his return to Spain.

15
'Farnese Hercules', page 67 recto, Italian Notebook, c.1770–85. Black chalk; 19·5 × 13·5 cm, 7⁵⁸ × 5¹⁴ in. Museo del Prado, Madrid

Like most eighteenth-century art students, Goya made copies of Italian High Renaissance works and the sculptures of antiquity. There are, for example, four detailed studies of the 'Farnese Hercules' (15), a cast of which stands in the art studio portrayed by Houasse in the 1740s (see 5). This famous statue, attributed to the Greek sculptor Lysippos (active in the fourth century BC) and signed by the Roman copyist Glykon, had become one of the most famous figures of antiq-

uity. The second great classical image which Goya drew three times (16–18) was the 'Belvedere Torso', a work somewhat later than the Hercules, dating from the Hellenistic period of Greek art. These renowned pieces of sculpture were particularly popular in the eighteenth century since their swelling muscles and dramatic poses suggested a profound emotional quality. Clearly Goya must have found this style of antique statue compelling and years later, when he made prints of atrocities committed during the Peninsular War, he was to remember his studies of classical sculpture and use them as models for his designs of naked corpses (see 154). As a complete contrast to the flat prints he had copied as a young boy, Goya was evidently fascinated by the volume of antique sculpture: he made drawings of the statues from different angles, showing their back, side and frontal views.

The artistic lesson of antiquity played a crucial part in the develop-
ment of Goya's later work and his supreme effort in getting to Italy,
alone and financially unaided, shows how conscious he was, even in
his early career, of the new style dominating artistic circles in Madrid.
His notebook lists an itinerary of places to see: Venice, Siena, Naples
and numerous other Italian cities. But it was the north Italian city of
Parma which offered him the most valuable professional advantage
of his visit. In 1771 he entered a student history painting competition
held at the Parmesan Royal Academy of Fine Arts. The painting he
submitted depicted that popular classical hero, Hannibal. Goya's
recently rediscovered oil painting, which he sent to Parma from Rome
on 20 April 1771, *Hannibal Viewing Italy from the Alps* (19), is a less
accomplished piece than the Hannibal sketch which Luis Paret had
presented to the Madrid Academy four years earlier (see 12). The
subject, that of the great man's first view of Italy, a country which he
intends to conquer, has a subtle connection with a famous political
painting from the 1730s, showing Charles (then the Infante Don
Carlos), later Charles III of Spain (r.1759–88), being led into Italy by

16–18
'Belvedere Torso', Italian Notebook. Black chalk
Left.
Pages 26 verso and 27 recto
Right
Page 28 recto

Pallas Athena and Mars, god of war (20). Executed by the Venetian painter Jacopo Amigoni (1685–1752) the work was painted for the prince's mother, Elizabeth Farnese, Queen of Spain, and was a tribute to Charles's Italian victories in retaking Naples and Sicily in 1734.

Goya's figure of Hannibal closely resembles Amigoni's figure of Mars. The symbolic overtones of this type of subject matter, a young man about to conquer Italy, transform Hannibal and Charles into heroes of a historical journey; this idea is underscored by Goya giving Hannibal a military helmet decorated with a winged dragon, a motif taken from ancient Roman military artefacts. He also refers to another popular classical statue, the 'Apollo Belvedere', and inserts in the foreground the allegorical ox-headed deity which symbolizes the River Po. The figure of Hannibal was sketched out in the Italian notebook, and the entire composition was rehearsed in a preliminary oil sketch.

Although Goya failed to win the gold medal for the first prize, his painting was awarded six votes by the academic jury in Parma, perhaps because its muted colouring of blues and pinks (very similar

to Amigoni's palette), and the carefully studied source material, created an Italianate effect: a compliment to the new country in which the young artist was learning his craft. These votes entitled Goya to an 'honourable mention' in the academy records, and although the rules of the Italian competition were certainly less strict than those of the Academy in Madrid, the honour gave Goya an essential academic seal of professional approval.

It is significant that for the competition Goya entered himself not as a pupil of the Saragossan religious painter, José Luzán, but of the by now far more renowned painter to the court of Charles III, Francisco Bayeu. Goya may have done this because he considered Bayeu to be a coming success in an artistic milieu which he wanted to broach, indeed it may have been Bayeu who encouraged Goya to travel to Italy.

Among the works Goya produced in Italy, the *Hannibal* painting now has only a limited historical interest, but Goya's determination to absorb the complexities of classical art made him consider other types of subject matter, discarding classical heroism in favour of more robust studies of classical and Christian iconography. In analysing classical sculpture he not only employs dramatic angles, but also reveals an obsession with portraying passion and violence. He is even thought to have produced rather dubious, erotic paintings of pretty girls performing antique sacrificial rituals, a theme which corresponded to contemporary tastes among European connoisseurs and dealers.

Pagan and Christian sacrificial or ritualistic scenes, popular among Italian and French painters, had developed into decorative, often *risqué*, pieces in the repertoire of Rococo art, the European style especially popular in the late seventeenth and early eighteenth centuries. In the later eighteenth century Rococo excesses of brilliant colours, rounded forms and erotic subjects, so boldly displayed in the art of François Boucher (1703–70), for example, were criticized by Jean-Jacques Rousseau in a prize-winning essay of 1750 for the Academy in Dijon, and in the philosopher and critic Denis Diderot's reviews of Salon exhibitions in Paris during the 1760s. Even the more restrained, quasi-classical compositions by Fragonard and Jean-

19
Hannibal Viewing Italy from the Alps, 1771.
Oil on canvas; 88·5 × 133·2 cm, 34⁷⁄₈ × 52¹⁄₂ in.
Fundación Selgas-Fagalda, Cudillero

20
Jacopo Amigoni, *The Infante Don Carlos Being Conducted into Italy by Pallas Athena and Mars*, c.1734.
Oil on canvas; 177 × 246 cm, 69³⁄₄ × 97 in.
Palacio Real, Segovia

Baptiste Greuze (1725–1805) retained this love of sensuality in scenes of sacred rituals. In Spain, the Church was similarly censorious, and in 1766 Pablo Olavide, a prominent statesman, was denounced to the Inquisition for having erotic paintings in his house. Goya too was to suffer from similar censorship in his later career, but even in this early phase of his life it is clear that he had begun to be intrigued by the dramatic and emotional artistic potential of both classical and religious imagery. The copies after religious paintings in his notebook of subjects like the story of Adam and Eve and Cain killing Abel show a profound interest in the physicality of the figures, just as he had probed the emotional properties of classical sculpture.

Goya's burgeoning skills met the challenge of academic art and classical history and, by the end of his Italian visit, they reveal the promise of later years, particularly in the way that the artist could adapt and change academic sources in an independent manner. As Goya made sketches after the Old Masters, he was also fascinated by life in the streets of Rome and by the works of contemporary masters. His notebook contains sketches of what already seem more characteristic

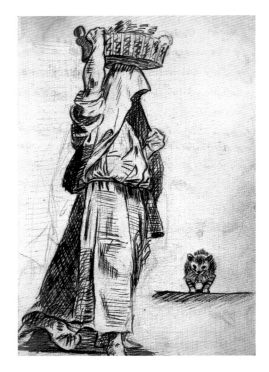

subjects: a woman carrying a basket on her head, an alley cat (21); scenes of violence and despair, grotesque masks and close-ups of sculpture reliefs of a particularly emotional or tormented nature (22). Goya's notebook shows that the lessons of classical and Renaissance art were always subordinate to personal interpretation.

What he took back to Spain in 1771 was a new status as an artist who had gained academic distinction abroad, and a new boldness and confidence which were to enable him to transform from within those very areas of Spanish art which had eluded him for so long. The Italian journey removed him from the restrictions of his provincial youth and proved a valuable experience. In later life the artist was to regard this major adventure as the turning point of his career. In 1779, when he applied for a salaried post at the Spanish court, he wrote that he had 'practised his art in his home town of Saragossa and subsequently in Rome where he lived at his own expense'. As an elderly man in the 1820s, he still recalled the importance of the visit when he stated that he had 'begun to paint original compositions by the time he went to Rome and he has had no teacher other than his

21–22
Italian
Notebook
Left
Drawing of a
woman with a
basket on her
head and a cat,
page 3 recto.
Ink and chalk
Right
Drawing of a
grotesque clas-
sical mask,
page 45 recto.
Ink, black and
red chalk

own observation of the celebrated artists and pictures in Rome and Spain from which he gained the greatest advantage'.

Goya's return to Saragossa was something of a triumph. He won a commission to paint the ceiling of the little choir (*coreto*) in the Cathedral of El Pilar in 1771, after competing for the job against an older painter from Madrid, Antonio González Velázquez (1723–94). His friendship with the Bayeu family reached its crowning moment when he married Josefa Bayeu, sister to Francisco, Manuel and Ramón. He referred in his Italian notebook to 'My marriage on the 25th day of July in the year 1773'. The Spain to which he had returned was a country immersed in a turmoil of reforms: to universities, convents and monasteries, in town and countryside, as the drive towards modernizing all aspects of society was relentlessly pursued. Agricultural reforms proved less effective, and the greed of landlords and the poverty of tenant farmers remained a depressing feature of Spanish provincial life. For a young painter with elevated ambitions, the need to leave provincial Aragon and pursue an honourable and profitable career in a large capital city must have been a tempting prospect, and, by symbolizing his unquenched ambitions, the Italian journey became his point of reference for personal and professional change. From the time of his return to Saragossa any major alteration in his life – marriage, the births of his children, his move to Madrid – were recorded in that same notebook that he had kept in Rome.

The development of a self-conscious sense of autobiography was also fruitful, and around the time of his marriage, he painted his earliest mature work, a *Self-Portrait* (see 2). Brooding and shadowy, with little of the ebullience which might be expected from a young man whose life had finally taken a turn for the better, the portrait anticipates the expression of human frailty that was to form Goya's most accomplished portrait style. His long hair is done up at the back of his head, the face is chubby, the eyes deep-set, the gaze fixed and penetrating. Unlike the more showy *Self-Portrait* by Luis Meléndez (see 8), Goya's personality seems introverted. As the first true masterpiece of Goya's life, this portrait gains strength from the realism which had crept into his drawings, and which derived in part from his study of classical art.

Court Life and Court Art Bourbon Patronage and Tapestry Cartoons

2

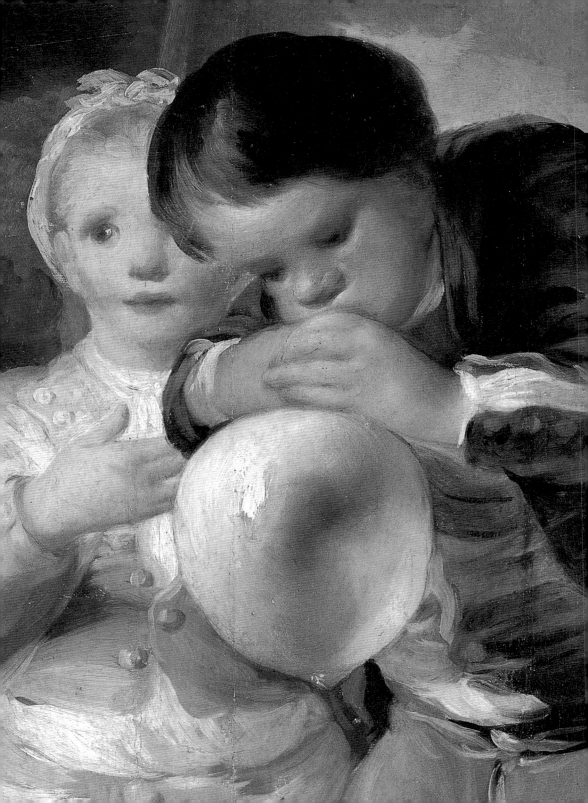

Despite his early education and patronage by the Catholic Church, Goya found his true vocation in secular painting, particularly after he began work for the Spanish court. Second only to his Italian visit, Goya's move to Madrid was to prove the most significant journey of his life. This important new stage in his career was recorded in his Italian notebook: 'On the third of January 1775 we left Saragossa for Madrid', he wrote with a flourish. Arriving in the capital seven days later, the young artist took the first steps in establishing his phenomenally successful court career. Within a comparatively short time he was to outclass his artistic rivals and emerge as the supreme painter of his generation. Yet his progress was fraught with setbacks and personal tragedy, influenced in part by the highly unpredictable way in which Spanish court life could determine an artist's career.

Political tensions and difficulties, and the competitive gamesmanship of colleagues, all of whom were attempting to adapt to the transitions in Spanish art that marked the reign of Charles III, affected the demands of royal programmes involving the fine arts. Charles's accession to the Spanish throne had initiated new policies towards the arts and accelerated the nation's economic and cultural reforms. After his elder brother Ferdinand died without issue in 1759, Charles had resigned the throne of Naples for that of Spain. His embarkation for his new kingdom took place on 6 October 1759 and his arrival was celebrated by numerous artists. In a painting by the Italian Antonio Joli (1700–77), depicting the memorable occasion of the king setting sail for Spain with his fleet of thirteen battleships and two frigates, watched by elegant crowds lining the port of Naples, a new interest in contemporary anecdote appears (24). Such works mirrored the taste for high and low life brought together in a single image, and came to popularize representations of grand, royal occasions, making them accessible and entertaining.

23
Boys Blowing up a Bladder
(detail of 34)

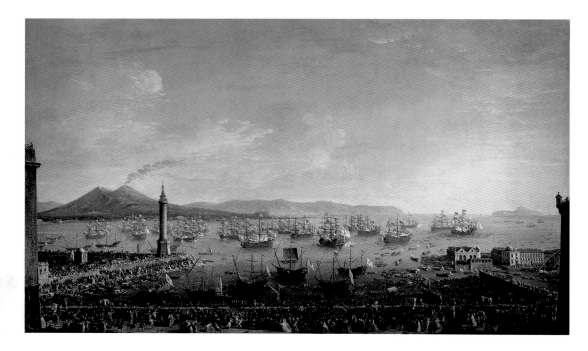

As an educated despot, Charles made sure that few areas of Spanish life remained untouched by his passion for national improvement. Some called him 'the Good Old King', others praised him as the first and only Enlightened monarch to rule in Spain. Under his benign sway historical and religious painting flourished. 'His Majesty is not indifferent to the advancement of the arts and much countenances his Royal Academy of Painting, Sculpture and Architecture', wrote an Italian visitor, Giuseppe Baretti, in 1760. Patronage of the Royal Academy of San Fernando, however, constituted only one outlet for Charles's ambitions. Many monuments to the Bourbon dynasty appeared and Madrid became a picturesque city: an exotic botanical garden was founded in 1774, and the gardens of the new Royal Palace were filled with statues of medieval Spanish kings. Military prowess revived, and history and scientific enquiry flourished; all these achievements were commemorated in visible form. The building of the Ministry of Marine in 1776 and the foundation of the Natural History Museum in 1771 were among the most significant memorials to Charles's reign. Grandiose architectural projects in Madrid, such as the embellishment of the new Royal Palace, were balanced by imagi-

24
Antonio Joli,
The Embarkation of Charles III from Naples,
1759.
Oil on canvas;
128 × 205 cm,
50 1⁄2 × 80 3⁄4 in.
Museo del
Prado, Madrid

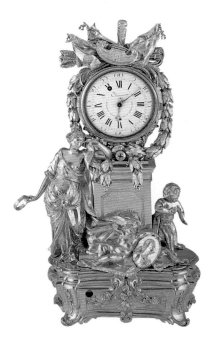

25
**Brothers
Cherost,**
Clock decorated
with allegorical
motifs in praise
of Charles III as
patron of the
arts and
sciences,
1771.
Gilt and bronze;
h.56 cm, 22 in.
Patrimonio
Nacional,
Madrid

native planning and extensive support for provincial economic growth. Roads and canals were built to link provincial regions, and new schools and hospitals were founded. Cities such as Cadiz, Barcelona, Segovia and Toledo were developed and beautified, and their native industries encouraged.

These enterprises link the period of Charles's reign with the social, political and philosophical aspirations towards progress that were characteristic of the wider phenomenon of the European Enlightenment. The king's supremacy as a patron of both arts and sciences was embodied in such creations as the elaborate clock made in 1771 by the French clock designers the Brothers Cherost (25): an object which combines skilled craftsmanship, stunning design and the most up-to-date mechanics. An austere and devout monarch, Charles was a man of considerable intellect who spoke several languages. As numerous artists settled in the capital, the king became the subject of many portraits. A phenomenally ugly man, whose distinctive features and austere lifestyle made him a particularly individual figure among the comparatively unremarkable Spanish Bourbon monarchs of the eighteenth century, he was to encourage

new gravity and realism in the art of his epoch. His favourite portrait of himself was the monumental canvas which Mengs painted in 1761, shortly after his arrival in Spain to take up his post as chief painter to the court (26). Mengs's clear, classical style endows the portrait with a sense of energy. The flamboyance of the king's gesture and the magnificence of his armour are balanced by his striking features: the huge nose, receding chin and brick red complexion.

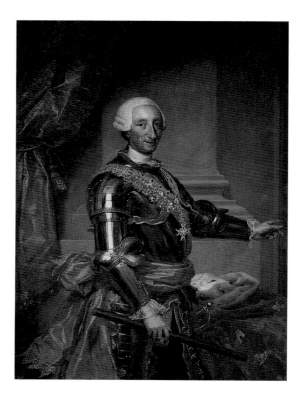

26
Anton Raphael Mengs,
Portrait of Charles III,
1761.
Oil on canvas;
154 × 110 cm,
60⅝ × 43⅜ in.
Museo del Prado, Madrid

27
Luis Paret y Alcázar,
Charles III at Dinner,
*c.*1770.
Oil on panel;
50 × 64 cm,
19¾ × 25¼ in.
Museo del Prado, Madrid

According to witnesses this image was accurate. A contemporary chronicler recorded that:

He was of middle size … And though narrow-shouldered was of a strong, athletic frame. His complexion, originally fair, was bronzed by the effects of his daily exercise, and the part of his face exposed to the weather formed a striking contrast with that which retained its natural hue. His features were strongly marked by a prominent nose and projecting eyebrows, and became harsher in proportion as they were affected by the advance of age.

In his portrait Mengs has deliberately emphasized both the monarch's athletic bearing and his ugly features, and such unrelieved precision became typical of Spanish portraits, even after Mengs had left the country. Goya himself espoused this same clarity of vision, and he too was to be quite uncompromising in his portraits of Spanish royalty. Certainly the king favoured the portrait by Mengs above all others: copies of it appeared on state documents, and replicas were sent

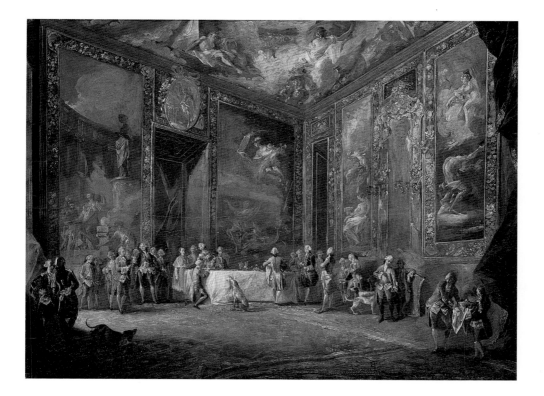

abroad to enter the collections of other European monarchs. Other more experimental portraits of Charles III also appeared, such as that by Paret, painted around 1770 (27). This shows the king at dinner: as he eats he receives ambassadors, petitioners and court visitors.

This public performance of an essential daily ritual was observed by many European royal families in the seventeenth and eighteenth centuries. Spanish monarchs punctiliously carried out traditional court duties which many foreign ambassadors found tedious. Again, contemporary descriptions reveal the accuracy of Paret's composition:

All the royal family dine publicly in separate rooms; and it is the etiquette to visit each apartment whilst they are at dinner, a most tiresome employ for those who are obliged to be there ... The last visit is to the King, who has a very odd appearance in person and dress; he is of diminutive stature with a complexion of the colour of mahogany; he has not been measured for a coat these thirty years, so that it sits upon him like a sack; his waistcoat and breeches are generally leather, with a pair of cloth spatterdashes on his legs. At dinner pages bring in the different dishes, and presenting them to one of the lords in waiting, he places them upon the table; another nobleman stands on the King's side, to hand him his wine and water, which he tastes, and presents on his knee; the primate is there to say grace; the inquisitor-general also attends at a distance, on one side, and the captain, who has the guard, on the other; the ambassadors are in a circle near him, with whom he converses for a short time.

This account of the king's dinner was written by Major William Dalrymple, who came to the Madrid court some fourteen years after Baretti. He refers particularly to the numerous officials in attendance on the king, and to the cardinal and inquisitor-general, both of whom were on hand to remind this Catholic monarch of the frailties of human existence.

Traditional paintings of human ambition and the glory of rank were replaced in eighteenth-century Spain by a more subtle, modern symbolism. The taste for an art which reflected insignificant details of everyday life permeated representations of grand historical events and popularized the imagery of the commonplace. Shortly before Goya arrived in Madrid young artists such as Paret had found new markets for contemporary scenes. Joli's depiction of Charles's embarkation (see 24) contrasts the warm blues and greens of sky and sea, the distant view of Mount Vesuvius and its volcanic cloud, with a meticulous elaboration of the clothes and accoutrements of the fashionable sightseers clustered in the foreground. Paret's painting of an antique seller's shop in Madrid (28) signalled the rise of a polished vernacular style with analogous contrasts and details of dress and objects carefully inserted to suggest the hierarchical nature

28
Luis Paret
y Alcázar,
*An Antique
Seller's Shop
in Madrid*,
1772.
Oil on panel;
50×58 cm,
$19\frac{3}{4} \times 22\frac{7}{8}$ in.
Museo Lázaro
Galdiano,
Madrid

of Spanish society. While royal portraits and the decoration of the throne room and principal reception rooms of the new Royal Palace in Madrid might glorify the power of the Bourbons and the growing prosperity of Enlightenment Spain, more popular images were also commissioned by the court and the aristocracy for less obvious propagandist purposes. While easel paintings, portraits, frescos and tapestries became part of the decorative refurbishment of society under the Bourbon monarchy, the life of the court itself was also reflected in art with a new objectivity.

During the reign of Charles III the artistic influence of Mengs pervaded the style of public images showing classical and sacred history, but this influence also extended to a celebration of the contemporary. As a consequence, younger painters were introduced to a new clarity and realism, even in low-life subjects, and the role of Mengs was especially crucial in the perceptive encouragement he gave to talented students. He had already singled out Paret as

a promising beginner, and he also encouraged Francisco Bayeu, employing him in the decoration of the Madrid Royal Palace. It was through his professional patronage of the Bayeus that Mengs noticed Goya. In fact, Mengs promoted the careers of a number of Spaniards who were to form the next generation of major artists at the Madrid court. It was on his recommendation that Goya and his second brother-in-law, Ramón Bayeu, on their arrival in Madrid in January 1775, were immediately offered work at the Royal Tapestry Factory of Santa Bárbara, since, among his many other court duties, Mengs had been created director of the factory. This establishment had been founded in 1721 by Charles's father, Philip V, in emulation of the great Gobelins tapestry factory in France. The modernization of Spanish society under the Bourbons had included the elevation of both fine and applied arts, and, just as Charles had brought the Capodimonte workshop from Naples to establish in Spain a centre for fine porcelain, so his promotion of his father's tapestry establishment signalled the revival of another native industry and fashionable aesthetic enthusiasm.

The new Royal Palace in Madrid contained a unique collection of Flemish tapestries which Spanish monarchs had bought or commissioned in the sixteenth and seventeenth centuries. Paret's painting of Charles at dinner (27) is a monument to the triumph of the tapestry as decoration and a sign of contemporary taste. Decorated with hangings showing huge allegorical scenes, the walls of the great dining salon dwarf the real-life figures, serving to set the transience of human life against the lasting value of great art. However, beyond the confines of royal palaces, tapestries played a particularly symbolic role in Spanish life, as well as furnishing practical interior embellishment. Immensely prized by Spanish aristocrats, the tapestry denoted social status and wealth, and even the lower classes took pride in the skills of native weavers. On special public occasions, such as the royal progress and coronation of Charles III, wealthy families hung tapestries from the balconies of their town houses, while the streets of Madrid were decorated with humbler examples of woven pictures (29). The skills of the weaver also came to prominence in new-style palace decoration.

29
Attributed to Lorenzo de Quirós, *Triumphal Arch in the Calle Mayor in Madrid,* c.1761. Oil on canvas; 112 × 163 cm, 44 1/8 × 64 1/4 in. Museo Municipal, Madrid

Paret's painting shows the dining room of Charles III hung with erotic mythological subjects. Changing taste at the Royal Academy and the influence of Mengs, however, favoured the simple grandeur of virtuous classical subjects, and in the moral climate of later-eighteenth-century enlightened taste, even the applied arts were subject to aesthetic purification. Exuberant tapestry designs in the earlier Baroque and Rococo styles, and their erotic subject matter, were superseded by emblems representing ideas of renewal, improvement and virtue couched in subjects of restrained simplicity. The new realism of portraiture, a taste for contemporaneity in art and, above all, the effects of the Enlightenment on public life throughout Spain, made

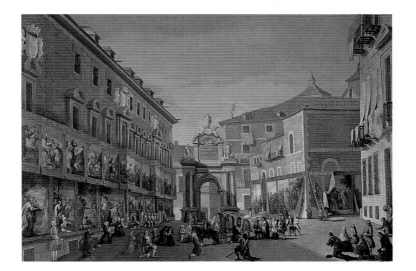

such new themes a crucial ingredient of the modern tapestry. Looking back to the imagery of earlier Flemish and Dutch tapestries with their emphasis on rural pursuits and a simple lifestyle, Spanish weavers devised a more updated programme of that type of subject matter.

In the royal dining room, as painted by Paret, the only creatures to roam freely are the king's hunting dogs. Hunting was the sole recreation that Charles III permitted himself, and he was said to love his dogs more than his children. 'He goes out a-sporting every day of the year, rain or blow, whilst at Madrid, once a day, in the afternoon; but in the country, morning and evening … The country all around his

palaces is enclosed for his sport', wrote Dalrymple. This was not unusual for Spanish monarchs; game hunting within an enclosed park had been traditional since the emperor Charles V first introduced the practice into Spain. In the 1630s Velázquez (with the aid of his assistants) designed one of his most popular works, *Philip IV Hunting Wild Boar (La Tela Real)*, which shows the Habsburg monarch within a *tela* or enclosure probably near El Pardo just outside Madrid (30). In the early sixteenth century Charles V had built a royal hunting lodge at El Pardo which was extended into a palace in the early 1770s, shortly before Goya arrived in Madrid. He and Ramón Bayeu were

30
Diego
Velázquez
and assistants,
*Philip IV
Hunting Wild
Boar (La Tela
Real)*,
c.1632–7.
Oil on canvas;
182 × 302 cm,
71³⁄₄ × 119 in.
National
Gallery,
London

first employed by the Royal Tapestry Factory to paint cartoons (*ie* designs for weavers to copy on looms) for tapestries destined for El Pardo. The subjects had already been worked out for the young artists, probably by Mengs and Goya's oldest brother-in-law, Francisco Bayeu. These included scenes of the hunt and the lives of huntsmen; and, given this traditional interest of the kings of Spain, it is not surprising that country life, sport and rural pursuits figure so largely in tapestry design of this period.

31
*The Wild
Boar Hunt*,
1775.
Oil on canvas;
249 × 173 cm,
98¹⁄₈ × 68¹⁄₈ in.
Royal Palace,
Madrid

Goya's first nine cartoons became part of a series of tapestries on the theme of hunting. They are the artist's earliest works to express his lively painterly response to a popular sport. Beginning his court career as a designer of cartoons, he was plunged into the production of everyday subject matter in a way that was to influence greatly the future direction of his creative vision. His first large cartoon portrayed the killing of wild boar (31) and was produced in collaboration with the Bayeus. This picture has a sense of immediacy and action which challenges the more courtly and elegant rendering of the same subject by Velázquez. *The Wild Boar Hunt* concentrates on a violent tussle between man and beast. Throughout these designs the importance of creatures – dogs, horses, birds; both dead and alive – becomes crucial to the compositions and equals the importance of the men. The rural setting is little more than a backdrop, and men and animals are isolated within the countryside. Even in the awkwardly narrow strips intended for wall-panel hangings, designs of a huntsman with his dogs setting off for a day's sport, or fishermen, seem absorbed in the wildness of nature. Goya's drawings of huntsmen (32) reveal a new technical proficiency and ease with the subject of skilled professionals efficiently performing their jobs. In such works nothing is left to chance, and the artist probably used life-models for the figures. Even an image of boys, embarking on a hunt of their own, expresses a strong feeling of individual physicality. It includes a detail of an owl perching on a pole that transforms the traditional subject into a new type of composition replete with intriguing symbols.

Although these hunting scenes are not his most original works, Goya evidently saw the whole enterprise as one in which he might eventually be free to devise his own subjects within the given format, since these early images express a sense of energetic commitment. In 1776, when he had been working at the factory for a year, he was commissioned to produce cartoons for the royal dining room in the palace at El Pardo. This was intended as a residence for the crown prince, the Prince of the Asturias (Charles III's heir), who was to become one of Goya's staunchest patrons. Unlike the king's dining room that had been painted by Paret, this dining room was to be hung with tapestries depicting popular country scenes and pastimes.

32
Two Hunters,
1775.
Black chalk
heightened
with white;
33·8 × 43 cm,
13³⁄₈ × 17 in.
Museum of Fine
Arts, Boston

Goya's cartoons are filled with figures dancing, fighting, drinking, having picnics, playing cards, flying kites and flirting. *The Parasol* (33) introduces the figures of *majo* and *maja*. These types, clearly identifiable by their costume and demeanour, can be described as 'heroic artisans', and they held a particular political significance for the lower classes in Madrid. They generally worked as servants, lackeys or small-scale entrepreneurs, though occasionally their activities crossed the line between honest industry and crime. *Majos* and *majas* were immortalized in music halls and theatres of the period. Their exotic dress and free behaviour were imitated by aristocratic admirers, and their appearance in the new programme of royal tapestry designs reflected the shift in taste towards popular contemporaneity and the idealization of the simple rustic life. Apart from the *majo* and *maja*, their children also furnished moralizing folk symbols, representing the innocence of rural pleasures. Goya's boys are well-fed, active and mischievous, at play in the countryside, blowing up a pig's bladder (23 and 34) or climbing a tree in search of forbidden fruit. Although these subjects contain the traditional symbolism of the fleeting qualities of youth and human happiness, Goya also paints adults in the midst of childish games, *majos* and *majas* who indulge in kite flying while others take part in conspiracies of love and honour. The observation of human behaviour is particularly acute and, when presenting his bill for the pictures, Goya was to write for the first time that they had been painted according to 'his own invention'.

This bold gesture of individuality betrays Goya's passion for artistic independence, although his subject matter still adhered to tradition. Ramón Bayeu produced cartoons showing children, country pursuits and Spanish domestic life in the eighteenth century. *Christmas Eve in the Kitchen* (35) comes from a series of small cartoons. The children play games and sing Christmas carols; one is blowing a balloon-shaped Calabrian bagpipe, another has pan-pipes, yet another a strange, archaic stringed instrument. The picture seems designed to memorialize the lives of ordinary people in Spain, while simultaneously exuding a cosy sense of peace and prosperity. The children are shown to be innocently employed in traditional and virtuous ceremonials, expressing the purity of the simple life. Goya's figures have

33
The Parasol,
1777.
Oil on canvas;
104 × 152 cm,
41 × 59⅞ in.
Museo del
Prado, Madrid

34
*Boys Blowing
up a Bladder*,
1778.
Oil on canvas;
116 × 124 cm,
45¾ × 48⅞ in.
Museo del
Prado, Madrid

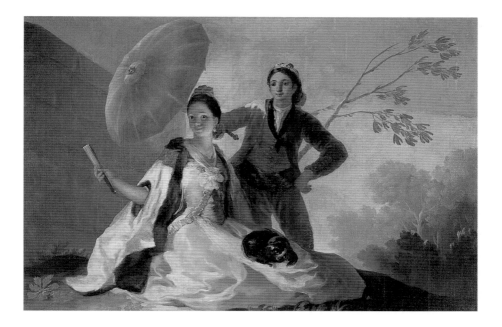

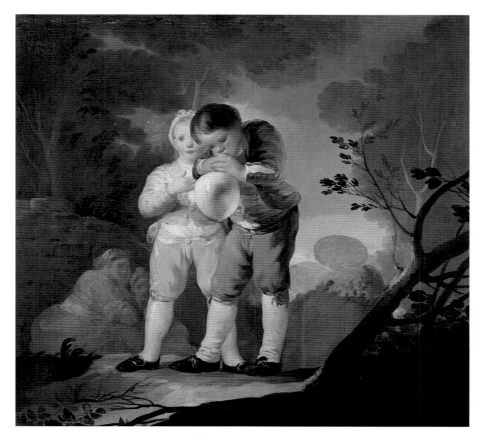

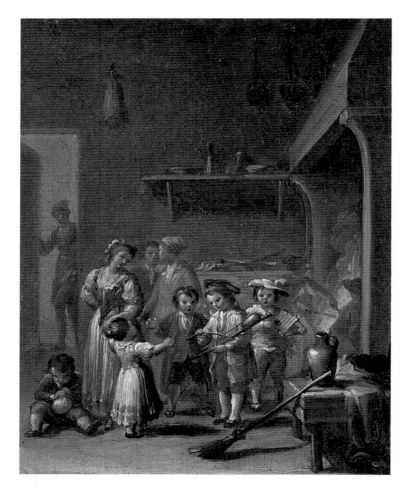

35
Ramón Bayeu,
*Christmas Eve in
the Kitchen*,
1786.
Oil on canvas;
19·3 × 15 cm,
7⁵⁸ × 5⁷⁸ in.
Museo del
Prado, Madrid

more energy than those painted by his brothers-in-law. His painting of a country picnic shows tough, rumbustious Spaniards drinking and enjoying themselves in a wide landscape (36). Francisco Bayeu's picnic scene of a few years later is more refined (37), the picnickers are weighed down by their costumes and seem self-consciously picturesque as they crowd around the wine bottles, loaves and pies.

Goya's early cartoons are the closest he ever came to distilling something like the classical Arcadian idyll – an idealized pastoral world where shepherds and shepherdesses lead pure, unburdened lives – from the bleak, poverty-ridden grind that comprised the lives of the Spanish rural poor. These programmatic schemes for palace tapestries reflect the fashion for simplicity, and Goya was keen to show his mastery of this type of subject. Nevertheless, even while fulfilling professional demands for images of enjoyment, hedonism and prettiness, Goya was unable to suppress that more rebarbative artistic vision which had appeared in some of his earlier images and even in the sketches of his Italian notebook.

His early years in Madrid were hard, shadowed by financial insecurity, and it is ironic that while he painted happy children enjoying the virtues and pleasures of Spanish rural life, his own children died in infancy. On one page of his Italian notebook Goya inscribed the full names of some of his children, together with their dates of birth, but he does not inscribe their deaths. To date, the loss of seven children has come to light: the first, Antonio Juan Ramón, born in Saragossa on 29 August 1774; then, in December 1775, when Goya and his wife had been settled in Madrid for nearly a year and he had already completed his first tapestry cartoons, Eusebio Ramón was born. Vicente Anastasio came in January 1777, Josefa Goya then had a miscarriage six months into her next pregnancy. The first daughter, María Pilar Dionisia was baptized in Madrid in October 1779. Francisco de Paula Antonio followed in August 1780 and another daughter, Hermenegilda, in April 1782. It was not until 1784 that Goya's son Javier, his only child to live to maturity, was born. The strain of enduring the deaths of his children, together with the requirement to paint pictures of people enjoying themselves, may

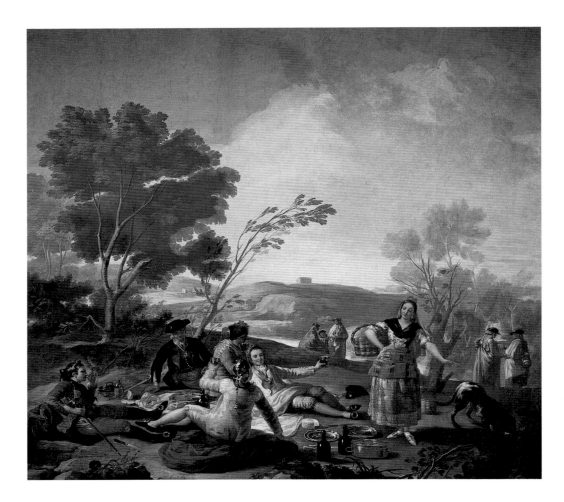

36
The Picnic,
1776.
Oil on canvas;
272 × 295 cm,
107 ¹⁄₈ × 116 ¹⁄₄ in.
Museo del
Prado, Madrid

have engendered in the young Goya a desire to turn his hand to something different, and indeed a more uncompromising style appears in much of the work he made during the late 1770s and 1780s.

In 1778 one of his largest, most ambitious and original tapestry designs was initially rejected by the weavers at the tapestry factory. *The Blind Guitarist* (38) expresses for the first time the artist's recurring fascination for infirm, outcast mendicants. The head of this sightless beggar is tilted backwards and forms a conflation of distorted features (39). The tapestry factory rejected the composition, osten-

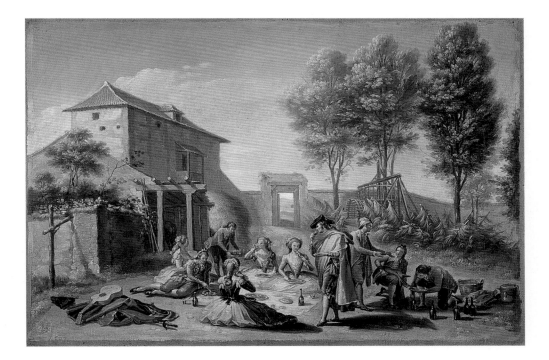

37
Francisco Bayeu,
A Country Picnic,
1784.
Oil on canvas;
37 × 56 cm,
14 ½ × 22 in.
Museo del Prado, Madrid

sibly because it contained too many figures; Goya returned a corrected version to the factory, without altering the face of the musician, and then transferred part of the original design into the largest etching he ever made.

This unconventional image marks the moment when Goya's art began to diverge drastically from the art of his contemporaries. The grotesque features of Goya's blind musician have a harsh, ironic quality, distinguishing the composition from other tapestry designs of the

38–39
*The Blind
Guitarist*,
1778.
Oil on canvas;
260 × 311 cm,
102 ½ × 122 ½ in.
Museo del
Prado, Madrid
Right
Detail

same subject. Paintings, prints and cartoons of singers, musicians and street performers with their attendant audiences, in which peasants and gentlemen rub shoulders, had formed one of the most extensive and well-loved themes in popular European art of the seventeenth and eighteenth centuries. In the 1740s a visiting French artist, Louis-Michel van Loo (1707–71), portrayed the whole Spanish royal family at a concert of well-dressed musicians, and Goya's contemporaries and predecessors at the Spanish court painted elegant musical evenings taking place in well-educated households, as well as designing images of low-life musicians and street performers for tapestries, porcelain and prints. *The Charlatan* by Giandomenico Tiepolo (1727–1804; 40), who came to Spain from Venice with his father in 1761, shows a street entertainer and salesman who commands more attention than clowns, beautiful masked courtesans or the solemn members of a religious procession. Although Goya obviously admired the Venetian street musicians painted by the younger Tiepolo, he would have seen blind musicians begging in the streets of Madrid, and the strength of his own perception of eccentrics, outcasts and the disabled developed into part of his taste for irony. In this way his cartoons became the most original to be produced in Spain, and brought him to the notice of the royal family.

In January 1779 Charles III, his son, the crown prince (who subsequently became Charles IV), and his daughter-in-law, the future Queen María Luisa, all publicly admired several of Goya's large tapestry cartoons. 'I kissed their hands for I have never been so happy', exulted Goya. 'I could not have wanted for more as regards their appreciation of my work, the pleasure with which they viewed it and the congratulations I received from the king, especially from their royal highnesses – and, finally, from the entire nobility.'

One of the cartoons that was so admired by the royal family, *The Fair in Madrid* (41), depicts a huckster and dealer in second-hand goods trying to persuade a foppish nobleman to buy a painting. This ironic theme of people masquerading in public, often pretending to be something they are not, was to resurface in Goya's later work, for example the print series *Los Caprichos* ('The Caprices') published in 1799 (see

40
Giandomenico
Tiepolo,
The Charlatan,
1756.
Oil on panel.
Museu d'Art de
Catalunya,
Barcelona

41
The Fair in
Madrid,
1778.
Oil on canvas;
258 × 218 cm,
101 5/8 × 85 7/8 in.
Museo del
Prado, Madrid

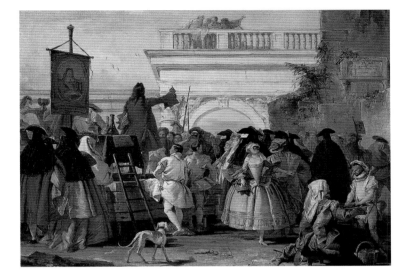

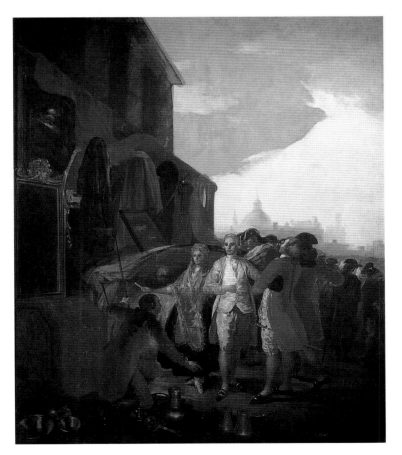

59 Bourbon Patronage and Tapestry Cartoons

Chapter 5). The royal family's approbation obviously encouraged him to pursue his own vision, but his subsequent success was in direct contrast to the sad fate of Luis Paret, who some years earlier had been similarly noticed by the Bourbons, and had suffered as a result.

As one of the most popular artists at court and the Academy, Paret had won his reputation by introducing a moral seriousness into the realities of his contemporary scenes. Such was his renown that he became the protégé of the king's younger brother, the Infante Don Luis de Borbón. This signal mark of favour, however, caused his downfall. Custom decreed that the Infante Don Luis should enter the Church. In 1774 as Cardinal Archbishop of Seville and Toledo, the prince was also popular at court. Major William Dalrymple wrote that: 'Don Luis, the King's brother … is the lowest in rank; he is the strangest-looking mortal that ever appeared, and his dress is not more peculiar than his person … he is of a most humane disposition, and is universally esteemed.' The following year, however, a scandal occurred concerning Don Luis which ruined Paret's career almost as thoroughly as that of Luis Meléndez, the still-life painter who had been cast out of court because of his father's indiscretions. Although Paret himself was an extremely circumspect man, in 1775 the prince, his patron, was discovered to have been pursuing a number of sexual intrigues with women procured for him by his servants. He was forced to leave the Church and contract a morganatic marriage with a wealthy heiress. Unable to be received at court, mainly because of his reputation as well as the nature of his marriage, the prince and his wife were sent to live on a large estate at Arenas de San Pedro near Avila, and in an effort to hush up the scandal, the prince's servants were also banished. Paret came under suspicion of having pimped for his master and, in the morally stringent atmosphere of the 1770s, this put an end to his court career. In the autumn of 1775 he was packed off to serve a term of exile on the island of Puerto Rico.

The loss of such a promising young master at this time left the court in Madrid more open to Goya, whose early career had been much less promising than Paret's, but whose prospects had moved far in advance of his rival. Redefining images of peasants in the tapestry

cartoons, investigating the possibilities of a less decorative court style, and injecting grim morals into real-life issues, were to become the principal features of Goya's burgeoning talent. The plight of Paret, the exiled painter, was unpromising; loss of royal favour was as disastrous as the loss of friends and the right to live in his native city. In 1776, when Goya completed his first picnic scene for the tapestry factory (see 36), Paret painted his first self-portrait on Puerto Rico, showing himself alone in a stormy landscape, reduced to the utmost poverty, dressed as a barefoot peasant carrying a machete, trying to hack a living out of the untamed landscape, his name and age inscribed on a crumbling fragment of a ruined classical building. This stark reminder of the brevity of life and talent is fantasy: Paret was not forced to work on the land but was in fact earning a living as a portrait painter. Nevertheless, he felt his disgrace keenly enough to send this self-portrait to Charles III as a visual petition, and in the following year his sentence was mitigated to internal exile in northern Spain.

Goya too was aware of the fragility of artistic ascendancy and the jealousy of colleagues. The death of Mengs in 1779 meant that there was a vacancy among the salaried court artists. Goya applied for the post, but was turned down on the grounds that,

he [Goya] shows great promise of improvement. Since ... there is no great urgency, and no present lack of painters to execute the works required by the court ... the applicant should continue to paint for the Tapestry Factory ... and so prove his progress and skill, in order that this may be taken into account at some future date, according to how the King should decide.

A year later Spain was at war with England, and the resulting economic stringencies reduced the number of public works. The tapestry factory was temporarily closed.

Before the closure of the factory Goya devised a new cartoon which he described as depicting 'four young men amusing themselves with a young bull' (42). The figure who swings around to face the spectator has a particularly distinctive face. Often regarded as a self-portrait,

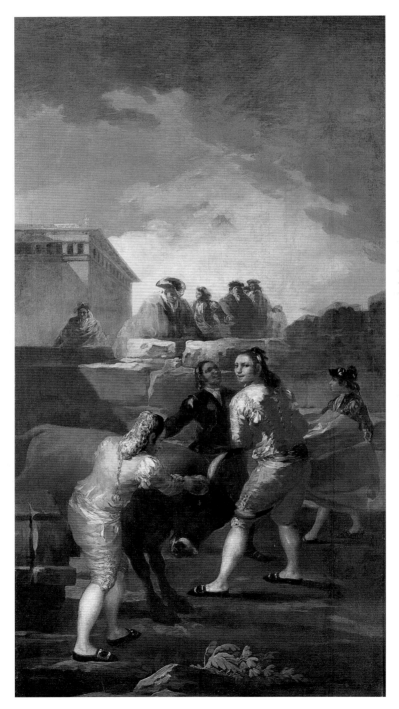

42
*Amateur
Bullfight*,
1780.
Oil on canvas;
259 × 136 cm,
102 × 53 ½ in.
Museo del
Prado, Madrid

43
*The
Rendezvous*,
1780.
Oil on canvas;
100 × 151 cm,
39 ⅜ × 59 ½ in.
Museo del
Prado, Madrid

this young amateur matador may hold personal significance, since Goya and his three brothers-in-law were all devoted bullfight enthusiasts. These young amateurs are in the prime of life; the central figure with his movement arrested in full swing, tilts up his face so that it catches the light. This scene of confrontation between youths and a young bull was one of a number of tapestries destined to hang in a bed- and antechamber at El Pardo. Goya devised two contrasting cycles of images: a celebration of ease and youth showing beautiful women and sturdy men indulging in sexual by-play; and the young amateur matadors, among soldiers, washerwomen, a doctor, woodcut-

ters, the *Blind Guitarist* and an atmospheric study of sexual disappointment, known as *The Rendezvous* (43). A girl waits for her lover in vain; her sensuous body swathed in her best clothes droops on blue drapery concealing a pile of rocks. Goya's inventory states that her companions are 'watching her sadness'. Here, the purity of virtue and innocent pleasure ultimately point only to the brevity of human happiness. The young provincial trying his hand at a country bullfight is not as bleakly impoverished as the wretched Paret's self-portrait as a banana-harvester, but nevertheless the idyll was undeniably beginning to disappear from Goya's art.

The struggles of his first Madrid years and the striking achievement of the early tapestry designs demonstrated Goya's potential greatness. By 1780 he could look forward to a successful career as a prosperous man, devoted to collecting flashy clothes, jewellery and going hunting. In his *Portrait of Charles III in Hunting Costume* (44), his chief patron, Goya seems to have looked back to the face of the king as painted by Mengs, but here the king is portrayed as a huntsman in a wide landscape. This portrait marks the point at which Goya progresses from his early hunting scenes to creating the portrait idiom of the true court artist, reflecting the enthusiasms of his protectors. But he was also to become a cautious, private and basically sceptical man, who viewed both the exalted and the humble of his own society with a clear and critical eye. Indeed, in the following years, Goya himself was to face humiliation, failure, hardship and illness. Even the 1780s began inauspiciously with a chaotic and acrimonious public commission which put Goya at odds with his provincial background, gave him a controversial public reputation, and caused deep divisions within his family circle.

44
Portrait of Charles III in Hunting Costume,
c.1786–8.
Oil on canvas;
206 × 130 cm,
81¹⁄₈ × 51¹⁄₄ in.
Private collection

3

As the tragic deaths of his children and the struggle to fulfil professional ambitions began to impinge on his work, so Goya continued to evolve a predilection for realism in his art. In this he was not alone. Alongside the elegance of hunting and the sentimentality of children's games, the Neoclassical simplicity which Mengs had introduced into Spain was supplanted by a darker vision. In Madrid scholars debated the true nature of Spanish art; some saw realistic and brutal subject matter as part of the Spanish artistic tradition. In his Italian notebook, Goya had tentatively explored the way that earlier artists had transformed violence and ugliness into masterpieces. After he and his wife moved to Madrid, he committed himself more positively to independent work and developed a more aggressive sense of his own status. Even before the move one of his brothers-in-law described him as 'always working', and in Madrid Goya began a number of freelance enterprises that were inspired by serious and tragic themes.

45
*St Isidore,
the Patron Saint
of Madrid,
c.1778–82.*
Etching;
23 × 16·8 cm,
9 × 6⅝ in

His public role as a tapestry designer had afforded him a living and helped him extend his powers in oil painting, sketches and prints. However, the salary of a tapestry designer was meagre and his works would not have been seen outside the court. Consequently, Goya needed a much greater public medium to establish his career. Although there is no record of where or when he learned to etch (a technique of engraving in which the design is bitten into a metal plate with acid), printmaking was to become a favourite medium for Goya. The effect of living in a large capital city after a childhood and youth spent in the provinces may have inspired the artist to see the city as a subject in its own right. In tapestry cartoons he had occasionally represented scenes involving *madrileños* (inhabitants of Madrid), *majos* and *majas*, and which took place against a painted background of the city. Madrid continued to intrigue Goya, and, in one of his early etchings, he shows the patron saint of the Spanish capital, St Isidore the Husbandman (45).

This twelfth-century agricultural labourer and ploughman, revered for his work among the dispossessed, was canonized in 1622; a pauper saint who became celebrated in effigy with festivals and processions held in Madrid. St Isidore, specifically associated with the city's poor, symbolizes the importance that the Spanish capital assumed in Goya's art. In much of the artist's best work Madrid becomes objectified: a city tormented by war and busy in peace-time; inhabited by the elegant and wealthy, yet teeming with crimi-nals, tarts, the ignorant and oppressed, and the ordinary working people (including salesmen, market-goers and innocents up from the country). While Rome may have opened his eyes to what could be achieved in painting, Madrid was to offer him images of the conflicting patterns of human behaviour in an age of continual crisis and change.

Apart from his public ambitions, Goya's work in general reveals a morbid interest in crime and violent death, and in the 1770s and early 1780s he may have been encouraged in this by the moral climate and the humane interests of his patrons. Scenes involving criminals, execu-tions and social injustice formed the antithesis of the rural idylls in Goya's tapestry cartoons. The penal system and the constant threat of crime in a country which had no national police force until the acces-sion of Joseph Bonaparte in the early nineteenth century provided subjects for art even more topical than Paret's representation of the antique-seller's shop or Joli's painting of Charles III's embarkation at Naples. Goya was undeniably the first major Spanish artist of the eigh-teenth century to broach this darker side of life. Around 1778 he produced an etching of another lone figure, *The Garrotted Man*, which he first sketched out carefully in crisscross strokes of brownish ink (46), and then transferred to an etching plate (47).

The fearful ceremonial of garrotting is the shadow side of the glitter-ing rituals painted by Goya's fellow court artists. The *garrote* was the Spanish means of executing criminals, although firing squads were also used. Taken to the scaffold in public, usually in a horse-drawn cart, the victim was seated with his head and neck fastened to an upright post by an iron collar. Originally a cord was put around the

victim's neck, and the executioner either worked a lever at the back of the collar or twisted the cord by means of a stout stick or cudgel. The aim was to dislocate, or even sever completely, the spinal column at the base of the brain. A large procession of priests invariably officiated on such occasions: 'He was conducted to a small wooden seat affixed to a post, firmly fixed in the ground. Being seated the cord which tied his arms together was carried round his body and the post ... An old Capuchin pressed the Cross to his lips.' This account describes a public execution in Spain witnessed in 1803 by the English diplomat, Charles Vaughan. Although Vaughan describes a firing squad rather than a garrotting, he was above all revolted by the show of religious fervour. Effigies of the Virgin and the dead Christ ('The most disgusting thing I ever saw', wrote Vaughan) were carried alongside the condemned man, who was also surrounded by large numbers of monks and priests.

Unlike visual chroniclers of public executions in other parts of Europe, whose prints of these events fed a widespread appetite for melodrama, Goya portrays his victim shortly after the execution has taken place. The corpse is seated in a bleak cell where the play of light and his tightly clasped hands suggest that he is a martyr rather than a criminal. Shying away from the documentary accuracy of the full panoply of public execution, Goya preferred to set his garrotted man alone in an unspecified interior. A hint of spirituality smoulders in the glimmering flame of the tall candle, and in the compassionate delicacy of the lines describing the dead man's facial expression (48). This man's outstretched bare feet and penitent's robe have a monumentality which Goya derived from earlier paintings of martyrdoms, as well as from his examination of classical statues in Italy.

He also studied the works of the Old Masters, particularly Velázquez, that were in the royal collection and in 1778–9 made a number of drawings after Velázquez's most famous paintings. The physicality of human figures, painted so eloquently by Velázquez, clearly inspired Goya in his search for a new purity of emotion and direct vision. One of the first major Spanish artists of the eighteenth century to scrutinize Velázquez's style, analyse it and absorb the main principles

46
Drawing for
*The Garrotted
Man*,
*c.*1778.
Sepia ink
over pencil;
26·4 × 20 cm,
10$^3_8$ × 7$^7_8$ in.
British
Museum,
London

47–48
Above right
*The Garrotted
Man*,
*c.*1778–80.
Etching;
33 × 21·5 cm,
13 × 8$^1_2$ in
Below right
Detail

into his own compositions, Goya nurtured a professional admiration for the Sevillan genius who had dominated Spanish court art in the seventeenth century. His ambitions to improve Spanish art by turning for inspiration to the heroism of ordinary life were vindicated by the example of Velázquez, and there is an echo of Goya's personal artistic enthusiasms in the way that Velázquez was described by eighteenth-century biographers.

The earliest collection of biographies of great Spanish artists had appeared in 1724, written by the first major Spanish art historian, the painter Antonio Palomino (1655–1726). Here Velázquez is described as a man of virtue whose moral subjects drew particular strength from his courage in depicting low-life character:

He availed himself of his richness of invention and took to painting rustic subjects with great bravado and with unusual lighting and colours ... Some reproached him for not painting with delicacy and beauty more serious subjects in which he might emulate Raphael, and he replied politely by saying that he preferred 'to be first in that sort of coarseness than second in delicacy'.

Palomino saw the precedent for such boldness in the spirit of ancient Greek artists: 'Those who have been eminent and shown perfect taste in this kind of painting have become famous. It is not just Velázquez who followed such lowly inspiration; there have been many others who were led by this taste and the particular character of its idea.'

The simple realism which Velázquez exhibited in his works of everyday subjects was also discernible in the naturalism of his state portraits. Goya published his first set of magnificent engravings after Velázquez's paintings in July 1778. The nine etchings consist mainly of portraits of Philip III and Philip IV, but Queen Isabel and Prince Balthasar Carlos also appear. Goya's interest in Velázquez's portraits indicates that he had already foreseen his own commitment to formal state portraiture, and his copies were free adaptations rather than replicas. He also etched Velázquez's portraits of the philosophers Aesop and Menippus and the court dwarves (49). The greatest of Velázquez's works, dated 1656, is *Las Meninas* (50). This complex painting, in which the daughter of Philip

IV poses with her maids of honour (*meninas*) in a strange dark room
in the royal palace, features the elegant figure of the artist himself,
dressed in his court costume as the king's major-domo. He surveys
the scene and prepares to put a touch to the painted canvas. In the
eighteenth century Velázquez's great picture became the most highly
prized item in the Spanish royal collection, which also contained works
by Titian (*c*.1485–1576), Raphael (1483–1520), El Greco (*c*.1541–1614)
and Pieter Bruegel the Elder (c.1525–69). The Bourbon monarchs and
their academic administrators prized this portrait because of its intel-
lectual content as well as its technical virtuosity. In his copy of this
work (51) Goya deliberately transformed the composition into a more
wilfully personal interpretation, but did not publish the print.

Although Goya never completed the larger set of prints that he had
originally contemplated producing, he was sufficiently satisfied with
his set of nine etched portraits after Velázquez to advertise them for
sale in July in the official government newspaper, the *Gaceta de Madrid*.
In December he offered a further two printed copies after Velázquez.
To achieve a depiction of substance and shadow, he had developed
an unorthodox etching technique, a bold method isolating the gaps

50
**Diego
Velázquez**,
Las Meninas,
1656.
Oil on canvas;
318 × 276 cm,
125 ¼ × 108 ¾ in.
Museo del
Prado, Madrid

51
Las Meninas,
c.1778–85.
Etching and
aquatint after
Velázquez;
40·5 × 32·5 cm,
16 × 12 ¾ in

between lines, including the white of the paper as part of the texture, and imparting a raw sense of energy to the final image. By 1779, when Goya executed his version of *Las Meninas*, he was already experimenting with a new engraving technique, that of aquatint, which employs acid-resistant varnish to create pools of shadow and soft stippling, reminiscent of watercolour or chalk, and which was to become so crucial to his production of the *Caprichos* some twenty years later (see Chapter 5).

The publication of his prints won Goya praise from visiting foreign diplomats, colleagues and scholars. Such tributes to his skill and originality ensured an encouraging reception for the prints and revealed a new enthusiasm for Velázquez, whose realism had begun to rival the popularity of the foreign styles of Mengs and Tiepolo. Mengs himself had even advised young artists to study Velázquez. In a state of growing nationalism, Spaniards looked back to their native artistic traditions, and Goya was perceived to be in the vanguard of fashionable taste. In this way the artist made powerful friends, such as the poet, lawyer and leader of the Spanish Enlightenment movement, Gaspar Melchor de Jovellanos, who was to nurture Goya's talent for more than twenty years. In 1781 Jovellanos gave a lecture at the Royal Academy in which he praised the foreign, classical art of the, by then dead, Mengs, but he also devoted more space to the great Spanish painters of the seventeenth century, such as Velázquez, José de Ribera (1591–1652), Francisco de Zurbarán (1598–1664) and Bartolomé Esteban Murillo (1617/18–82), who had bequeathed specifically Spanish artistic values to the world. Realistic and profoundly emotional, pictures by these eminent masters portrayed the dark side of life, as well as the beauties of nature. Old people, the deformed, sick and dying were never considered too ugly for a Spanish painter's brush. Whether or not Goya heard Jovellanos's lecture, he would almost certainly have shared such sentiments. Committed to energetic realism and an unflinching analysis of the world, as well as to beauty and elegance, his art caught the mood of a society that was becoming increasingly introverted and self-analytical.

As in England, where the foundation of the Royal Academy of Arts in London in 1768 had provided a centre for British artists to promote national styles and ideas, so Madrid with its Royal Academy became the aesthetic focus for the revival of national art. In 1780 Goya obtained the coveted position of *académico de mérito* (academician) at the Royal Academy, and the piece he submitted for the competition again indicates his sensitivity to prevailing fashion and political expediency. *Christ on the Cross* (52) is a smoothly painted male nude devised as a tribute to Mengs, who had been particularly helpful to Goya in his early career and had died the previous year. Goya's heroic painting is dramatically conventional but is also imbued with a humane and positive physicality that recalls the martyred isolation of *The Garrotted Man* (see 46–48). Later, Goya used this theme in equally grim but secular subjects: people in prison, facing execution; the vulnerable and rejected who, in isolation, fall prey to dark fancies and forces. Just as his print of *St Isidore* (see 45) shows the lonely image of a saint in supplication, so the tormented and persecuted figure of the prisoner, the condemned man and the isolated artist enter Goya's work in the years 1778–80, and remain until the end of his life.

Charles III's impetus to modernize all sections of Spanish society, from industry to education, extended to the Church as well as the preservation of the privileges of the ruling élite. While in some ways the century saw an improvement in the lives of ordinary people, mirrored by an increase in population, there was also a corresponding increase in crime and unemployment. In Spain the power of the nobility ensured that there was little opportunity for social mobility, yet even the most powerful families could not escape the gradual erosion of their areas of political and social control, as new ideas and political movements gathered pace throughout Europe. Nowhere is this more noticeable than in the controversial position of the Catholic Church in Spain during the eighteenth century.

The role of the Church varied from region to region, as did its power over people's lives. Strictures regarding religious painting were stringently applied in some places, while in others changes were allowed. The difference between church painting in the provinces and in large

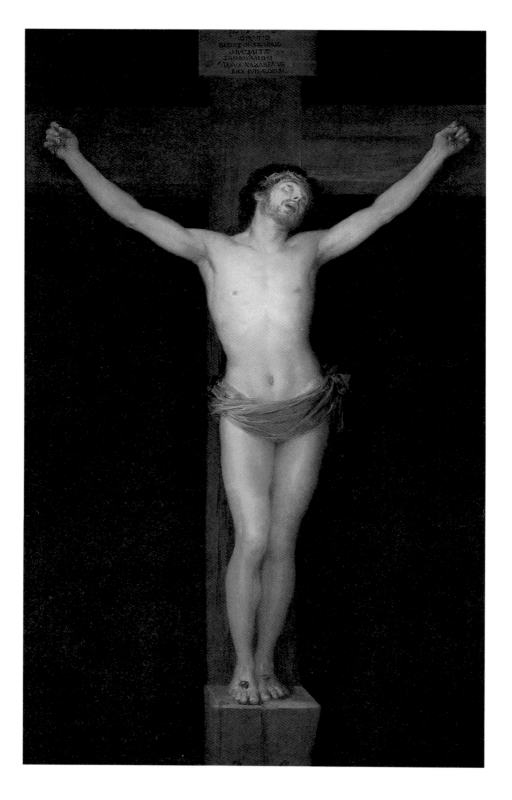

urban centres became a matter of debate. Sophisticated connoisseurs, for example, expressed disgust at the lavish ornamentation and conventional prettiness of provincial depictions of the Virgin Mary and famous local saints. At a time when the Catholic Church in Spain felt itself to be vulnerable, the position of the Church artist, especially in provincial regions, was especially sensitive.

Despite the demands made on Goya in Madrid, he retained his connections with Saragossa, where the wealth of the Cathedral of El Pilar (53) and the devoutness of local congregations made the city an important centre for ecclesiastical art. Religious ceremonies held at El Pilar were said to be among the most lavish in Spain and foreign visitors remarked on the richness of the cathedral interior. The figure of the Virgin was covered by a dress of silver and precious stones; sacred utensils used in services were solid silver and the vestments of the clergy were breathtakingly opulent, embellished with gold and jewels. The building and decoration of the great cathedral were still incomplete, and artists, architects and designers from Aragon and beyond were drawn to Saragossa in search of important commissions. Having already worked at the cathedral, Goya obviously saw opportunities to extend his reputation in his home region.

The Chapel of the Virgin of the Pillar was a particularly significant and well-loved feature of the cathedral. Completed by the most inventive Aragonese architect, Ventura Rodríguez (1717–85), this chapel incorporated smaller side chapels with domes and elaborate pillars. The decoration of this architectural complex was an immense and prestigious task, and Goya had already offered his services in a bid to obtain a lucrative public commission. However, in planning a new series of decorative paintings for this chapel, the cathedral commissioners offered the work to Goya's brother-in-law Francisco Bayeu. Bayeu was at this time undeniably the more important and better known artist in Saragossa, having achieved a distinguished reputation in Madrid.

In 1780, after some three years' delay and a lengthy correspondence with the cathedral commissioners, Bayeu finally agreed to carry out the work, but stipulated that his brother Ramón and brother-in-law

Goya should also be employed as assistants. The cathedral authorities agreed, as long as the younger men worked under Bayeu's supervision. In May 1780 Bayeu expressed his irritation with the project, because his brother and Goya were being made to do too much work for too little money. Ramón Bayeu had been ill that year, and already work at the cathedral was behind schedule. 'My brother's health is better although he is still in some pain, but I pray to God and the Virgin of El Pilar that he will make a good recovery', wrote Bayeu. In August, when Goya's wife gave birth to her fourth son who died, Goya would already have been working on sketches for the cathedral. According to Francisco Bayeu the cathedral authorities had increased the number of required paintings but offered no extra cash. 'I wouldn't do it,' wrote Francisco Bayeu, 'but it will be as they wish.' The 'they' refers to Goya and Ramón Bayeu, who, despite their academic qualifications, and the success of Goya's etchings after Velázquez and his tapestry cartoons, were anxious to obtain such important ecclesiastical work.

Goya's task was to paint one of the domes above the side chapels, while his brothers-in-law took on the other domes, and all were to be frescoed with images of the Virgin Mary. The subjects included the Virgin as Queen of the Saints, Queen of the Angels and Queen of the Martyrs

(which was to be painted by Goya). By Christmas 1780 a crisis blew up and the whole project was plunged into confusion and recrimination.

On 14 December 1780 the Board of Works at the cathedral called an extraordinary general meeting.

The Administrator of the works reported that Don Francisco Bayeu, Painter to His Majesty, had come to see him and explained that there had been some friction with Don Francisco Goya. The latter had refused to permit the said Bayeu to correct his work and bring it into line with the other paintings as the former wished, in order to achieve the necessary overall effect; so Bayeu requested that the gentlemen of the Board be informed, and that they should excuse him from carrying out his commission.

These days little is known about Francisco Bayeu, but as he was an important and influential master in the 1780s, Goya must have seemed like an upstart. Here was a man who had come from an obscure background, whose undistinguished beginnings as an artist had promised little, and who had married Francisco's sister with such a small income that the couple had been supported by Francisco's charity, recommendations and references. Nevertheless, Goya's elevation to the rank of academician had radically altered his career prospects. The daring realism of *The Garrotted Man* (see 46–48), the powerful cartoons of *The Blind Guitarist* (see 38, 39) and *The Fair in Madrid* (see 41) show how Goya's individual talent was reaching fruition, and it is understandable that the artist would have been reluctant to work under his brother-in-law's supervision while they produced the sketches for Saragossa, despite the fact that this had been a contractual condition. Bayeu himself had been a loyal supporter of Goya's career, so why did he go to the cathedral Board of Works in December 1780 and try to sabotage his reputation?

Goya's passion for the realism of traditional Spanish painting may have meant that he was unsuited to the demands of provincial church decoration, but Bayeu's complaint was the beginning of a disagreement which poisoned relations between the two men completely. At first the Board of Works seems to have wanted to avert

a scandal, and there are no more references to either artist in the minutes until February 1781, when they report that Francisco Bayeu had finished painting the vaulting between the tabernacle of the Holy Chapel and the Chapel of St Anne, and that Goya was finishing his dome portraying the Virgin as Queen of the Martyrs. One of Bayeu's sketches for his fresco of *The Virgin as Queen of the Saints* shows his warm, pretty colours and delicate tones (54). Goya's sketch for *The Virgin as Queen of the Martyrs* is more robust in colouring (55) and composed with the bold strokes that characterized the style of his tapestry cartoons. A voluptuous blonde woman, swathed in gold and blue, not unlike the girl in *The Rendezvous* (see 43), lies sensuously across the clouds on the right side of the painting. St Encratis, martyred in Saragossa during the persecution of Christians by the Roman Emperor Diocletian, is also robed in blue and gold. She stands to the right of the composition holding her martyr's symbols of hammer and nail; she was tortured in 304 AD and her liver was torn out, a relic of which was said to be preserved in Saragossa. Goya's designs of buxom female saints may have surprised Francisco Bayeu and shocked the cathedral authorities as well as the provincial congregation, but his sketches for the single female figures of the Virtues finally provoked the antipathy of the entire Cathedral Chapter.

At their meeting in February the Board of Works decided that it was time to have the works inspected by the archbishop, and that this should take place one evening just before he went out for his walk. A month later Goya attended a board meeting at which he presented his four sketches for the single female figures of the Virtues. These were intended to decorate the pendentives (triangular-shaped panels between the archways at the foot of the dome). At this meeting Goya was confronted officially with what became the greatest public humiliation of his career.

On 10 March the minutes record:

Don Francisco Goya presented his sketches for the four pendentives to the dome above the chapel of Saint John in the Chapter House of the Cathedral. Their subjects are the Virtues: Faith, Fortitude, Charity and Patience, and they correspond to the cupola painting of the Most Holy

54
Francisco Bayeu,
Sketch for *The Virgin as Queen of the Saints*,
c.1776–80.
Oil on canvas;
101×81 cm,
$39^{3}4 \times 31^{7}8$ in.
Museo de la Catedral de la Seo, Saragossa

Mary Queen of the Martyrs. When the Members of the Board had seen these sketches they did not express their approval on account of certain defects that were noted, particularly in the drawing representing Charity, whose figure was not suitably decent. Also the backgrounds of the other studies, as well as appearing to lack detail, are darker than is desirable, and not in the right style … Since the Board had heard how dissatisfied the public had been with the dome painting and because there was as little care and taste discernible here as in his [Goya's] other work, they were placing the whole matter in the hands of Don Francisco Bayeu. They hoped the latter would take the trouble to examine these sketches for himself and consider whether the Board were just in their observations and their resolve that the pendentives should be executed in a manner fit to put before the public without fear of censure.

After more than 200 years it is hard to know whether the members of the Board were right in their decision. If, as they say, there had been a public protest over Goya's fresco of the Virgin as Queen of the Martyrs, then they had little option, but it is difficult to know precisely what the finished fresco looked like in Goya's day. The paint-

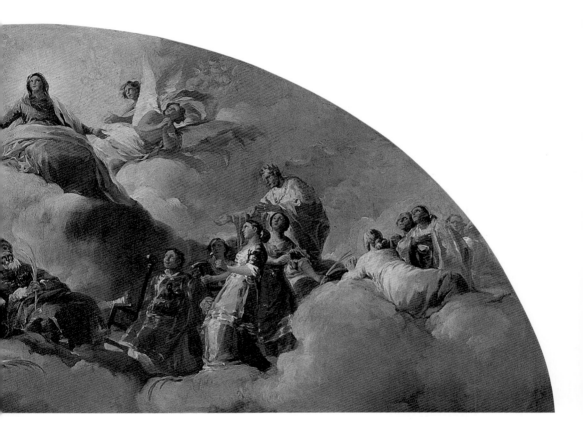

55
Sketch for *The Virgin as Queen of the Martyrs*, 1780.
Oil on canvas;
85 × 165 cm,
33 ½ × 65 in.
Museo Pilarista,
El Pilar,
Saragossa

ings in the chapel have been restored, although the surviving images are sufficiently preserved to show Goya's energetic fresco technique. However, the original sketches of the pendentives which the Board so disliked have not come to light. Just as the artist's etchings after Velázquez might have been regarded by professional engravers as technically unorthodox, so his religious work retains much of that sensuous, dramatic style which must have appeared thoroughly indecorous in provincial Spain of the 1780s. At Saragossa the taste for elaborate and rich vestments, for gold, silver and precious stones decorating religious icons and objects, was balanced by the demand for overall decorum. Goya's artistic individuality made his divine figures flesh and blood and focused on a realistic view of suffering humanity.

A week later, on 17 March, he wrote the longest letter of his life to the Board of Works of the Cathedral, expressing anger and bewilderment. In it he says that he has been subjected to a barrage of gossip, accusation, public innuendo and 'malevolent prejudice', all prompted by the vindictive treachery of his brother-in-law Francisco Bayeu. In his opinion, none of this had anything to do with any justifiable criticism of his work. But his honour as a painter had been impugned. 'My entire living', he writes, 'depends upon my reputation as a painter and if one day that reputation is even slightly tarnished, then my career is destroyed.'

He goes on to say that since he is a member of the Royal Academy in Madrid he is legally entitled to work independent of anyone's judgement. This was quite true. The royal charter given to the Madrid Academy laid down that once an artist became a member he was automatically elevated in rank and could enjoy the privileges and entitlements of an aristocrat. In his letter Goya goes on to claim that, purely out of politeness, he had shown his preliminary sketches to Bayeu, when they were both still in Madrid, and that Bayeu had approved them. Bayeu had subsequently let Goya go ahead and paint the Virgin fresco without any demur, so why did he go behind Goya's back and complain to the Board in December? The answer is obvious, writes Goya. Bayeu was waiting for Goya to commit some public error and lose the credit and reputation he had already acquired.

Goya's counter-accusations against his brother-in-law only made matters worse, and the whole issue became the talk of Saragossa. A few years earlier Goya had painted murals in the basilica of the Carthusian Monastery of the Aula Dei outside Saragossa, where the other Bayeu brother, Manuel, had taken his monastic vows. The murals had been well received, and one of the members of the community now wrote to Goya begging him to be careful and not offend either Bayeu or the cathedral authorities:

It would be taken very badly if you picked a fight with an entire Cathedral Chapter ... This is your first commissioned work of any note and it would be a great pity if you were to leave it in litigation; for even if you won your case you would acquire the reputation of being a vain and difficult man. In the eyes of the Chapter Don Francisco Bayeu is the premier artist of the day, on the verge of becoming first painter to the king, whereas you (although perhaps more talented) are merely a beginner and have yet to establish a reputation.

The fact that Goya's talent and prospects were already being regarded as greater than those of Bayeu is significant and may have sparked off the disagreement in the first place. Whether Goya was considering suing the cathedral is not known, but he tried to act on this advice. He wrote a more submissive statement to the Board, agreeing to correct his work under Bayeu's supervision. But by May 1781 all these good intentions were dissipated. The administrator of the Board of Works reported that Goya had come to see him in a furious rage and had been extremely rude, saying that he intended to return to Madrid immediately, leaving the work undone because he was only losing time and his reputation by staying in Saragossa. Moving with comparative speed the Board of Works paid him for his work to date, and promised to add a bonus if Goya agreed to finish the job and leave quietly. Goya returned to Madrid. Even there the matter had become known. Manuel Bayeu wrote in August 1781: 'The king must have been informed of the events at Saragossa. There has been much concern among painters to form an alliance to protect a fellow member.' It seems possible that the Royal Academy had united in sympathy with Goya's plight and Bayeu's discomfiture, and both

were offered a new royal commission to paint an altarpiece for the large Madrid church of San Francisco el Grande. The Bayeu family sided against Goya. 'I love Goya dearly but not in defiance of truth, reason and the interests of my own brothers', wrote Manuel Bayeu. Goya's reaction to the Saragossa affair came to be regarded as emotionally exaggerated, and the whole episode blew over. Goya never painted anything for the Cathedral of El Pilar again, but went on to paint pictures for the cathedrals of Valencia, Seville and Toledo, as well as numerous churches throughout Spain.

Until the moment that Bayeu went to the Board of Works, his rivalry with Goya had been friendly. After Saragossa the battle for professional supremacy became bitter and more ruthless. 'When I think about Saragossa and painting, my blood boils', Goya wrote to his old school-friend, Martín Zapater, a wealthy landowner in Aragon. He was never to forget the slur on his reputation, and the return to Madrid provoked him into a frenzy of self-promotion and a prolific output which established his position as the most powerful and eminent painter in Spain.

Towards the second half of the eighteenth century, as the Church was subjected to more organized reforms, the grandeur of much European ecclesiastical art declined. Even in Spain, where the transcendent imagery of El Greco in the sixteenth century, and Murillo and Zurbarán in the seventeenth, had founded a school of original religious art unchallenged in Europe, native religious painting became narrow and cautious. Only Goya's bold innovations contributed modern solutions to this hidebound subject matter.

In 1788, seven years after his style had been censured as indecorous by the Board of Works at the Cathedral of El Pilar in Saragossa, Goya for the first time gave full freedom to the monsters he had as yet only hinted at in his art, and this act of artistic liberation took place in another cathedral. The Duke and Duchess of Osuna, Goya's newest powerful benefactors and patrons, commissioned two paintings for their family chapel in Valencia Cathedral. They were to show the life and work of their ancestor, the Jesuit saint Francis Borgia. A member of one of the noblest families in Aragon, Francis Borgia was the grandson of King Ferdinand V, who, together with Queen Isabella,

had established the political supremacy of Spain in the early sixteenth century. Created viceroy of Catalonia on his marriage, Francis became a Jesuit after the death of his wife. He was ordained in 1551, having given up the privileges and possessions of rank, wealth and power. Goya took this renunciation as the theme of his first painting, which shows the saint taking leave of his family in order to follow his priestly vocation. Renowned as an inspiring preacher, St Francis Borgia travelled throughout Spain and into Portugal. Extravagant panegyrics and numerous fictitious anecdotes appeared in biographies of the saint, and from these accounts comes the subject of the dramatic second painting, *St Francis Borgia Attending a Dying Impenitent* (56). The saint is depicted in a bare room, his eyes full of tears, holding a crucifix while a young man, convulsed and rigid at the approach of death, lies back on a narrow bed. In the shadows behind the bed stand the demons. Charles Vaughan, who visited Valencia Cathedral in February 1803, noticed these paintings:

The side aisles of the Cathedral are furnished with open chapels filling up the spaces between the columns supporting the roof. They are ornamented with paintings, one of which from its subject, attracted my attention – a dying person represented in the greatest agony, having refused apparently to kiss the crucifix in the hands of a priest. Standing near a legion of devils are at his bedside anxiously awaiting the separation of the soul from the body.

The intense interplay between the saint and the fiends was more robustly achieved by Goya in the sketch (57). The continual artistic deference to drama, suffering and human emotion offered by religious subject matter appealed to Goya's more sophisticated patrons. While Church and court might have accorded Goya mixed success, his private patrons allowed him to express the unquenchable energy of his dark, mature vision.

The subject of St Francis Borgia is also significant. In 1767 the Jesuit Order had been exiled to Italy by Charles III as a way of restricting the power of the papal court (curia) in Spain. In the scenes from the life of one of the foremost Jesuit saints, Goya took on the theme of a

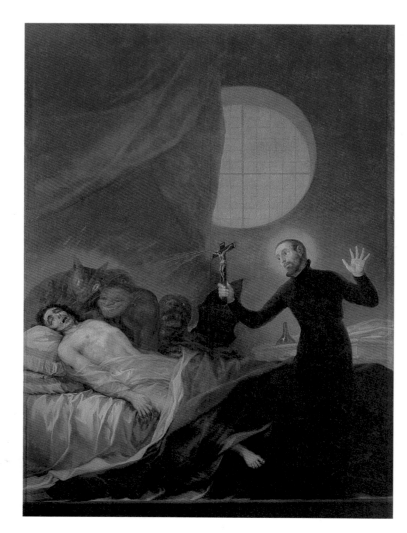

56
*St Francis Borgia
Attending a
Dying
Impenitent*,
1788.
Oil on canvas;
350 × 300 cm,
137⁷⁄₈ × 118¹⁄₄ in.
Valencia
Cathedral

57
Sketch for
*St Francis Borgia
Attending a
Dying
Impenitent*,
1788.
Oil on canvas;
38 × 29·3 cm,
15 × 11¹⁄₂ in.
Private
collection

powerful ruler abandoning his position in his search for spiritual fulfilment. In December 1788 Charles III died, only seven months before the citizens of Paris stormed the Bastille and signalled the start of the French Revolution. The contrasting themes of the savage energy of a mob and the plight of prisoners were further subjects crucial to the maturing of Goya's repertoire, while oppression by the powerful became a familiar preoccupation in his search for independence.

4

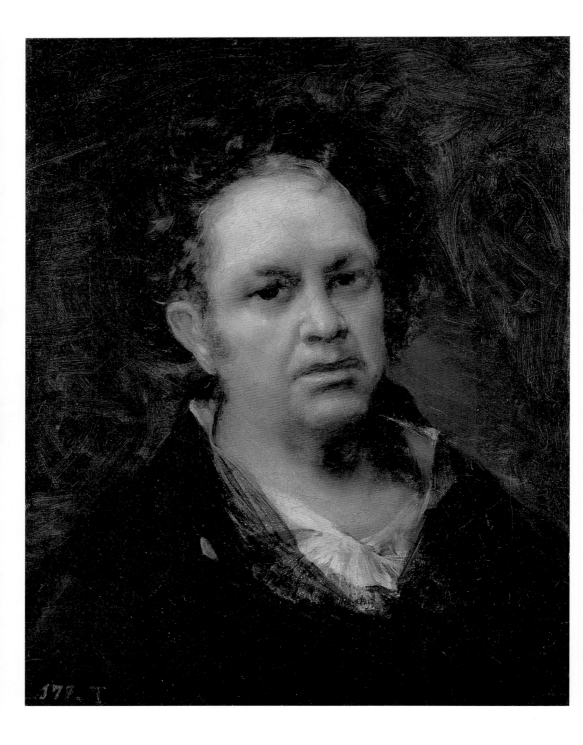

Powerful men, beautiful women, philosophers, poets, fellow artists, actors and matadors form a glittering array of the great and the good in Goya's Spain. His expressive portraits also reflect international fashions of the day, and show influences from portraitists in other European countries. Through portraiture Goya became more intimately connected with the educated Spanish élite, who often allowed the artist greater freedom to express his aesthetic views than his royal or Church patrons. For his admirers, both in his own time and after his death, the portrait remained his most enduring achievement.

As a signifier of artistic and ideological change, the eighteenth-century portrait is a unique historical phenomenon. Few, if any, major artists of the period failed to try their hands at portraiture, and the subject became the most popular type of art to appear at public exhibitions in both Europe and America. The Enlightenment portrait formed a particular medium of artistic debate, in which the glorification of rank, wealth and material power took second place to the portrayal of virtue, intelligence and a charitable attitude towards the unfortunate. Above all, sitters expected the artist to produce a good likeness, even if this meant an unflattering view. Men of letters, statesmen, famous women, poets and actors are the subjects of some of the most stylish portraits of the era. In England Sir Joshua Reynolds (1723–92) elevated the simple half-length portrait and bust portrait to extraordinary heights of expression; James Barry (1741–1806) included portraits of contemporary literary figures in his huge philosophical murals for the Royal Society of Arts in London entitled *The Progress of Human Culture*; the Philosophical Society of Philadelphia founded its own gallery devoted to portraits of members, which were hung beside great philosophers of the past; while in France, Jacques-Louis David (1748–1825) added a sculptural clarity to portrayals of revolutionaries, the French bourgeoisie, and luminaries at the Napoleonic court.

58
Self-Portrait,
*c.*1815.
Oil on canvas;
46 × 35 cm,
18 1⁄8 × 13 3⁄4 in.
Museo del
Prado, Madrid

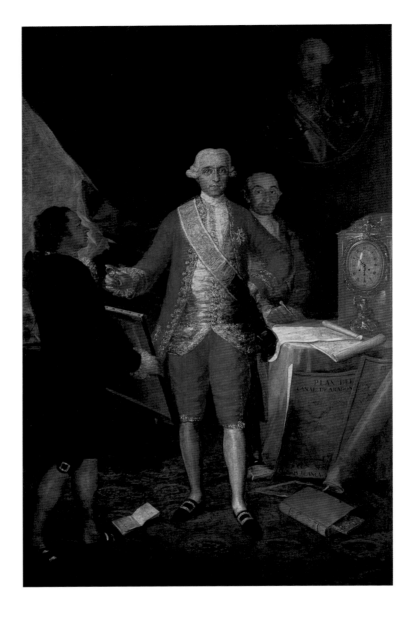

The heritage of Spanish portraiture from the sixteenth and seven-
teenth centuries is particularly rich, and Goya always nurtured a deep
respect for his native traditions. As he rose in artistic eminence at the
Spanish court, Goya was to meet the challenge of the modern portrait
with remarkable originality. Nevertheless, despite Goya's enthusiasm
for Spanish portraits of the seventeenth century, for the art of
Rembrandt van Rijn (1606–69) and for the great paintings of the High

Renaissance which he had seen in Rome, his own portrait technique took time to mature, and it was not until 1783 that he obtained his first major commission. It came from the principal statesman of the day, the Count of Floridablanca, then Minister of the Interior for Charles III and soon to become the prime minister (59).

The likeness by Goya is now largely admired because it forms a bold experiment in which the artist included his own self-portrait. This daring detail challenged Velázquez, whose self-image had formed such a striking figure in *Las Meninas* (see 50). As the earliest formal full-length portrait Goya ever produced, the painting of Floridablanca is also one of the darkest and sets a pattern for mature compositions of similar formality. The cluttered, windowless interior forms a crowded space, jumbled with symbolic references and obscure allusions to power, enlightenment and connoisseurship. Standing full-length, wearing a brilliant scarlet suit, the subject fixes the spectator with piercing blue eyes. Two other figures emerge from the gloom: the court architect stands beneath a portrait of Charles III; and Goya himself has just entered the room from the left, still recognizable as the young, long-haired man from the early *Self-Portrait* (see 2), although by this time he would have been thirty-seven. Turning slightly towards the principal sitter, Goya forms a dwarfish figure beside the tall minister (a tribute to the sitter's rank rather than an accurate portrayal). The canvas held by the artist is nailed to a stretcher but is unframed, signifying that it is probably a recently completed sketch being submitted for the patron's approval. The prominence of the latest timekeeping device, a newly invented clock, reveals the late hours that the minister keeps, working for the benefit of the state, although he appears willing to interrupt state affairs, even at night, in order to make time for the artist.

The whole portrait adds up to a painted celebration of avant-garde taste, modernity and social reform. A book by Antonio Palomino about the techniques of painting lies on the floor with a marker in it, suggesting that the minister, as an educated man of fashion, not only possesses such a book but is actually in the process of reading it. A blueprint for the completion of the Imperial Canal in Aragon is

59
Portrait of the Count of Floridablanca, 1783.
Oil on canvas; 262 × 166 cm, 103 ¼ × 65 ½ in. Banco de España, Madrid

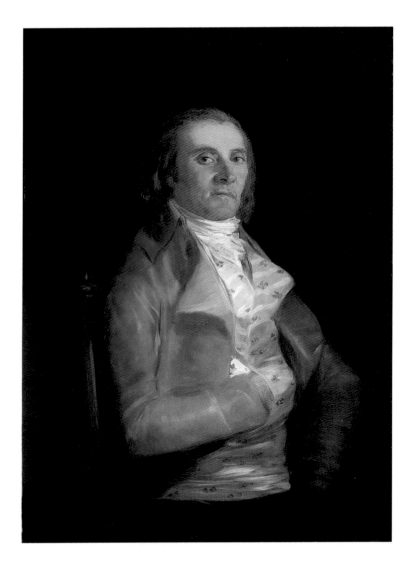

propped against the table, a detail which the Aragonese Goya must have been especially concerned to place in a prominent position. Floridablanca regarded his support for this new feat of engineering as a memorable achievement of his ministry.

The painter's incorporation of current events and interests contrives to make Floridablanca look like the perfect patron. 'I always get a lot of attention from the minister. On some days I spend two hours in his company', wrote Goya. 'He tells me that he will do whatever he can for me.' Such men with their traditions of public service and their paraphernalia of wealth and rank provided the raw material of Goya's best portraits.

Goya's portrait style of the 1790s, in particular, reached a superb accomplishment and was noted in his own lifetime as an artistic symbol of the revival of Spanish greatness under the Bourbon monarchy. In 1798 when a half-length portrait of a comparatively humble sitter, the court gilder, Don Andrés del Peral (60) appeared at a Royal Academy exhibition, an anonymous art critic writing for the *Madrid Daily* (*Diario de Madrid*) burst into a panegyric extolling the genius of Goya, comparing such talent to the spiritual and cultural renaissance of the whole Spanish nation. A similar level of skill to that seen in this work appears in the portrait of Charles IV's minister of justice, Gaspar Melchor de Jovellanos (61), also dated 1798. Although the composition – a gentleman seated at a writing desk – is conventional by eighteenth-century standards, and was continually used by artists in England and France, Goya's vivid transformation of this well-known model rescues the sitter from dullness or pomposity.

Jovellanos represented the spirit of Spain edging into the mainstream of the European Enlightenment. In his writings, which were often critical about many aspects of Spanish society, he was especially rancorous on the subjects of prejudice and superstition. His political leanings were tolerant and progressive, but he was also considered to be a man of moral virtue and patriotic ascendancy. A newly appointed government minister, Jovellanos is portrayed as a melancholy thinker, leaning on his hand (62). The Spanish poet, Juan Meléndez Valdés, also painted by Goya (63), praised the attitude of Jovellanos to power: 'sad

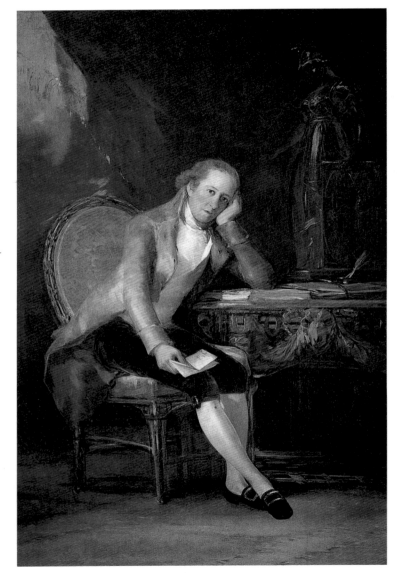

61–62
Portrait of Gaspar Melchor de Jovellanos,
1798.
Oil on canvas;
205 × 133 cm,
80³⁄₄ × 52³⁄₈ in.
Museo del
Prado, Madrid
Far right
Detail

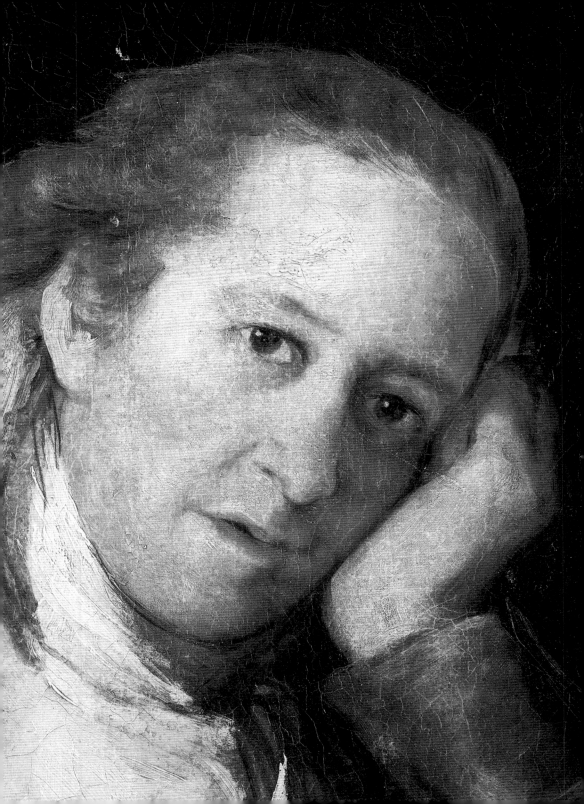

and dejected ... Never was he greater in my eyes ... down his cheeks coursed tears of virtue.' Jovellanos is posed with his feet placed uncertainly, his facial expression abstracted, his ministerial briefs unopened on the desk.

It is not known how much money Goya received for the portrait of Floridablanca, but some records suggest that he had to wait a long time for payment. Jovellanos, however, paid Goya 4,000 reales (about £40 in the money of the period) for his full-length likeness, and by that time Goya was a comparatively wealthy man. However, his prices do not seem as high as those charged by artists of comparable status in other countries. In England Sir Joshua Reynolds made over £6,000 per year from portraiture alone, and in France Jacques-Louis David was to become a millionaire, in contemporary terms.

Jovellanos and Manuel Godoy (64), who became the first secretary of state in 1792, Francisco Cabarrús (65), who founded the first national bank in Spain, and the striking figure of Floridablanca, offered the portrait artist more opportunities for free expression than Church commissioners or the tapestry factory. Goya's gallery of formidable statesmen, military men and administrators became a record of historical personalities whose influence on the development of Spanish society was profound, and included the power brokers who perished in the wake of failed reforms and changing ideologies.

His portraits are also classic testaments to the vanity of human endeavour and worldly power. From the background of his youthful Catholic education, his study of the great Catholic art of Italy and Spain, and his taste for irony, Goya painted the powerful of his country with a lively realism which often uses telling details to make the subjects seem oddly vulnerable: the darkness of Floridablanca's office; the pensive gravity of Jovellanos; Godoy's adipose neck and fingers, which weaken his triumphant pose as victorious Generalísimo after his victory in the brief War of the Oranges against Portugal in 1801. Despots, time-servers and fixers, these men remain immortalized by the painter's skill in a state of fragile humanity, their claims to fame grandiose, and matched only by the catastrophic decline of their country and their inability to remedy it.

63
Portrait of Juan Meléndez Valdés, 1797.
Oil on canvas; 73·3 × 57·1 cm, 28⅞ × 22½ in.
Bowes Museum, Barnard Castle, County Durham

64
Portrait of Manuel Godoy, 1801.
Oil on canvas; 180 × 267 cm, 70⅞ × 105⅛ in.
Royal Academy of San Fernando, Madrid

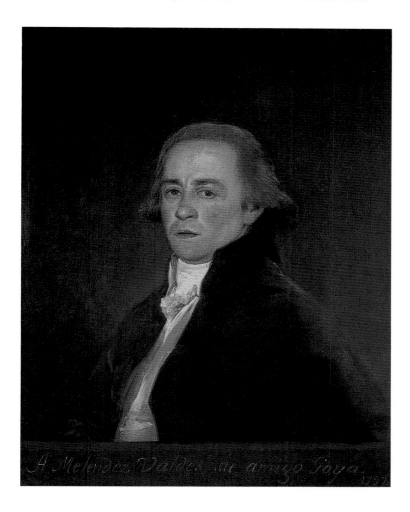

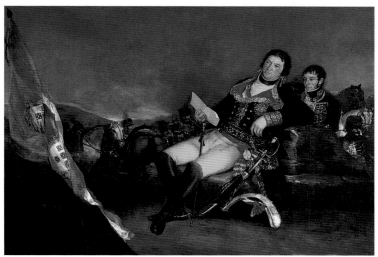

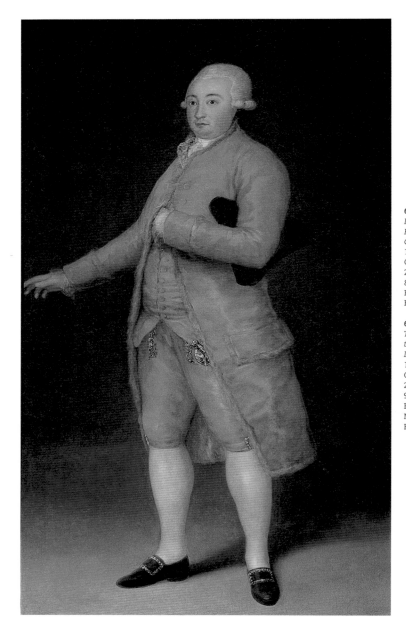

65
*Portrait of
Francisco
Cabarrús*,
1788.
Oil on canvas;
210 × 127 cm,
82³⁄4 × 50 in.
Banco de
España, Madrid

66
*The Family of
the Infante Don
Luis de Borbón*,
1783.
Oil on canvas;
248 × 330 cm,
97³⁄4 × 130 in.
Fondazione
Magnani-
Rocca, Parma

As someone who was to chart in painting and drawing the collapse of public life in Spain, before and during the Peninsular War of 1808–14, Goya dedicated his portraiture to the retrieval of subtle human qualities which mitigated the tedium of many plain and unmemorable sitters. In the same year as he painted Floridablanca, he was patronized by another high-ranking personality, the king's disgraced younger brother, the Infante Don Luis. While his marriage had put him outside the rigid hierarchies of the Madrid court, Don Luis was also known for his advanced taste in the arts: he owned an immense

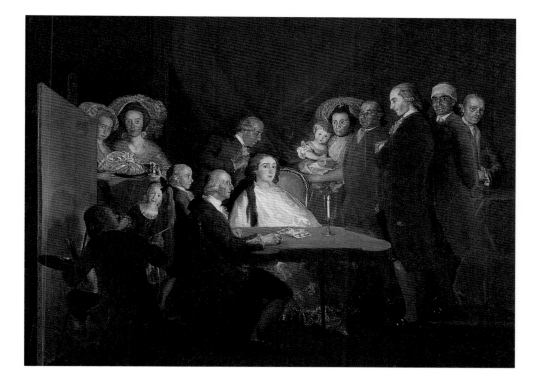

collection of paintings, and expressed his enthusiasm towards new styles by employing contemporary artists. His protection had ruined Luis Paret, but he remained the artist's patron even while Paret languished in exile. This reputation as a connoisseur made the Infante an attractive prospect for itinerant artists and musicians who flocked to his palace in the 1780s. In private letters Goya praised the Infante Don Luis as a kind man who treated his artists familiarly, bestowing presents on the artist's wife, and taking Goya hunting on his estate.

Goya made several portraits of Don Luis's family and retinue, the most memorable of which is the large group painting showing family, servants and courtiers assembled before bedtime (66). They form a group of life-size figures huddled together in one of the strangest portraits Goya ever attempted. The Infante has been playing cards, while his wife is having her hair dressed for bed by the court hairdresser. Goya includes himself at work on a large portrait of the Infante's wife, the Aragonese noblewoman, Maria Teresa de Vallabriga, who also encouraged Goya as a painter from her home region. Like the court hairdresser, who concentrates his energies on the lady of the house, the painter depicts himself as a virtuoso at work. Courtiers, maids, the court composer, Luigi Boccherini, and

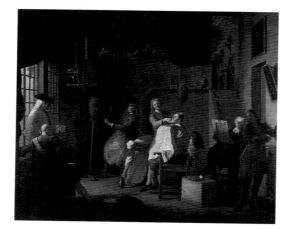

67
Michel-Ange
Houasse,
*The Barber's
Shop,*
*c.*1725.
Oil on canvas:
52 × 63 cm,
20 ½ × 24 ⅞ in.
Patrimonio
Nacional,
Madrid

the Infante's three children, form a rigid group round the elderly prince. The scene is imbued with a feeling of human impermanence set against the evanescence of artistic inspiration, and the inhabitants of this nocturnal scene are sparsely illuminated. The portraitist places himself as someone who hovers on the outskirts of this small closed society, unlike the hairdresser who performs his duties as an essential member of the family circle.

In Spain, the hairdresser and the barber had traditionally enjoyed elevated social status. When Velázquez worked at the court of Philip IV, the first signal honour he received, in 1628, was a grant of the same remuneration as the court barbers. In the eighteenth century

the art of the professional hairdresser was particularly evident in high-society portraits. Michel-Ange Houasse, the French artist who had worked for Charles III's father, portrayed smart barbers at work on their customers (67). One, waiting for attention, examines his reflection in an ornate gilt mirror while others gossip, showing that the barber's shop is a popular meeting place. Similar deference towards hairdressers existed during the reign of Charles III, and by the 1780s, when Goya was approaching the peak of his career as a portraitist, the fashion for powdered hair and wigs, worn high and wide in England and France, had reached Spain.

The portrayal of Floridablanca, Jovellanos and the Infante Don Luis drew attention to the sitters' education as refined artistic amateurs through references to earlier styles of portraiture, books and objects. The importance of fashionable furniture, clothes and hair, rather like the significance of pictures, a clock or a statue, formed distinguishing features of the enlightened portrait. Frivolous and grave aspects of personality are combined in Goya's portraits with astonishing verve, but the importance of costume and hairstyles, in particular, opened up further dimensions of the painter's art.

In Spanish society of the late eighteenth century costume had assumed particular political significance. While foreign fashions might signify the sitter's modern tastes and emphasize the aesthetic symbolism of rank, Spanish costume became an expression of national values. Floridablanca, Jovellanos and Cabarrús are dressed in foreign, mainly French fashions, with knee-breeches, satin jackets and buckled shoes expressing their sophistication. Godoy, as a captain-general, wears a national uniform of high rank and military splendour. Women of status had an even wider diversity of costume to draw on, dressing themselves in French or English fashions, or parading in the exotic dress and mantillas of the low-class *maja*. This custom became so widespread that laws were enacted to prevent this confusion of ranks through costume. Such abundant fashions at the disposal of the moneyed classes provided Goya with a means of varying his portraits, particularly when showing the same person, or members of the same family.

Among his most supportive aristocratic employers were the Duke
and Duchess of Osuna, who had succeeded to the title in 1788,
the year that Goya decorated their chapel in Valencia Cathedral.
He painted a family group portrait to mark their new rank (68).
Even before their elevation, the duchess in her previous station

68
*The Family of
the Duke of
Osuna,*
1788.
Oil on canvas;
225 × 174 cm,
88⁵⁄₈ × 68¹⁄₂ in.
Museo del
Prado, Madrid

69
*Portrait of the
Duchess of
Benavente,*
1785.
Oil on canvas;
104 × 80 cm,
41 × 31¹⁄₂ in.
Private
collection

as Duchess of Benavente (69) had become one of the leaders of fash-
ion. A plain woman, noted for her intellect, taste and rank, she draws
the spectator's attention not through symbols denoting intelligence
but through the most up-to-date fashions, just as the Infante's wife

remains the focus of attention through her employment of a front-rank, personal hairdresser (see 66). The duchess wears a *robe à l'anglaise* of dark blue silk, tightly fastened at the back, while her front-fastened bodice is trimmed with an elaborate rose-pink bow at the breast, below a gauze scarf or kerchief. In the 1780s skirts were often set into the bodice over hip pads attached to stays (70), and the duchess has decorated the padding round her hips with roses and white silk ribbons. But the principal glory of the portrait is her hair, which is surmounted by a straw hat, and trimmed with ostrich feathers and pink ribbon, similar to that on the dress. The hat tops a complicated hairstyle, and through this the duchess displays her taste for modern fashion by adding ringleted curls to the outline of her hair beneath the hat, the sort of detail that appeared in plates from the important Paris fashion periodical *Cabinet des Modes*.

French fashions set a standard for sartorial elegance in the 1780s, when the introduction of a dress known as a Polonaise transformed the fashionable Spanish woman's wardrobe. The name was derived from a Polish fashion for a tight-fitting bodice and full skirt, with an overgown looped up over the skirt in bunches. Goya's earliest depiction of such a dress is in the portrait he painted to celebrate the marriage of the young Marquesa de Pontejos (71). This harmonious picture with its silver-grey and rose tonality is deceptively simple, and at first appears to be emulating images of young, aristocratic ladies posed in rural settings, symbolizing virtue and innocence, which eighteenth-century portraitists such as Jean-Marc Nattier (1685–1766) in France and Thomas Gainsborough (1727–88) in England had made their own. The *Portrait of the Marquesa de Pontejos* also owes much to Mengs in the subject's tight silhouette and solid contours, but Goya's sensitivity to delicate fabrics such as lace and gauze was only ever matched by Gainsborough.

The outstanding difference in Goya's portrait, however, lies in the landscape, where unrestrained, surly shadows of woods and rocks form an encroaching darkness which could never have come from the palette of an artist as delicate as Gainsborough, or a master of the robustly physical such as Mengs. In the 1790s, having become the

70
Woman's dress,
c.1770s–80s.
h.80 cm, 31½ in.
Museu Tèxtil i
d'Indumentària,
Barcelona

71
Portrait of the
Marquesa de
Pontejos,
c.1786.
Oil on canvas;
210 × 126·4 cm,
82¾ × 49⅞ in.
National
Gallery of Art,
Washington, DC

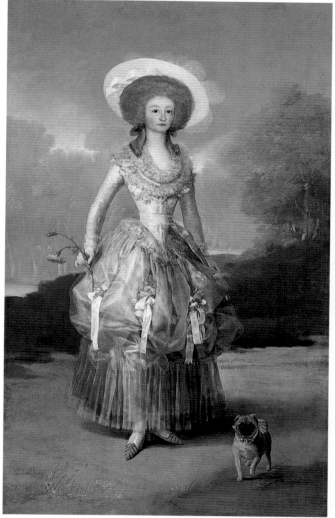

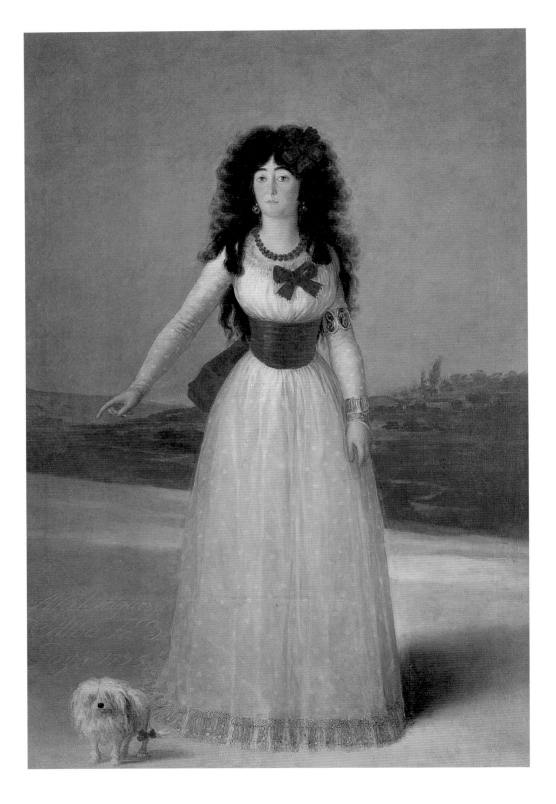

undisputed portrait master of the Spanish aristocracy, Goya was to take the same format and develop it even more boldly. The Duchess of Alba (72), probably his favourite female subject, occupies a bleak, stormy and arid landscape. The painter retains the presence of the dog, but the hand, instead of being clenched around a carnation, points provocatively. Even the fashionable white dress and the scarlet trimmings seem stiff with an internal tension.

The ascendancy of Mengs's style in portraits of the late eighteenth century is particularly noticeable in likenesses of fashionable women. In Rome in the 1750s Mengs had become renowned for his accuracy in depicting costume, and his *Portrait of the Marquesa de Llano* (73), which was to become the most popular portrait of the era, introduced the masquerade portrait into Spain. Goya, who was to surpass Mengs in his exploration of both male and female portraiture, took up the challenge and demonstrated how the fashionable female portrait could become as much a vehicle for experiment as that of the rational and educated male. However, men, too, wore exotic costumes and gratified their desires to appear stylish. Portraits of '*élégants*' in France, 'macaronis' in England and '*petimetres*' in Spain gave rise to a flashy, affected portrayal of men in which the complexity of clothes and hairstyles could outweigh those of the women. The occasional foppishness of these sitters, the elaborate fashions such as triple-collared overcoats and muslin cravats, created an enthusiasm for complex portraits which the austerities of Spanish society in the 1780s and 1790s could do nothing to suppress.

Even in a more informal portrait mode, Goya was never averse to embellishing the pure externals of a friend's dress. Sebastián Martínez (74), a wealthy businessman from Cadiz, had, like Goya himself, risen from the ranks of obscure and humble villagers. Martínez came from a village in central northern Spain and made a fortune in the wine trade. His art collection was particularly rich; he possessed works by Titian and Peter Paul Rubens (1577–1640), among others, and he also built up a large collection of prints. However, unlike the tastefully sophisticated Floridablanca and the

72
Portrait of the Duchess of Alba, 1795.
Oil on canvas;
194 × 130 cm,
76 ½ × 51 ¼ in.
Alba Collection, Madrid

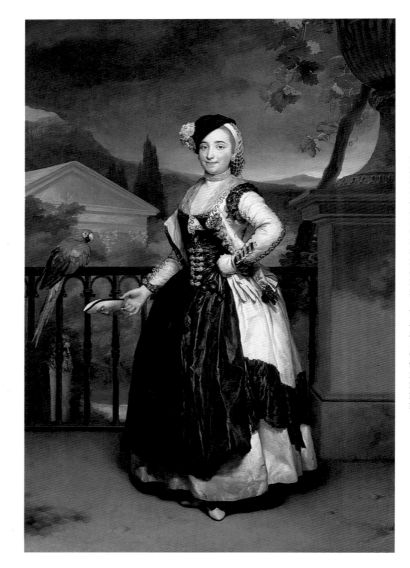

73
Anton Raphael Mengs,
Portrait of the Marquesa de Llano,
1774.
Oil on canvas;
218 × 153 cm,
85⁷⁄₈ × 60¹⁄₄ in.
Royal Academy of San Fernando, Madrid

74
Don Sebastián Martínez,
1792.
Oil on canvas;
92·9 × 67·6 cm,
36⁵⁄₈ × 26⁵⁄₈ in.
Metropolitan Museum of Art, New York

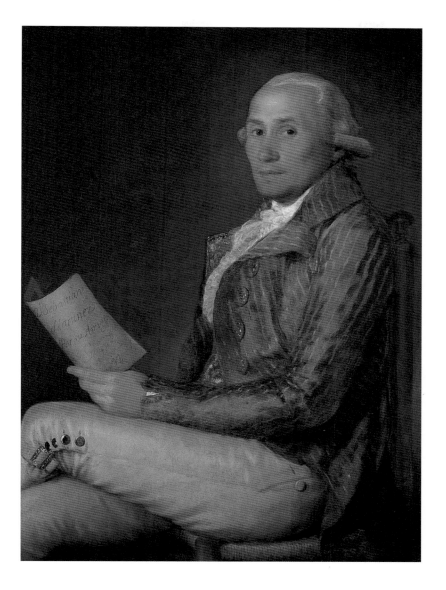

Infante Don Luis, Martínez's self-image eschews any hint of academic connoisseurship. Here Goya concentrates entirely on sartorial novelty. Martínez is shown wearing a narrow-backed, double-breasted coat with fitted waist, tight cuffs and large buttons. The material was probably silk, decorated with blue, gold and green stripes (a favourite motif of French *élégants* in the 1770s). Worn with tight-fitting gold breeches, the whole outfit has a slightly dated showiness. The spotless white necktie and yellow breeches correspond to the more sentimentalized images of English gentlemen of taste that influenced portraits of sensitive and artistic young men in northern Europe during the 1770s and 1780s. The rolled side curls and back pigtail may be natural hair, which began to replace powdered wigs by the 1780s. Martínez's hair is dressed for a formal occasion, just as his clothes are quite different from the everyday wear of humbler sitters such as Martín Zapater (75) or Don Andrés del Peral (see 60). In the *Art of Hairdressing or the Gentleman's Director* by Alexander Stewart, which appeared in England in 1788, the difficulties of obtaining an effect as apparently simple as Martínez's powdered curls are elaborated. The formality of the sitter's turnout contrasts with the intimacy of the inscription which appears on the paper held in Martínez's left hand: *D[o]n Sebastian / Martinez / Por su Amigo / Goya / 1792* ('Don Sebastian Martinez by his friend Goya 1792'). The capital initial on the word 'Amigo' ('Friend') suggests the closeness of their relationship.

The image of Martínez forms another high-point of a particular portrait style, that of the intimate half-length, painted on an apparently informal level, with the subject close to the picture surface and the spectator's scrutiny. This offered an opportunity for a deeper analysis of the sitter, and corresponds to the acute studies of English writers and thinkers such as Dr Johnson, Oliver Goldsmith and Edmund Burke that Sir Joshua Reynolds executed. The expression of a mutual accord between sitter and painter imbues these portraits with their vivid immediacy.

Many of Goya's sitters became either close friends or supportive patrons, such as for example Jovellanos, the Infante Don Luis, the Duchess of Alba and the Osuna family; and Sebastián Martínez was

75
Portrait of Martín Zapater, 1790. Oil on canvas; 83 × 65 cm, 32³⁄₄ × 25⁵⁄₈ in. Private collection

to prove the most intimate and useful of contacts during Goya's illness of the 1790s. So wide was Goya's range of sitters that they form a complete cross-section of Spanish eighteenth-century high society, and it may have been through his growing clientele of distinguished portraits that the artist finally obtained a salaried post at court in 1786. Exulting in a new sense of financial security, Goya bought his own carriage and increased his number of private commissions. As his personal fortune grew (he makes continual references to money in letters), these financial interests brought him into professional contact with the first national bank to be founded in Spain. The Banco de San Carlos (now called the Banco de España) was established through the efforts of Francisco Cabarrús (see 65), a merchant banker and financier, who persuaded Floridablanca to support the enterprise in 1782. Goya invested in fifteen shares, deposited his

savings in the bank and, possibly through his acquaintance with the minister, was invited to paint the founder directors. These portraits still hang in the bank's own gallery above the main offices in Madrid, and investing in works of art has been a tradition among Spanish banks ever since. The portrait of Cabarrús is probably the best of the series. A fat strutting man, he is depicted rather as Reynolds had painted the pudgy Samuel Johnson, as a highly intelligent personality caught in the middle of speaking and making a rhetorical gesture. Cabarrús was to fall from favour and be imprisoned in 1790, but his portrait remains a testimony to his vigour. For his part, the senior director of the bank, the Count of Altamira, was so impressed with his own portrait that he commissioned Goya to paint his whole family.

In 1784 Goya's wife had given birth to Javier Goya, the only one of the artist's children to reach maturity. Goya's painting of the Duke of Altamira's five-year-old son (76) is yet another bold innovation, but again there may well have been a personal interest in the child, since Manuel Osorio was not much older than Javier Goya. In this work the painter again departed from international precedent. In England and France portraits of children with their pets had always been popular, and in Spain royal children were painted with pet birds or dogs, in the way that earlier princes and princesses might have been shown with their dwarves. In his painting of the little boy, Goya recalls these earlier images, and the work stands as a Spanish counterpart to such portraits as Reynolds's *Master Herbert*, exhibited at the London Royal Academy in 1776, in which the child is transformed into the infant god Bacchus, surrounded by lions. Although Manuel Osorio has not been endowed with mythological character, his stunted body, seen beside the large cats, places him in the role of a Velázquez dwarf. Manuel Osorio's father was himself of dwarfish stature, and his son's large head, small body and tiny hands may have prompted Goya to remember his copies of Velázquez's dwarf (see 49). But the child himself is not the only source of the grotesque in this portrait. The cats watching the bird are reminiscent of the supernatural monsters that Goya had inserted into his Valencia Cathedral easel paintings a year earlier (see 56). The magpie holds in its beak a visiting card inscribed with Goya's name. The fashionable

76
Portrait of Manuel Osorio Manrique de Zuñiga,
1784.
Oil on canvas;
127 × 101·6 cm,
50 × 40 in.
Metropolitan Museum of Art, New York

scarlet suit of the child is as eye-catching as the suit worn by the Count of Floridablanca; this is a 'skeleton suit', made from a single piece of silk, puffed out around the hips to accommodate a nappy, and pulled tight on the torso. It covered the whole of a child's body like a modern babygro, and was mainly reserved for children of the highest rank.

Elaboration and the distortion of details were always crucial to Goya's art as a portraitist. In a letter to his best friend, Martín Zapater, he enthusiastically describes his fascination with the changing contours of the human face:

I should like to know if you are elegant, distinguished or dishevelled, if you have grown a beard and if you have all your own teeth, if your nose has grown, if you wear glasses, walk with a stoop, if you have gone grey anywhere, and if time has gone by for you as quickly as it has for me. I have become old and wrinkled, you would not know me except for my snub nose and sunken eyes … what cannot be denied is that I am very conscious of my forty-one years and you perhaps look as young as you did in Father Joaquin's school.

Written in 1787 the letter dates from Goya's period of continual demanding work and antedates the most famous portrait of Zapater (75), which has a monumental informality, and an internal simplicity, that constitute a tribute from one great man to another. Like Martínez, Zapater holds a piece of paper expressing the artist's friendship, making particular reference to the many letters he had received from Goya. The paper is inscribed, *Mi Amigo Mart[i]n / Zapater. Con el / mayor trabajo / te a hecho el / Retrato / Goya / 1790* ('My friend Martin Zapater, I have done your portrait with the utmost care, Goya, 1790'). In the 1790s similar personal inscriptions appear on Goya's most sensitive portraits, adding a further dimension to the sitter's identity, for the artist paints his subject intimately as friend rather than client. Signed and dated 1790, this half-length image contrasts with the public portraits of monarchs and courtiers. That year, Goya went back to Saragossa for a month from October to November, and it was during this visit, away from the pressures of the court, that the portrait was made.

In the last two decades of the eighteenth century, Goya became artistically supreme in Spain. The year 1788 saw the death of Charles III and the accession of Charles IV and his consort María Luisa. The coronation of 1789 led to Goya being given the position of Court Painter with an increase in salary, and commissions to paint portraits of the new king and queen (77, 78). He was not the only artist to benefit from the new order. After the death of his old patron, the Infante Don Luis, Luis Paret y Alcázar had been allowed to return to his native Madrid in 1787. In 1791 he completed a painting recording the ceremony of September 1789 at which the Prince of the Asturias (later Ferdinand VII) swore allegiance to his father, the new king, in the Church of San Jerónimo el Real in Madrid (79). Charles IV was said to have approved of this painting, but the artist was never to achieve Goya's type of success, although his discreet irony in painting formed a parallel to Goya's ferocious realism. But in the formal production of state images Goya was equally committed to portraying the pomp and elegance of wealth and power.

Goya's coronation portraits of Charles IV and María Luisa were exhibited on state occasions and in public buildings. As in so many of his formal portraits, here too the artist made a particular feature of costume and orders. King Charles IV wears a scarlet suit, the colour a little more muted than on the costumes of Floridablanca and Manuel Osorio. While almost as ugly as his father, Charles IV was chubbier, fuller-figured and of less arresting presence. Despite the bright colour of his clothes, he is nevertheless far more austerely dressed than his forefathers had appeared in their state portraits. The queen too is dressed soberly, only her elaborate hat and wide hair (in the French fashion) add a slight sense of frivolity to her sombre image.

The portrayal of the queens of Europe in the eighteenth century was probably even less original than that of their consorts. Portraits of the Hanoverian royal family, and the many portrayals of the Bourbon queens of Spain and Italy are largely studio works. However, Elisabeth-Louise Vigée-Lebrun (1755–1842), working at the French court before the Revolution, made more memorable portraits of Marie Antoinette. She recorded her desire to persuade female sitters to

77
*Portrait of
Charles IV*,
1789.
Oil on canvas;
137 × 110 cm,
54 × 43 3⁄8 in.
Tabacalera,
Madrid

78
*Portrait of
María Luisa*,
1789.
Oil on canvas;
137 × 110 cm,
54 × 43 3⁄8 in.
Tabacalera,
Madrid

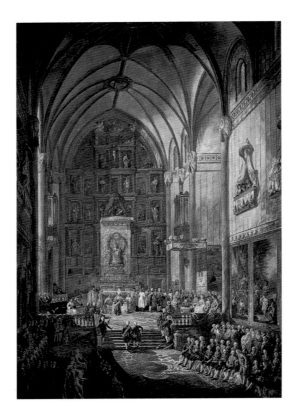

79
Luis Paret
y Alcázar,
Ferdinand VII
as Prince of the
Asturias Taking
his Oath of
Loyalty to the
King his Father
in 1789,
1791.
Oil on canvas;
237 × 159 cm,
93 $^3/_8$ × 62 $^5/_8$ in.
Museo del
Prado, Madrid

remove their heavy make-up because she wanted to portray them
in the fashionable simple style. Unlike Vigée-Lebrun, Goya shows no
such prejudice. Just as he delighted in fashionable clothes, so he
seems also to have enjoyed the challenge of cosmetics. His state
portrait of Queen María Luisa includes the beauty spots she wore,
as well as her darkened eyebrows, and his later portraits of the
queen, when she was comparatively elderly, reveal an enthusiasm
for the artificiality of a woman's toilet. The Duchess of Alba too used
eyebrow pencils, kohl and rouge; later portraits again show their
sitters to be wearing powder and rouge.

Goya's informal relationships with Spanish noblewomen reflect the
social independence which aristocratic women were able to show
subordinates and friends. English visitors to the Spanish court often
expressed their consternation at the relaxation of etiquette that high-
born wealthy women enjoyed. Early attempts to improve the position
of women in Spain had enabled both married women and widows to

assume a degree of social independence that was denied the unmar-
ried female. The Duchess of Alba was particularly well known for
her charm and wilfulness, and one of Goya's earliest references to
her, in a letter to Zapater, describes how she persuaded him to make
up her face: 'You'd be better off coming to help me paint the Alba
woman, who yesterday came to the studio to make me paint her
face, and she got her way; I certainly enjoy it more than painting
on canvas, and I still have to do a full-length portrait of her.' The
use of cosmetics by wealthy female sitters, which had so perplexed
Vigée-Lebrun, appears in several portraits by Goya of the Duchess of
Alba (see 119) and the queen, notably those in which they wear the
maja's costume. Such passionate devotion to exotic dress reveals the
unorthodox manner in which Spanish female portraits deviated from
their European counterparts.

In the 1790s, when Goya became director of painting at the Royal
Academy as well as the king's chief painter, his most fruitful years
of artistic production still lay ahead, but the consciousness of his
own mortality may well have given him the impetus for his more
experimental work. 'I wish people would leave me alone and let
me live quietly, carrying out the work which I am obliged to do and
spending the remaining time on things of my own', he wrote. Spain
plunged deeper into economic recession and the political situation
abroad worsened, while Goya seemed to become more particularly
prey to the problems of his new status. 'I spend a lot,' he wrote,
'because my position demands it, and anyway, I like it.'

In self-portraits the artist reveals his fascination with elucidating
complicated, semi-philosophical ideas about artistic status and individ-
ual freedom. The eighteenth century saw many changes in the way that
artists depicted themselves, and the pictorial heritage of self-portraits
in Spain was particularly rich. Goya had studied Velázquez's *Las Meninas*
(see 50) and admired the picture partly, one suspects, because the court
painter is represented as a gentleman, showing off his honours as well
as his skill. Such an artist was credited with raising the status of paint-
ing to a liberal art, but Velázquez was not the only seventeenth-century
Spaniard famous in the eighteenth century for his self-imagery.

Bart.ᵉ Murillo seipsum depin gens pro filiorum Votis acpreci bus eXplendis

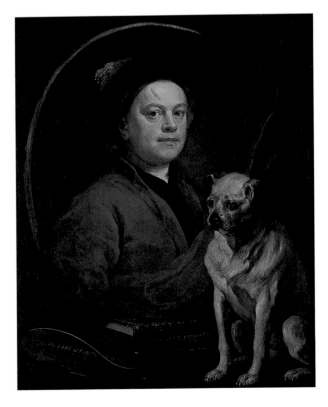

80
Bartolomé
Esteban
Murillo,
Self-Portrait,
*c.*1670–3.
Oil on canvas;
122 × 107 cm,
48 × 42 ¹⁄₈ in.
National
Gallery, London

81
William
Hogarth,
The Painter
and his Pug,
1745.
Oil on canvas;
90 × 69·9 cm,
35 ¹⁄₂ × 27 ¹⁄₂ in.
Tate Gallery,
London

In 1729 a well-known Spanish self-portrait, by Bartolomé Esteban Murillo, the Sevillan master, was brought to England (80). In 1740, having been bought by the Prince of Wales, it became a source of reference for English painters. Probably a private work for the artist's own family, this bust portrait is devised as a painting set within a painting. A few years later William Hogarth (1697–1764) borrowed Murillo's composition as inspiration for his own self-image (81). This intellectual format appealed to Hogarth, who transformed his deceptively straightforward likeness of a man in working gear into a summary of intellectual aspirations held by the serious artist. He even plays on the spectator's expectations by manipulating the drapery in the painted portrait so that it spills over into the apparently real world of his pet pug, his palette and the copies of Shakespeare, Swift and Milton which serve as props to the illusory painting. By placing his portrait above the masterpieces of British literary geniuses, Hogarth offers his self-image as an elevated statement about the intellectual demands of painting. Below Hogarth's head and shoulders lies his palette on which a wavy line appears, next to which the artist has inscribed the words: 'The Line of Beauty | And Grace | W H 1745.' The serpentine line represents Hogarth's definition of perfect beauty, the fundamental form from which all beauties in nature and art are derived, and which he was later to discuss in his treatise *The Analysis of Beauty* (published in 1753).

The enigmatic talent of artists for creating miraculous illusions out of paint, chalk, pen and ink on canvas, paper or an etching plate was something that eighteenth-century philosophers frequently debated. When, in 1765, the critic and philosopher Denis Diderot reviewed one of Fragonard's major paintings of a classical subject, he was to break off with a heartfelt cry: 'It is a scene of extreme joy, frantic debauchery, unthinkable drunkenness and fury. Ah! If only I were a painter.' The idea that great artists could summon up a reality more vivid than that of a writer or philosopher was attractive to artists and their admirers. The intricate references to aesthetic matters in Hogarth's self-portrait of 1745 show how self-portraiture itself became a means of exploring the artist's perplexing psychology.

Goya, who was eighteen when Hogarth died, absorbed this early eighteenth-century tradition of balancing the known and the practical against the unknown, the intellectual and the fantastic. His most startling pictorial experiments often seem to follow the example of earlier European masters. Hogarth and his English contemporaries, for example, conducted vigorous artistic researches into the realities of human existence and the meaning of beauty. In France, painters such as Fragonard and David made artistic forays into philosophy and literature. And the world of eighteenth-century aesthetic games, where artists could become philosophers and showmen, and one painting could contain an infinity of meanings, plots and arguments, was to find in Goya its most distinguished exponent.

His intriguing *Self-Portrait in the Studio* (82) has been dated as early as 1775–80 and as late as 1795. The loose style and distinctive colouring are typical of Goya's painting from the 1790s, but the vigorous pose makes it unlikely to have been painted after the artist's life-threatening and lengthy illness of 1792–3. Consequently a date of 1791–2 seems sensible. The work provides a Spanish equivalent to the visual manipulations of Hogarth's much earlier picture. Goya's concern with his own status moved him to devise a new, specifically modern updating of self-imagery, and he portrays himself as a stocky figure in an embroidered jacket and elaborate jabot, topped by a heavy shallow-brimmed hat. The crown of the hat is adorned with metal supports designed to hold candles, to illuminate the artist's nocturnal working hours. Through the window daylight floods into the studio and falls across the easel painting on which the artist works. Apart from the easel, the only other objects in the studio are a table, an expensive silver inkstand and writing paper.

The light in the studio illuminates the paper and ink, turns the artist's silhouette to darkness, faintly shadows his face, and picks out the chunky ring on the forefinger of his painting hand. His hat is cocked rakishly at the spectator, and there is more than a hint of vanity in the elegant turn of his silk-stockinged calves. Yet this is someone who, perhaps, is not quite at ease – a raffish, rather truculent man, extricated momentarily from an interior world of inspiration, about

82
Self-Portrait in the Studio,
*c.*1791–2.
Oil on canvas;
42 × 28 cm,
16 ½ × 11 in.
Royal Academy
of San
Fernando,
Madrid

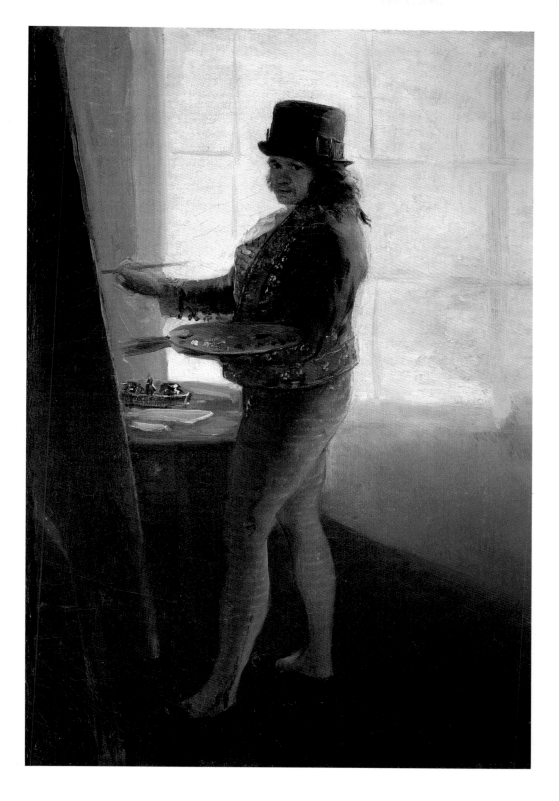

which the outsider grasps as little as they do of the unfinished picture on the easel. Owing to its oblique placement, the frame of the window distorts the lie of the far wall. Goya cannot be painting the portrait itself, since the size of the actual work is 42 × 28 cm (16½ × 11 in): much too small to correspond to the large work on the easel.

Such subtle visual games with size, space and light are integral to Goya's more informal, private pictures. When the *Self-Portrait in the Studio* was painted he was approaching fifty – elderly, in fact, by eighteenth-century standards – and his concern with his appearance and age, mentioned in his letters to Martín Zapater, are revelations of his own frailty, similar to those hints of mortality that he had inserted into the portraits of his most powerful sitters. The drenching light hints at the imaginative world from which the artist draws inspiration, and this self-portrait ushered in a period of feverish activity, devoted to the darker, more quirky sources of inspiration.

After Goya's death in 1828, Javier Goya was to write a memoir of his father in which he stated that Goya particularly admired the work of Rembrandt. The Dutch artist formed a special point of reference for the Spanish master, and his work is comparable because of his many analytical self-portraits. Although Goya only produced about a third as many as Rembrandt, his own face and figure display analogous qualities of insight and mood, which turn every piece of self-scrutiny into a puzzle for the spectator to explore. What Goya may have found in Rembrandt was perhaps similar to what Hogarth found in Murillo: a way of expressing the indefinable power of the artistic imagination. This faculty gained cult status in the later eighteenth century, when it was associated by writers of the Romantic movement with such concepts as 'genius' and 'the sublime'. It was seen as comparable to a force of nature, and was considered to be the prime source of artistic energy.

Goya's *Self-Portrait in the Studio* is a rare example of an eighteenth-century self-portrait showing the full-length figure of the artist. One of the most famous pictures of a painter standing full-length in his studio before an unfinished canvas was produced in the Netherlands by Rembrandt in 1629. *The Artist in his Studio* (83) is now no longer

83
Rembrandt van Rijn, *The Artist in his Studio*, 1629. Oil on panel; 24·8 × 31·7 cm, 9¾ × 12½ in. Museum of Fine Arts, Boston

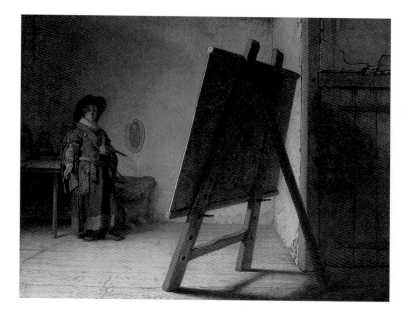

regarded as a self-portrait but instead as a generalized study of an artist engaged in the lonely business of perfecting his craft. The painting was well known in the eighteenth century, and was interpreted as a pictorial parable on the sense of sight. The artist sees reality, but he also sees other, imagined worlds. The allegory of sight in relation to the fine arts was a very traditional subject, which was widely explored in the eighteenth century, when practising painters such as Hogarth published their own ideas about the primacy of artistic perception. In his lectures at the Royal Academy in London, Reynolds too, later stressed the need to educate the eye, pointing out the crucial importance of young artists' learning to observe the most beautiful paintings of the past. Just as Goya studied the enlightened portrait of the educated man of affairs and filled it with details complimenting the sitter on his education, ability or perspicacity, so the 1791–2 self-portrait retains a similar idea.

A salient feature of Goya's portrait of Floridablanca (see 59) is the eyeglass; Floridablanca holds it out as a symbol of enlightened sensibility and intelligence, a tribute to the sitter's rational perception. In eighteenth-century portraiture eyeglasses or spectacles were used as signifiers of high intellect; the most famous figure

to be portrayed in this way was that fanatic devotee of Reason, Robespierre, whose hawklike features, beneath the flattering lens, were sketched in 1794, just before he fell from power and was guillotined. Another famous painting to transform short-sightedness into a manifestation of furious intelligence was Reynolds's portrait of Giuseppe Baretti (84), engravings of which appeared in 1780. Baretti had been one of the most lively and accurate of foreign observers to visit Spain in the eighteenth century, and had published his *Travels through Spain, Portugal and France* in 1760. In another portrait of Baretti, by the Irish artist James Barry, the sitter holds the eyeglass close to his face as he reads a book. The American statesman and scientist Benjamin Franklin was also rarely portrayed without his spectacles.

Goya's paintings of Floridablanca, Cabarrús, Meléndez Valdés, Jovellanos and Godoy transformed the portrait into a species of history painting. In the classical hierarchy of artistic subject matter, history painting was placed highest because it showed human beings taking part in some great moment of triumph or tragedy. Although portraiture had traditionally been considered a lesser subject, the enlightened portraits of the eighteenth century concentrated so often on noble actions and the supremacy of the sitter's intellect or moral virtue that they effectively became histories in their own right. Reynolds's greatest portraits were often referred to as histories, and the originality of Goya's portraits contributed so astutely to the sitter's sense of character that they too became regarded as more than simple likenesses.

French, English and Spanish artists of the later eighteenth century, concerned to explore the constituents of their inspiration, produced many dazzling self-portraits. Sir Joshua Reynolds paid himself the ultimate compliment as a man of letters and learning, as well as a fine artist, by portraying himself as an old bespectacled man (85). So did the French painter, Jean-Baptiste-Siméon Chardin (1699–1779; 86) and Goya himself (87). Symbolizing a bookish, intellectual capacity and enlarging the eyes as signifiers of the wearer's power of perception and reason, the inclusion of spectacles in portraits served to express an activity as intangible as the workings of the mind, and

84
Sir Joshua Reynolds, *Portrait of Giuseppe Baretti*, 1774. Oil on canvas; 73·7 × 62·2 cm, 29 × 24½ in. Private collection

85
Sir Joshua
Reynolds,
Self-Portrait,
1789.
Oil on panel;
75·2 × 63·2 cm,
29⁵⁄₈ × 24⁷⁄₈ in.
Royal Collection

86
Jean-Baptiste-
Siméon
Chardin,
Self-Portrait with
an Eyeshade,
1775.
Pastel;
46·1 × 38 cm,
18¹⁄₂ × 15 in.
Musée du
Louvre, Paris

87
Self-Portrait,
c.1797–1800.
Oil on canvas;
63 × 49 cm,
24⁷⁄₈ × 19³⁄₈ in.
Musée Goya,
Castres

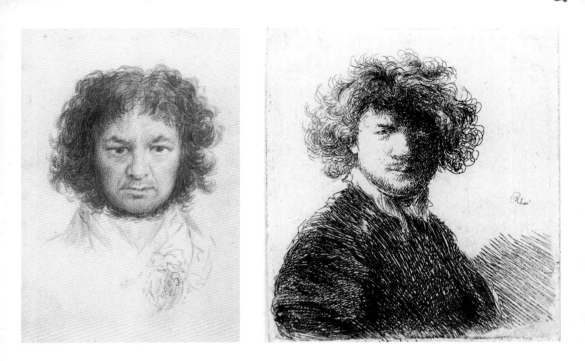

more particularly, the imagination. Goya's *Self-Portrait* with spectacles makes the sense of sight into its principal theme.

As he grew older, Goya turned to a more profound exploration of his face and head. In one sketch (88) there is something of the Romantic sensation of the wildness of genius and the potency of the creative imagination, expressed by the staring eyes and the dramatically curling hair. While Goya may still have been examining self-portraits by Rembrandt (89), which also study the effect of untidy hair, the role of the untamed artistic temperament obviously appealed to him. The swaggering, rather dressy man who dominated his studio (see 82), changes to a figure expressing darker moods. Self-portraits from much later in the artist's life transfer the action from outward performance of the job in hand to the less tangible workings of the mind. In a life-sized study of the artist's head (see 58) dating from around 1815, Goya seems to express a feeling of malign glee as he sets his face aslant under an unkempt thatch of hair, allowing his severe features to swim out from a void of furiously brushed-in blackness. The artist whose creative processes may defy description has become the image of genius breaking the boundaries of rules and restrictions.

88
Self-Portrait,
1798–1800.
Indian ink
and wash;
15·2 × 9·1 cm,
6 × 3⁵⁸ in.
Metropolitan
Museum of Art,
New York

89
**Rembrandt
van Rijn**,
*Self-Portrait
with Curly Hair*,
1630.
Etching;
6·2 × 6·9 cm,
2¹₂ × 2³₄ in

5

Fran.co Goya y Lucientes,
Pintor

As he reached the summit of his public career, Goya bore a heavy burden of competing professional demands. In the 1780s he had written of his desire to be left alone to 'get on with things of my own', and towards the end of the decade, at the same time as he was under pressure to produce public images, his art began to explore a more realistically uncompromising side of life.

By the 1790s the obligations of state functionary clashed with his intelligent apprehensions of the realities of his society, and his subject matter began to change even more noticeably than in earlier years. Increasing population and attendant unemployment had changed late

90
*Francisco Goya
y Lucientes,
Painter,*
plate 1,
Los Caprichos,
1797–8.
Etching and
aquatint;
21·9 × 15·2 cm,
8⅝ × 6 in

eighteenth-century Spain into an unstable and restless nation. In 1781 Charles III had been obliged to call out the Spanish army to deal with 'gangs of criminals who commit murder and rape … and live by robbery and smuggling', and in 1802 Charles IV commanded the captain-generals of his army to devote themselves to arresting a 'vast number of criminals, highwaymen and smugglers'. Foreign visitors were aghast at the numbers of muggers and thieves who operated, sometimes in broad daylight, with insolent ferocity. In the second half of the eighteenth century, certain regions, including Goya's native Aragon, created their own rural police forces. This was the background to Goya's increasing interest in subjects of criminal activity, crimes and the variable (often oppressive) conduct of Spanish law enforcement and justice.

In 1787 Goya's intimate patrons, the Duke and Duchess of Osuna, commissioned a series of works depicting rural subjects. In these the artist seesawed between perennially popular images of Spanish country life – beautiful peasant girls flirting with handsome youths, idyllic scenery, children at play – and graver themes, such as a workman being injured on a building site and highwaymen slaughtering the passengers of a stagecoach. Similar changes also ruffled the

91
Summer or
Harvesting,
1786–7.
Oil on canvas;
276 × 641 cm,
108 ¾ × 252 ½ in.
Museo del
Prado, Madrid

tranquil order of Goya's tapestry cartoons of this period in a new series of designs portraying contemporary life in the Spanish country-side using traditional seasonal themes.

The largest cartoon Goya ever produced, *Summer* or *Harvesting* (91), was one of a series portraying the four seasons. At a time when Spain was suffering a severe famine, Goya filled the picture with eccentric details: he shows unsteady haystacks about to engulf the children playing among them; the harvesters look almost sinister, and one man shows off his rotten teeth in a snarling grin. The last cartoon in the series, *Winter* or *The Snowstorm* (92), is Goya's sole painting of snow.

In these later cartoons Goya scoured each subject for new ideas, often going against the techniques and images required by the weavers, namely big figures with strong silhouettes, large areas of bright pigments, and simple, easily identifiable subjects. One sketch, rejected by the factory, is among the painter's most memo-rable subjects: a picnic held on the banks of the River Manzanares on St Isidore's Day in May (93). Goya described this as an arduous challenge because of the large number of figures involved and the tumultuous atmosphere of excitement engendered by this popular festival. His composition drenches the well-dressed figures in early summer light and sets them against a view of Madrid: the church of San Francisco el Grande, where Goya had painted an altarpiece, and the Royal Palace, that monument to Bourbon taste and power, show up as clearly as images in a topographical panorama. Bought from Goya by the Duke of Osuna, this sketch is one of the last of Goya's paintings to show Madrid as an elegant, frivolous city.

During the late 1780s and early 1790s, Goya was still obliged to perform administrative duties for the court. After the accession of Charles IV in 1788, his position as deputy director of painting at the Royal Academy of San Fernando (he became Director in 1795 after the death of Francisco Bayeu) involved extra tasks, together with the running of a studio with assistants and pupils. In 1789 Goya's anxieties centred around the illnesses suffered by his sole surviving child, Javier. 'I have a four-year-old son who ... has been so ill that I have had no life of my own for all this time. Thank God he is now

93
*The Meadow of
St Isidore,*
1788.
Oil on canvas;
44 × 94 cm,
17³⁄₈ × 37 in.
Museo del
Prado, Madrid

better', he wrote. Outwardly, a man of genius and substance, pursuing a glittering career and the focus of admiration and professional envy, Goya occupied an elevated position in Spanish society. Privately, he became prey to doubts and fears which engendered increasing scepticism towards the success he had spent so many years achieving. Even in the most lofty company his mood seems disturbed and suspicious. In 1791 he records: 'I went today to see the king, my master, and he received me very kindly. He spoke to me of my little Paco's pox [Paco was Javier Goya's pet name, and he had probably just had chicken pox]. I told him this was true [ie the child had been seriously ill] and he shook me by the hand and then began to play on his violin.' Charles IV's touch may have been a particular mark of favour, similar to the king's touch for healing scrofula, customary among the monarchs of England and France. Equally, however, it distinguished the monarch's courage and fearlessness in the face of disease from the superstitious ignorance of the common man.

Nevertheless, such favour only fuelled Goya's perception of the vulnerable nature of his position. 'I was very nervous because there had been someone of my profession who had said, in that quarter [ie to the king] that I no longer wished to paint for His Majesty, together with other stories which contemptible people invent.' This recurring obsession was later to find a positive form in sketches of ugly figures whispering or gossiping together. Goya's anxieties and exhaustion over public work, which he mentions in letters to his confidant, Martín Zapater, must have been known to people at the court, and they reveal the neurosis of someone overtaxed by the strains of court and academic life.

Public festivities celebrating the coronation of Charles IV in 1789 took place in many Spanish cities, and lasted until the end of the year. Ironically, they coincided with the revolutionary fervour that was gathering in France. The comparative austerity of the public portraits of the King and Queen of Spain may have reflected a shift in taste, as the new monarchs surveyed their impoverished and restless nation. The French Revolution was ultimately to have a catastrophic effect on Spain, curtailing economic growth and new enlightened freedoms.

The Enlightenment had flourished in Spain under the influence of ideas from northern Europe, and the art academies had benefited from close professional ties with France: art students were regularly sent to Paris on study scholarships, and books and prints after modern French paintings were imported into Spain as regularly as fashions in dress and hair. But there were also close political alliances, which had been forged after the Bourbon triumph in the War of Succession. France and Spain were united against England, and Charles IV was first cousin to the French king, Louis XVI (r.1774–92).

Anxious to propitiate the revolutionary government in France, however, the new king dismissed his anti-revolutionary minister Floridablanca, and for a short while Spain remained on comparatively friendly terms with her neighbour. This uneasy and short-lived period of calm ran parallel with Goya's last tapestry cartoons, works which were produced under duress. The king wanted comic scenes of 'rustic' subjects to decorate his office in the Escorial Palace. Goya at first refused to carry out the work, then was obliged to agree. Painted in 1791–2, these cartoons appear decorative but also exhibit rebarbative stylistic features in their interpretation of subjects involving games and pastimes: men performing on stilts; a country wedding in which the bridegroom is hideous and the wedding party forms a sinister group; girls tossing the straw-stuffed dummy of a foppish man in a blanket and grinning widely. *Little Giants* (94), another innocent subject of children playing in the countryside, recalls earlier, more idyllic scenes, but the child riding piggy-back on another's shoulders wears a broad-brimmed hat and displays sharp teeth. The child being ridden is shadowed, his neck cut by the stranglehold of the other child's legs, a compositional echo from the print of Goya's youth, *The Garrotted Man* (see 47).

News of the storming of the Bastille in July 1789 had provoked in Spain, as in other parts of Europe, intense excitement, with protesters and supporters openly debating the political implications. Broadsheets, popular songs, articles and essays lauded France as the home of freedom. In England, sketches and caricatures of the main events appeared. Only a couple of weeks after the Bastille was

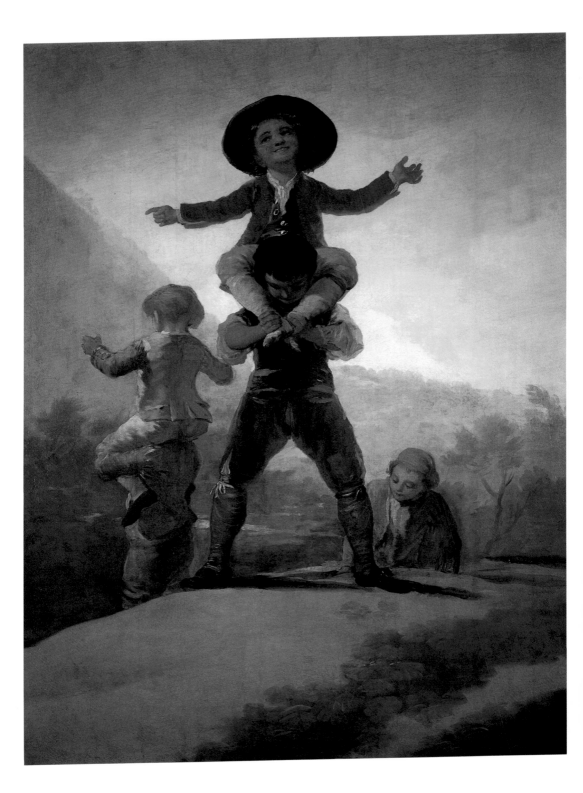

taken, for example, the English draughtsman and caricaturist James Gillray (1756–1815) designed his pro-revolutionary print *France Freedom, Britain Slavery* (95). The theme of the print points to an unfavourable contrast between the triumphant return of the French finance minister, Jacques Necker, who had been dismissed by Louis XVI a few days before the fall of the Bastille, and the authoritarian tax and excise laws of prime minister William Pitt, who tramples on the British crown. This sympathetic attitude towards France as the home of freedom made the print popular in Europe. On the left Necker is carried shoulder-high by a grateful populace. This is an example of the new-style political imagery circulating in Europe, and whether or

94
Little Giants,
1791–2.
Oil on canvas;
137×104 cm,
54×41 in.
Museo del
Prado, Madrid

95
James Gillray,
*France
Freedom,
Britain Slavery*,
1789.
Coloured
etching;
27·5×46 cm,
10⁷⁸×18¹⁸ in

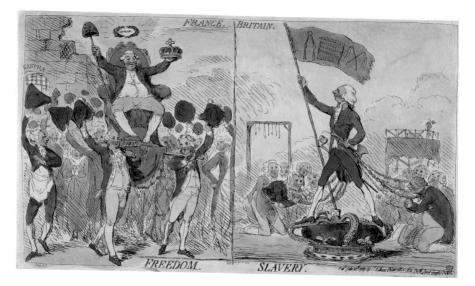

not Goya knew this particular print, the strange shape of the child in the hat with its outstretched arms in *Little Giants* echoes the figure of Necker by Gillray. The popular print – particularly crude political allegories – increasingly became a source of inspiration for the artist as he developed an interest in over-simplified perspective, similar to that found in political cartoons and caricatures by British artists such as Gillray and Thomas Rowlandson (1756–1827).

Even at this supremely demanding stage of his life, Goya was evidently contemplating the production of a more independent style of work, and shortly before the illness which left him permanently

deaf, he declared publicly that there were 'no rules in painting'. This disconcerting artistic impiety was uttered not at a private gathering of friends but in an address delivered to colleagues at the Royal Academy in Madrid in October 1792. Some of his colleagues were shocked; the rules which the academy had evolved so laboriously under Mengs in the 1760s had formed the basis on which students were taught, and the study of geometry, mathematics and classical literature had become the mainspring of the state artist's profession. With one bold statement Goya had demolished the foundations of such artistic dogma.

As an aesthetic liberator Goya was unorthodox. He had few direct followers and no notable pupils. Yet in the period of transition from the eighteenth-century Age of Enlightenment to the Napoleonic Wars of the early nineteenth century, he was finally to escape from the shackles of public art and reveal himself as a man of profound originality and startling effrontery. When he challenged the Royal Academy, he spoke with the authority and earnestness of its director of painting and the king's chief artist. By 1792 he occupied an unassailable position at the heart of the artistic establishment in Spain, and this must have made his revolutionary stand against the ordered system of Spanish art training appear doubly provocative. Yet the passionate tone of his address, advocating the relaxation of rules for students, also pleaded for freedom of expression for all artists.

After this speech to the Royal Academy, Goya was granted a holiday. His brother-in-law, Ramón Bayeu, had endured a long illness and was to die in 1793, and Goya himself was fatigued and unwell. Leaving his family in Madrid he travelled to Seville and then to Cadiz. From there Sebastián Martínez wrote to the Madrid court on 19 March 1793:

My friend, Don Francisco de Goya left the Court, as you know, with the intention of seeing this city [ie Cadiz] and the other towns on the road, so passing his two months' leave. However, it was his misfortune to fall ill in Seville and, believing that he would be better cared for here, he decided to come accompanied by a friend. He arrived at my house in a deplorable condition, in which he remains, having been unable to go out

of the house. We must help him to recover, regardless of time or expense, but I do fear that it will be a lengthy business. Therefore I have taken the liberty of bothering you to ask if you would be so kind as to allow Goya to send the doctor's reports as proof of his condition, so that he might be granted an extension; or take whatever course you wish. This friend [Goya] is conscious of the favour he owes you and he wanted to write at length on the matter, but I forbade him to do so, knowing the harm this will do to his head which is the source of the sickness.

A few days later Martínez wrote to Martín Zapater:

This is a bad day on which to write, but that must not prevent me from replying to your kind letter of the 19th [March]. Our friend Goya is progressing slowly, but his condition has improved a little. I have confidence in the spa, and I am sure that when he takes the waters soon in Trillo he will be restored to health. The noises in his head and the deafness are no better, but his eyesight is much improved, and he is not so confused as he was when he lost his sense of balance. Now he can go up and down the stairs perfectly well, and at last he can manage things which were impossible before. They tell me from Madrid that his poor wife was quite ill on St Joseph's Day, and that a major factor was her worry over her husband, although she knows that he is here with me. We shall see how he is in April, and at the beginning of May we will have to think carefully what to do.

Cadiz, on the southerly tip of the Spanish Atlantic coast, was a busy seaport, known for its exotic trading routes to the West Indies and the Middle East. It became famous in the nineteenth century among British tourists as a picturesque Spanish holiday resort and a popular centre for sea bathing. Trillo was a watering place on the River Tagus, not far from Madrid, with sulphur springs. The faith in the healing power of water treatment was particularly strong in the eighteenth century, when famous European resorts such as Bad-Ems in Germany, Bath in England and, especially, Spa in Belgium, a town near Liège with mineral springs, were visited frequently by European monarchs and aristocracy, as well as the middle classes. Goya himself was an enthusiast for this form of treatment. In old age he was granted leave of absence from the Spanish court in order to take the waters at the

French spa of Plombières. Modern diagnosticians have attempted to identify the nature of Goya's illness. In the 1920s it was asserted by one doctor that the artist suffered from arteriosclerosis after catching measles in youth, which might account for his deafness. He may also have endured two attacks of typhoid fever. In the 1930s a new and totally unverifiable theory suggested that Goya had contracted syphilis, but this has been discounted by later diagnosticians, who have tentatively explored several new theories about Goya's health. One of these suggests that the artist was a schizophrenic; another that he suffered from Menière's disease, which affects the hearing and sense of balance. Clinical depression and chronic lead poisoning from the proximity of lead-based oil paints have also been put forward as the causes of Goya's affliction. In conclusion, however, the records of Goya's symptoms and treatment are probably insufficiently specific to diagnose the illness with any certainty. All that can be deduced from the historical evidence is that in the eighteenth century spa treatment was generally given to people with so-called 'morbid' conditions, that is those suffering from neuroses, and diseases of the nervous system, as well as rheumatic fever and certain types of mental illness, such as depression.

During Goya's absence from Madrid the situation in France had deteriorated, and the arrest and imprisonment of the French royal family in 1791 meant that war with France was inevitable. Goya's sufferings in Cadiz in January 1793 coincided with the execution of Louis XVI in Paris; condemned on 17 January 1793 by a vote taken at the National Convention, he was publicly guillotined in the Place de la Révolution four days later. The votes in favour of his death included that of the leading French artist Jacques-Louis David, whose political power and income as the foremost government painter in France far outstripped anything enjoyed by Goya in Spain.

Visual records played a significant role in the French Revolution, and were matched by the urgency of artistic response throughout Europe to the political violence in France. A new wave of memorial images, from paintings, sketches and anonymous prints to mugs, handkerchiefs and medallions bearing effigies of the doomed king

flooded Europe. The massacre of aristocrats and priests which took place in September 1792, after the Duke of Brunswick's threat to destroy Paris if the French royal family were not freed, was also depicted. In Spain Charles IV alerted the Holy Office of the Inquisition to act as censors at borders and prevent inflammatory political material from entering the country. Anti-French feeling was rife. While Goya's illness temporarily removed him from the centre of political turmoil, he would have been aware of the implications. The suppression of Spanish newspapers and enlightened periodicals, the threats made against those of his patrons and friends who were suspected of harbouring sympathetic attitudes towards France, and the growing power of the Holy Office as it attempted to carry out its repressive public role, were to transform the nation which Charles III had tried to enlighten into an oppressed and inward-looking society under Charles IV. The fall of the Bourbon monarchy in France made the fragile Spanish royal family extremely nervous.

Goya endured a lengthy convalescence and returned to Madrid in mid-1793, but having been rendered stone deaf, he was still unfit for public commissions. His deafness would eventually force him to resign his post at the Royal Academy in 1797. In the meanwhile he painted his first documented freelance pictures for a private exhibition among members of the Royal Academy. In January 1794 he sent to the vice-director a number of what he called 'cabinet paintings', accompanied by a letter:

In order to occupy my imagination, mortified by my illness, and to recuperate in part the great expenses that my illness has caused, I have devoted myself to painting a set of cabinet paintings, in which I have realized observations that are normally not permitted by commissioned works, and in which caprice and invention have free play.

The reference to his expenses is particularly significant. In the 1780s, as his professional position had grown, so had his responsibilities. Not only was he keeping a wife and a young son, but he also seems to have been helping out several indigent relations. His elder brother, Tomás, received money that was channelled through Martín Zapater, and Goya was godfather to Zapater's eldest child. His mother, now a

widow, also needed financial aid, as did Goya's elder sister Rita. Apart from this, as Goya himself admitted, he liked to live well. His carriage, his horse and his expensive boots imported from England, his French lessons, and his interest in tracing his family tree, and his adoption of the honorific title 'de', so he became 'de Goya' rather than plain 'Goya', all indicate someone much concerned with improving his status even beyond the high position in life he already occupied. He may have regarded a new type of art as a financial investment and obviously intended to sell his 'cabinet pictures'.

The cabinet picture in the eighteenth century was generally a work reserved for the intimate setting of a study, a boudoir or a small antechamber. In some contexts the private 'cabinet picture' could be erotic, even pornographic. Small paintings and prints were popular at this time, and a vast quantity of pornographic imagery was available in Europe to wealthy collectors. Goya's 1794 'cabinet pictures' do not fall into this category, although it is hard to be certain which paintings formed part of the original batch. The only pictures definitely known to date from this time have striking subjects which seem to have been new in eighteenth-century Spain; a number of bullfight scenes, a fire in which people are being rescued, a shipwreck, and a view of the yard of a lunatic asylum. Painted on shiny pieces of tin and scissor-cut into rectangles of roughly similar size, the scenes are built up with thick layers of brown underpainting that roughened the smooth base, and the figures tremble like frail effigies against this thick encroaching background. In the *Yard with Lunatics* (96), the last of the series, completed in January 1794, the whip held by the attendant is thickly illuminated and forms an arc over the head of the madman in the left foreground. Struggling figures also dominate in the *Shipwreck* and *Fire at Night*. Tightly painted, remote and touching, the images emerge through a dense, dragging brushwork that defines details.

While some of these strange subjects were new to Spain, in the general context of European art they were well in line with popular subject matter. The catastrophe painting, a work which showed some exciting or horrific event with people acting out of desperation, had

96
Yard with Lunatics,
1793–4.
Oil on tin plate;
43·5 × 32·4 cm,
17 1⁄8 × 12 3⁄4 in.
Meadows Museum, Dallas

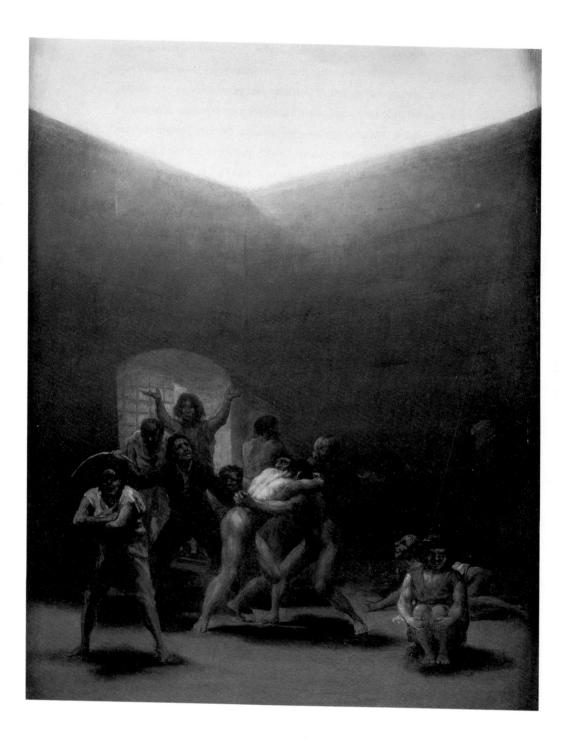

been particularly popular in France, where shipwrecks, family crises, battle scenes and acts of heroism were the staple ingredients of the state-approved painting on display at the annual Salon. In England, Hogarth had portrayed figures from the underworld, and eighteenth-century London was as full of outcasts and eccentrics as contemporary Madrid. Hogarth's images of those who exist on the margins of society – rakes, harlots, procuresses, crooks, drunks, people stricken with venereal disease or insanity – were no less harsh than those whom Goya fished out of the gutters in Madrid and monumentalized in his graphic art of the 1790s. The prison and madhouse haunt Hogarth's paintings and etchings as much as Goya's: the last scene of Hogarth's series *A Rake's Progress* is set in Bedlam, the great London asylum, a place that the artist must have visited. Goya's tin-plate pieces included a prison scene, as well as a view of the exercise yard of the Saragossa lunatic asylum, which he claimed in a letter to have seen first-hand. These masterpieces from the troubled interlude of convalescence demonstrate a conviction that painting beyond the established rules could extend an artist's powers.

Goya's progress away from the more frivolous imagery of the tapestry cartoons, his early private images like *The Garrotted Man* (see 46–48) and copies after Velázquez (see 49 and 51) suggest a continuing desire to introduce a fashion for high seriousness into Spanish art. At this time, after his illness and with his desire to work on personal images, his relationships with private patrons became especially crucial. The unpredictable political situation and the impoverished exchequer combined to make this decade among the most experimental and free periods of Goya's life. His contact with the Duke and Duchess of Osuna, Jovellanos, the scholar and art historian Juan Augustín Ceán Bermúdez, the poet Juan Meléndez Valdes and the playwright Leandro Fernández de Moratín became rich and valued professional relationships, encouraging his output as an independent master. And one particular patron, the Duchess of Alba, probably helped to transform his vision entirely.

María del Pilar Teresa Cayetana de Silva, thirteenth Duchess of Alba, was a duchess in her own right and, after the queen, was the woman of highest rank in Spain. A first full-length portrait, when he visited

97–98
Sanlúcar Album, 1796–7. Indian ink and wash; 17 × 9·7 cm, 6¾ × 3⅞ in. Biblioteca Nacional, Madrid
Right
The Duchess of Alba
Far right
Verso of 97 showing woman lifting up her skirts

her at her palace in Madrid, was followed by many other depictions; in 1796, after the death of her husband, he spent a summer on her estate at Sanlúcar de Barrameda near Cadiz. From these visits and their subsequent friendship he constructed in paint, ink and chalk a series of intimate portraits of the duchess, her life, her servants and her retainers, forming a unique visual record of this beautiful, sophisticated and wealthy woman. One contemporary poet, Manuel Quintana, also enjoyed the duchess's hospitality and memorialized her beauty in his work. The first of Goya's major albums of drawings dates from his sojourn on the Sanlúcar estate, where he made vivid, fragmentary sketches of the Duchess of Alba and other figures, both real and imaginary.

The majority of these sketches, executed in brush and Indian ink, are highly erotic fantasies of young women, and a few more decorous but recognizable portraits of the duchess, from the elegant woman who liked dressing up in fine clothes (97), to the angry, frustrated woman tearing her hair or clutching her head, or to the childless

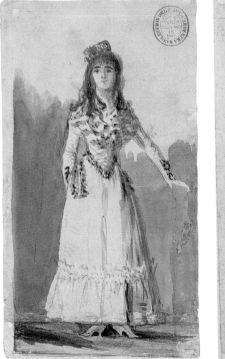
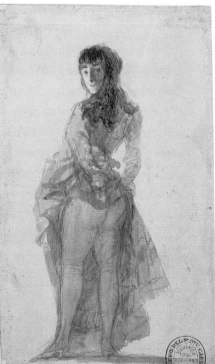

woman nursing her adopted mulatto daughter. The darker side of these provocative but light-hearted pieces appears in the figure of another woman who deliberately displays herself. In one drawing, on the reverse of the portrait of the elegant duchess, she is darkly shadowed with a long nose, raising her skirts (98) and smiling lewdly at the spectator over her shoulder; in other sketches she is shown nude, seated, masturbating in front of two grinning men, or as one of two women playing together on a bed. The sensuous display of erotic poses, from the elegant and elusive duchess to the lewd and available courtesan who trawls in the duchess's wake like a *doppelgänger*, reveals not only Goya's interest in sexual imagery but also his fascination with opposites and reversals. The repressive nature of the society in which he lived, the weakness he had experienced while ill, his disabling deafness and the onset of age, were sufficient to release in him a new, violent sense of liberation, and in this album of drawings he laid out the boundaries of future subject matter.

As his art continued to show violent departures from fashionable Neoclassicism, so his awareness of moral matters appears stronger. His own education had benefited from acquaintance with men such as Jovellanos, Sebastián Martínez and Godoy: powerful statesmen, cultured reformers and rich philanthropists, who gave him new insights into the power of the art he practised. Under the protection of the Osuna family, the Duchess of Alba, government ministers and talented writers, he continued to attract commissions which allowed him to display his brutal, often turbulent vision. Evidence suggests that these highly educated supporters may have influenced the artist's increasing boldness in developing his own tastes, enabling him to gain access to knowledge of foreign fashions. Sebastián Martínez's extensive print collection contained a huge range of images from abroad, and Jovellanos had a large number of foreign books in his collection, including a first edition of Edmund Burke's *A Philosophical Inquiry into the Origin of our Ideas on the Sublime and Beautiful*, which was first published in 1757 and translated into Spanish in the first years of the nineteenth century.

This influential treatise challenged the second century AD text *On the Sublime* by the classical writer, Dionysius Longinus, and was one of the earliest pieces of writing to categorize the physical and emotional reactions to aesthetic stimuli. The experience of viewing scenes of unusual horror, vastness or immeasurable quantity created in the spectator a strange thrill which could be positively identified as 'Sublime'. For late eighteenth-century artists, the popularization of the concept of 'the Sublime' enabled them to attempt subjects which ran counter to the fashion for calm and serenely rational classical images. A new fashion for mystery, violence, the supernatural and experiences involving the viewing of extreme natural phenomena, such as great mountains, storms, earthquakes, volcanoes and avalanches, became the dominant fashion in literature at the end of the eighteenth century and ushers in much of the imagery of the Romantic movement. In painting, too, the Sublime appears in the work of a prominent Swiss artist in England, Henry Fuseli (1741–1825); in the storm scenes of the French painter admired by Diderot, Joseph Vernet (1714–89); in the early works of the English landscape painter J M W Turner (1775–1851); the paintings of the eruption of Mount Vesuvius by Joseph Wright of Derby (1734–97); and in the misty, atmospheric views by the German painter Caspar David Friedrich (1774–1840). Goya himself may not technically have been a 'Sublime' artist any more than he can be positively identified with European Romanticism, but his penchant for images of violence and fantasy, what he called 'caprice and invention', shares the prevailing taste for the dark uncertainties of life which attracted so many critics and visitors to art galleries at the end of the century.

In June 1798 Goya sent an account to the Duke of Osuna for 'six pictures showing subjects of witches'. He was paid 1,000 reales (about £10 in the money of the period) for each of these small paintings. Witchcraft scenes were popular as Sublime images in European art of the late eighteenth century, as part of the taste for the supernatural. In Spain, enlightened liberals rejected the common superstitions but were well aware of the long history and the resulting cruelties that such beliefs had inflicted on innocent people. The persecutions of the Holy Office of the Inquisition against heretics,

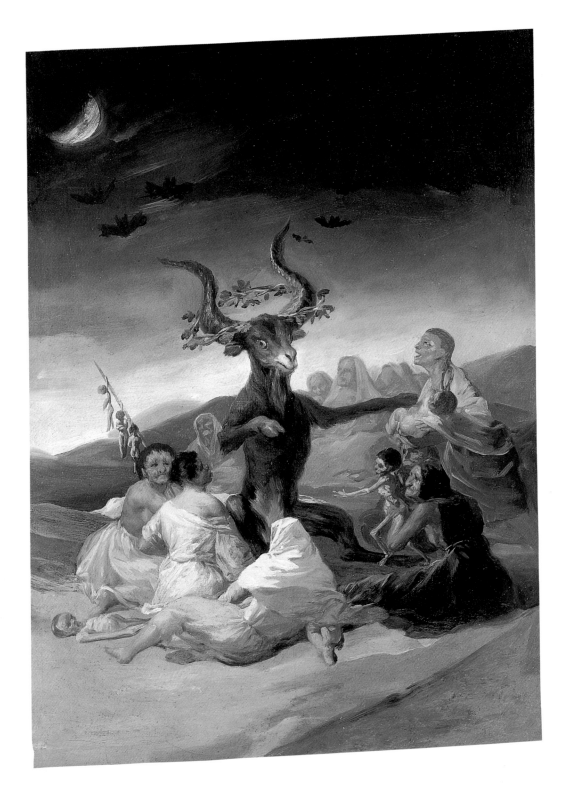

witches and those said to practise demonic rites were often seen as abuses of power. During Goya's lifetime such abuses were still practised, although it is sometimes hard to know for certain if the records of eighteenth-century executions, imprisonments and confiscation of accused people's property were religious or secular in origin. For Goya the subject of witchcraft was to become crucial to his new serious style.

The six witchcraft paintings for the Osunas were made for the duchess's boudoir in the family's country house. On the whole the subjects are comparatively frivolous. Two were taken from eighteenth-century plays satirizing popular superstitions. Not all of these scenes, however, are given a light-hearted treatment. *The Witches' Sabbath* (99) also has a literary source, but the details are disturbing: babies are sacrificed at night to the he-goat, traditionally seen as the physical manifestation of Satan. In the foreground a young, veiled woman reclines in a manner similar to the reclining female saint in the sketch of *The Virgin as Queen of the Martyrs* that Goya had painted eighteen years earlier (see 55).

The ironies in this painting could be seen as political as well as literary and social. Witchcraft may have been derided by wealthy educated people, but in the countryside, where people were enduring great poverty and infant mortality was rife, such superstitions persisted. Goya's relish in designing these disconcerting scenes is also evident in his drawings. His Madrid Album comprises a large series of sketches showing subjects from contemporary life, and especially the plight of women. The drawings feature a young girl with long dark hair, full breasts and shapely legs, who is variously made love to, beaten and persecuted, terrified and imprisoned. She is also shown in happier circumstances: on a swing, at a party, walking in the open air with friends or flirting with young men. Sometimes she is naked; mostly she wears fashionable clothes, such as the *maja* costume with its lace mantilla and flounced skirt.

Other marginal figures that inhabit these drawings include huntsmen, foppish men about town, the so-called *petimetres*, and virile *majos*, the male equivalent of the *maja*. There is also an elderly witch, known as

99
The Witches' Sabbath, 1797–8.
Oil on canvas; 43·3 × 30·5 cm, 17 × 12 in.
Museo Lázaro Galdiano, Madrid

100
**Luis Paret
y Alcázar,**
*Celestina and
the Lovers,*
1784.
Watercolour;
41 × 30 cm,
16 ⅛ × 11 ⅞ in.
Private
collection

Celestina, another personality borrowed from traditional Spanish literature, and who was to become a particular symbol in Goya's art.

Celestina first appeared in a sixteenth-century Spanish drama, as both a procuress and a witch. She is nurse to a beautiful girl, Melibea, whose doomed love affair, arranged and facilitated by Celestina, ends with the death of the lovers. The story is both comic and pathetic, and the play became widely popular in Europe in the seventeenth century, when it was translated into several languages. The eighteenth century saw a revival of the story and widespread interest in the Celestina character. A beautiful and highly finished drawing by Luis Paret makes the old woman into an arresting figure: seated in a shabby room, telling her beads, she is interrupted by the two lovers (100). Executed in 1784, Paret's rich and decorative version of the story antedates Goya's Celestina compositions, although it is not likely that Goya could have known of his design. Nevertheless, both artists shared similar interests. Paret introduces elements of witchcraft (on the back wall of the room hang garlic and the wings of a bat), and his Celestina holds in one hand the spectacles that denote someone with knowledge and enlightenment. Goya also designed bespectacled witches, and Celestina became even more monumental in his later work. He shows

her lurking in corners, reminding youth and beauty that they too must fade and wither. Generally a creature of evil omen, she becomes a grotesque being who acts as a moral corrupter of the young; occasionally she can function as a representative of wisdom. She appears in Goya's work of this period as one of an army of apparitions: people wearing masks, ghosts, deformed and corrupted priests, the outriders of death and destruction. In the Madrid Album she plays the role of an old woman begging from a beautiful *maja*; and lurks beneath an archway with another *maja*, a prostitute, waiting for clients (101).

Some especially sinister drawings are less obviously gruesome, but mirror a savage realism based on topical abuses. *How they spin!* (102) bears, like many in this series, Goya's own inscription. Three girls with shaven heads sit spinning. The words 'Sn Fernando' signify that they are destitute beggars in a Madrid hospice which housed the homeless. The figure on the left wears elaborate earrings and is older than the others, who appear to be child prostitutes taken off the streets and taught a useful trade. But the image of the spinners also

has a deeper meaning, concerned with devising the fates of men. Like Celestina, the prostitute personifies many of the ills of society, and this dovetailing of reality and fantasy forms the original creative source of Goya's new vision.

These sets of drawings link the Madrid Album to what became the artist's first mature and independent masterpiece, a set of eighty prints, published in 1799, entitled *Los Caprichos* ('The Caprices'). Sometimes the scenes look as if they are part of a play, a parade of eccentric figures. Mostly they are deeply pessimistic and cynical. Spain becomes a place akin to the medieval vision of Dante's *Inferno*, rife with evils of all kinds: hypocrisy, mendacity, cruelty and moral corruption. The influences of thirty years of life as a professional artist are all examined: Church, state, the court, the law, the medical profession, the arts and sciences, the streets of Madrid, rural life, contemporary poetry and philosophy, theories about the poor, the rich, the diseased, the young, the old; a whole vast synthesis is brought to bear on a welter of vice, immorality and vanity.

103
Drawing for frontispiece to *Los Caprichos*, 1797–8. Red chalk; 20 × 14·3 cm, 7⅞ × 5⅝ in. Metropolitan Museum of Art, New York

As confirmation of how the artist stamped his own personality on the *Caprichos*, the first plate shows a profile self-portrait (see 90). Unlike the image of Goya in his studio with the light of reason illuminating his canvas (see 82), or the bespectacled head and shoulders (see 87), this portrait is highly fashionable. Goya wears the latest in headgear, the beaver stove-pipe hat of the dependable self-made man, an image of advancement, solid in the assurance of success. With this one image Goya restates his self-identification with modernity, and his glance slants sideways in the finished print – unlike the preliminary drawing (103), where he stares ahead and away from the spectator.

The methods Goya used here were complicated and up-to-date. Traditional etching formed the basic technique, but Goya combined this with the comparatively recent invention of aquatint. The clean lines bitten out by acid on the surface of a small plate are complemented by pale tones, like wash, composed of tiny dots obtained by dusting the plate with particles of resin. Such areas loom up behind the artist's profile in plate 1 and lend rich shadows to his coat. Equally important to these plates was the addition of very fine

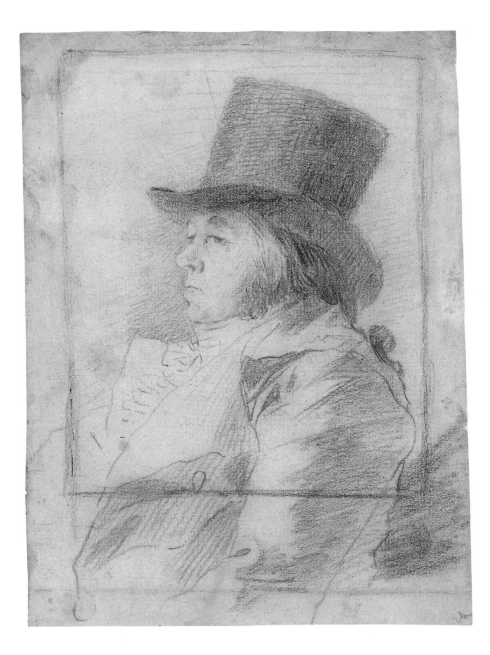

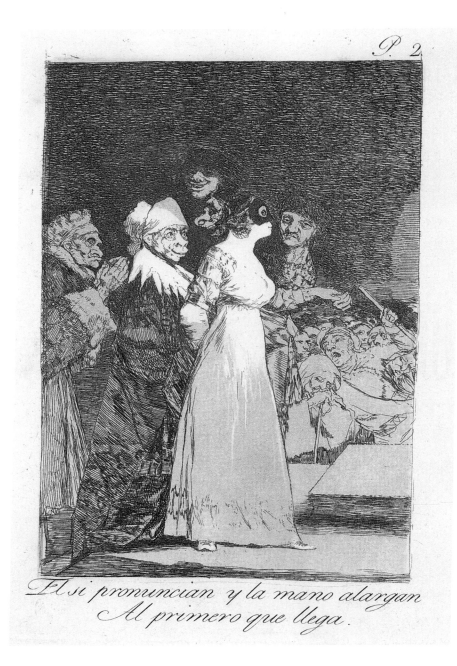

El si pronuncian y la mano alargan
Al primero que llega.

grooves scratched straight on to the surface of the plate with a sharp tool. Such drypoint scratches and squiggles are particularly fundamental to these etchings, and areas such as the profound blackness of the background or the muted shadows and deep lines around eyes and hands were graphic equivalents to the atmospheric, loosely-placed brushstrokes on paintings.

As figure designs, the compositions depict specific situations. Plate 2 is a *tour de force* of draughtsmanship (104). The young girl who had appeared so frequently in Goya's sketches is shown at her own

104
They say yes and give their hand to the first comer,
plate 2,
Los Caprichos,
1797–8.
Etching and aquatint;
21·7 × 15·2 cm,
8 ½ × 6 in

105
Designs for masks,
page 11 recto,
Italian Notebook.
Ink, chalk and wash

wedding. The caption reads: 'They say yes and give their hand to the first comer.' A girl's lack of discernment in contracting her marriage is expressed by the mask across her eyes. Desiring both status and the freedom conferred on women of rank after marriage, the girl holds out her hand. She is led forward by a male figure with a shadowy, sinister face and heavy-lidded eyes. More sinister are the grotesque heads which loom up in the background. A hideous mask is tied to the back of the girl's head. Goya had designed similar masks in his Italian notebook, one of his earliest pictorial obsessions (105). Here the mask

is a crucial focus of attention, eyed by the attendant male figure, possibly the prospective bridegroom, whose own deformed face indicates that he too wears a mask. Behind is a Celestina, clasping her hands as if in prayer. In the distance a congregation of ill-favoured hobbledehoys, some half human, is led by another Celestina and a figure waving a stick.

Goya's portrayals of disastrous marriage contracts, paralleled in contemporary literature, were a recurring subject for satirists and moral reformers. In Spain plays, poems and songs portrayed the plight of unhappily married couples, and Goya relied on his new language of modern emblems, in which the mask, the hermaphrodite, the diseased or deformed figure became metaphors for contemporary moral issues.

The sequence of prints which follows is devoted to deception in various forms. People pretending to be something they are not, people deceiving each other, playing cruel tricks on the young and vulnerable, and men as well as women play their part in the designs. Plate 6, *Nobody knows themselves* (106), again uses masks and carnival heads to create a world in which uncertainty and ambiguity undermine human relationships. The man and woman in the foreground wear contrasting black and white masks. Behind them are the creatures of the night formed out of carnival hats and heads. Even the perspective is ambiguous. The ground recedes up to the squatting figure, and it is hard to know where it leads from there because the whole world has metamorphosed into an illusion.

These designs evolved from observations of reality recorded in Goya's albums of the 1790s. One Indian ink drawing (107) sketches out an apparently inconsequential encounter between a man and a woman beneath a parasol. The subject recalls the image of Goya's early tapestry cartoon (see 33), but this later drawing focuses more strongly on a precise situation. Subsequent workings out of the design demonstrate how Goya removed the parasol to concentrate attention on the intimate reaction between the two participants. In the final print (108), Goya adds his favourite detail of the eyeglass. The moral is now explicit: however closely the man scrutinizes the girl he will never truly know what she is.

106
Nobody knows themselves,
plate 6,
Los Caprichos,
1797–8.
Etching and aquatint;
21·8 × 15·3 cm,
8⅝ × 6 in

107
Couple under a parasol,
Madrid Album,
1796–7.
Indian ink and wash;
22·1 × 13·5 cm,
8¾ × 5⅜ in.
Kunsthalle,
Hamburg

From Madrid high society Goya moves to the underworld and a nocturnal scene of robbers waiting for their prey, smoking beside a dead, gibbet-shaped tree, a symbol of coming disaster. The growth of crime and criminal fraternities in urban and provincial Spain, which had become such a major evil in Goya's society, stimulated the artist's enthusiasm for these new designs of highwaymen and prostitutes. He also returned to the subject of the public execution which had preoccupied him twenty years earlier in *The Garrotted Man* (see 47). Another nocturnal scene places a terrified but determined woman beside a hanged corpse (109); the woman is plucking teeth from the dead man's mouth to make a magic potion. The superstition that touching an executed corpse could cure disease was widespread throughout Europe. In London in 1786 members of the crowd attending a public execution at Newgate had climbed the scaffold and touched the hanged man's hands. In 1799 a woman bared her breasts for the hanged criminal's touch. This odd gesture, thought to cure

Nadie se conoce.

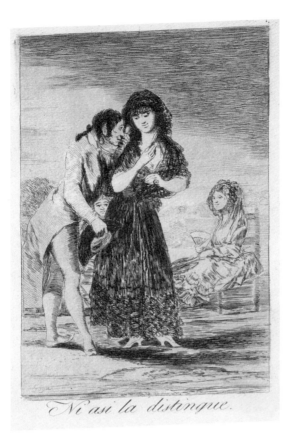

Ni asi la distingue.

108
*Even so he
cannot make
her out*,
plate 7,
Los Caprichos,
1797–8.
Etching and
aquatint;
19·6 × 14·9 cm,
7 ¾ × 5 ⅞ in

109
Tooth hunting,
plate 12,
Los Caprichos,
1797–8.
Etching and
aquatint;
21·6 × 15·1 cm,
8 ½ × 6 in

breast cancer, continued until well into the nineteenth century. Goya's fascination with public executions must have made him aware of these customs. In his print he illuminates the woman's jutting breasts as she holds a cloth to her face to mask the stench of rotting flesh.

Women play particularly important roles in the *Caprichos*. Celestina and the prostitute appear in numerous prints and occasionally demonic or supernatural activities replace their dishonourable professional dealings. Young girls and aged women become fatalistic and sinister figures whose powers extend to interfering in the affairs of mortals. In a parody of a traditional hunting scene, that of a bird trap, two young women and a crone create a trap for humans out of a dead tree, waiting like the highwaymen to snare their prey. The birds are now unwary lovers who, once enmeshed, are plucked and spitted. 'All will fall', reads Goya's caption, and among the trapped figures hovers a caricature of his own face.

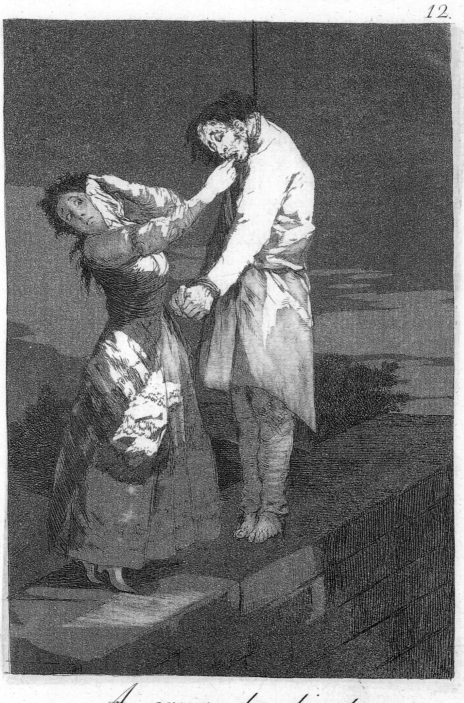

A caza de dientes.

Further designs showing the confrontation between the weak and vulnerable and the ruthless and powerful include two Inquisition scenes. These subjects were of particular topical interest in Goya's day, although he chooses to set his scenes in the historical past, probably the sixteenth century, when the Inquisition was at the height of its power. The persecution of heretics during Goya's lifetime remains a confused area of Spanish history, and new documentation reveals that there were few if any burnings in the eighteenth century. Recent information has come to light which demonstrates that, although responsible for many atrocities, the Holy Office in Spain was probably less savagely severe than in any other western European nation. In 1646 the English traveller and chronicler John Evelyn wrote that he was more afraid of the Inquisition in Milan alone than in the whole of Spain. Nevertheless, as Spain declined as a major European power during the seventeenth and eighteenth centuries, so the mythology of Spanish Inquisitional terror acquired even greater credence in popular belief.

The critics and reformers of religion in Goya's day were eager to circulate new tales and often unverifiable statistics which exposed the Holy Office as a major instrument of tyranny in Spain. The powers given to the Spanish Inquisition during the period of the French Revolution, the trials of enlightened statesmen who had tried to modernize Spain, and the banning of Enlightenment literature added up to a picture of an organization dedicated to the defeat of social progress. By the end of the Peninsular War in 1814, the Inquisition was seen as the principal reason for the country's economic and political decline.

Goya's Inquisition designs mirror the opinions of his enlightened patrons, particularly the sympathy felt for victims of the Inquisition's power. In one a woman sits on a stage wearing a penitential dress and tall hat. The ecclesiastical court listens as the judge reads out the sentence to a gathering of monks and priests with heavy-lidded eyes and wide mouths. The image summons up memories of *The Garrotted Man* (see 46–48) and *Christ on the Cross* (see 52), as well as the iconography of the *Taking of Christ* which Goya had painted for Toledo

110
No remedy, plate 24, *Los Caprichos*, 1797–8. Etching and aquatint; 21·7 × 15·2 cm, 8 1⁄2 × 6 in

111
Because she was susceptible, plate 32, *Los Caprichos*, 1797–8. Aquatint; 21·8 × 15·2 cm, 8 5⁄8 × 6 in

Cathedral (completed in 1798). The pale victim of persecution by the Holy Office is subsequently depicted, half naked, riding a donkey to the place of execution (110) and is obscenely restricted by a wooden halter on her neck and arms.

Another print which follows the theme of crime, punishment and persecution shows a different woman under restraint, in a dark dungeon (111). This subject has been traced to a contemporary murder trial of a woman who had helped her lover murder her

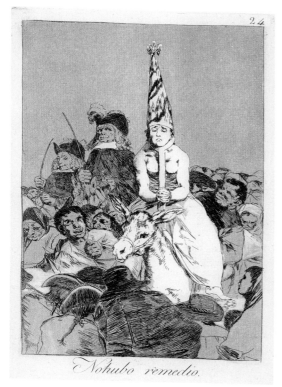

Nohubo remedio.

Por que fue sensible.

husband. Both were subsequently tried and executed. The *Caprichos* contain further references to criminals and corruption, but these are placed in the wider context of social ills. The hairdresser, the drunk, the quack doctor and spoiled children are all given sinister roles, and they dovetail with the graver issues of the Holy Office, the plight of convicts and the eternal prostitute. Even the portrait painter is not spared. When Goya had painted the Infante Don Luis and his family

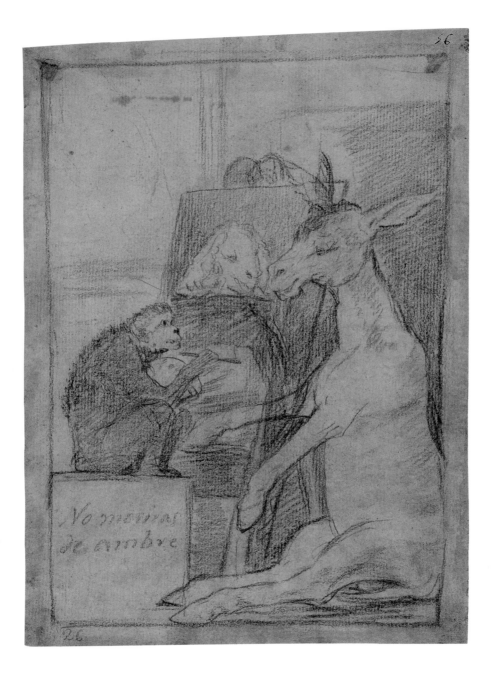

¿No morirás de ambre

(see 66) he wrote that the patron had jokingly called him a 'painting monkey [*pintamona*]', and perhaps he was recalling this when he designed a monkey painting the portrait of a donkey wearing a judge's wig. On the drawing (112) Goya writes: 'You will not die of hunger.' The finished print replaces the original caption with the legend: 'Neither more nor less' (113), a more pointed observation on the vanity of sitters and the guile of portraitists.

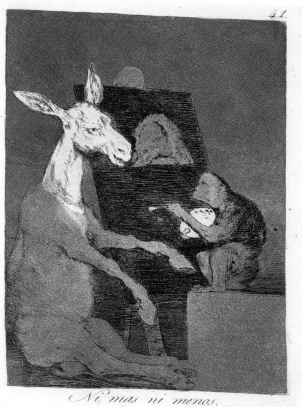

112
You will not die of hunger,
1797–8.
Red chalk.
Museo del
Prado, Madrid

113
Neither more nor less,
plate 41,
Los Caprichos,
1797–8.
Etching and
aquatint;
20 × 15 cm,
7⁷⁄₈ × 5⁷⁄₈ in

This section leads to the central image of the eighty prints, plate 43, 'The dream of reason produces monsters' (114). A figure of an artist is shown collapsed over a wooden block. He has been drawing or writing. Four species of creature inhabit the dark void surrounding him – a lynx, a cat, a host of bats and seven owls, one of which is also partly a cat, who jabs the sleeper on the arm with a sharp stylus. Two sketches reveal that Goya originally intended to make this striking

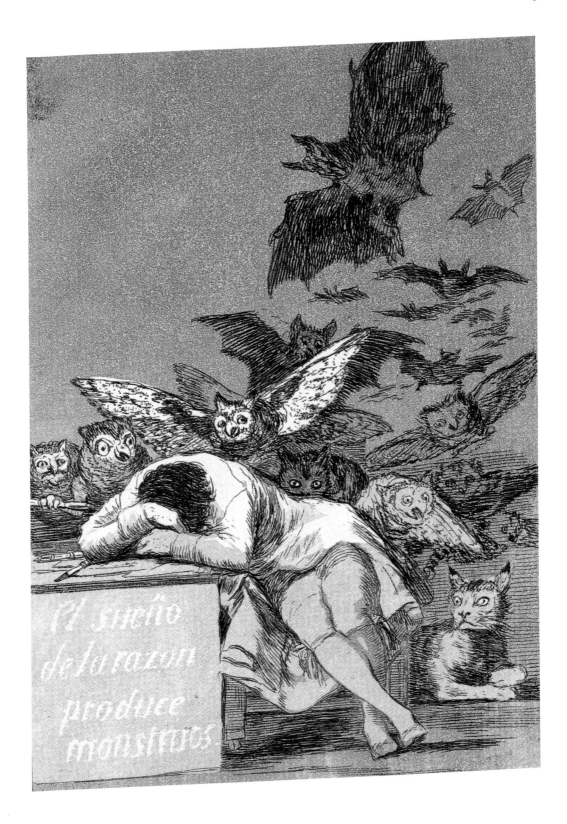

design into the title page of the whole work. One bears a longer caption which eventually became part of an article promoting the *Caprichos* in the *Madrid Daily*. Here Goya speaks of himself as an author, but he is also a dreamer. The dream was a traditional device, used by artists and writers in Spain as well as in other European countries to introduce subjects of a fantastic, philosophical or obscure nature, and Goya initially considered calling these prints *Sueños* ('Dreams') instead of *Caprichos*. The glittering material world of the state artist is here undercut by the monstrous uncertainties of the 'imagination unfettered by Reason', as Goya wrote on the sketch.

Moral and philosophical elements in the *Caprichos* comprise themes and ideas often present in pictures by Goya's contemporaries. February 1799, the month of publication of the *Caprichos*, also saw the death of Luis Paret. He died in poverty, never having retrieved the glittering career which his youthful ascendancy had promised him. In 1780 he, like Goya, had achieved membership of the Madrid Academy, submitting a painting of a philosophical subject, *The Prudence of Diogenes* (115). A nocturnal scene, illuminated by flickers of firelight and inhabited by odd figures dressed in exotic robes, the work possesses a complex theme. The story is a pagan counterpart to the medieval and Renaissance subject of the Temptation of St Anthony but here the hero becomes the Greek philosopher Diogenes, who studies books of mathematics, philosophy and geometry. Seated on the right, he turns away from a crowd of strange figures who personify the vices, follies and dangers which afflict mankind – Vanity, Avarice, Superstition, Mendacity, Ambition, Flattery and Death are depicted in various ways with their appropriate emblems. The most dramatic figure is a magician, who, his arms wreathed with snakes, carries a basin of fire and an owl on top of a pole. He symbolizes Superstition, that popular Spanish weakness so often referred to by Goya in the *Caprichos*. Paret's painting still hangs in the Royal Academy, where it was sent by the artist in 1780, and Goya would have been familiar with its unusual imagery and subject. The philosopher who rejects the fantastic, dark irrational world of folly, vanity and damaging illusions reappears as Goya's dreaming artist beset by the ephemeral creatures of the night.

114
The dream of reason produces monsters, plate 43, *Los Caprichos,* 1797–8. Etching and aquatint; 21·6 × 15·2 cm, 8 ½ × 6 in

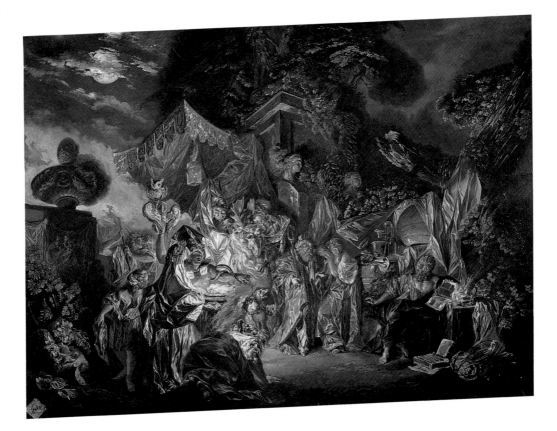

The last section of the *Caprichos* is devoted to the bleak and threaten-ing world of dark forces and supernatural phenomena. Witches, magicians and beings whose physical deformities reflect their inner corruption sustain a bitterly satirical narrative. Unlike Paret, who had painted his figures as recognizably human, carrying their emblems and acting out their roles with theatrical elegance, Goya carves meaning into the substance of the figures themselves. Limbs, eyes, heads, hands and feet are tailored, like *clothes*, to express the nature of their symbolic functions. In the Madrid Album, for example, Goya had drawn his child prostitutes as spinners (see 102). In England the poet and artist William Blake saw the child-whore as especially symbolic of the ills of eighteenth-century London:

But most thro' midnight streets I hear
How the youthful harlot's curse
Blasts the new born Infant's tear,
And blights with plagues the Marriage hearse.

115
Luis Paret
y Alcázar,
The Prudence
of Diogenes,
1780.
Oil on canvas;
80 × 101 cm,
31¹⁄₂ × 39³⁄₄ in.
Royal Academy
of San
Fernando,
Madrid

116
They spin
finely,
plate 44,
Los Caprichos,
1797–8.
Etching and
aquatint;
21·4 × 15 cm,
8¹⁄₂ × 5⁷⁄₈ in

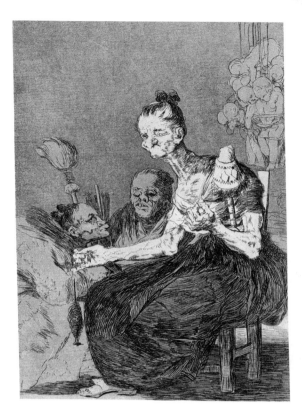

Published as one of his *Songs of Experience* of 1794, the poem 'London'
incorporates the image of urban poverty and corruption, and Blake's
own printed images, although entirely different from Goya's, treat
similar ideas: setting prostitution and corruption against innocence
and gaiety. Goya's prostitutes, like Blake's, are rarely representatives
of pleasure. In the *Caprichos*, by associating them with spinners of
men's fates, the Spanish artist endows the figures with an emblem-
atic, oppressive universality. Plate 44 of the *Caprichos* shows the spin-
ners again, transformed into witches (116). A tall bony hag sits in the
foreground with her distaff. Two more squat on the left with their
brooms. A cluster of dead babies hangs in the gloom behind, just as
they had hung from the witch's pole in *The Witches' Sabbath* (see 99).

Witches and babies continue to appear, the innocent young murdered
or corrupted by the elderly. The bony witch becomes a double-sexed
hermaphrodite with a lantern jaw, male torso, broad shoulders
and small hands (117). Here children are abused by groups of

hermaphrodite males. One sucks a baby's penis, another, floating in the sky, caresses two young children. The central motif of a witch igniting a brazier with a child's wind provides a swirling pattern for the whole composition.

Such details have a shocking explicitness, but in the broader context of prints in general, similar motifs had appeared in political art, especially in the French and English polemical images produced in the wake of the French Revolution. Gillray, having turned violently anti-French after the execution of Louis XVI and the ensuing Terror, produced savage satires, such as one showing the *sans-culottes* eating their victims and cooking a baby over a fire. At this time the visual emphasis and language of political imagery changed fundamentally, and old-fashioned caricatures were replaced by a new dramatic robustness as regards the expression of personality. New 'Sublime' tastes for violence and scatological detail entered the vocabulary of the satirical broadsheet, and in Spain some even saw the French Revolution itself as a 'Sublime' revolution.

Goya's *Caprichos* may have been viewed in a similar light. The Osuna family bought four copies of the complete work and were said to have held private charades in their country house where the king and queen and Manuel Godoy were played out as figures from Goya's prints. Proof that the *Caprichos* were seen as potentially powerful political satires also lies in the way that they came to be used by other Spanish printmakers during the 1808–14 war with France (118). But, as Goya himself explained, the *Caprichos* were not intended as caricatures of specific individuals, or as overt political censure of current issues. Instead, they formed part of an experimental visual language. On 6 February 1799 he advertised the prints in the local paper, the *Madrid Daily*. A short article by him appeared on the front page.

A collection of prints and capricious subjects, invented and etched by Don Francisco Goya. The author is persuaded that the censure of human error and vices (although this seems like the preserve of oratory and poetry) may also be a worthy object of painting: as subjects appropriate to his work, he has selected from the multitude of stupidities and errors common to every civil society, and from among the ordinary obfuscation

117
Blow,
plate 69,
Los Caprichos,
1797–8.
Etching and
aquatint;
21·3 × 14·8 cm,
8³⁄₈ × 5⁷⁄₈ in

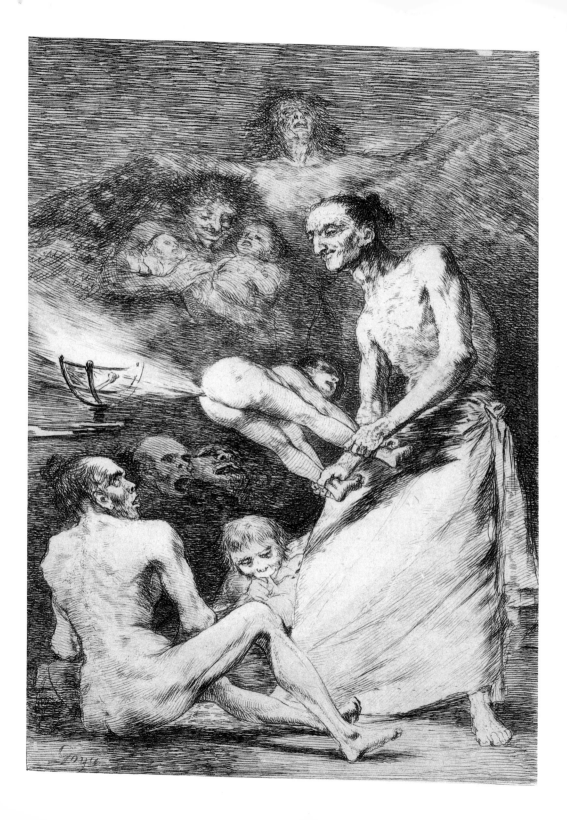

and lies condoned by custom, ignorance or self-interest, those which he believes most appropriate to furnish material for ridicule, and at the same time, fantasy.

He goes on to state that his work is entirely free from the influences of other artists and from the demands of caricature.

Goya's written disclaimer that these were not caricatures may have been intended to protect himself from prosecution, but some contemporary admirers of the *Caprichos* shared the Osunas's belief that these prints caricatured the king and queen, their favourite, Manuel Godoy, Jovellanos, the Duchess of Alba, and many of Goya's staunchest supporters. As Goya writes, however, the images were comparatively new in the history of art, combining both fantasy and reality, and offering proof, perhaps, of the artist's fertile imagination. His constant use of the term 'author' for himself shows how strongly he prized his originality in choosing the themes and devising the compositions, just as in his early years he had written 'my own invention' on cartoon bills for the tapestry factory. In the two centuries since Goya's prints were first published, scholars have pointed out the numerous theoretical and artistic influences, but the artist himself would have been loath to admit that – beyond a few quotations from well-known poets such as Jovellanos, and despite parallels in the dramas of his friend, Moratín the Younger – any other person or work had played a part in the evolution of these remarkable prints.

A number of contemporary reactions focused on Goya's subject matter rather than his methods. 'Saw a book of witches and satires by Goya', Pedro González de Sepúlveda, professor of engraving at the Royal Academy in Madrid, recorded in his diary. 'Didn't like it, it's very obscene.' As an engraver himself, Sepúlveda ought to have shown the keenest professional interest in Goya's revolutionary techniques. But the shock of the subjects clearly revolted him, just as others were intrigued. One admirer saw the *Caprichos* as an exercise in morality, and thought that the images were so unusual that they should be given to art students to copy. By the 1830s art students in Paris were, in fact, recorded as having Goya's *Caprichos* in their portfolios along with prints by Rembrandt and Albrecht Dürer, the greatest artists in

118
Anonymous,
Napoleon Dreaming of his Defeat by Spain and Russia, Beside him Manuel Godoy Laments,
c.1812.
Coloured print;
17·4 × 20·7 cm,
6⁷⁄₈ × 8¹⁄₈ in.
Museo Municipal, Madrid

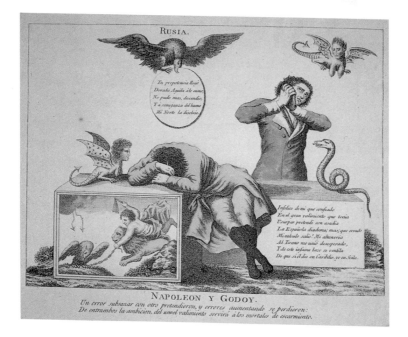

RUSIA.

Tu prepotencia llegó
Dorada Águila á le cume,
No pudo mas, descendió,
Y á semejanza del humo
Mi Norte la disolvió.

Infelice de mi que confiado
En el gran valimiento que tenia
Usurpar pretendí con osadia
La Española diadema; mas que errado
Mi calculo salió! Mi altaneria
Al Tirano me unió desesperado,
Y de este infame laze se rendila
De que si el dia en l'ardelio, yo en Seila.

NAPOLEON Y GODOY.

Un error subsanar con otro pretendieron, y errores aumentando se perdieron:
De entrambos la ambicion, del uned valimiento servira á los mortales de escarmiente.

the history of graphic design. Even today the *Caprichos* repel and
intrigue modern audiences. Their savagery, enigmatic meanings and
very personal observations on human nature characterize an artist
obsessed by the power of his own masterpieces. Just as Goya could
carry out his public duties at the Academy while also declaring his
artistic deviation from the officially approved system of teaching, so
he had asserted his right as an independent genius to offer the public
his most private and freely contrived images.

Goya not only advertised the prints in the newspaper but put them
on sale in a shop beneath his own Madrid apartment, where luxury
items such as scent and liqueurs were sold. Unlike most print design-
ers at that time who advertised editions of one or two prints, Goya
advertised and sold his *Caprichos* as a complete book for 320 reales
a set, the cost of an ounce of gold. This was a high price, although
it works out at around 4 reales per print, which was the standard
price for popular engravings. Few sets, however, were sold, and
Goya was left with some 240 on his hands, most of the first edition.
In 1803 he donated these, together with the copper plates, to the
Royal Printworks, in exchange for a pension for his son. Several early

editions were printed. Years later, as an old man, Goya affirmed that he had withdrawn the *Caprichos* from sale because he had been afraid of the Inquisition. Given the violence of some of these plates, the explicit sexual scenes and the caricatures of greedy, drunken monks and priests, threat of prosecution by the Holy Office may have been a distinct possibility. However, there is no record of any interference from the Church. And, underlying the *Caprichos* is a moral austerity and a scale for judging vice and virtue which derives ultimately from much Catholic dogma. The vanity of human desires, a traditional theme in Spanish painting, is compressed into these didactic images.

In observing the world around him, Goya imbued his art with striking moral force. Emblems and satire, inventive realism and a quirky choice of subjects became the means by which he evolved the power of his mature work, showing a society in decline. The criminal, the prisoner, the charlatan, the prostitute, the idler, drunkard and abuser have become the new anti-heroes of the artist's vision. In this way the *Caprichos* remain a unique visual chronicle of a great country's slide to disaster.

6

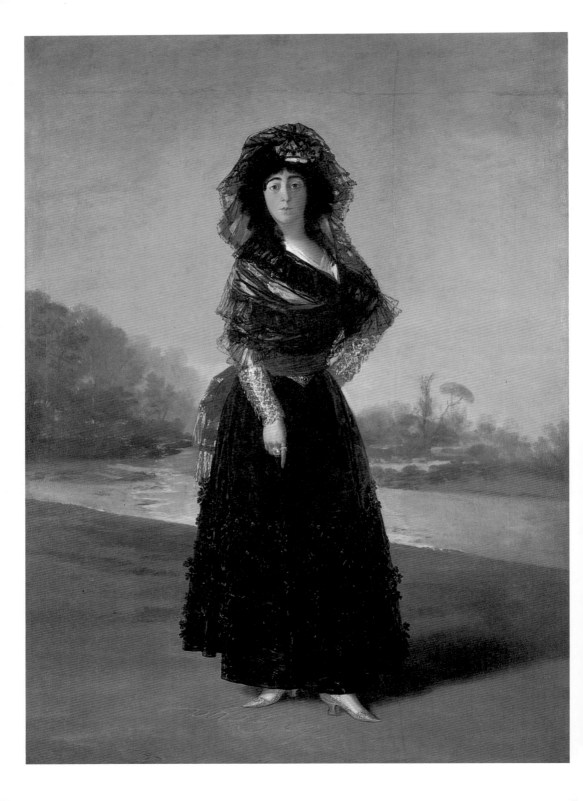

The eleven years from 1797 to 1808 were a volatile period in Spain, ending with a long, bloody war and economic ruin. The patronage of Charles IV and his consort María Luisa inspired new decorations of state palaces and the appointment of state artists, although a deteriorating economic situation meant that comparatively few artists received court appointments. Goya's eldest brother-in-law, Francisco Bayeu, once the most promising and influential painter in Spain, applied for the post of Principal Court Painter in 1790 but was refused the honour, although until his death in 1795 he enjoyed a court salary of 50,000 reales per annum (about £500 in the money of the period).

119
Portrait of the Duchess of Alba, 1797.
Oil on canvas; 210·2 × 149·3 cm, 82⁷⁸ × 58⁷⁸ in.
The Hispanic Society of America, New York

In some ways state patronage followed the example set by the previous king, Charles III, and major decorative schemes under Charles IV involved the erection and embellishment of private villas and churches. Many such painted decorations, carried out by Goya's colleagues at court, continued to focus on contemporary subjects and allegories of Spanish political ascendancy. In a country increasingly disturbed by economic problems, this artistic hyperbole masked social unease. Occasionally, in a particular allegory or specifically humorous or grotesque scene of everyday life, the uncertainties of Spanish society appear subtly reflected; but equally discernible is the anxious concern with status on the part of artists themselves as they competed for a decreasing number of commissions.

Goya's long illness and ensuing deafness failed to damage his career, but in 1798 he presented a petition to the king in which he requested payment of arrears in salary. 'Six years ago my health broke down completely. My hearing in particular has suffered and I have grown so deaf that without sign language I cannot understand what people are saying. It has been, therefore, impossible for me to practise my profession during this period.' His chief supporter, Jovellanos, used his influence to obtain a lucrative commission for the ageing artist,

and only a few months after presenting his petition, Goya was required to paint in fresco the cupola and apse of a recently built church on the outskirts of Madrid, San Antonio de la Florida.

During the eighteenth century, changes in taste and the nature of patronage had created a marked division between secular and ecclesiastical painting in Europe, with secular subject matter coming to the fore. In predominantly Roman Catholic areas, however, such as southern Germany, Italy and Spain, church building and decoration were still enthusiastically pursued. After 1789 the Revolution had virtually put a stop to Church art in France, and in England most painters were engaged in providing portraits and landscapes for wealthy private patrons. Even in Rome, Neoclassical enthusiasm for antiquity exemplified by such artists as Mengs, who had worked there for Cardinal Albani before coming to Spain, attracted public attention to pagan, rather than religious, subjects.

In Spain, however, Church art remained the principal professional commitment of both urban and provincial artists. Goya's religious paintings, enormously varied in style and content, are probably less well known than his secular work, but at San Antonio de la Florida he executed one of the most independent projects of his whole career. No restrictive iconographical programme appears to have been imposed on him by the Church, and he carried out the whole decorative scheme with extraordinary speed and originality, achieving a masterpiece of expressive novelty.

Situated on the bank of the River Manzanares, the Hermitage of San Antonio de la Florida had originally been a local shrine patronized by customs officers and washerwomen, whose picturesque idling on summer days had appeared in an early tapestry cartoon by Goya. In Spanish the word *manzana* means 'apple' and this fertile area beside the river provides the fruit from which local cider is still brewed today. When distinguished members of the Spanish court acquired property in this desirable district, the old shrine was pulled down in order to widen the road. The Duchess of Alba, King Charles IV, María Luisa and Manuel Godoy bought up the land around the site of the church, and by the 1790s the district had become an exclusive

residential quarter. Part of the area can be glimpsed beyond the river in the sketch for the Festival of St Isidore which Goya had painted in 1788 (see 93). In 1792 the court architect, Felipe Fontana, designed a new Neoclassical church in the shape of a Greek cross with shallow arms and an apse (120). The small cupola dominates the interior, and this, together with the vaulting of the apse, was where Goya painted his fresco (121).

Despite his bitter professional setback at the Cathedral of El Pilar in Saragossa in 1780–1, Goya had emerged as a particularly talented painter of public buildings and churches. The challenge of interior decoration clearly fascinated him, since, even in old age, he was to decorate his own house with large murals (see Chapter 8). The idea of creating an interior environment in which paintings and archi- tecture complement each other demanded the type of skill achieved by the greatest High Renaissance and Baroque painters.

While the religious function of the chapel remained an important focus of attention, in July 1798 Charles IV obtained a brief from Pope Benedict XIV making the little church into part of the independent parish of the chapel Palatine under the administration of the court priest and First Chaplain of the Army. This virtual annexing of the church to the Crown transformed the building into a centre for fash- ionable court worship and gave it an inherent independence that was to be matched by the dynamic innovations of Goya's decorations. Already in June 1798 he had ordered a large quantity of light and dark ochre, vermilion, red earth, Venetian umber, black earth and green clay. He also requested eighteen large earthenware pots and a ream of good-sized paper. More red earth and ochre were supplied later in the same month, and in July five dozen large paintbrushes, a dozen fine- haired brushes, various other sizes of brush and four pounds of glue. Later in July came an order for more ochre, fine crimson, red earth, more paper, more yellow, more brushes and a number of sponges. In August he asked for ivory black, more pots and basins for his assis- tant to grind the colours in, and some darker-toned shades: indigo, ivory black, Molina blue and London carmine (which appears to have been among the most expensive of the reds). Badger-hair brushes came

120–121
The Hermitage
of San Antonio
de la Florida,
Madrid
Above
Exterior
Right
View of interior
showing the
fresco of *The
Miracle of St
Antony of Padua*
in the dome,
1798

next, along with lamp black and crimson lake. All these items are listed by the tradesman in his bill to the court. Goya also charged Charles IV for the hire of a carriage to transport him to and from the church.

The list of Goya's expenses during the summer months of 1798 has been preserved in the archives of the Royal Palace in Madrid. It reveals the amount of effort involved in the planning of such a commission, quite apart from the task of painting itself. Although the dome in San Antonio de la Florida is only some 5·8 m (19 ft) in diameter, the sheer physical labour of completing such a work, for a man of fifty-two who was stone deaf, with probably no more than a single assistant, is astonishing. On the tradesman's bill there is no mention of scaffolding, which would have been needed to enable Goya to climb up to the dome, but it must have been particularly robust, since the execution of this fresco is energetic, and close examination of the technique has revealed that the artist's methods were unorthodox and furiously dynamic.

The exercise of painting a ceiling more than 9·1 m (30 ft) above the ground was an exhausting, even risky undertaking. A famous sonnet by Michelangelo (1475–1564) enumerates the tribulations he experienced in executing the great fresco on the ceiling of the Sistine Chapel in Rome. Goya's small dome in San Antonio de la Florida is nowhere near as famous, but it too shares something of the sense of energy, independence and commitment of the High Renaissance artist. It was also a uniquely bold approach to what, by eighteenth-century standards, was becoming an anachronistic method of painting.

Fresco painting usually demanded the co-operation of a team of masters and assistants, all working from prepared sketches and cartoons. The most famous practitioner of the art of fresco in the eighteenth century was the Venetian painter Giambattista Tiepolo, who had decorated domestic and public architecture all over northern Italy and in southern Germany before coming to Madrid to paint the throne room of the new Royal Palace (see 14). Goya knew and admired Tiepolo's work, and even acquired his own collection of sketches by the Italian master. As a young student visiting Madrid for the Academy competitions in the 1760s, he may well have climbed the

scaffolding in the Royal Palace, as did many other art students at the time, in order to watch Tiepolo at work. Nevertheless, it is not known when Goya learned the technique, and his earliest fresco in Saragossa betrays a number of defects. Just as there is no evidence that he received any formal training as a printmaker, so too his skill at frescoing seems to have been acquired empirically.

The task at San Antonio de la Florida was so arduous that Goya petitioned the king for a further salary for an assistant: 'His help is necessary if I am to carry out the work your majesty may deign to commission from me.' Goya's principal assistant and pupil at that time was Asensio Juliá (1767–1830), a young Valencian known as 'El Pescadoret' because he came from a fishing family. The portrait which Goya made of this obscure artist shows him on the site of a major public commission, wearing a full-length painter's overall and dwarfed by scaffolding and planks, and with various brushes and a mixing pot at his feet (122). Through this portrait, Goya conveys an impression of the arduous task faced by the frescoist.

Employing the traditional manner of grouping figures around an illusionistic balustrade and painting a blue sky above, Goya created in fresco the illusion that the dome itself was open. This had been an invention of north Italian artists during the Renaissance, and the lavish colours and exotic portraits in Goya's fresco owe much to Venetian decorative art, but the style has been developed far beyond its original influences. A wealth of warm, bright hues enriches the vivid animation of the figures, and Goya's unorthodox improvisations in the wet plaster (in contrast to the carefully premeditated designs usually employed in fresco) sprang out of heavy separate brushstrokes and the mingling of colours which, at a distance, merge to create the impression of silk, satin, cloth and flesh.

The ferocious stippling, dabbing and streaking on Goya's fresco is startling. He finished off details by painting on the dry plaster, as did most Renaissance painters; and the whole subject, from rural setting to minor details of clothing and features, was vigorously elaborated to suit the demands of the site. By the 1790s devising compositions that involved a mass of people had become one of

Goya's particular creative passions; even the small tin-plate paintings depict group subjects, for example the *Yard with Lunatics* (see 96), *The Fire* and the *Prison Scene*. Some of the artist's best religious paintings are crowd-based scenes, such as the *Taking of Christ* painted for the Archbishop of Toledo, and delivered to the sacristy of Toledo Cathedral in 1799. The story Goya depicted in San Antonio de la Florida was a popular tale of a saint whose oratory attracted huge crowds – a quasi-magician-preacher and one of the most famous figures in the Catholic calendar, the Portuguese saint, Antony of Padua.

This thirteenth-century Franciscan left Portugal for Italy, where he made his reputation with dramatic open-air sermons. His performances became so popular that, according to legend, wherever he preached shops closed, offices suspended all business and even hardened criminals were brought to confession. As a unique cult figure he was identified with mendicants and poor peasants, and was particularly venerated as an intercessor for the dispossessed, the sinful and the deviant. It is this aspect of St Antony's life which seems to have attracted Goya, although the magic of divine preachers was also a popular theme in Spanish literature.

Like St Francis Borgia who had tried to save the dying man (see 56, 57), the story of St Antony of Padua also turns on the presence of death, but here a resurrected corpse plays a leading part. Although credited with many miracles, St Antony's performance in this episode came from popular religious fiction. On learning that his father had been wrongly accused of murder, St Antony was said to have flown through the air from Italy to his native Portugal. The climax of the story takes place in a Lisbon courtroom where, in front of judges and witnesses, the saint brings the victim to life so that the real murderer can be identified. Goya chose to paint this dramatic moment of resurrection, but changed the setting. Instead of a thirteenth-century Portuguese courtroom, the miracle takes place in a mountainous landscape, and, in contrast to the beauties of nature, the huddled crowd of witnesses form a motley crew, their physical defects and failings highlighted by bright sunshine. Some wear contemporary costume; others, particularly the women, are dressed in exotic, Eastern-style,

122
Portrait of Asensio Juliá, c.1798.
Oil on canvas; 54·5 × 41 cm, 21 1⁄2 × 16 1⁄8 in.
Fundación Coleccion Thyssen-Bornemisza, Madrid

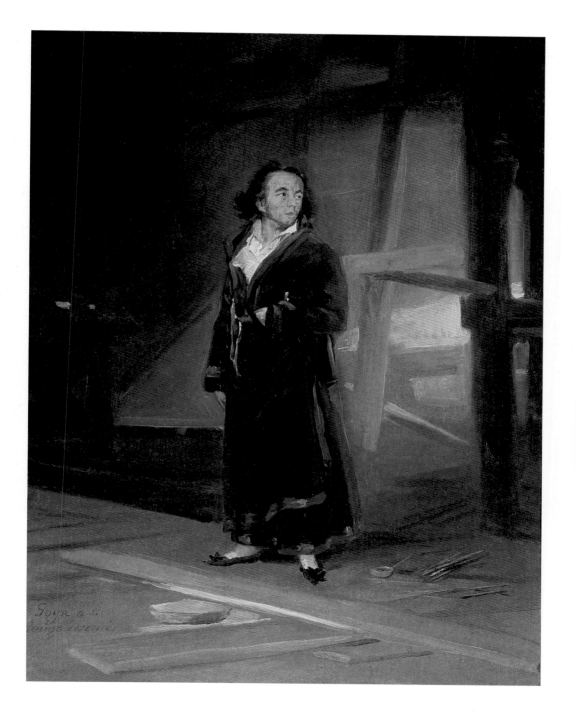

highly-coloured drapery and jewels. Many of the figures are ugly, with round, flat faces, dotted or shadowed eyes and grim expressions. One man has snaggle teeth, another has bushy white hair; others appear scarcely human. The corpse is helped to rise by the people around him, his emaciated greenish-yellow skin, large ears and close-cropped head reflect similar physical qualities of the stunted heads and bodies of the curious children. More predatory males, seductive females, vagabonds, and a blind beggar with a staff make up the inhabitants of this make-believe countryside.

On the pendentives and vaults Goya painted a host of joyous angels. These sections serve to mark the contrast between two distinct worlds: the divine and the profane, although the angels are set below the dome and consequently nearer to the real world. St Antony himself is a serene young man whose nimbus conveys both his spirituality and his rational superiority, but the main deviation from the original story appears in the laconic way that so many of the witnesses ignore the miracle. One man in a large hat actually turns his back to walk away. There has been much speculation as to

who the real murderer may have been. Goya in fact seems to suggest that almost anybody in his fresco, apart from the saint and the corpse, might be capable of such a crime. Some of the crowd appear openly hostile, while the children display curiosity rather than reverence at St Antony's legendary talent for influencing ordinary people with his virtue, eloquence and the performance of a miracle.

Eighteenth-century artists in other European countries had also examined similar themes: in England, for example, Hogarth had painted mixed groups of people at an election, in a theatre audience, or as witnesses to a miracle. *The Pool of Bethesda* for St Bartholomew's Hospital in London shows Christ standing among witnesses, whose ordinariness surprised more doctrinaire spectators. In Spain any public spectacle – a dressage show, a coronation or royal embarkation, like those painted by Paret or Antonio Joli (see 24) – included a wide variety of characters designed in small format. However, the portrayal of crowds changed particularly in revolutionary France, where political prints and modern history paintings showed the power of massed humanity, announcing violent social and political upheavals. The so-called Tennis Court Oath of June 1789, the storming of the Bastille the following month, and later the coronation of Napoleon (123) were major historical events involving numerous witnesses and participants, and revolutionary images by David and his pupils used large crowds in a composition as a means of signifying the importance of the event. Unlike David, Goya's multitudes are anonymous, vulgar and often brutal. In the *Caprichos*, as well as in numerous private works, and even in a religious fresco, Goya betrayed his fascination with devising deviant personalities, and the crowd watching St Antony's strange miracle look like a parade of *Caprichos* personalities, brought together in a single composition.

The church of San Antonio de la Florida was consecrated in July 1799, almost a year after the completion of the frescos, and some five months after the publication of the *Caprichos*. There is no contemporary reaction to these paintings on record, but the king and queen must have been satisfied because three months later, in October, Goya was promoted to Principal Court Painter, and received not only the

123
Jacques-Louis David,
The Coronation of the Emperor and Empress, 1805–7.
Oil on canvas;
621 × 979 cm,
244⅝ × 385¾ in.
Musée du Louvre, Paris

salary but an extra 5,500 reales to offset the expenses of a carriage. The church itself, which now houses Goya's own tomb, has become a place of pilgrimage for those who admire his art and, perhaps appropriately, the fresco signifies a profound change in the artist's images of powerful individuals.

The tribute which Meléndez Valdés had offered to Jovellanos at the minister's modest reluctance on assuming power (see Chapter 4) reflected broader European perceptions of material greatness as manifested in actions of virtue. Goya's 1797 portrait of Meléndez Valdés (see 63), whose face, dotted with smallpox scars, retains the humane, undeviating realism with which Mengs had endowed his portrait of Charles III, provided another moral corrective to the image of the great man of power and ambition. Goya's commitment to court and monarchy, which included making inventories of palace collections, teaching at the Royal Academy and supplying state images for different occasions, satisfied the artist's material ambition. But his artistic supremacy in Spain also coincided with the wider perception of revolutionary mobs, and the way in which these can only be controlled or inspired to action by acute situations and individuals of rare personal charisma. At the turn of the century the rise of Napoleon Bonaparte formed a new paradigm of ascendancy in public life.

In Spain the most intriguing personality to achieve power at this time was Manuel Godoy. The war with France, which had begun in 1793 and ended with the Treaty of Basel in 1795, brought this young Guards officer to public prominence. He came from a minor aristocratic background and had risen from obscurity to fame in the 1780s. Having been made Captain-General of the army in 1793, he was created 'Prince of Peace' in 1795 with an annual income of a million reales and a large estate. Like so many of Goya's patrons, Godoy saw his position as inextricably linked to the enlightened modernization of Spain, in which the support of Spanish culture, notably the fine arts, was crucial. This man of action also became a man of affairs, and, having married the daughter of the Infante Don Luis, he inherited a large part of the Infante's fortune and the art collection. Godoy was patron to a number of contemporary artists, and he assumed the

position of Protector of the Royal Academy, something he was particularly proud to recall in his memoirs. His meteoric career drew strength from his profound personal friendship with Charles IV and María Luisa, but he lacked the instinct for political survival. In August 1798, just as Goya would have been starting his San Antonio de la Florida frescos, Jovellanos resigned from the government and Godoy's subsequent attempts to introduce progressive reforms into Spain made him vastly unpopular, prompting a storm of vicious innuendo about his relationship with the royal family. In this plight, the beleaguered monarchy and their favourite minister may have looked again to France, where the most powerful individual in modern history had come to prominence.

By 1797 General Napoleon Bonaparte was master of the Directory in France, the new republican government, and in November 1799 he staged his *coup d'état*. This hero, whose control of vast armies and crowds was far beyond that of Godoy, signified the pinnacle of human energy, which he directed into a power-base for personal aggrandizement. Goya was clearly interested in the portrayal of power and, unlike his many contemporaries who delegated details of formal portraits to assistants, he spent long hours on first-hand observation. His growing reputation as a supreme portraitist was to strengthen his international standing as well as his position in Spain, and in 1798 he painted the new French ambassador, Ferdinand Guillemardet (124), a former doctor and member of the Paris Convention, who had voted for the death of Louis XVI. The modernity of Goya's portrait matched the formidable personality of this, his first foreign sitter. The portrait is bright, taking its colour scheme from the tricolour, and when the sitter returned to France in 1800, this composition attracted interest among French painters. It was later to influence the great French Romantic painter Eugène Delacroix (1798–1863), who was a friend of Guillemardet's son.

The cessation of hostilities with France had resulted in a new alliance between Spain and her revolutionary neighbour. In 1799, the most famous European image of absolute power appeared in the guise of David's painting of Napoleon 'calm on a fiery horse' (125). With

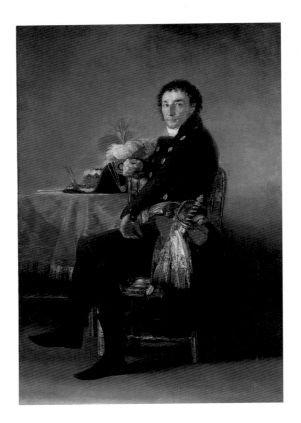

124
*Portrait of
Ferdinand
Guillemardet*,
1798.
Oil on canvas;
186 × 124 cm,
73 ¼ × 48 ⅞ in.
Musée du
Louvre, Paris

125
**Jacques-Louis
David**,
*Bonaparte
Crossing the
St Bernard Pass*,
1800.
Oil on canvas;
260 × 221 cm,
102 ½ × 87 in.
Musée
National du
Château de
Versailles

this memorable picture the French painter created the greatest
secular icon of the early nineteenth century. Portrayed crossing the
St Bernard Pass on his way to conquer Italy, following in the tracks
of Hannibal and Charlemagne, David's heroic image of Napoleon was
also to appear in numerous engravings. The power of Napoleonic
imagery coincided with a widening of Goya's repertoire, which was
fully stretched in these years immediately preceding the fall of the
Bourbons in Spain. After the San Antonio de la Florida frescos, the
artist's professional relationship with the Spanish monarchy reached
its high-point; he produced masterpieces of formal portraiture for
them with a courageous audacity. While the revolution in France
and the fall of the French Bourbon monarchy doubtless engendered
fears among the Spanish Bourbons, there is little sign of this in their
portraits, apart from a strengthening of personal presence and a
greater concentration on their humanity.

David had reinterpreted the equestrian portrait as an image of
absolute power, and the notoriety of his painting of Napoleon cross-
ing the Alps may explain why such portraits became so common in
Europe in the early 1800s. The pictorial tradition of great national
figures riding on horseback had, however, been established much
earlier by Titian in the sixteenth century, and was consolidated by
Anthony van Dyck (1599–1641) and Velázquez in the seventeenth.
Having already etched copies after Velázquez, Goya was well placed
to design equestrian portraits of Manuel Godoy. As a talented rider,
Godoy, like many Spaniards, regarded horsemanship not only as a
test of physical skill and courage but also as a mark of rank. In the
1770s Paret had portrayed the whole royal family taking part in a
complex equestrian display, and Charles IV and his consort were
well known as enthusiastic riders. Goya admitted in a letter that
the equestrian portrait was one of the most difficult tasks a painter
could tackle.

The Prussian ambassador recorded Godoy's devotion to horses:

He rises early, talks for some time to his Master of the Horse and the people of his household. At eight o'clock he rides on the track at his house outside the town where he is joined by the queen, who comes to watch him. This recreation lasts until eleven. The king also takes part in it, if he is back from his shooting in time.

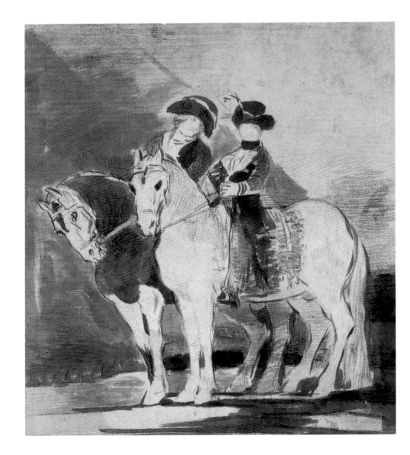

126
Study for a double equestrian portrait, 1799–1801. Pencil, brush and sepia wash; 24 × 20·6 cm, 9 ½ × 8 ⅛ in. British Museum, London

Goya's portraits of Godoy on horseback, dating from the first half of the 1790s, have not come to light; the only known works are a sketch of doubtful authenticity and a portrait of a mounted picador, which may once have borne the head of the 'Prince of Peace'. For political reasons Goya's images of Godoy were largely destroyed or lost during the Peninsular War, although the full-length portrait of Godoy on the battlefield still survives in the Madrid Academy (see 64). But Godoy's

influence is present in the two equestrian portraits Goya made of the king and queen. A sketch of two riders (126) shows the queen and a mounted companion who has recently been identified as Godoy himself. Goya may have been asked to make a double equestrian portrait, but what he eventually executed were two magnificent individual portraits of the Spanish monarchs (127, 128).

In September 1799 Queen María Luisa wrote to Godoy about the time she had spent posing for her equestrian portrait: 'I've spent two and a half hours mounted on a plinth with five or six steps leading up to it, with my hat on, wearing a cravat and a cloth dress, so that Goya can get on with the painting.' The informal record of how this powerful woman submitted to Goya's requirements continues in subsequent letters, which describe her state of exhaustion after further long sittings. These took place in the king's apartments because Goya apparently found the proportions suitable, and because they were less likely to be disturbed as he concentrated on the work. His concern to achieve a successful composition was obviously immense. The queen described the whole episode as 'torment', but the crucial importance of this particular work outweighed other considerations.

Infra-red photographs of María Luisa's equestrian portrait demonstrate how many alterations were made to the setting and the outline of the main figure. The artist designed a strong silhouette against an unstable and stormy background which includes one of the royal palaces, possibly the Escorial. A similar, almost sculptural solidity appears in the twin portrait of Charles IV. The king's right shoulder and the outline around María Luisa's hat were heavily corrected, but in both Goya's brushwork is particularly active.

Similar brushwork is noticeable on the more intimate portraits of people such as his friend Sebastián Martínez (see 74) and animates the portrait of Jovellanos (see 61, 62). The equestrian portraits of the king and queen owe a lot to those that Velázquez had made of the Habsburg royal family in the previous century, a painterly decision made possibly for political reasons. The monarchs who ruled Spain during the seventeenth-century Golden Age stood at the head of a powerful nation; Charles IV, on the other hand, headed an unstable

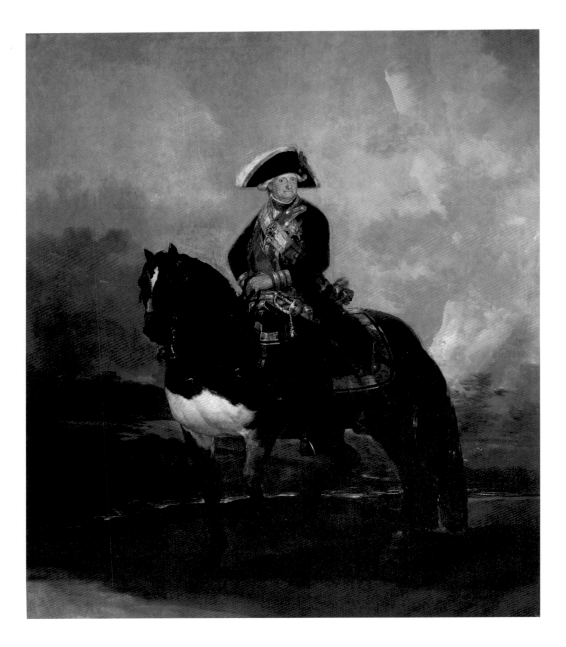

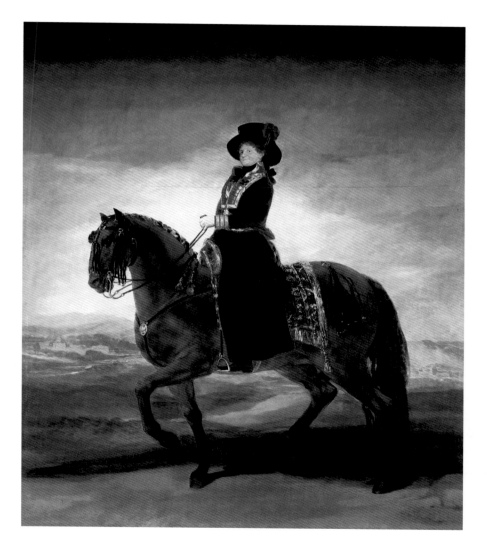

128
*María Luisa
on Horseback*,
1799.
Oil on canvas;
335 × 279 cm,
132 × 109⁷⁄₈ in.
Museo del
Prado, Madrid

and increasingly weak government. His impressive equestrian portrait makes direct reference to past traditions and monarchical dominance, while the queen's head has something of a swagger in its tilt.

As a talented amateur artist in her own right, the queen took a keen interest in Goya's technical boldness in this elevated branch of the portraitist's art. She was even satisfied with the depiction of her horse, a special favourite named Marcial which had been given to her by Manuel Godoy. These equestrian portraits have always been exhibited as a pair, and were two of only three works by Goya to be put on public view when the Prado in Madrid first opened as a national museum in 1819. They are linked through their use of colour, a low viewpoint and the way that the king is slightly turned as if leading his consort. This emotional sense of communication between the two figures cuts across the rigid formality of the images. And the way in which these elevated characters were prepared to have themselves shown as human and vulnerable, as well as powerful, came to replace the more elemental and remote images of power which had dominated so much state portraiture in Europe.

Two of the greatest state portraits in history were produced in the early years of the nineteenth century, during the Napoleonic era: David's coronation scene (see 123) in which the empress Josephine is crowned by her husband Napoleon, and Goya's group portrait of the family of Charles IV (129). They were painted within five years of each other, but as portraits they are worlds apart. Both works are hedged about with profound political implications and, in this sense, too, they stand in direct opposition to each other. David portrays the birth of the First Empire in France, while Goya immortalizes the last years of a monarchy that was to fall seven years later, in 1808.

Artistically David was faced with a more demanding commission. The identities of the figures as well as the sense of the moment and ritual are all crucial to the image. This is a glittering, inhuman spectacle of absolute power being illegally assumed. Certain details, such as the earring lying against Josephine's cheek, the crumpling of stiff formal costumes, shadows on faces, the pride of Napoleon's mother who is visible in the middle distance amid a family group (although she was

not actually present at the coronation), all serve to relieve the cold formality of the occasion. Goya's portrait is essentially designed to show the monarchs as a family: affectionate and united. Nevertheless, most of the family members played a part in the shaping of Europe during the early nineteenth century.

On the extreme left we see the king's second son, the Infante Don Carlos María Isidro, who was later to lead the Carlist movement against his elder brother in the struggle for succession in the early 1830s. The future Ferdinand VII, at that time aged seventeen, became one of the worst Spanish kings of modern times, having succeeded to the throne after forcing his father, Charles IV, to abdicate in 1808. The elderly woman with the fashionable black patch is Doña María Josefa, the king's sister and daughter of Charles III, who was to die before the portrait was completed in 1801. The mysterious younger woman whose face is turned away from the spectator and shrouded in darkness represents the future bride of the crown prince, whose identity was then unknown because no marriage had yet been arranged. She recalls the bridal figure in plate 2 of the *Caprichos* (see 104). Next to her is one of the king's younger daughters, the Infanta María Isabella, who became consort to Francis I, King of the Two Sicilies. The most formidable figure in the group is the queen, María Luisa, then in her fiftieth year. Her gown is speckled with gold and ultramarine and her comely arms reach for her youngest children, in particular the little Infante Francisco de Paula Antonio, who was born in 1794 when rumours that the queen was sleeping with Manuel Godoy were rife among the diplomatic community at court. The king, also splendidly dressed, aged fifty-three, is here in the final years of his reign. Like his wife, he was to die in 1819 after eleven years of exile in Italy. Other members of the group are the king's younger brother and former son-in-law, the Infante Don Antonio Pascual; and the Infanta Doña Carlota Joaquina, the king's eldest daughter and wife of João VI, King of Portugal. The young man standing behind the royal pair is Don Luis de Borbón, heir to the Parmesan branch of the family. His wife, who stands next to him, was the middle daughter of Charles IV, Doña María Luisa Josefina, and holds their son, Don Carlos Luis, who was eventually to become the Duke of Parma.

129
The Family of
Charles IV,
1800–1.
Oil on canvas;
280 × 336 cm,
110³⁄8 × 132³⁄8 in.
Museo del
Prado, Madrid

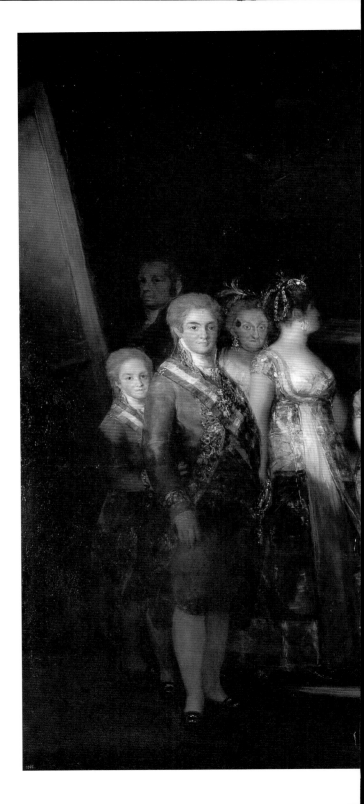

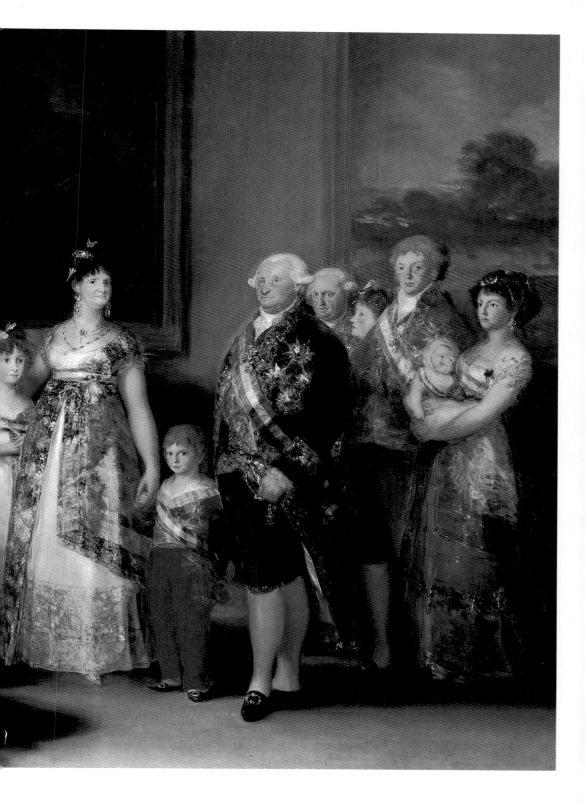

Most of these sitters were painted first in highly detailed, finished sketch portraits (130), which now hang next to the large finished group. Queen María Luisa seems to have admired these sketches as much as the main work, perhaps because they reveal how Goya laid his colours on to the prepared canvas. The artist included himself in the background, another pictorial reference to *Las Meninas* (see 50), while the queen's dominance echoes the pose of the little princess in the foreground of Velázquez's painting.

The queen was immensely taken with Goya's portrait, and the king authorized his treasurer to pay large sums to the artist for painting materials. The bill for the colours alone came to several hundred pounds in the money of the period. Under Charles IV, Goya was allowed considerable latitude in his business negotiations, and, through his majestic achievement of the group portrait, the amassing of a large quantity of materials. David had some difficulty in getting out of Napoleon the large amount of money he demanded for his masterpiece of the coronation. This is perhaps what characterized the difference in patronage between an ancient, cultivated monarchy, and a new, aggressive dictatorship with few traditions. Napoleon's patronage of the arts organized artistic activities into a pattern similar to a military machine, while the Spanish monarchy pursued more subtle, intimate relations with their artists. Goya's group emphasizes the closeness of a family and the rights of succession, while in David's *Coronation* (see 123) it is Napoleon himself, not Pope Pius, who crowns Josephine as empress. In Goya's portrait the king and queen may dominate the composition, but they also stand as vulnerable mortals, and it is the group which functions as the source of power rather than any single individual.

The closeness of relationships in the portrait reflects the almost incestuous realities of the sitters' lives. Intermarriage between first cousins, uncles and nieces was even more of a standard custom among the Spanish aristocracy than it was in Spanish villages, its purpose being to preserve rank and wealth within the family. The House of Bourbon traced descent from French Bourbonnaises of the tenth century, and the various branches of this illustrious family

130
Sketch for the
*Infante Carlos
Maria Isidro*,
1800.
Oil on canvas;
74 × 60 cm,
29 1⁄8 × 23 5⁄8 in.
Museo del Prado,
Madrid

131
**Vicente López
y Portaña**,
*Commemorative
Portrait of the
Visit of Charles IV
and his Family to
Valencia
University*,
1802.
Oil on canvas;
348 × 249 cm,
137 1⁄8 × 98 1⁄8 in.
Museo del Prado,
Madrid

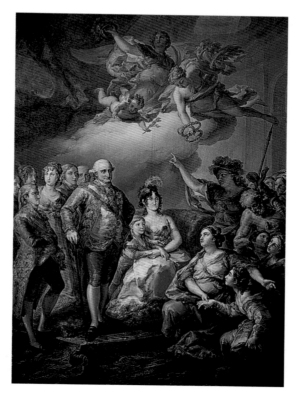

gave rulers to France, Parma and Naples in Italy, and Spain. The Bourbons were also renowned for their patronage of education, as well as the arts, and this tradition was as important as their rights to succession. In 1802, a year after Goya had completed this impressive group, some of the same sitters were portrayed by another leading Spanish artist, Vicente López y Portaña (1772–1850; 131).

His painting commemorates a visit made by the royal family to Valencia University, and is very much a 'history' piece, rather than a straight group portrait. The crown prince, his two younger brothers, and the king and queen are all shown as patrons of learning. The allegorical figures represent the various university faculties which are protected by Minerva, the goddess of wisdom, who is crowned by figures of Peace and Victory. Such an image was in keeping with the late eighteenth-century fashion for depicting a progressive and enlightened monarchy. The importance of the image of Peace alludes to the achievement of Manuel Godoy, who had concluded peace with Portugal after the War of the Oranges, which ended in 1801.

Goya's portrait of the Bourbons makes no reference to war or peace. But his own commemoration of the auspicious victory appears in his full-length portrait of Godoy on the battlefield (see 64), where he displays captured Portuguese banners. During these last few years of his power the minister was receiving criticism from all sides, even from the crown prince, Ferdinand. Satirical prints attacked the king and queen as well as Godoy's administration. Goya was to provide works of art for this hated minister, decorating Godoy's vast palace in the centre of Madrid with allegories symbolizing the minister's enthusiasms and achievements. In this sense Godoy became a particularly important patron, although nowadays he is mainly remembered as the collector who acquired Goya's *The Nude Maja* (132) and *The Clothed Maja* (133).

These two famous works have come to symbolize Goya's life and art almost as much as his other famous 'pair' of paintings, *The Second of May 1808* (see 164) and *The Third of May 1808* (see 165). They date from the period of the artist's life when, having created the *Caprichos*, he continued to analyse, in his personal drawings, the sexual freedoms

and sensuous attractions of young women. But in terms of subject matter these paintings may have their roots in the seventeenth century. In 1680 Juan Carreño de Miranda, court artist to Charles II, had painted two ravishingly decorative oils of an overweight female dwarf, 'La Monstrua' ('Girl monster'), both nude (134) and clothed (135). According to a contemporary account 'La Monstrua' had been born near Burgos and came to the Spanish court in the same year that Carreño painted her. Her real name was Eugenia Martínez Vallejo, and her portrait was commissioned by the king, who provided the gorgeous red, white and gold dress she wears in the 'clothed' painting. At six years of age she weighed more than two full-grown women and was precociously developed. In the nude painting she is given the identity of the classical god of wine, Bacchus, probably to mask her nudity with a decorous mythological disguise.

Goya would almost certainly have known the two paintings, since they were in the royal collection to which he, as court artist, had continual access (in 1801 the paintings appear on an inventory of one of the royal palaces). While the Spanish appetite for images of deformed human beings was traditional, and Goya himself had included dwarfs in the *Caprichos*, his two *Majas* have no such freakish qualities. The traditional claim that the reclining figure may have been a portrait of the Duchess of Alba cannot be substantiated, as portraits of the duchess show her face to be quite different. The *maja*'s face corresponds more closely to the drawing of the sharp-nosed woman lifting her skirts that Goya had sketched in the 1790s (see 98), the profane *demi-mondaine* who inhabits the underworld of Goya's art and could be seen as companion to the wicked Celestina. Monumentalized into these two magical paintings, she is no female monster, but she manages subtly to retain her underworld associations.

Censorship of the female nude in painting had been an obsession in eighteenth-century Spain. Only Mengs had prevented Charles III from having dozens of nude paintings in the royal collection burned. Charles IV had also wished for a conflagration but had been similarly thwarted. The royal family's primness in this respect was undermined by the increasing influence of French fashions in literature, painting and dress.

132
The Nude Maja,
*c.*1798–1800.
Oil on canvas;
97 × 190 cm,
38 ¼ × 74 ⅞ in.
Museo del
Prado, Madrid

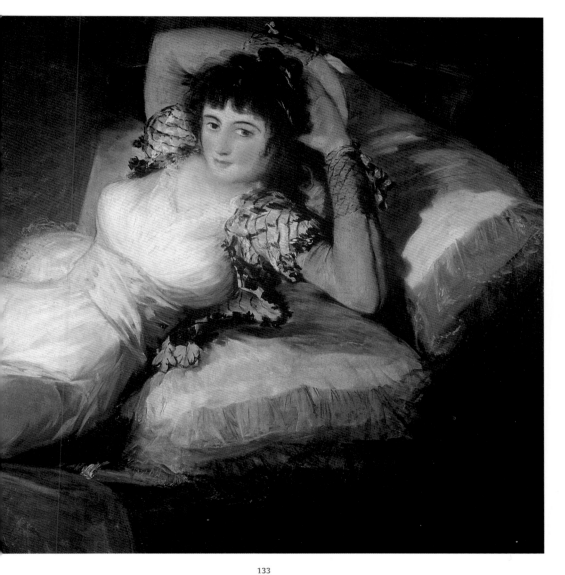

133
The Clothed Maja,
c.1798–1805.
Oil on canvas;
95 × 190 cm,
37 $\frac{1}{2}$ × 74 $\frac{7}{8}$ in.
Museo del
Prado, Madrid

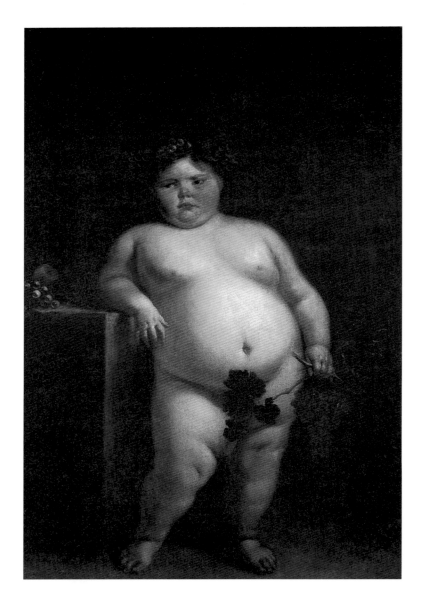

134
**Juan Carreño
de Miranda**,
'La Monstrua'
Nude,
1680.
Oil on canvas;
165 × 108 cm,
65 × 42 ½ in.
Museo del
Prado, Madrid

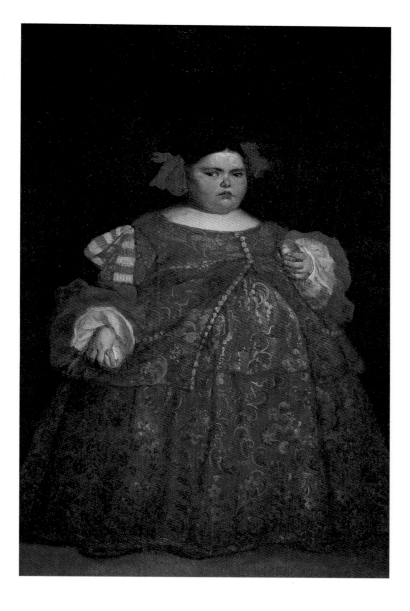

135
Juan Carreño
de Miranda,
'La Monstrua'
Clothed,
1680.
Oil on canvas;
165 × 107 cm,
65 × 42 ⅛ in.
Museo del
Prado, Madrid

While staying on the Duchess of Alba's estate, Goya had made draw-ings of nude and clothed women, and he is pictorially consistent in the elaboration of the *Clothed Maja*'s face with rouge, powder and kohl for her eyes and eyebrows, while leaving the *Nude Maja*'s face pale. The *Clothed Maja* wears Turkish trousers, an embroidered waistcoat, and golden Turkish slippers. Such attire, together with satin bed-coverings, was the standard accompaniment of Turkish-style portraits in England and France in the late eighteenth century. 'The dresses of our ladies have inclined very much to the Persian and Turkish', wrote a fashion correspondent in the *Magazine à la Mode* in 1777. Similar Eastern-style figures entered French painting in the early nineteenth century, such as the fashionable nude 'Odalisque', whose supreme portrayer was David's pupil, Jean-Auguste-Dominique Ingres (1780–1867).

Unlike the saffron, gold, scarlet and black tones of the *Clothed Maja*, the nude is bathed in pearl grey, pink, pallid greens, muted blues, and satiny whites. The artificial and unreal qualities of both setting and anatomy remove the figure from the real world as thoroughly as the *Clothed Maja* is removed from it by her Turkish disguise. Manuel Godoy must have enjoyed the sight of such up-to-date sophistication in Goya's art. Whether or not he planned to create a private cabinet of titillating pictures which he could enjoy at his leisure, his enthusiasm for the subjects paralleled that of Sebastián Martínez, who commis-sioned Goya to paint sleeping girls on the panelled overdoors of his house. The spread of improper subjects seems to have increased as Spain and France drew closer in political and cultural alliance, while the different types of work commissioned by Goya's public and private patrons demonstrated the artist's extraordinary versatility.

The pressure of formal work continued as the artist approached his sixties, although, after completing the portrait of the family of Charles IV (see 129), he executed no more large commissions for the king. The seductive quality of the two *Majas* hints at an artistic reaction to the glittering salon pieces of commissioned work, while Goya continued also to make drawings of deviants and outsiders. Even public portraits immortalizing the aristocracy appear sometimes like a rogues' gallery of the humiliated and vanquished.

The sketches that Goya had prepared for the royal family's group portrait include a painted darkness that looms round each figure, a characteristic background of Goya's mature style. This darkness is built up using such pigments as indigo, charcoal and olive brushed on to a standard terracotta ground. A similar darkness had encircled his much earlier *Portrait of Floridablanca* (see 59) and almost smothered the plain family of the Infante Don Luis (see 66), and it would become even more pervasive as Goya moved towards the grimmer subjects of his last thirty years.

In 1802 the Duchess of Alba died. A drawing reveals that Goya attempted to design a tomb for her, showing the effigy of a woman supported by cloaked and hooded attendants, like mourners on a classical sarcophagus. In his last portrait of the duchess (see 119) she is not surrounded by darkness but clothed in black, a mark of respect to her widowhood. Her mourning rings, however, are inscribed 'Goya' and 'Alba', and she points to the sand at her feet in which is traced the motto 'Solo Goya' ('Goya alone'). Whatever their relationship, Goya was clearly moved by the beautiful woman who had been his patron for so many crucial years. The duchess presented an image of purity in her 'white' portrait (see 72), while the 'black' portrait of 1797 seems to be replete with the imagery of death.

In 1805, when Goya was commanding his highest prices, he painted his most classically-styled portrait, that of the beautiful Marquesa de Santa Cruz (136). This work forms an essay in the internationally popular Grecian style. The Marquesa de Santa Cruz recalls David's Madame Récamier, recumbent on an antique-styled couch (137). With her Greek lyre she also recalls the ladies painted by Sir Joshua Reynolds in the 1770s, masquerading as Terpsichore, the muse of dance and song. But the marquesa's head is crowned with autumnal leaves, evoking a sense of mortality, similar to that of the black figure of the Duchess of Alba. Both women seem to address the spectator: the duchess with her pointing finger and challenging expression; the marquesa with the twist of her body on the couch, set against a background web of black brushwork. Here there is the feeling that is implicit in all Goya's later art: the light never entirely dispels the

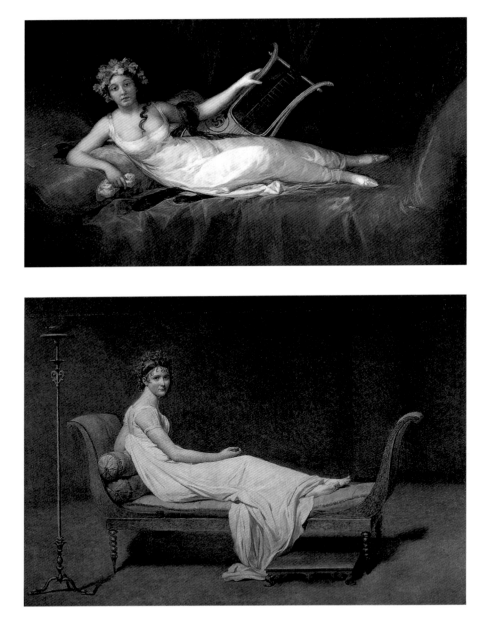

darkness but only renders it more inchoate and visible. Behind the highly finished radiance of the marquesa's face, temporal and mortal associations loom.

As visual props, musical instruments (as well as singers) inspired a series of compositions very different from the flattering portrait of the Marquesa de Santa Cruz. *Song and dance* (138) of *c.*1801–5 portrays a grotesque woman singing and rising in the air, while her companion below seems about to remove a sinister mask. Other sketches and prints from this period create analogous caricatures out of the subject of sound, music and musicians. In one a blind guitarist is gored by a bull; in another, two ugly monks fall about in hideous laughter; and in yet another, a skeletal witch prepares to eat a baby, and two more grotesque figures of indefinable sex rattle tambourines and 'rise up joyfully' (according to Goya's caption). In all these designs the artist objectively summons up a state of hideous ecstasy, not unlike that expressed by some of the crowd present at the miracle in the fresco in San Antonio de la Florida.

During the uneasy few years before the French invasion of 1808 and the ensuing Peninsular War, Goya plunged himself into the production of eccentric pictures: of madmen, witches, beautiful women, grotesque demons and cannibals. His delight in images of violence, in strange figures and disturbing situations, outweighs the moral corrective of social commentary or the expression of political conscience, which is often ascribed to his strange evolution of a post-Enlightenment fascination with the underdog. Images of the deformed and diseased also appear among his drawings at this time and offer a pessimistic vision of society. However, Goya's exploration of the bestial nature lurking in human beings parallels similar interests among early Romantic artists working in other European countries. A drawing from his Album C, inscribed: 'This man has a lot of relations and some of them are sane' and dated around 1803–24 (139), portrays the madman as so socially outcast that he wears a pelt, has grown long nails and seems on the point of actually changing into a beast. A large colour print by William Blake of 1795, showing the biblical outcast Nebuchadnezzar (140), living like a beast in the

136
Portrait of the Marquesa de Santa Cruz, 1805.
Oil on canvas; 130 × 210 cm, 51¼ × 87¾ in.
Museo del Prado, Madrid

137
Jacques-Louis David,
Portrait of Juliette Récamier, 1800.
Oil on canvas; 174 × 244 cm, 68½ × 96⅛ in.
Musée du Louvre, Paris

138
Song and dance,
*c.*1801–5.
Indian ink
and wash;
23·5 × 14·5 cm,
9 ¹⁄₄ × 5 ³⁄₄ in.
Courtauld
Institute of
Art, London

139
This man has a lot of relations and some of them are sane,
no.52, Album C,
*c.*1803–24.
Indian ink
and wash;
20 × 14 cm,
7 ⁷⁄₈ × 5 ¹⁄₂ in.
Museo del
Prado, Madrid

140
William Blake,
Nebuchadnezzar,
1795.
Colour print
finished in
pen and
watercolour;
44·6 × 62 cm,
17⅝ × 24½ in.
Tate Gallery,
London

wilderness, reflects a similar perception. Both artists perceived this irrational violence to be linked to the violent society in which they lived, and both have furnished memorable icons for early Romantic art, with which they are so frequently associated.

Primitives and deranged mentalities further preoccupied Goya in his uncommissioned work produced in the first years of the nineteenth century, when a sense of negative values and pictorial contrasts dominate his aesthetic interests. A contrast to the two *Majas* appears in a pair of cannibalistic scenes (141, 142), thought to represent the deaths of two Jesuit missionaries, Gabriel Lallement and Jean de Brebeuf, who were tortured and murdered by Iroquois Indians near Quebec in 1649. A black hat lying on the ground in the first of Goya's paintings (141) has been taken to be a priest's hat, but Goya's cannibals are not in fact Native American Indians, since they are portrayed with facial and bodily hair, and in the second picture the victim's head, held so conspicuously by the central cannibal, is clean-shaven and longhaired. Here the figure displaying itself in the centre

141
Cannibals Preparing their Victims, c.1805.
Oil on panel; 32·8 × 46·9 cm, 13 × 18½ in.
Musée des Beaux-Arts et d'Archéologie, Besançon

142
*Cannibals
Contemplating
Human
Remains*,
c.1805.
Oil on panel;
32·7 × 47·2 cm,
12⁷⁄₈ × 19⁵⁄₈ in.
Musée des
Beaux-Arts et
d'Archéologie,
Besançon

appears to have no sexual organs, as though Goya were implying that cannibals live in a state of sexless innocence. Goya's grinning cannibal who flays a corpse in the first picture, smiling ecstatically, has a classical body, which associates this figure, perhaps, with later Romantic symbolism that explored the relationship between classicism, 'primitive' human impulses including cannibalism, and the behaviour of the modern hero.

In earlier illustrations which Goya might have known, such as the sixteenth-century volumes by Theodor de Bry (1528–98) entitled *América*, the gutting of corpses by cannibals is the subject of a detailed illustration in which the savages are shown as existing in a state of innocence, while the behaviour of the European conquerors is represented as far more savage and cruel. Popular literature, paintings and prints had inclined to treat the subject of Europeans and Christians becoming cannibals after some catastrophe, such as a shipwreck or a war. However, cannibalism among Europeans, particularly as part of sexual gratification, appeared in the most controversial

and subversively popular novel of the 1790s, *The New Justine or the Misfortunes of Virtue*. Written in the Bastille by Donatien Alphonse François de Sade, better known as the Marquis de Sade, this novel was first published in the Netherlands and Paris in 1791, and underwent numerous printings, six in the following decade alone. In the book savage acts of debauchery are committed by educated French aristocrats, by crooks and ordinary, apparently respectable, men and women, and even by a community of Benedictine monks. Although it is unlikely that Goya had direct access to such material, some of the scenes of atrocity that he painted at this time do correspond to a few of the episodes in the book, just as his cannibals seem to prefigure the interests of later Romantic poets and painters.

In the Second Canto of his epic satirical poem *Don Juan* (published 1819–24), Lord Byron tells the story of a shipwreck during which the starving castaways draw lots to see who will eat whom. The victim, who dies a Christian, has his veins sucked dry ('But first a little crucifix he kissed / And then held out his jugular and his wrist'), the first draught going to the famished surgeon who opens them.

This association between educated European Christians and savage behaviour became an intriguing subject for creative artists in the early nineteenth century. Even painters were drawn to this strange theme. In 1819 Théodore Géricault (1791–1824) exhibited in Paris a painting of

an infamous shipwreck, that of the French frigate *Medusa* which had sunk in the Indian Ocean in 1816 (143). According to two survivors, the ship's doctor and engineer, the victims adrift on their raft were driven by hunger to gnaw at the corpses of their dead comrades. In a preliminary sketch for his great painting, Géricault designed a vivid interpretation of this scene. Unlike this younger French genius, Goya was more likely to turn to cannibal imagery for allegorical or satirical purposes, rather as he had done with the public execution and criminal murderer. It is perhaps on account of his delight in experimenting with such brutal subjects that he became renowned as the painter who had scarified the underbelly of human passions.

Goya's retirement from the Royal Academy and from large court commissions enabled him to seek out new subjects and devote himself to his domestic career. In 1805 his son Javier married into a wealthy Aragonese family, and Goya commemorated this event by producing miniature portrait roundels in copper of the bride and groom (144, 145), and the bride's family. Goya's wife, too, is portrayed in a small sketch, the only portrait of her which can be positively identified (146).

Relaxing in financial security and retirement, Goya could offer his son and daughter-in-law a home of their own. He was now free to create as he wished, most of his old rivals – Francisco and Ramón Bayeu, Luis Paret – were dead; his son was settled. But at this point in Goya's career, the international situation worsened. Godoy had secured an alliance between France and Spain against Portugal but, in reality, he had delivered Spain into Napoleon's power. Portugal had refused to come to terms with Napoleon, who sent an army to occupy the country in October 1807. With French troops in Spain, Crown Prince Ferdinand, who suspected Godoy of plotting to usurp the crown after the death of Charles IV, appealed to the French emperor for help. The upshot of this was that by 1808 Madrid was under French domination. As a consequence, Godoy's unpopularity reached a high point; in March a mob sacked his palace, and Charles IV and María Luisa were forced to abdicate. The crown prince became Ferdinand VII, but Napoleon had other plans for Spain. Ferdinand was summoned with

143
Théodore
Géricault,
The Raft of the Medusa,
1819.
Oil on canvas;
491 × 716 cm,
193¼ × 282 in.
Musée du
Louvre, Paris

his parents to Bayonne, on the border with France. There he too was obliged to abdicate. He and his parents remained as Napoleon's prisoners, while the French emperor replaced the Bourbon monarchy with a new king, his own brother Joseph, who was proclaimed Joseph I, King of Spain. When this news reached Madrid there was a violent outburst of public protest, and the stage was set for the conflict that Spaniards call the War of Independence.

144
Javier Goya,
1805.
Oil on copper;
diam. 8 cm,
3 ⅛ in.
Private
collection

145
*Gumersinda
Goicoechea*,
1805.
Oil on copper;
diam. 8 cm,
3 ⅛ in.
Private
collection

146
*Doña Josefa
Bayeu*,
1805.
Pen and
black chalk;
11·4 × 8·2 cm,
4 ½ × 3 ¼ in.
Private
collection

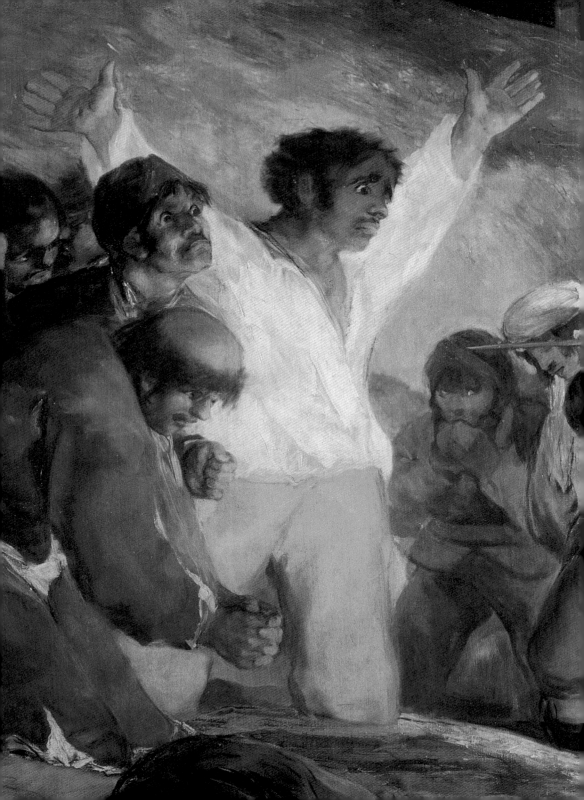

On 2 May 1808 French cavalrymen entered Madrid to put down a popular uprising. Mounting civilian unrest had turned into a series of riots in which Spaniards fought French soldiers in the streets while the Spanish army, garrisoned outside the town, remained uncommitted to either side; and was publicly thanked for this tacit support by Marshal Joachim Murat, Napoleon's general-in-chief of the French armies in Spain. Having arrived at the Spanish capital on 25 March, Murat was well placed to quell the insurrection of 2 May. This he did with the help of ninety-six members of Napoleon's famous Turkish bodyguard, the 'Mamelukes'. It was this episode more than any other which sparked off the civil war and inspired, six years after the events, Goya's two magisterial war paintings: *The Second of May 1808* (see 164) and *The Third of May 1808* (147 and 165).

147
The Third of May 1808
(detail of 165)

The complexities of this war, which involved conflicts in different regions and guerrilla operations carried out by partisans, became subjects of detailed scrutiny and record by numerous artists. Some accompanied the commanders into battles, while others followed the major episodes and actions from newspaper reports. All of Napoleon's campaigns involved teams of professional artists who made records from battle plans, according to the instructions and sketches drawn up by Napoleon's minister for the arts, Dominique-Vivant Denon. The most famous and popular purveyor of battle scenes was David's star pupil, Antoine, Baron Gros (1771–1835), whose majestic paintings of such famous battles as Aboukir and The Pyramids were to become the chief exhibits in the Hall of Battles at Versailles. In England, too, many artists were employed to record, in print and paint, the events of the Napoleonic wars. Even the great landscape artist J M W Turner immortalized such famous conflicts as the Battle of Trafalgar. Pictures of war-fare, popular throughout Europe at this time, reflect, almost certainly, deeper preoccupations with motifs of cataclysm and the

image of the hero which were fundamental to the Romantic movement.

The war in Spain was unique in the idiosyncratic artistic response it evoked and the far-reaching consequences for art history. The establishment of art academies in Spain in the eighteenth century had educated a new generation of major artistic talent, and a number of Spanish art students went to Paris to complete their training at the studio of David, Napoleon's chief court painter. For his part, by 1808 Goya had reached an unassailable position as the leading native master, whose originality and revolutionary techniques were becoming known in France. In the period before the war, teams of French draughtsmen had started to produce views of Spain for guidebooks, which were highly sought after by an increasingly enthusiastic French audience. This fascination with Spain was fuelled during the French conquests of 1808, and the looting of native masterpieces from obscure Spanish convents, private collections, cathedrals and public buildings by French generals, civil servants, soldiers, writers and diplomats. Spanish art was to form a vital source of inspiration for succeeding generations of French artists, from Delacroix to Édouard Manet (1832–83).

148
*Allegory of the
City of Madrid*,
1810.
Oil on canvas;
260 × 195 cm,
102 1⁄2 × 76 7⁄8 in.
Museo
Municipal,
Madrid

There are few records of Goya's activities during the war. He probably spent most of the six years of conflict in Madrid, but in 1808 he visited his hometown of Fuendetodos and went to Saragossa, invited by General José Palafox, to 'study the ruins of the city and depict the glorious deeds of the people'; he described in a letter his 'deep personal involvement with the achievement of my native city'. He is also recorded as making official pictures of the siege for the Spanish side and donating canvas to help the Spanish war effort.

By May 1809 he had returned to Madrid where the usurping French government commissioned him to paint portraits of the new King of Spain, Joseph Bonaparte. One of these, a painting known as *Allegory of the City of Madrid* (148), hung in the town hall and was altered some six times. It was overpainted with an inscription honouring the new Spanish constitution of 1812 after Joseph fled the city, a restored portrait of Joseph when he returned, another reference to the constitution after Joseph finally fled, a portrait of Ferdinand VII when the Bourbon monarchy was restored, two inscriptions honour-

ing the constitution yet again, and finally another inscription about
the events of 2 May 1808. These changes were all made by Goya and
later artists, between 1810 (when Goya finished the work) and 1872.
The fact that such alterations were made to one state painting demon-
strates the ideological nature of the political changes that took place
in nineteenth-century Spain.

Goya was subsequently decorated by King Joseph and may even have
carried out some administrative duties for the French. However, he
also built up in paint, ink and chalk a visual chronicle of his fellow
Spaniards' struggle against the invaders. One can only speculate about
this confusing political contradiction. In 1814 he painted an eques-
trian portrait of General Palafox (149), who had invited the artist to
Saragossa and had become the revolutionary 'captain-general' at the
head of the Aragonese 'Cortes', the regional legislative assembly or
parliament that had assumed power in the region following the French
taking of Madrid. Palafox led an army of anti-French protesters. After

the abdication of the royal family and the failure of Spanish forces to expel the invaders, peasant armies formed a military bulwark against the French, and Palafox and his supporters in Saragossa managed to hold the enemy at bay for almost a year. This inspiring bravery stimulated public imagination throughout Europe, particularly in England where the principal allies of Spain were mobilizing.

In June 1808, barely a month after the collapse of Spain, a Spanish delegation arrived in London. Their mission was to urge the British to intervene. A month later a similar deputation arrived from Portugal. Lieutenant-General Sir Arthur Wellesley was put in charge of a force to go to Portugal. The French were considered invincible. 'Tis enough to make one thoughtful', Sir Arthur was recorded as saying. 'They may overwhelm me, but I don't think they will outmanoeuvre me.' He was nearly forty and had had a chequered career, but his campaign

on the Iberian Peninsula became the turning point of his life, bringing him an earldom, a Spanish estate, a priceless art collection, the acclaim of the whole continent and a vast number of decorations. It also brought him, fleetingly, into contact with Goya.

The two men did not meet until 1812, but the chaotic nature of the war, as recorded by Wellesley, who was to become the Duke of Wellington in 1814 (he was created Viscount Wellington in 1809 and Earl of Wellington in 1812), in dispatches and letters, and Goya in terms of imagery, focused on similar perceptions. Both men expressed profound admiration for Spanish partisans; both were to deplore and retain vivid memories of the atrocities carried out in the countryside against the native populations. Above all, the two men saw the real heroes of the war as anonymous figures, largely drawn from the underclasses of Britain and Spain. The British army consisted of what Wellington called in 1831 the 'scum of the earth', and his dispatches from Spain continually lament the lack of money, the arrears of pay for the troops, and the shortage of equipment, notably ammunition. 'I am on my last legs', he wrote in 1810, just when Goya began to portray in prints the desperate courage of similar combatants.

The artist's true achievement during the war lay in the gradual creation of a vision of rural catastrophe and heroism which has rarely been equalled. Cult characters from the different social hierarchies of Spanish contemporary life, who had formed the subjects of so many of his popular masterpieces in previous years – draggle-tail *majas*, stout labourers and wrinkled hags – were reincarnated in his work as representatives of a new, savage Spain which fought the invader with dogged persistence.

By November 1808, much resistance to the French had fizzled out. Nevertheless, in some regions, fighting continued, and Saragossa, in particular, became a symbol of Spanish defiance. Charles Vaughan published his *Narrative of the Siege of Saragossa* in London in 1809, a pamphlet which was sold in aid of the city's inhabitants. He described the populace who were defending their home against the French as 'ill-armed and undisciplined'; but he had also seen monks making cartridges, and women and children forming themselves into

149
Portrait of General Palafox, 1814.
Oil on canvas; 248 × 224 cm, 97³⁄₄ × 88¹⁄₄ in.
Museo del Prado, Madrid

relief parties taking provisions and supplies to the batteries. Money was particularly tight. While Wellesley, who had entered Spain in July 1809, fumed over his underpaid army, Palafox was reduced to near penury. According to Vaughan, the heroic Aragonese general had, in all, around 2,000 reales for his entire army (in the money of the period, about £21). Nevertheless, the courage and ferocity of the ill-disciplined mob created legends almost every day, as when Palafox's brother led a detachment of armed peasants to meet 8,000 French infantrymen and 900 cavalry. While Vaughan's pamphlet went into several editions in London, and *The Times* raised large sums of money by public subscription to help 'Spanish patriots', Goya remained in his studio in occupied Madrid and began to etch his most enduring and moving series of prints. It was probably through his printmaking activities, rather than the planning and execution of large public paintings, that the experience of this war influenced Goya's career.

The influx of French diplomats, civil servants and military men into Madrid made the city into a more internationally open place, alive with new influences and ideas, and the hardships and restrictions of a war situation also resulted in new unexpected freedoms. The abolition of the Inquisition by the usurping government of King Joseph I may have led to a greater variety of literature being available. The French also revived the popular sport of bullfighting, which Manuel Godoy had banned in 1805 as barbaric, uneconomical and 'unenlightened', and the Madrid bullring was repaired. For many of Goya's enlightened friends and patrons the French represented civilized progress, and even Goya's portraits of this time seem to reflect the French style of the early nineteenth century. General Nicolas Guye was so satisfied with Goya's portrait of him (150) that he commissioned the artist to portray his little nephew as well. Painted in 1810, Guye was a French hero and received the Royal Order of Spain from Joseph Bonaparte in 1811, the same year that Goya himself was given the decoration.

The prints Goya produced at this time, now entitled *The Disasters of War*, form perhaps the most uncompromising artistic record of conflict ever produced. The artist's inspiration came from the analysis

150
Portrait of General Nicolas Guye,
1810.
Oil on canvas;
108 × 84·7 cm,
42 ½ × 33⅜ in.
Virginia Museum of Fine Arts, Richmond

of rural guerrilla combat, even squalid and grotesque episodes of rape, murder, the mutilation of corpses, the abandonment of children and the atrocities committed by French troops and their Spanish opponents. The compositional simplicity of these prints is particularly arresting. Unlike official war artists, Goya was not obliged to represent the grand-scale dramas of major battles, and his skills found stimulus instead in the destruction of rural communities and the suffering endured by his adopted city of Madrid.

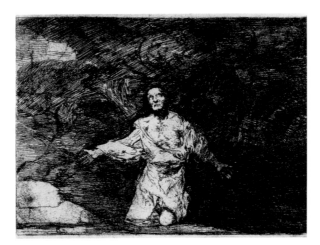

151
Sad presentiments of what is to come,
plate 1,
The Disasters of War,
c.1810–15.
Etching;
17·5 × 22 cm,
6⁷⁸ × 8⁵⁸ in

The *Disasters* were produced over some six years and offer only a bleak, questionable conclusion, closing with an equivocal and sceptical vision of a changed and damaged postwar nation. Each plate bears a caption, and sometimes an observation about what is taking place in the design; occasionally Goya also adds a moral or epigram. But, in a manner quite different from the satiric and poetic captions of the *Caprichos*, Goya's commentaries here are terse and sombre.

Unlike the frontispiece to the *Caprichos*, which had consisted of the flamboyant, fashionable bust portrait of the artist (see 90), the frontispiece to the *Disasters* is memorialized by the figure of a distraught, middle-aged man wearing torn clothes, who kneels in what is possibly a cavern or a nocturnal landscape (151). Assuming the pose of a saint or hermit, such as St Francis or even St Isidore, already depicted by Goya in his youth (see 45), this man rolls his

eyes heavenwards, but no transcendental response appears. Only the caption, 'Sad presentiments of what is to come', moves the spectator on to the main body of the work.

On a proof copy of the *Disasters* series which Goya gave to a friend, the artist transcribed his own title: *Fatal Consequences of the Bloody War in Spain against Buonaparte and other Emphatic Caprichos*. The work was never published in Goya's lifetime, and it was not until years after his death that the Royal Academy in Madrid acquired the complete set of copper plates, publishing a first edition entitled *The Disasters of War* in 1863. By then Spain and France were politically linked through the marriage of the Spanish noblewoman, Eugènie de Montijo, to the French emperor, Napoleon III. In the changed world of the 1860s, with the nephew of Napoleon I on the French throne, Goya's original title would have been politically inappropriate and obscure, a specific reference to a past conflict which became both a civil war and a defensive action against France. The new title conjures up the image of war in a more universal sense and is not a misleading gloss, since Goya's prints evoke a collective vision of major conflict, avoiding recognizable figures or identifiable battles, and including few topographically authentic settings.

The *Disasters* comprise a complete, self-contained work of art, made up of eighty out of a total of eighty-two separate images (two were not published in the first edition), linked by three principal themes. The first of these, probably begun around 1810, focuses on how men and women in the Spanish countryside confronted the invasion, and was inspired by images of piled corpses, which people flung into mass graves. These prints include incidents of fighting, executions and murder. The second theme shifts to urban-based settings and centres on the famine that afflicted Madrid in 1811–12. Finally, up to about 1815, Goya demonstrates how the end of the war and the restoration of the Spanish Bourbon monarch, Ferdinand VII (r.1814–33), brought about even greater disasters.

From plate 1, after the frontispiece, these cycles of subject matter divide the narrative into a tripartite visual record. Plates 2 to 47, showing the early stages of the guerrilla war, chart events of national

significance in small scale, and the most heroic and decorative episode in this section is drawn from the siege of Saragossa, memorializing the heroic roles of Spanish women. At Saragossa Charles Vaughan noticed that women were admired for their exploits. One, María Agustín, achieved an international reputation as a heroine and was immortalized in paintings, prints and poetry. In 1809 Lord Byron travelled to Spain and met her in Seville, where she was showing off the medals presented for her action at the old city wall of Saragossa, when she had brought food to members of the battery. All, including the girl's lover, were killed outright and no one was left to defend the breach in the city's defences. The girl took over single-handed and fired the gun until reinforcements arrived. A number of portraits and prints depicted her bravery, but few images are more evocative than Byron's words in *Childe Harolde's Pilgrimage*, *Canto I*: 'Oh! had you known her in her softer hour, | Marked her black eye that mocks her coal-black veil, | Heard her light, lively tones in Lady's bower, | Seen her long locks that foil the painter's power, | Her fairy form, with more than female grace, | Scarce would you deem that Saragoza's tower | Beheld her smile in Danger's Gorgon face.' Many more Aragonese heroines distinguished themselves in the siege, among them Casta Alvarez, Benita Portoles and Francisca Artiga. Goya chose to pay homage to all of these women (152) by highlighting the drama of an unspecified heroine, her back turned to the spectator, poised before the climax of the action, when she will fire the twenty-six-pound cannon. The composition has an innate sexuality that eschews the conventions of contemporary portraits of heroes.

In these prints areas of blank space weigh heavily against the figures and direct the attention towards the anonymity of aggressors and victims, and the discomforts and tedium between the action. Similar techniques appear in sketches by other artists who recorded this war. A watercolour attributed to the British war artist Henry Thomas Alken (1785–1851) is a tribute to the 10th Regiment of Dragoons, who are shown billeted with their horses and Spanish grooms in a Gothic convent or church crypt, highlighting the scarcity of horses during the campaign, when men took second place to their mounts (153).

152
What courage!,
plate 7,
The Disasters of War,
c.1810–15.
Etching with aquatint;
17·5 × 22 cm,
6⅞ × 8⅝ in

153
Attributed to Henry Thomas Alken,
10th Regiment of the Dragoons in Spain,
c.1812.
Watercolour;
22 × 28 cm,
8⅝ × 11 in.
National Army Museum,
London

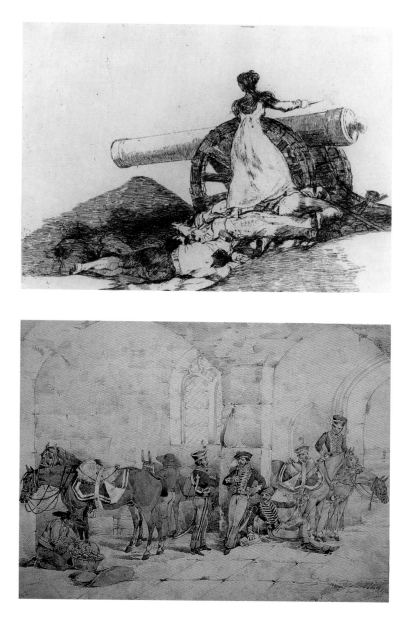

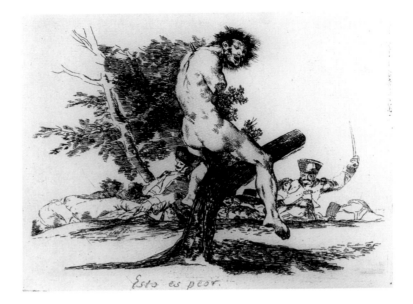

'I have seen many persons hanging in the trees by the sides of the road, executed for no reason that I could learn, excepting that they had not been friendly to the French invasion … the route of their column on their retreat could be traced by the smoke of the villages to which they set fire', wrote Wellington. Other British officers recorded similar scenes: 'Mothers were hung up with their children by their sides, and fires lighted below them.' The importance of the witness becomes particularly crucial in a time of war, when so many of the participants are never known and so many of the dead never identified. And although Goya's etchings were particularly difficult to produce at such a time, when the artist was forced to use old etching plates and inferior materials, his methods were skilful and innovative. For the first time in Spain the technique of 'lavis' – when acid is brushed directly onto a copper plate without stopping out the design with varnish – was used. This artistic determination may have been fuelled by a sense of outrage. The figures attract attention, especially those in compositions representing atrocities and massacres set in undefined backgrounds. Dismembered corpses placed on trees like grotesque fragments of classical sculpture (154 and 213) reveal a compositional similarity to the studies Goya had made forty years earlier of the 'Belvedere Torso' (see 16–18) and the 'Farnese Hercules'

154
This is worse,
plate 37,
The Disasters of War,
c.1810–15.
Etching with lavis;
15·7 × 20·5 cm,
6 ¹⁸ × 8 ¹⁸ in

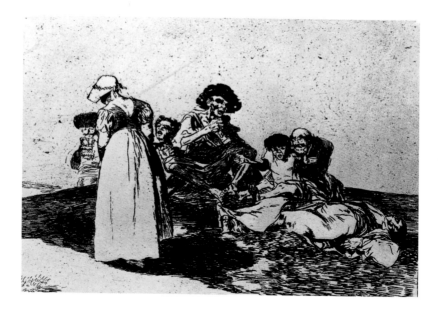

155
*The worst is
to beg,*
plate 55,
*The Disasters
of War,*
*c.*1810–15.
Etching with
lavis;
15·5 × 20·5 cm,
6 ¹⁄₈ × 8 ¹⁄₈ in

(see 15). To underline this immediate sensation of horror, Goya wrote the words 'I saw this', under another scene of dispossessed and terrified refugees. The drawings for these plates also betray the immense efforts involved in their evolution; he often made several finished drawings for a single image. The acute shortage of canvas at this time meant that his resources for painting were limited and underscores the importance of his etching techniques.

The creation of this semi-documentary record of the war cut across Goya's previous roles as portraitist and academic administrator. The city itself appears obliquely in compositions from the second section of the etchings, plates 48 to 64. Plate 55, *The worst is to beg*, shows another heroic and anonymous woman bringing food to a huddle of starving people (155). She retains her humanity in physical terms, while the starving seem to lose theirs. On another plate Goya wrote that the starving and the well fed belonged to entirely different races, and the perspective becomes particularly evocative, with wide arcs of space making the figures sculptural. The suffering of the dying elevates these figures to a super-human status, while the intercessor, charitable woman, priest and stout man disposing of a corpse, carry the burden of pity and retribution.

The identities of guerrilla commanders became legendary in the peninsula and remained immortal after the fighting ceased. However, few of these shared in the greatest moment of triumph, when Wellington entered Madrid on 12 August 1812 after his decisive victory at the Battle of Salamanca in July. Joseph Bonaparte had fled, the city was freed and the population turned out on the streets in a display of wild enthusiasm, quite different from the mobs who had poured onto the city streets to attack the French four years earlier. 'I am among a people mad with joy', wrote Wellington. Another British officer, Major William Napier, who wrote a history of the war, describes how the people mobbed Wellington. 'They crowded round his horse, hung upon his stirrups, touched his clothes, or, throwing themselves upon the earth, blessed him aloud as the friend of Spain.' The city was draped with flags and tapestries, as at a coronation, and rang with bells. Actors and street comedians performed alongside the procession, men and women kissed the soldiers, and a celebratory series of bullfights was staged in Wellington's honour. Only a few months earlier Wellington had written: 'The British army have not been paid for nearly three months. We owe nearly a year's hire to the muleteers ... we are in debt for supplies in all parts of the country.' This ragged army was now raised to the rank of gods. The British artist William Hilton (1786–1839) painted the scene in bright colours, with vivid, quasi-classical figures surrounding Wellington, as if he were a Roman emperor (156). But it was Goya who memorialized the duke in more individual portraits.

The British army pursued the French back into their native land, and during the final years of the war and the campaign in the Pyrenees, war artists excelled themselves in portraying the main combatants. Anonymous Spanish artists depicted Wellington on a fiery horse and as the Duke of Ciudad Rodrigo (157). Wellington himself had separate portraits done of the heads of all his Peninsular War officers. Goya's most publicly acclaimed image of Wellington was, predictably, an equestrian portrait. Wellington wears a blue Spanish cavalry cloak and is distinguished by his compact and comparatively small head; he rides a huge charger in a stormy landscape. This image, like that of General Palafox on his horse (see 149), represents the nearest chal-

156
William Hilton, *Triumphant Entry of the Duke of Wellington into Madrid, 22 August 1812,* 1816. Oil on canvas; 99 × 137 cm, 39 × 54 in. Stratfield Saye House, Hampshire

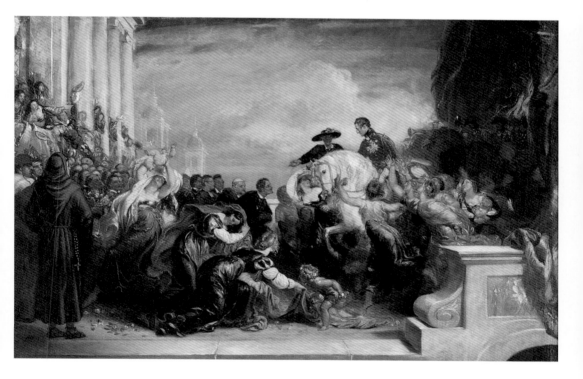

lenge Goya ever made to David's equestrian image of Napoleon painted twelve years earlier (see 125). In Wellington's portrait the tonality is sombre, and has darkened over the years, but the French flavour of this portrait is not coincidental. X-rays have revealed that this rider once bore the head of a Frenchman, possibly that of Joseph I himself, whom so many Spanish artists, including Goya, had painted during the usurping monarch's tenure of the Spanish throne. Nevertheless, the exhibition of Goya's equestrian portrait of Wellington at the Royal Academy in Madrid pleased both the public and the duke. By this time Wellington had been proclaimed 'Generalísimo' of the Spanish army – the position Godoy had occupied years earlier. A comparison between their two portraits shows how Goya could change his style to suit each personality. Painted in 1801 (see 64), one shows Godoy relaxing on the battlefield, dismounted, reading, accompanied at a respectful distance by his *aide de camp*, his victory symbolized by captured standards. The victorious duke of 1812 (158) is shown alert, suspicious and alone, his face and eyes providing the main focus of attention. The austere setting and lack of any tributes in the shape of captured standards, prisoners or attendants creates the image of a man of action, in sole command.

A similar impression of personal energy is evoked by the more famous bust portrait, also made in 1812, which gave Goya considerable trouble (159). Wellington insisted on taking the portrait with him on his campaign in the north of Spain, and the picture was framed while still wet, in a frame that was too small. The resulting damage meant that a year or two later he sent it back to Goya for corrections. In addition, depicting the medals and honours that Wellington had accumulated throughout the campaign set Goya an arduous task: the scarlet jacket is thickly encrusted with painted corrections as the artist tried valiantly to keep up with their number and type. Eventually, however, the portrait ended up with the wrong medals and an incorrect uniform, and Goya subsequently made a drawing of Wellington as a vain peacock (160). Wellington's newly acquired titles, the estate near Granada which the Spanish interim government had bestowed on him, and his reputation as a notorious womanizer, fuelled his deteriorating reputation in Madrid.

157
Anonymous,
Portrait of the Duke of Wellington,
c.1813.
Coloured etching and aquatint;
15·4 × 10·4 cm,
6 × 4¹⁄₈ in.
Museo Municipal, Madrid

158
Equestrian Portrait of the Duke of Wellington,
1812.
Oil on canvas;
294 × 240 cm,
115⁷⁄₈ × 94¹⁄₂ in.
Wellington Museum, Apsley House, London

Although ultimately successful, Wellington's later campaign in the peninsula was scarred with terrible battles, humiliating reversals and, finally, the inadvertent destruction of the town of San Sebastián in 1813 by British troops. This provoked passionate anti-British sentiments in the Spanish press, with polemical articles and cartoons.

Nevertheless, even Ferdinand VII was moved to reward the British commander. During the flight to France, Joseph I's baggage train dropped numerous items which Wellington retrieved, and among these were paintings looted from Spanish collections, including works by Velázquez and Correggio (c.1489–1534). The general

159
The Duke of Wellington, 1812–14. Oil on panel; 64·3 × 52·4 cm, 26 3⁄8 × 20 5⁄8 in. National Gallery, London

160
The Vain Peacock, 1812–14. Ink wash; 23 × 33 cm, 9 × 13 in. Museo del Prado, Madrid

offered to restore these pictures to the Spanish Crown, but Ferdinand magnanimously allowed Wellington to keep them. By the end of the war in 1814, however, when Ferdinand was about to be restored to power, Spanish gratitude for the British intervention had worn very thin and the adulation of Wellington was waning. At this point it was the gigantic figure of Napoleon, conquerer of so many nations and seemingly an unstoppable force, who was metaphorically personified by the English and Spanish as a great Colossus. Together with the allies, Wellington was finally to defeat Napoleon at the Battle of

Waterloo in 1815, but, at the time of the war in Spain, the impression in Europe was still of Napoleon's superhuman powers. A print issued in Italy in 1811 (161) shows him as the Colossus of Rhodes, one of the great classical wonders of the world, dominating the Spanish armies, whose only ally is Britain. Goya painted a similar composition some years later (162).

His eye for the most searing aspects of war was matched by a few of his Spanish colleagues, who, despite very different stylistic preoccupations, were also to introduce a note of brutal realism into their own reworkings of the iconography of civilian suffering. In 1818 José Aparicio Inglada (1770–1838), a Neoclassical painter who had

161
Bartolomeo Pinelli,
Spain in 1810, The Colossus,
1811.
Engraving after
F Pomares;
14·4 × 24·6 cm,
5⅝ × 9¾ in

162
The Colossus,
c.1812–16.
Oil on canvas;
116 × 105 cm,
45¾ × 41⅜ in.
Museo del Prado, Madrid

learned his techniques in the studio of David, portrayed the Madrid famine of 1811 (163) with almost comparable humanity. However, Goya's prints, along with Wellington's dispatches, the histories written by Robert Southey and Napier, and passages in Byron's *Childe Harold*, are treasured as the most vivid and memorable accounts. From Goya's comparatively small images came the modern iconography of war, an artistic achievement matched only in the great literature of the period; also remarkable is the emergence of a new figure, that of the artistic witness, who sets out to record what is generally left unrecorded.

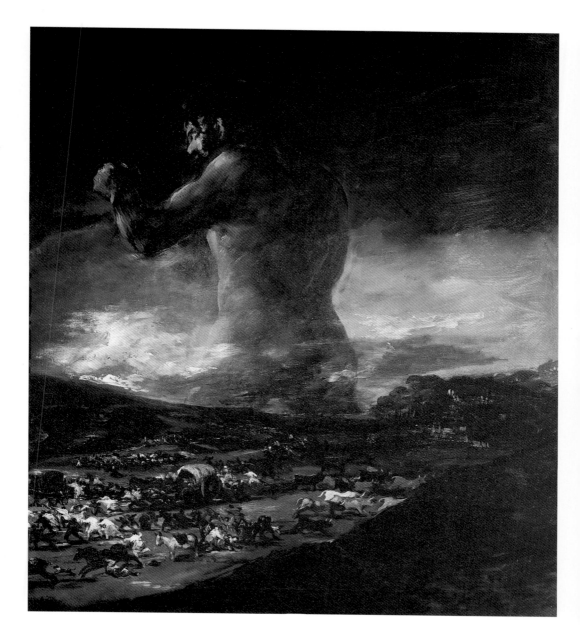

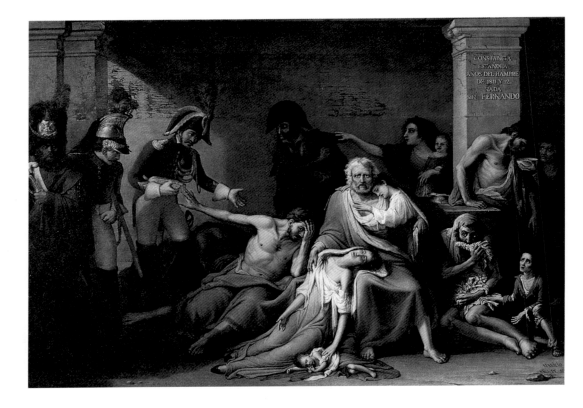

During the war patriotic Spaniards had formed a parliament in Cadiz.
Here the modern state of Spain was analysed and fiercely debated,
and the majority of deputies in Cadiz were eager for liberal reforms.
In 1812 a new liberal constitution for Spain was drawn up. In the
same year Goya's wife died, and he divided his property between
himself and his son Javier, who acquired all the pictures in his father's
collection. Most were given low valuations, probably because of the
war, when pictures would be unlikely to sell at high prices, and partly
perhaps as a way of avoiding the crippling taxes levied by the French.
Despite the optimism surrounding the new constitution and rejoicing
at the end of the war, the restoration of the Spanish national govern-
ment brought about bitter reprisals, and Goya was forced to justify
many of his actions to the authorities. In November 1814 Fernando
de la Serna, director general of postal services, reported on the
political conduct of all those employed by the royal household
during the period of French occupation. Goya, described as 'one of
the most distinguished professors of fine art' in the country, had,

from the entry of the enemy into the capital lived shut up in his house and studio, occupying himself with works of painting and engraving, ceasing to see most of the people he had formerly dealt with, not only because of the difficulties caused by his lack of hearing, but also because of the hatred he professed for the enemy ... He promoted the cause of the invasion of Aragon and the ruin of Saragossa, his native birthplace, the horror of which he wished to commemorate in paint.

According to this report, Goya had wished to flee the country but was prevented by the threat of having all his goods confiscated by the police, and was now left in reduced circumstances because he had refused to draw a salary from the French. He had only survived, so he claimed, by selling his jewellery.

In 1814 Goya petitioned the provisional government, stating that the war had impoverished him, so that although he wished to paint 'our glorious insurrection against the tyrant of Europe', he would need financial support. He received a small monthly stipend while he painted *The Second of May 1808* (164) and *The Third of May 1808* (165). His petition concerning the financing of these pictures may seem defensive in an increasingly oppressive atmosphere of postwar recrimination, but the completed works reveal just how passionate was the artist's commitment to the subjects.

The explosive start of the Peninsular War in May 1808 was seen in Spain as eminently paintable. As early as November 1808, just six months later, one of the honorary lay members of the Royal Academy in Madrid made a speech in which he offered twenty *doblones* of his own money as down payment for a public subscription to commission works of art commemorating the heroism of the ordinary inhabitants of Madrid. Many of the best works, created as memorials to the heroic events of this time, did not appear until the French had been driven out of Spain, and after the restoration of Ferdinand VII in 1814. Ferdinand himself lent his support to the stimulation of artistic responses to the war. In November 1814 he reopened the Royal Academy and made a speech in which he encouraged artists to begin work on memorials and on restoring the buildings damaged by the conflict, and Goya's colleagues devoted themselves to images that

163
José Aparicio Inglada,
The Famine in Madrid,
1818.
Oil on canvas;
315 × 437 cm,
124 $\frac{1}{8}$ × 172 $\frac{1}{8}$ in.
Museo del Prado, Madrid

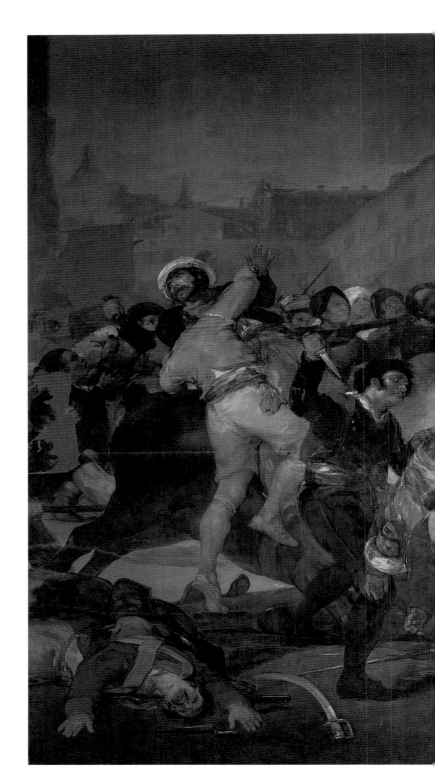

164
The Second of May 1808,
1814.
Oil on canvas;
266 × 345 cm,
104⁷⁄₈ × 135⁷⁄₈ in.
Museo del
Prado, Madrid

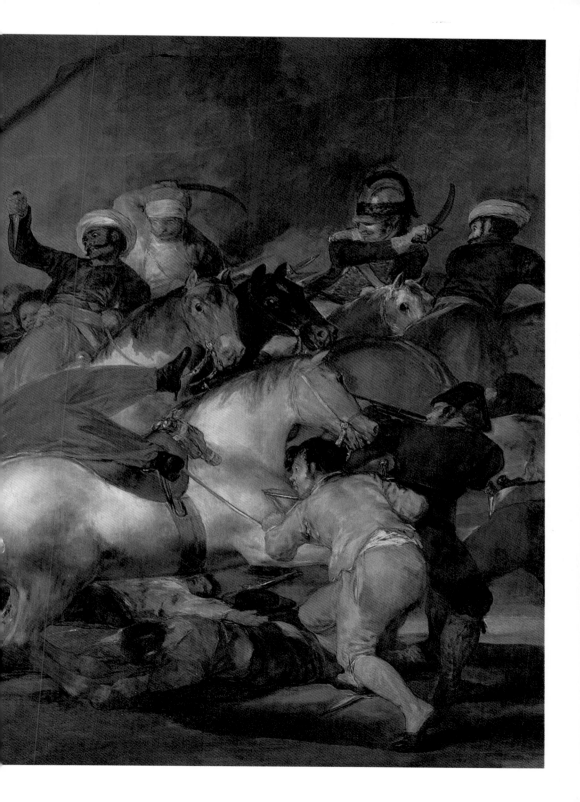

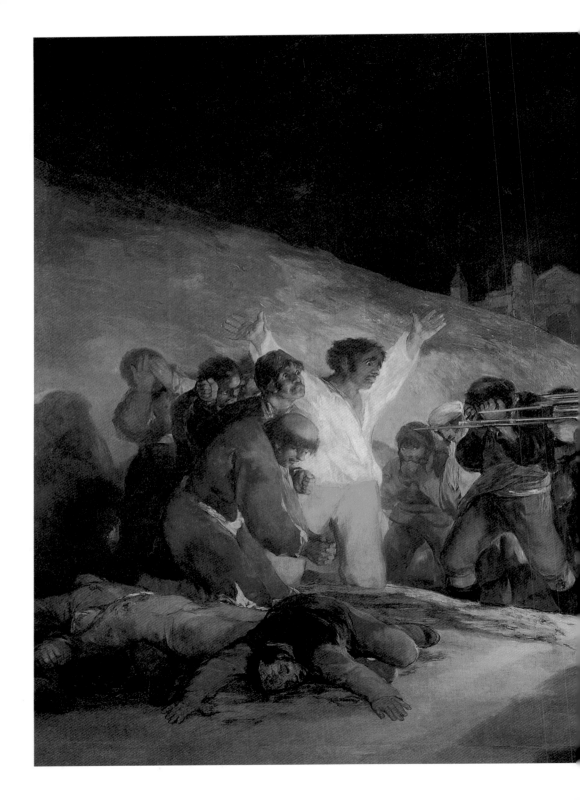

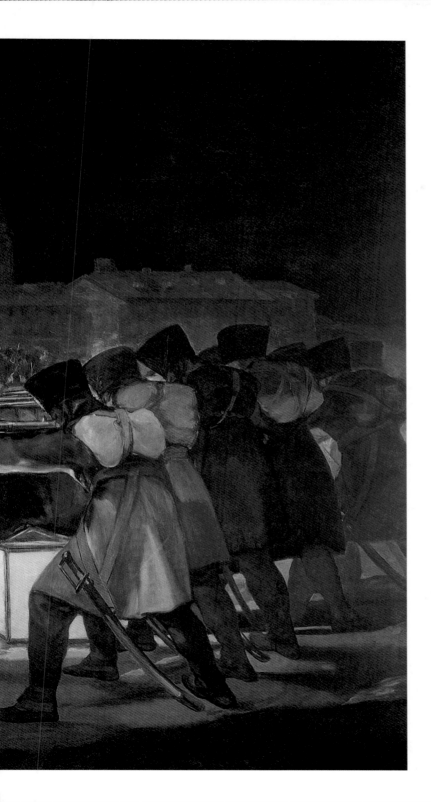

165
*The Third of
May 1808,*
1814.
Oil on canvas;
266 × 345 cm,
104 $\frac{7}{8}$ × 135 $\frac{7}{8}$ in.
Museo del
Prado, Madrid

immortalized the catastrophic tumults of 1808. Tomás López Enguídanos, for example, produced a series of prints showing the events of 2 and 3 May 1808 in the capital city, restaging in visual format the principal engagements and recorded acts of heroism (166). Similar subjects continued to be produced in Spain for almost half a century.

The most popular representations of the events of May 1808 in Madrid appear to have derived from witnesses' accounts of the men and women who attempted to aid two Spanish artillery officers, Daoiz and Velarde. These courageous soldiers had defended the Monteleón Park against the French until they were killed. Statues to the two men still

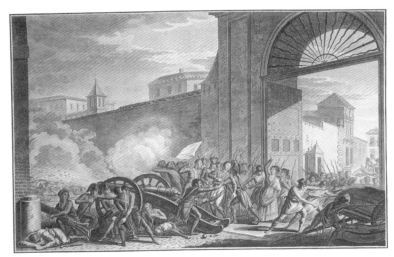

166
Tomás López Enguídanos,
The Second of May in Madrid,
c.1813.
Etching, drypoint and aquatint;
34·6 × 42·1 cm,
13⅝ × 16⅝ in

167
Manuel Castellano,
The Death of Daoiz,
1862.
Oil on canvas;
299 × 390 cm,
117⅞ × 153⅝ in.
Museo Municipal, Madrid

stand in modern Madrid, and paintings and prints depicting their deaths were produced throughout the nineteenth century. Manuel Castellano's large academic piece, *The Death of Daoiz* (167), shows the height of the action, but was in fact painted in 1862, fifty-four years later. Goya, too, memorialized the two historic dates which signalled the outbreak of the war, years after the fighting took place. Like Castellano, whose painted image of a war remote in time must have been constructed from records and accounts, so Goya too must have pondered the type of heroic memorial with which he might immortal-ize the casualties. Unlike his *Disasters of War*, which were essentially personal images, his grand war paintings were public, presentation

pieces, and in them dramatic gestures, brilliant colours and large, striking figures become crucial to the representation of patriotic self-sacrifice.

By 1814 Goya's genius seems to have reached a new flowering which responded particularly to the challenge of large and dramatic pieces of contemporary history. Unlike Enguídanos, and in an utterly differ-ent manner from future masters such as Manuel Castellano, however, he avoided the documentary identification of setting and character.

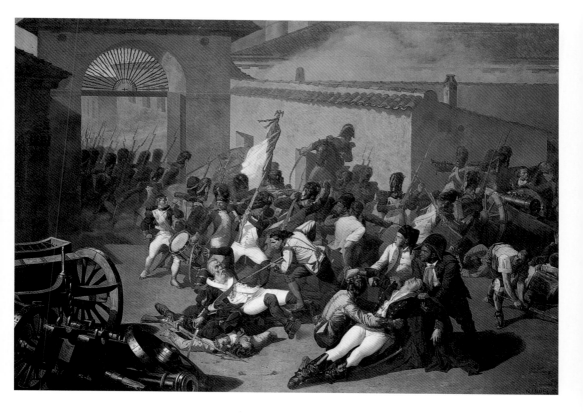

Taking as his principal subject the attack which people in Madrid had made on the French on 2 May 1808, the first of these two pictures is painted in pinks, oranges, blues, greys and browns. While these quasi-pastel colours might seem odd as a scheme for such a savage and violent subject, the *Second of May* relies for its effect on a deliberate vagueness of setting and a delineation of Spanish types, rather than identifiable characters, as Goya had done in the *Disasters of War*.

Perhaps because Goya was at this time particularly concerned
with making his own record of the war in black-and-white prints,
so, too, the influence of prints is particularly discernible in these
two paintings. This influence came not merely from prints engraved
by Goya himself, but also from the multitude of popular flysheets
and political ephemera that was issued during the war. As in other
parts of Europe, the popular visual images inspired by the Napoleonic
wars were particularly inventive. In both the *Second of May 1808*
and its companion piece, the *Third of May 1808*, a strong reliance on
slightly flattened perspective and muted colouring, and the sugges-
tion of a humbler, more dynamic type of image which does not derive
from the influence of official academic history painting appear,
perhaps as a tribute to designers of ephemeral visual polemics.

One such image is a coloured engraving which uses the bullfight to
express the political divisions of the war (168). Issued in Madrid in
1811, this cartoon by an anonymous artist represents French generals
as bulls and Spanish captains of guerrilla detachments as the mata-
dors. The disposition of each *suerte*, or manoeuvre, corresponds to
the principal battles. Here the war cartoonist adopts a series of
symbols in which humans and animals ape each other in surreal
display. Goya's *Second of May* is not an allegory, but his way of depict-
ing human and animal bodies, for example the dummy-like mameluke
reeling from his saddle, imbues the scene with a sense of primitive
power. The painted areas around the horses' hindquarters are also
bull-like, anticipating modern bullfight posters, and the picture monu-

mentalizes the importance of the moment, absorbing the visual language of violent sport and transforming it into a masterpiece of conflict and liberation.

Goya's *Second of May* is the first major modern painting of civilian street protest, a subject which would become crucial to French artists, whose own volatile political history in the nineteenth century established the need for the protest picture as a new chronicle of contemporary history. It took Eugène Delacroix to create a polished modern allegory in his monumental *Liberty Leading the People* (169), which depicted the uprisings in Paris during the revolution of 1830. Executed a generation earlier, with muted colours, struggling men and animals, Goya's scene also endows the energy of popular protest with the illustriousness of great art. It is no coincidence that nineteenth-century French artists who depicted civil insurrection – Delacroix, Gustave Courbet (1819–77), Honoré Daumier (1808–79) and Manet – were all to turn to Goya as a point of departure.

The companion piece, the *Third of May*, has become even more famous, haunting the covers of history books, appearing on postage stamps and postcards. It has been used to epitomize the art of Goya, as well as the spirit of Spanish revolutionary heroism. This violent yet moving image depicts the public execution of insurgents on 3 May 1808, the day following the insurrection. In contrast to the vigour of the street battle, in which the Spaniards appear, momentarily, to be gaining the upper hand, this massacre of civilians, which the French carried out in reprisal for the insurrection, has been painted in the most eye-catching colours. Here, in glowing whites, golds and scarlets against the sombre blacks, greys and browns of the background, the doomed men are immortalized, the street fighters from the *Second of May* meet their fate. One or two are recognizable: the corpse sprawled below the living victims, a prone male figure with matted blood-soaked hair and shattered skull, is identifiable as the hero with the dagger, stabbing the horse in the right-hand foreground of the preceding picture. This 'before and after' aspect of the two paintings corresponds to Goya's planning of the *Disasters of War*, in which individual plates are often linked, like a newsreel film representing sequences of action.

168
Anonymous,
Allegory on the War of Independence, 1811.
Coloured engraving and aquatint;
20·1 × 30·7 cm,
7 ⅞ × 12 ⅛ in.
Museo Municipal, Madrid

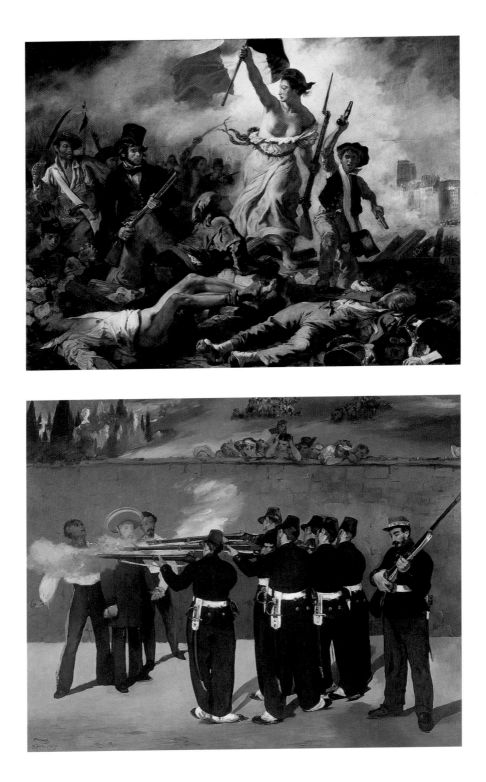

Some fifty years later, Manet chose to paint the execution of the emperor Maximilian in Mexico (170), using Goya's *Third of May* as an artistic point of departure. Goya's strikingly simple composition, derived from the gestures of the figures and probably taken from other contemporary popular prints, focuses on the confrontation between victims and executioners. The white-shirted man with rolling eyes has dark stigmata in the palms of his outstretched hands, which, together with his pose, relate him to the figure of Christ on the Cross. Also, the man's somewhat inflated size beside the other victims and the executioners makes him into a sacred, sacrificial twin of the *Colossus* (see 162).

The fate of Goya's two paintings is clouded in obscurity. It has recently been suggested that Goya produced another two great war paintings and that all four were displayed on a triumphant pyramid or arch, erected to celebrate the end of the war and the return of Ferdinand VII to his capital city. But at the Madrid Royal Academy the most significant painted memorial to appear in the postwar years was not by Goya. A touchingly simple Neoclassical painting came from the studio of another artist, who had been a pupil of David, José de Madrazo y Agudo (1781–1859). His *Death of Viriathus, Leader of the Lusitanians* (171) painted in 1806–7 while the painter was in Italy, was brought to Madrid when Madrazo returned to his native land in 1817. Choosing as subject matter the fate of a second-century BC guerrilla general, Viriathus, who was treacherously murdered by his own servants after he had successfully defended the Iberian Peninsula against the might of the Roman army, Madrazo paints the moment of Viriathus being discovered dead in his tent. The painting was exhibited in 1818 in Madrid, where it struck a deep chord. Goya's *Disasters of War* immortalized guerrilla fighters in general, rather than any specific leader, while the *Third of May* created a hero who approximates to a Spanish Everyman. For a doctrinaire artist such as Madrazo, however, pictorial tributes to dead Spanish heroes could only be expressed in terms of classical tragedy. The significance of the theme of treachery and betrayal in his picture made it appear as a uniquely political comment. Madrazo's contemporaries almost certainly read the painting as a visual attack on all the foreign invaders, and, particularly, on the Spaniards who had supported them.

169
Eugène
Delacroix,
*Liberty Leading
the People*,
1830.
Oil on canvas;
260 × 325 cm,
102 ¹⁄₂ × 128 in.
Musée du
Louvre, Paris

170
Édouard
Manet,
*The Execution of
the Emperor
Maximilian*,
1867.
Oil on canvas;
252 × 305 cm,
99 ¹⁄₄ × 120 ¹⁄₈ in.
Kunsthalle,
Mannheim

While remaining principal court artist, Goya was also to witness the
rising star of Madrazo at the Fernandine court. Having retrieved the
Viriathus subject from Spanish history and transformed it into a
major masterpiece for the new era in Spain, Madrazo may have been
viewed as the true artistic representative of Ferdinand's reign and the
new age of absolutism. At nearly seventy years of age, Goya was too
elderly to be under much pressure to provide many works of art for
the new king, but even his portraits of the monarch contain little of
the originality which had been displayed so brilliantly in the portraits
of Ferdinand's parents. The restoration of the Bourbon monarchy gave

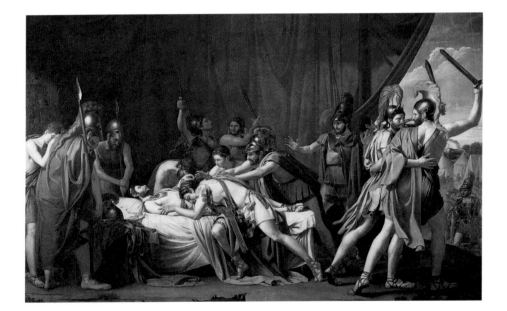

rise to an outburst of nationalism, and the erosion of civil freedoms
and a persecution of political opponents occurred with comparative
speed. The new king's popularity among peasants and landowners
was balanced by the antipathy of the intelligentsia, and while Goya,
whose education, experience and tastes had raised him above his
social origins, might have applauded Ferdinand's patronage of
bullfighting, his favourite entertainment (172), he would also have
been disquieted at the king's restoration of the Inquisition, his repres-
sion of the liberal opposition, and, above all, the way that he immedi-
ately overturned the liberal constitution.

171
José de
Madrazo
y Agudo,
*The Death of
Viriathus,
Leader of the
Lusitanians,*
c.1806–7.
Oil on canvas;
307 × 462 cm,
121 × 182 in.
Museo del
Prado, Madrid

This period of deteriorating political freedom inspired the last part of the *Disasters of War*. The third and final section of the prints, plates 65 to 80, consists of what Goya called *Caprichos enfáticos* ('Emphatic Caprices'). The true meaning of this mysterious term is hard to define. Obviously it held profound personal significance for the artist. These images reject the stark realism of the war and famine themes and move towards fantasy, including grotesque combinations of human and animal forms. Beasts and men, monsters and freaks appear in complex political allegories or as symbols of darkness, like that of the vampire bat with a human face feeding off a corpse.

172
Antonio
Carnicero,
View of the Bullring in Madrid,
1791.
Etching and colour wash;
41 × 49·5 cm,
16¹⁄₈ × 19¹⁄₂ in.
Museo Municipal, Madrid

The 'Emphatic Caprices' form a satire following many vital contemporary issues, and draw upon an obscure Italian poet, Giambattista Casti. Rather like a nineteenth-century George Orwell, who in *Animal Farm* (1945) was to chronicle the Russian Revolution in terms of animals in a farmyard, Casti's poem 'The Talking Animals' portrays the political manoeuvrings of a state in which animals represent the principal factions. Goya personifies Spanish liberals as a white horse who 'defends himself well' (173), a veiled approach to political satire that became a theoretical refuge in the nineteenth century for other artists and writers threatened by oppressive political systems. In post-

war Spain, particularly after 1815 when censorship of the press was introduced, the obliqueness of political discourse provided a contrast to the free speech of foreign visitors. In 1814 Charles Vaughan described seeing the sentence of death passed on liberal supporters of the 1812 constitution, and also witnessed a sentence converted to a pardon as a man was led out to die. In 1816 public executions and imprisonments increased, and in 1817 a young American student of Spanish literature, Charles Ticknor, recorded his impression of post-war Spain: 'The King is a vulgar blackguard. So notorious and so impudent has corruption become, that it even dresses itself in the livery of law and justice.'

Goya's most telling print from this series shares the same universal quality as his earlier depictions of war. The inscrutable allegorical and political references, which make this part of the *Disasters* so difficult to understand, are not present in the plate *Truth has died* (174). The title alludes to events in Madrid in May 1814, when a royal decree set aside the liberal constitution of 1812 and a statue of Liberty was publicly burned. However, there is also another implicit meaning. For an artist to survive in such a society, truth is no longer appropriate. More than twenty years earlier, at the Royal Academy, when Goya had attacked the rules, he had also declared his artistic commitment to truth. In a world of repression and persecution, artistic truth sought safety in patterns of symbols rather than in direct pictorial statement.

173
He defends himself well, plate 78, *Caprichos Enfáticos* from *The Disasters of War*, c.1815. Etching; 17·5 × 22 cm, 6⁷⁄₈ × 8⁵⁄₈ in

174
Truth has died, plate 79, *Caprichos Enfáticos* from *The Disasters of War*, c.1815. Etching; 17·5 × 22 cm, 6⁷⁄₈ × 8⁵⁄₈ in

The artist must have produced his 'Emphatic Caprices' in some secrecy, and after completing the *Disasters*, he gave them to his son for safe keeping. Having already suffered under the new government (*eg* his character scrutiny under the new political 'purification' law, which resulted in Serna's report; harassment caused by having to answer for the professional duties he had carried out for the French during the occupation, his intermittent lack of salary and protestations that the war had ruined him), Goya was forced to confront the backlash of a postwar purge. In November 1814 the Inquisition seized *The Nude Maja* and *The Clothed Maja* (see 132, 133). After the fall of Manuel Godoy in 1808, his collection of paintings had been

confiscated. A Frenchman, Frédéric Quilliet, had catalogued the collection and itemized the two Goyas, but after the French defeat in 1814 the collection was dispersed, and the *Majas* were among pictures attributed to artists who 'have occupied themselves with the creation of works indecent and prejudicial to public good.' In January 1815 Goya was accused as the author of 'the woman dressed as a *Maja* on a bed', and on 16 March he was ordered to appear before the tribunal of the Holy Office to explain why he had painted the works and who had commissioned them.

It seems unlikely that the Inquisition did not know that the paintings had come from the collection of Manuel Godoy. Still alive and living in exile, Godoy had become synonymous with everything corrupt, decadent and dishonest, and associated with the prewar regime of Charles IV, although he had been the last 'enlightened' minister to attempt reform. Goya's earlier association with Godoy was dangerous in the new climate, analogous to his position as an artist who had carried out administrative duties for the French. His attitude towards Ferdinand's tyrannical rule was expressed in his representations of the newly restored Inquisition as the engine of power. This and other ills of postwar Spain were to be central subjects in his work as both draughtsman and painter in the last period of his life.

8

The Cadiz Cortes which had framed the liberal constitution of 1812 saw the war as a revolution against the tyranny of old, traditional laws. However, by the end of the war, many Spaniards saw the return to absolutist monarchy and the Inquisition as a means of restoring patriotic Spanish values, which had been undermined by 'enlightened' foreign influences of the prewar years. Consequently, the ideals of the Cadiz Cortes became discredited and the liberal constitution, already repudiated by King Joseph, was also set aside by the newly restored Bourbon monarchy of Ferdinand VII in 1814. Arguably, the Cadiz Cortes attracted such odium because of its criticism of the Church and, in particular, the Holy Office of the Inquisition. A pamphlet entitled *The Tribunal of the Inquisition*, attributed to one of the deputies of the Cortes, was so strong in its condemnation of the Inquisition that a group of approving Englishmen translated it in 1813 and sent a copy to the British commander in chief of the Mediterranean, Sir Edward Pellew. They wrote that the pamphlet reflected 'the novelty of literary freedom [which] has encouraged the discussion of many topics of political importance, hitherto interdicted by the Spanish legislature'. The text looks back to the thirteenth century as a period of 'darkness, ignorance and error' and describes 'terrible events, in which the Church and state ... offered to the world a spectacle of the most ruinous revolution'. The Holy Office of the Inquisition is visualized as a symbol of Spain's economic ruin and the miserable lives of the population, and a clear parallel is drawn between the nation's contemporary suffering from the 'invasion of the Tyrant of Europe' and the height of Inquisitional power.

This type of polemic may have been familiar to Goya, and although he remained in his post as chief painter to the postwar Bourbon monarchy, he nevertheless reveals at this time a change in attitude. Feeling perhaps sufficiently oppressed by the situation to attempt the challenge of political allegory, he produced drawings that portrayed

175
*The Burial of
the Sardine*
(detail of 177)

the type of torture employed by the Inquisition and in the persecution of liberal minorities, and paintings concerned with irrational human behaviour. From youth to old age he had worked for every ruler in Spain; from Charles III to the usurping French king, Joseph I, and the restored monarchy of Ferdinand VII; and for ministers of state, from Floridablanca and Jovellanos to Manuel Godoy. Throughout these periods he had always behaved with total professionalism, immune from political dogma; but the pictorial challenges of the postwar period, and the violent political confrontations of the reign of Ferdinand VII, seem to have infused his work with melancholy, satirical and rebarbative subjects, and a greater commitment to allegory, obliqueness and myth.

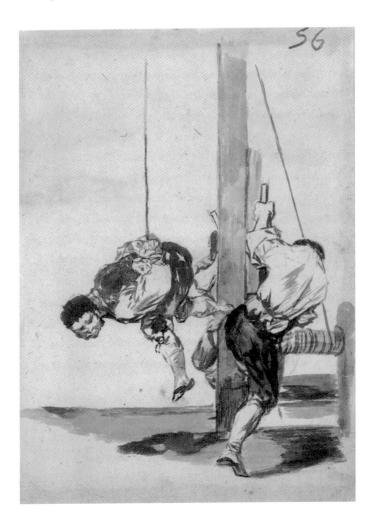

176
Torture of a man,
no.56,
Album F,
c.1815.
Sepia wash;
20·5 × 14·3 cm,
8 1/8 × 5 5/8 in.
The Hispanic
Society of
America,
New York

Although he had been painting and sketching imaginary scenes of execution, torture and imprisonment since *The Garrotted Man* (see 46–48), the changed situation in Spain gave new impetus to the pessimism of his vision. Studies of victims from the history of the Holy Office seem to comment obliquely on the violence of contemporary authoritarian repression. They also find a clear parallel in the descriptions of the deputy's pamphlet which had so impressed the English.

A pulley suspended to the ceiling, through which is passed a thick rope, is the first spectacle which meets the eye of the unhappy victim. The attendants load him with fetters, and tie a hundred pounds of iron to his ankles; then they turn up his arms to his shoulders, and fasten them with a cord: they fasten the rope round his wrists and having raised him from the ground they let him fall suddenly, repeating twelve times, with a force so great, that it disjoints the most robust body.

Goya's drawing of a man being tortured in a similar way (176) comes from one of the artist's postwar albums. The man is hauled up by a pulley, his hands fastened behind his back. Many similar drawings depict human beings twisted into impossible shapes through being fettered, enclosed in stocks or fastened to frames and racks. Sometimes the drawings also refer to contemporary episodes of torture or punishment and bear brief and laconic captions: *For being a liberal*, *It's better to die*, *What cruelty*, *For discovering the movement of the earth*, *For marrying whom she wished*, *For speaking a different language*, *For being Jewish*. This sequence of sketches has an innate richness and elegance of line. Achieved with a restrained application of dark sepia wash and the merest of underdrawing, these sketches could perhaps have been intended to form yet another series of images for engraving. The underlying theme visualizes the plight of political and racial outsiders. Unlike Goya's studies of deviants – criminals, drunks or prostitutes, for example – who are separate from the mass of people because of their actions, these victims come to grief for deeper, more innate and involuntary reasons.

It is tempting to set these drawings beside paintings that Goya made of sinister crowds. *The Burial of the Sardine* (175 and 177) is one of a number of panel paintings dating from the postwar period of the artist's life

that analyse people under the influence of mass hysteria. This carnival scene is inspired by the actual festival celebrated in Madrid in February, when, during three days of dancing, masquerade and irrational behaviour, people could dress in harlequin costumes or as Moors, wear animal masks, cavort in the streets and accost passers-by.

The traditional eighteenth-century masquerade scene, popular examples of which were designed by Giandomenico Tiepolo, Paret and even Hogarth, has been transformed by Goya into a sinister mass of surreal dancers whose capering recalls something of the primitive energy of the cannibals (see 141, 142). A similar energy is distilled from the other panel paintings in the series, *The Procession of the Flagellants* and *The Madhouse*, where the insane are confined within an arched interior, rather like an abandoned church crypt, and the different types of madness are itemized by the use of clothing and headdress. The Indian chief, the great general, the religious lunatic and the half-naked saint, are all presented like the chorus of some strange play. Finally, the perspective of the series changes, as the nocturnal trial in *Inquisition Scene* (178) presents a more realistic sense of sinister performance.

These wooden panels are among Goya's most enduring small works: they were extensively copied in the nineteenth century after the artist's death, remaining as symbols of postwar Spain. They also relate to Goya's famous crowd scenes which have caused some biographers to see the artist as an elitist, whose derision of working class and rural populations was only matched by his obsession with violence. Similar compositional arrangements of figures appear in his postwar depictions of the bullfight, where again the principal performers confront a fragmented, often sinister crowd in a display of heroism, wild action and violent death.

A second literary-political polemic, *Bread and Bulls* (also translated into English in 1813), dates from 1793–6 and was once thought to have been written by Jovellanos, whose critical attitude towards bullfighting was as well known as that of Godoy, who banned the sport in 1805. Today this satirical treatise is attributed to the writer León de Arroyal, who describes how the elegant Greeks invented

177
The Burial of the Sardine, c.1816. Oil on panel; 82·5 × 62 cm, 32 1⁄2 × 24 1⁄2 in. Royal Academy of San Fernando, Madrid

178 Overleaf
Inquisition Scene, c.1815–19. Oil on panel; 46 × 73 cm, 18 1⁄8 × 28 3⁄4 in. Royal Academy of San Fernando, Madrid

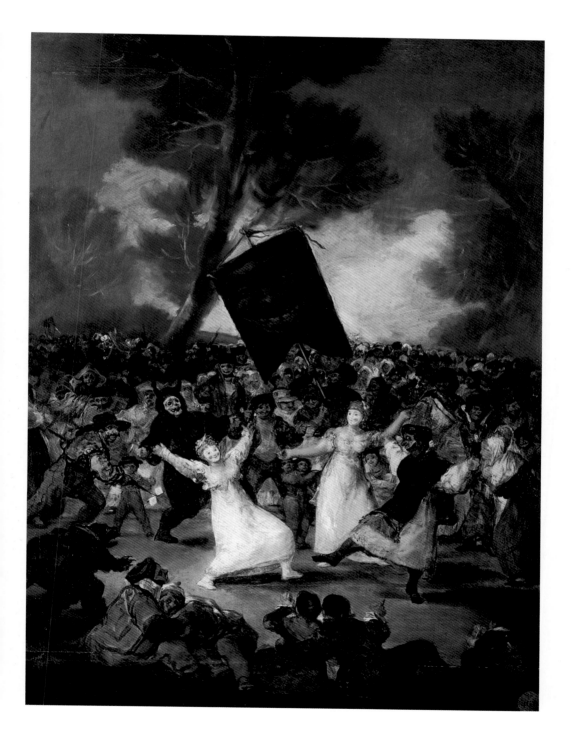

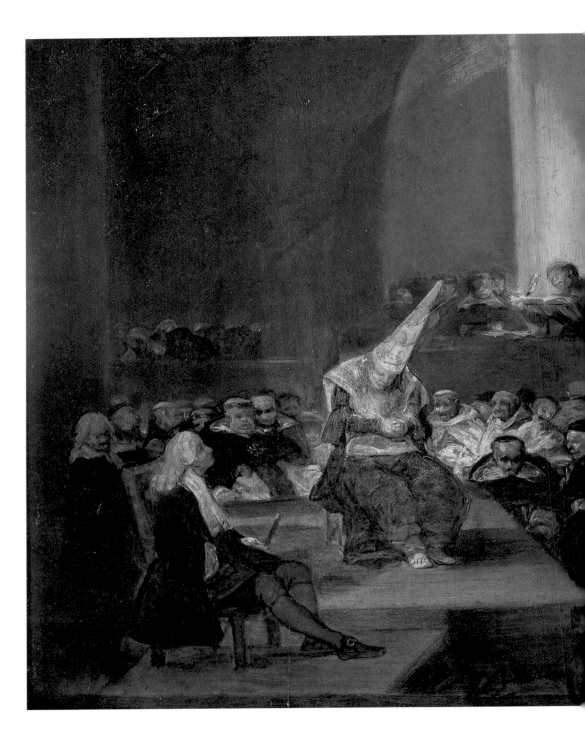

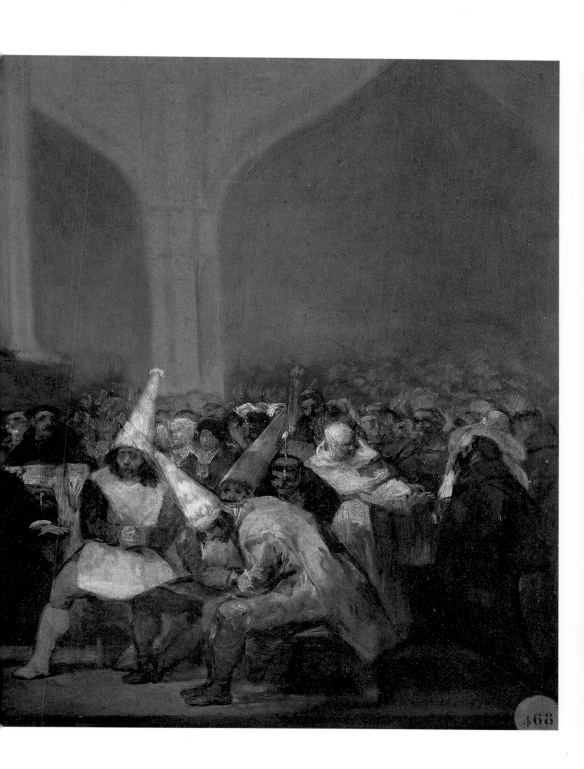

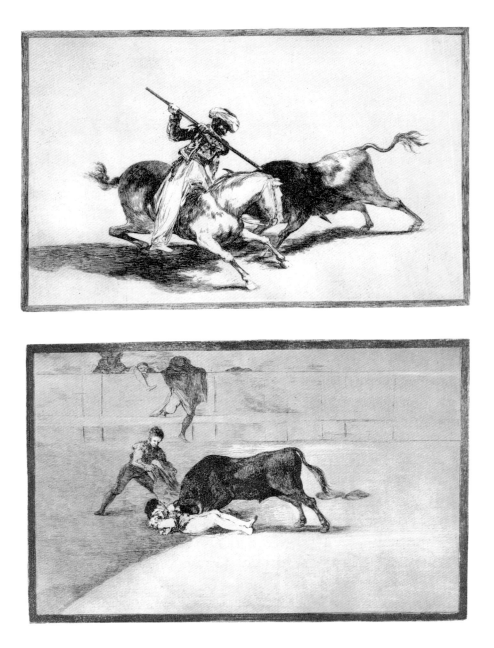

tragedy 'to eradicate from the soul the ignoble passions of fear and terror; the polished Spaniards have invented the bull-feast, where deeds are realized more horrid than even the Greeks have feigned'. The crowd around the bullring are described as a 'numerous assemblage of both sexes, crowded together without reserve: tavernkeepers and grandees; barbers and dukes; courtesans and matrons; laymen and clergy', and the bullfight audience is compared with the superstitious mobs at religious festivals. Early nineteenth-century Spain had officially frowned on bullfighting after the death in the Madrid bullring of the matador Pepe Hillo (Pepillo Delgado) in 1801, but the prohibition of the sport was reversed in 1808 and restored again as a popular gesture by the new king Ferdinand. In exile Manuel Godoy lamented the nation's return to the bloodthirsty and primitive ritual, particularly after Ferdinand VII closed down universities but founded a school of bullfighting in Seville.

179
The brave Moor, Gazul, is the first to lance bulls,
plate 5, *Tauromaquia,* 1815–16.
Etching and aquatint;
25 × 35 cm, 9⁷⁸ × 13³⁴ in

180
The death of Pepe Hillo,
plate 33, *Tauromaquia,* 1815–16.
Etching and aquatint;
25 × 35 cm, 9⁷⁸ × 13³⁴ in

Goya's third graphic masterpiece, published in 1816 and entitled *La Tauromaquia* (The Art of Bullfighting), was advertised on 28 October 1816 in the *Madrid Daily* as a collection of prints designed and engraved by Goya, depicting both the history of bullfighting and the principal manoeuvres. The artist's expertise came from his frequent visits to the bullring in Saragossa as a young man, and to Madrid where he had seen the most famous matadors, Costillares, Pedro and José Romero and Pepe Hillo himself. Having painted portraits of both the Romeros, Goya must have studied the numerous prints and illustrations of the sport. The best known were composed by Antonio Carnicero (1748–1814), who designed a set of prints, some handcoloured, in the 1780s (see 172). Carnicero died in 1814 but his bullfight prints remained classic works and were probably more fashionably popular than Goya's *Tauromaquia*. Employing his engraver's skill to challenge Carnicero's achievement, Goya designed a wide arena where varied methods of bullfighting take place: on horseback, on foot, and the moments when the matador rides the bull. In one section Goya shows how the ancient Moors introduced the sport into Spain, with designs employing a deliberate 'antique' primitivism, as if taken from ancient vase paintings.

181
Drawing for
Feminine folly,
*c.*1815–19.
Red chalk and
sanguine
wash;
23·2 × 33·2 cm,
9 1⁄8 × 13 in.
Museo del
Prado, Madrid

In all these prints the viewpoint is wide-angled and dramatic, especially in plate 5 (179), where a Moor stabs a bull with a long lance. The isolation of the fighter as he faces the bull is epitomized by prints of eighteenth-century matadors, and the fatal goring of Pepe Hillo in the Madrid bullring (180) is memorialized by the sculptural delineation of the doomed fighter's legs and thighs, highlighted against the shadowy background. The dying matador lies in a position recalling the statuesque corpses in the *Disasters*.

Although the *Tauromaquia* was not a commercial success, Goya's production of original graphic designs evidently continued to absorb his energies outside of his renewed output of portraits, religious art and work for the court. Having bought a large number of fine-quality copper plates, he embarked upon his last, most mysteriously personal sequence of etchings. These works called the *Disparates* ('Follies' or 'Nonsenses'), or *Proverbios* ('Proverbs'), have eluded many attempts to explain them. More densely enigmatic than the *Caprichos*, and more abstract than the 'Emphatic Caprices' from the *Disasters*, these compo-

182
Feminine folly,
c.1817–19.
Disparates,
c.1816–23.
Etching with
aquatint;
24×35cm,
9½×13¾in

sitions have few precedents and virtually no parallels in nineteenth-century art, but may be connected with the artist's interest in carnival themes, which he had often explored in his personal drawings and paintings. The copper plates of this strange graphic masterpiece were packed up in a box until Goya's death, to be sold by his heirs later in the nineteenth century. Like the *Disasters*, they were not printed during the artist's lifetime, and their arrangement and subject matter have baffled most of Goya's biographers. Recently they have been discovered to have affinities with literary fiction as well as contemporary events, and their carnivalesque qualities gave free rein to Goya's predilection for designing strange groups of figures and wild behaviour. Modern scholars have compared one plate to a scene from Jonathan Swift's *Gulliver's Travels* (1726), which was well known in Spain. Another plate shows a group of women tossing two dummies or puppets in a cloth, and is entitled *Feminine folly* (181, 182). A clue to these images may lie in the many drawings Goya made for such prints, mostly in red chalk and reddish wash, known

as 'sanguine' because it looks like blood. The softness of such a medium lends an impression of improvisation, and this method piles up the wash to create shapes and shadows which can dictate the ultimate form. Occasionally Goya seems to work like a modern abstract artist, dominating the medium and exploiting its natural qualities.

Goya's technical fascination with the freedom of the imagination corresponds to the creative approach of many artists who devised similar methods. Turner was seen to pour watercolour on to a sheet of paper and scrub at it until the image emerged; Blake attributed his strange images to an intense inner vision which dictated the design; John Constable (1776–1837), apparently literal in his approach to natural scenery, was nevertheless to perceive and interpret his landscapes through a profound emotional involvement. For other creative geniuses the potential of the poetic image or musical motif emphasized the primary role of improvisation. Samuel Taylor Coleridge's experiences with opium, which led to the composition of the poem *Kubla Khan* (1816) while in a state of dreaming, is the most commonly quoted and extreme example. As recounted to a violinist in the court orchestra at Darmstadt, Beethoven, too, envisaged his creative compositional patterns as dependent upon a powerful mental process stimulated by outside sources and this extraordinary faculty reproduced itself through an almost limitless variation on a primal theme:

The basic idea never deserts me; it rises and grows. I hear and see the picture in its complete extent, as in a mould, and there only remains the task of writing it down … Ideas come I know not from where, uncalled for, indirectly or directly. I could seize them in my hands – out-of-doors, in the woods, on walks, in the middle of the night, in the early morning, suggested by moods such as the poet translates into words and I into sounds.

As a corollary to Beethoven's statement, it could be argued that the composer's system, with its fragmentary visual illumination, its glimpses and hints of another order of things, parallels the methods of fine artists who also work in terms of images born from a single idea. The imagination itself was invested with specific meaning during the period of High Romanticism. Keats wrote that: 'The imagi-

nation may be likened to Adam's dream. He awoke and found it truth.' Goya's massive albums of drawings, like Beethoven's notebooks in which he jotted down ideas in words rather than musical notes, are all fragments of an inner translation of the outer world. Goya's initial ideas, stated almost brusquely in chalk, ink or wash, were then adapted and retranscribed into finished engravings or paintings. The importance of sketchbooks and notebooks in Goya's artistic method reveals that he, like Beethoven, never abandoned the original idea. The hooded figure, young and old women, the witch, the devouring monster, the grotesque cavorting crowd, haunted his imagination to the end of his life.

The softness of the drawings for the *Disparates* has a rippling quality: this tendency towards soft, evocative sketching which may have been the reason why Goya, in his old age, was attracted to the new medium of lithograph. This kind of print is produced using a stone slab, or other suitable material, on which a design is drawn in a greasy crayon, to which printing ink adheres. He was taught the technique by the draughtsman Bartolomeo Sureda (1769–c.1850) whose portrait Goya had painted in 1804–6. One of his earliest lithographs (c.1819–22) is a study of a young woman reading to a group of boys. At first the scene appears as a cosy domestic interior. Then, as the characteristically freakish heads of the girl's companions emerge from the darkness of the print, the familiar sense of disorientation is achieved (183).

For Goya, who became the first major European artist to experiment with the technique, evolving more spontaneous effects than were possible with engraving fed his appetite for the improvisational drawing style he had employed in the *Disparates*. The fragmentary yet portentous quality of these printed images seems entirely calculated. Advancing old age and the violent and unpredictable nature of political life in Spain may also have contributed to Goya's increasingly introverted work. He still carried out public commissions and won praise and a large fee for an altarpiece painted for the Sacristy of Seville Cathedral in 1817. But his dedication to the private imagery and techniques based on scribbles, smudges and pools of wash seems

to have become the mainspring of his creative energies. What remains is often fragmented and disconnected. The words 'folly', 'caprice', or even his favourite term 'invention', may all signify a profound series of aesthetic experiments.

In his *Philosophical Fragments* the great German philosopher of the Romantic movement, Friedrich von Schlegel, elucidated the relationship between the concept of irony and the nature of the 'fragment'. He also wrote that a fragmented and eternal potential was the true nature of creativity: 'The romantic kind of poetry is still in the state of becoming; that, in fact, is its real essence; that it should forever be becoming and never perfected.' Goya's visual fragments might be viewed as a similar type of poetic creation. He understood how the potential of the unfinished or ambiguously changing form

was a source of visual power, and this idea sustains much of his late work, linking it ultimately to European Romanticism. Here lies the fascination with the half-formed or unfinished, the ruined or roughly 'natural', even the chaotic sense of dissolution in nature, that can be arrested by the evanescent clarity of the artist's vision which hints at the inner world of the dreamer. Goya's 'Dream of Reason' had created a vision of things not seen by the eye; imagery that relied on a mix of familiar and unfamiliar to create those small scenes in ink or chalk of remote and strange events and figures. The vivid evocations of aquatint, lavis, wash drawing and lithograph not only stimulated Goya's creative mind but drove him at the end of his life to new and extraordinary heights of expression. His artistic maturity not only unites him with Romanticism but also prefigures the freedoms enjoyed by twentieth-century artists.

In his mid-seventies the artist finally decided to leave Madrid. A contract dated 1818 was drawn up for his purchase of a gentleman's country villa, known as a *quinta*. This villa stood in deep countryside to the west of Madrid and is described in a longer contract drawn up in 1819 when Goya moved in: 'A country house built of adobe brick, two low buildings with various internal divisions, a courtyard and two storage lofts.' According to the records this was a spacious dwelling, with farmland and a semi-formal garden, with a small fountain, surrounded by trees. A woodcut illustration of Goya's house was published in one of the artist's first full-scale posthumous biographies, written by Charles Yriarte and published in 1867 (184).

It was in this house, known as the 'Quinta del Sordo' ('Country House of the Deaf Man'), that Goya created his 'Black Paintings', oil-based murals that were painted straight on to the plaster walls of two large rooms, between 1820 and 1823. Although little-known during the artist's lifetime, these enigmatic compositions have become supreme visual metaphors for Goya's life and art.

Like the *Disparates*, which they somewhat resemble, these masterpieces are mysterious. Goya's reasons for so embellishing his own house, a large, self-imposed task, carried out when he was nearing eighty and in poor health, are also obscure. When he frescoed the

dome of San Antonio de la Florida he had at least one assistant. In his own house he had no one, except, possibly, his son. Javier Goya's painting career is also mysterious and largely unrecorded, although he may have executed a witch scene in the upper room of his father's house, which has since disappeared. Javier wrote of his father: 'His own predilection was for the paintings he kept in his house, since he was free to paint them as he pleased. In this way he came to paint some of them with a palette knife instead of brushes. These were always his special favourites and he looked at them every day.' Javier's reference to 'the paintings he kept in his own house' could describe easel paintings or murals. Equally hard to establish is exactly what the murals looked like when they were first completed and who might have seen them. Even their original colouring may not correspond exactly to the purple-black, indigo and burnt umber tones of the fourteen paintings which today hang in the Prado Museum in Madrid.

In 1819 Goya fell ill and, according to his own testimony, his life was saved by the prompt and efficient care of his doctor, Arrieta, whose neat, benign figure overshadows Goya's in a monumental double portrait painted in 1820 (185). This life-size work was also extremely ambitious, designed perhaps to show how illness and old age had not diminished the originality of Goya's artistic vision. The inscription forms a flattering dedication to the doctor and explains that the picture was a present expressing the patient's gratitude. Arrieta is shown at work, a medical man dressed in green, which is the

184
Saint-Elme
Gautier,
Sketch of
La Quinta
del Sordo,
pen drawing
published by
Charles Yriarte
in L'Art, 1867,
vol. 2

185
Self-Portrait
with Dr Arrieta,
1820.
Oil on canvas;
117 × 79 cm,
46 1⁄8 × 31 1⁄8 in.
Minneapolis
Institute of
Arts

Goya agradecido, á su amigo Arrieta: por el acierto y esmero con q.ᵉ le salvó la vida en su aguda y peligrosa enfermedad, padecida á fines del año 1819, á los setenta y tres de su edad. Lo pintó en 1820.

symbolic colour of hope. He tends Goya in a dark interior. In the background three heads emerge from the murk, almost threatening to engulf the pair in the foreground. One head on the left looks like another, profile portrait of the doctor and is cut off short at the neck, which suggests that it may be a painted sketch. The portrait itself was copied at least once by Goya's assistant, Asensio Juliá (see 122), who had helped paint the San Antonio de la Florida fresco. The work constitutes a profound advance in the elderly artist's mature style.

The painting of this portrait would have been done when Goya was living in the 'Quinta' and had already started to paint his murals. Whether or not the background to Arrieta's portrait shows some of the sketches on the walls of the room where Goya is being tended, is another mystery. In the painting Goya portrays himself as a sick old man, and the theme of old age, infirmity and death provides the only identifiable linking programme of the paintings.

Long after Goya's death the murals were extensively damaged, mostly by water seeping through the adobe brick of the walls. Adobe is a porous clay brick, made using a technique imported from Mexico and Peru by Spaniards in the sixteenth century. As a basis for wall-paintings, this particular type of brick could not have been less suitable. In the 1860s Goya's paintings were photographed, and from these prints and a few more, taken some years later, it is possible to see how water damage had distorted some images and obliterated others. By the 1870s, when the house belonged to a German, Baron Erlanger, techniques for transferring wall-paintings on to canvas were considerably advanced, and, in an attempt to preserve these masterpieces by Goya, the murals were removed from the walls. What remained of them at the end of this risky undertaking was then extensively restored by a Spanish history painter, Martínez Cubells (1845–1914).

Recent scholarship has teased out an impressive quantity of new information which enables the historian to speculate about the original state of Goya's pictures. One or two were engraved in the nineteenth century, and the surviving prints confirm that the restorer Cubells can be praised for an almost miraculous achievement in resurrecting the principal outlines of the compositions and restoring a

general impression of Goya's originals, but he was, nevertheless, obliged to repaint a number of details. There is also a suspicion that the restorations may reflect contemporary prejudices about Goya's art.

The choice of rooms to paint, subject matter, colouring and style were all Goya's own. Ever since he wrote the letter which postdates his illness of 1792–3, he had stood by his decision to paint uncommissioned work and in this way achieve artistic freedom. While his earlier freelance images were small-scale easel paintings, etchings or drawings, the purchase of the 'Quinta' with its two spacious principal rooms gave Goya the chance to stretch the limits of his personal art on a grand scale. In both upper and lower rooms the subjects give form to pictorial obsessions that had appeared in the *Caprichos* and *Disparates*. The effect of these murals must have been sufficiently striking to overshadow the existing decorations, which apparently consisted mainly of eighteenth-century wallpaper. The texture of these works was originally thick and crumbly, the details were created with thick dabs of paint, using a brush or a palette knife. Each painting was probably intended to be viewed from a specific distance.

An anonymous article published in *Le Magasin Pittoresque* in 1834 claimed that Goya 'threw a mixture of colours into a pot and hurled them violently on to a large whitewashed wall'. This interpretation, probably based on hearsay, might, nevertheless, have derived from the method Goya adopted for his strange decorations. The two rooms apparently possessed only one or two windows and a limited light-source seems to have been an essential part of the experience of viewing the paintings. Whether or not Goya wore the hat with candle-holders that appeared in the *Self-Portrait in the Studio* (see 82) is not recorded. But the thickness of paint implies that the figures and settings may have been animated under artificial light, as well as the natural light from the windows which, it has been recently suggested, was used for the painted light-source in the pictures.

On entering the principal ground-floor room, the visitor would have been confronted with a door at the far end, flanked by a mural on each side. On the left side was Judith, the beautiful and pious Israelite

widow who cut off the head of the powerful Assyrian general Holofernes, after he attacked Judaea. The apocryphal Old Testament Book of Judith had provided many painters with the image of a dramatic heroine whose courage had saved her country from a ruthless invader. The parallel between Judith and the Spanish heroines who had fought so valiantly in the Peninsular War might have attracted Goya to the subject, and Judith's emblematical meaning, Virtue resisting Sensuality, contrasts with the painting on the other side of the door showing Saturn, the god of agriculture who came to personify Time (186). After being warned by Mother Earth that one of his children would usurp him, Saturn bit off their heads. His rolling eyes and bearded face may derive from a drawing in Goya's Italian notebook (see 22). The lower limbs were so badly damaged that the true significance of the image is hard to interpret, but from early photographs Saturn also appears to have been sexually aroused (his erection either crumbled in the transfer from wall to canvas or was removed by the restorer as too obscene). He might, therefore, have been originally portrayed by Goya as both life-taker and life-giver, while the door set between these two paintings could have served as an ironic reference to an underworld passage through which the two victims might be expected to pass.

Similar ironies appear in the rest of the murals. In the ground-floor room the long horizontal panels bore painted crowds of figures whose rolling eyes, sharp features and lumpy bodies recall those in Goya's prints. A blind guitarist appears, leading a procession of rural hobbledehoys, who were later interpreted as revellers going to the tomb of St Isidore. Much in the reading of these images is speculative and, just as the *Disasters* had a posthumous title conferred on them, so the subjects of the 'Black Paintings' were later postulated by Goya's executors and critics.

In the downstairs room the blind singer stands opposite another group showing a coven of rural witches with large eyes and snoutish faces, worshipping the 'Great He-goat', a figure recalling the goat that Goya had painted for the Duchess of Osuna (see 99). A charming *maja* in a dark dress and mantilla, holding a muff, completes the scene. In

186
Saturn,
1820–3.
Oil on canvas
(transferred
from plaster);
146 × 83 cm,
57 1⁄2 × 32 3⁄4 in.
Museo del
Prado, Madrid

the nineteenth century the room may have functioned as a dining
room and, according to one account, musical parties took place
there. Beside Judith, Saturn, the Witches and the Blind Singer, two
elderly, skeletal figures trying to eat soup occupied a panel above the
entrance, and an elderly bearded man leaning on a stick with another
figure shouting into his ear flanked the entrance door. This detail
plays both on the name of the house and on the disability of its owner
and author of the paintings. On the opposite side of the entrance was
a portrait of a girl leaning on an elaborate balustrade (187), reminis-
cent of that surrounding an expensive tomb. This girl is thought to be

187
La Leocadia,
1820–3.
Oil on canvas
(transferred
from plaster);
147 × 132 cm,
57⅞ × 52 in.
Museo del
Prado, Madrid

188
The Letter,
c.1812–14.
Oil on canvas;
181 × 122 cm,
71⅜ × 48 in.
Musée des
Beaux-Arts,
Lille

Goya's young housekeeper, Leocadia Weiss, with whom the artist
lived for several years. Although no known portrait of her exists, her
friendship with Goya may also have inspired an earlier easel painting
of a similar girl reading a letter (188). The palpable, thick paint of this
picture and the dark colours of the figures, the images of washer-
women in the middle distance, make the painting one of those frivo-
lous and erotic 'caprices' that Goya painted either during or shortly
after the war. The girl in the mural appears to be in mourning, rather
like the Duchess of Alba in her 1797 portrait (see 119).

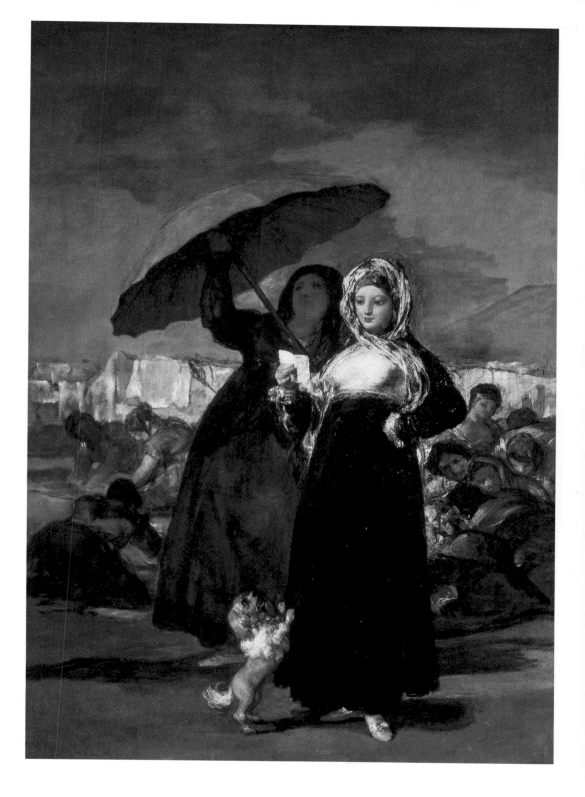

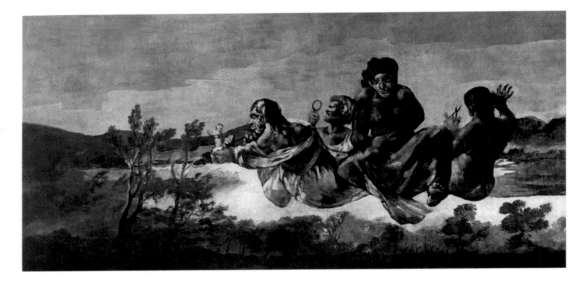

189
The Fates,
1820–3.
Oil on canvas
(transferred
from plaster);
123 × 266 cm,
48 ½ × 104 ⅞ in.
Museo del
Prado, Madrid

The upstairs room contained another series of pictures whose meanings are also hard to elucidate: a man masturbating and being laughed at by two younger spectators, a group of people huddled round a book or paper, a couple of men fighting with clubs, two flying figures being shot at by a soldier, and a dog apparently drowning in sand. One monumental composition (189) recalls the subject of spinners, or Fates, which Goya had first begun to design in the 1790s. Now they have become the classical Three Fates: spirits who were believed to determine the destinies of men. Lachesis measures the thread of human life, and holds the spindle, Clotho spins the thread, while Atropos holds her open scissors, ready to cut the thread at the moment of death.

Although these murals summon up the impression of Goya as a morbid fantasist, a theme that later novels, plays, films and poems about the artist have enthusiastically endorsed, the mythological subjects and contrasts between elegant beauty and grotesque ugliness must have endowed the rooms with extraordinary brilliance and grandeur when they were first painted. The confrontation between male and female figures, and the subjects of old age and death, may strike an appropriate note of finality in the artist's long career. However, if Goya initially contemplated a rural retirement in the company of these eccentric images, then he soon changed his mind. The completion of the 'Black Paintings' ushered in another period of artistic renewal, and the sheer effort of completing such a comparatively major series must have meant that the artist was extremely fit for his age. In 1823 when the paintings would have been finished and Goya had reached the age of seventy-seven, he drew up a Deed of Gift making the house, grounds and contents over to his grandson, Mariano Goya. In the document the artist's improvements to the house are listed. They include an extension to the garden front, a house for a resident gardener, a well, a new drainage system, fences and vineyards; the size of the estate had grown to some 10·1 hectares (25 acres). The obsession with gardening which seems to have overtaken Goya in old age may also have increased the value of the property considerably. Despite the wealth of information included in this document, Goya's murals are not mentioned.

When Mariano Goya finally sold the house in 1859, he was sufficiently impressed by his grandfather's posthumous reputation to commission several valuations of the paintings. Up to that time he and his father, Javier, had done little to the rooms in which the pictures were painted. By 1854, however, the paintings were included in a guidebook to Madrid, and a few years later a French biographer of Goya mentioned the country-house paintings as 'scenes of local customs'. Had Goya remained in Spain until the end of his life, and had the subsequent history of his country been less violent and unstable, then the paintings might have been recorded in print form in their original state. Despite subsequent damage, however, the image of Saturn devouring his son (see 186) has become representative of Goya's mature art, and early critics of the 'Black Paintings' used them to adopt a moral stand in their assessment of Goya's eccentric genius. Was he mad, wicked, or simply a practical joker? Could pictures such as the 'Black Paintings' be considered as works of art at all? Goya's desire in his private art to paint and sketch anonymous failures, defectives, lunatics and cruel atrocities, as well as pretty girls, landscapes and still lifes, might be seen as a private gallery of mordant, satirical, even at times unnecessarily cruel pictures analysing the horrors of a diseased imagination, and the 'Black Paintings' have come to be considered the harshest and most daring works Goya ever produced.

The last four years of his life were simultaneously disrupted by political changes and full of new masterpieces. A liberal coup temporarily ended the tyranny of Ferdinand VII, but the king was restored to full power in 1823. Early in 1824 Goya seems to have gone into hiding while reprisals were taken against political dissidents. An amnesty in May enabled Goya to petition Ferdinand for permission to visit France. This was given, and Goya made straight for Bordeaux, where he was welcomed by his liberal friends in exile. Nevertheless, Goya continued to draw his pension from the Spanish king. In the summer of 1824 he went to Paris. At this time he met Joaquín María Ferrer, a banker who was to advise Goya on the sale of his lithographs in France. He appears to have been constantly watched by the secret police at the request of the Spanish ministry of the interior, but nothing sinister came of this. In the winter of 1824–5 he settled in

Bordeaux with Leocadia Weiss and her daughter Rosario, remaining there until his death in 1828. Although married, Leocadia Weiss seems to have separated from her husband some time after the death of Goya's wife. Born in 1814, Rosario was to become a painter, Goya apparently adopted this child and in 1821 he stated that she should be treated 'as if she were his own daughter'. It is generally assumed that Rosario Weiss was, in fact, Goya's natural child, although she was registered as the legitimate daughter of her mother's husband, Isidoro Weiss, a merchant of German descent.

The last and most intriguingly decorative of the works which Goya made indicate the adventurous nature of his late artistic experiments. A series of miniatures on ivory were produced during this first French sojourn. The traditional subjects for miniatures were portraits, whereas these tiny, exquisite objects relate in style and subject matter to the 'Black Paintings'. After the death of the greatest eighteenth-century miniaturist, the English artist Richard Cosway (1742–1821), the medium declined in popularity, and Goya must have been one of the last major artists to try his hand at this highly skilled method of painting.

Eighteenth-century miniaturists had painted in watercolour on ivory and achieved translucent effects. Goya's method was to blacken the ivory, then remove part of the surface blackness, adding a little watercolour wash, so that the image emerged as light on dark. 'Last winter I painted on ivory and I have a collection of nearly forty exercises, but they are original miniatures which I have never seen the like of before', he wrote. This emphasis on originality is characteristic. The blackened background and sculptural forms which emerge from the darkness create solid areas of flesh. The figures dominate the compositions. Despite their small size, they express intense animation, and as such they form an artistic polarity to the murals in the Quinta del Sordo.

Goya perhaps saw the 'Black Paintings' as similarly endowed with his most personal sense of originality. Their colouring, subject matter and setting paid little artistic lip service to the convention of decorating grand buildings. But traditions of formal, public decoration seem irrel-

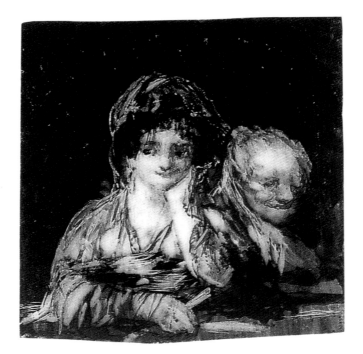

190
Maja and a Celestina, 1824–5. Carbon black and watercolour on irregular ivory plaque; 5·4 × 5·4 cm, 2⅛ × 2⅛ in. Private collection

191
Spanish Entertainment, 1825. Lithograph; 30 × 41 cm, 11⅞ × 16⅛ in

evant to the 'Black Paintings'. Tiepolo had decorated palaces; so had Goya. Earlier artists such as Rubens had painted their own houses, but the murals in Goya's house are perhaps more generally related to large commissions for private interiors in which the status of the owner is commemorated. In the early 1800s he had painted allegorical murals for Manuel Godoy's palace in the centre of Madrid, and these works were seen by both artist and patron as emblematical tributes to the minister's personal ambitions in the arts, sciences, commerce and agriculture. Years later Goya endowed his own family home with a similar sense of personal status.

The miniatures too may have been a reversal of accepted traditions, an approach often used in commissioned portraiture. Having already memorialized his own family in portrait miniatures at the time of his son's wedding (see 144, 145), he returned to the technique to work out more private allegories. Like the murals, the miniatures are hard to understand in terms of early nineteenth-century fashions of painting. They include a *maja* and Celestina (190), which some believe is in fact a self-portrait; a biblical subject, Susanna and the Elders; a man

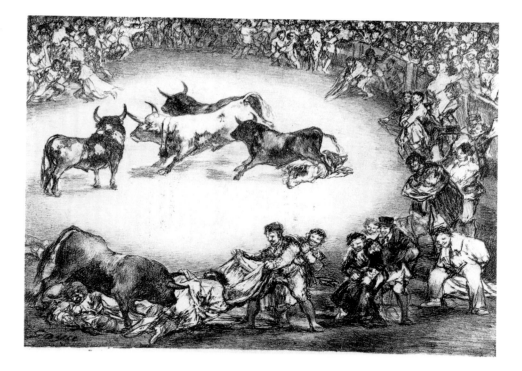

picking fleas from a dog; a monk frightening an old woman; a number of naughty, grotesque children; and a man eating leeks. They derive from those imaginative obsessions which Goya had pursued for more than thirty years in his professional life.

Although he became seriously ill in 1825, he continued painting. Even more importantly, he continued to make large numbers of drawings, which show how fertile and dynamic his imagination remained. By this time too he was also hard at work on lithographs, mainly of bullfight scenes (191). Against a tough and vibrant crowd, a group of thuggish matadors take on stocky little bulls and, although Goya's representation of the bullfight has by now developed away from the precision of the *Tauromaquia*, the abstraction of this strange *Spanish Entertainment* still has a nationalistic feeling, if the title has more than a hint of irony.

In 1826 Goya visited Madrid and requested permission to retire. His salary was converted into a pension of 50,000 reales (around £500 in the money of the period), enabling his final years to be comparatively comfortable. His last drawings and etchings return

obsessively to earlier subjects, with one or two new ones: people on skates; people condemned to death; sketches of the guillotine, strange types of transport such as a dog pulling a man in a cart, which Goya recorded that he had seen in Paris, an old man on a swing smiling to himself. His last self-portrait shows him clean-shaven and wearing a cap (192).

192
Self-Portrait Aged 78,
1824.
Pen and
sepia ink;
8·1 × 7 cm,
3 1⁄8 × 2 3⁄4 in.
Museo del
Prado, Madrid

193
Cayetano Merchi,
Head of Goya,
c.1800–10.
Bronze;
h.45 cm,
17 3⁄4 in.
Royal Academy
of San
Fernando,
Madrid

The great Romantic Salon exhibitions held in France at this time, the aesthetic rivalry between Ingres and Delacroix, debates over style and subject matter, all seem to have passed Goya by. His last works were said to be 'slapdash', his friends sound weary when they write about him, and his style was mainly known in France through pirated copies of the *Caprichos*. His murals were left to decay, his *Disasters* hidden from view.

The artist's final years reveal him as the genius who achieved as much in his old age as many achieve in a lifetime. While his youth had centred around the struggle to succeed, his old age appears like a long period of total vindication. Shortly before he died, he was described as a 'philosophical painter'. It would be difficult to attach a precise philosophical system to Goya's art, but implicit contradictions

in his pictures, and his delight in exploring the opposing themes of reality and fantasy, all create a distinct metaphysical world out of a wilful, incongruent imagination.

Between 1795 and 1812 the Italian sculptor Cayetano Merchi (1747–1823) worked in Spain. He is now chiefly remembered for the bronze head of Goya which he made some time during his Spanish visit (193). This head was owned by the Goya family and was given to the Royal Academy of San Fernando by Goya's grandson, Mariano, in 1856. Goya's head is sharply turned, his eyebrows jut out above deep-set eyes, his hair streams in unruly curls, expressing the energy of genius. This same idea had been evoked in the self-portraits by Velázquez and Rembrandt in the seventeenth century, and by Meléndez in the eighteenth. The distillation of intellectual power, which eighteenth-century self-portraits by Hogarth, Reynolds and Chardin had explored, had developed by the late nineteenth century into a Romantic fashion for summoning up a mysterious creative presence. Goya, the passionate advocate of the individuality of artistic vision, had himself become a symbol of that change.

9

194
**Vicente López
y Portaña,**
*Portrait of
Goya,*
1826.
Oil on canvas;
93 × 75 cm,
36⅝ × 29½ in.
Museo del
Prado, Madrid

The story of how Goya's posthumous reputation developed through the nineteenth century and into the twentieth makes a fascinating study. Astute planning by the Goya family and the establishment of a Goya mythology by Spanish and French critics contributed to the growth of interest in the artist's pictures. However, the relative scarcity of works by Goya in salerooms in the nineteenth century, and the absence of a major retrospective exhibition until some seventy years after his death, also created a sense of mystery surrounding his career. Above all, it was artists from several European countries who fuelled the later appreciation of this eccentric Spanish master. Delacroix, Manet, Daumier and the Norwegian painter Edvard Munch (1863–1944) all delved into different aspects of Goya's art; and without the pictorial homage paid to Goya by modern masters such as Paul Cézanne (1839–1906), Paul Klee (1879–1940), Pablo Picasso (1881–1973), Francis Bacon (1909–92) and George Grosz (1893–1959), the dispersal of Goya's studio and the sparse exhibitions of his works in the century following his death might have stifled much of the subsequent interest among scholars and writers. Other reasons for the posthumous high esteem in which Goya's art was held came partly from political factors.

As for the artist himself, his last four years were spent mainly in Bordeaux surrounded by many distinguished Spanish exiles. To them he came to symbolize the unquenchable spirit of Spanish Liberalism that Ferdinand VII had persecuted so ruthlessly after the Peninsular War. The artist died on 16 April 1828 and was buried in the cemetery of the Grande Chartreuse in Bordeaux. His interment in the vault of the Muguiro family shows the lasting friendship and admiration of Juan Bautista, Conde de Muguiro, whose portrait formed one of the artist's final masterpieces (195). Related to Muguiro through his son's marriage, Goya clearly treasured this last powerful connection, and the inscription on the portrait makes pointed reference both to his

friendship with the sitter and the artist's age, eighty-one in May 1827. This was a justified cause for self-congratulation, given the severity of his illness in 1825. 'I lack everything and only my will remains', he wrote. Nevertheless, the portrait of Muguiro betrays no diminution of skill.

Goya was buried next to another distinguished refugee, Don Martín Miguel Goicoechea, Javier Goya's father-in-law. At the artist's deathbed stood Antonio Brugada (1804–63), a young art student, also in political exile, who was destined to become one of the most intriguing and talented of Spanish Romantic landscapists. In this way, Goya spent his last months amid the representatives of Liberal Spain. After the death of Ferdinand VII in 1833, many of these exiles returned to their native land. They were to ensure that the memory of this grand old man of Spanish art was kept alive in Spain during more enlightened, although temporary, periods of democratic rule in the nineteenth century.

In the world of postwar Madrid, where Goya may have appeared as an isolated genius, his enigmatic presence was not forgotten. Pride in his growing international reputation is discernible in the chronicles of contemporaries, in catalogues of the royal collection in which Goya is described as 'enjoying his old age', and in the powerful portrait which Vicente López y Portaña painted of Goya two years before the elderly artist's death (194). Vicente López himself owned works by Goya, as did the other major Neoclassical genius at the Fernandine court, José de Madrazo y Agudo, who bought copies of the *Caprichos* and the *Tauromaquia*. When Antonio Brugada returned to Spain, he was invited to draw up an inventory of the artist's surviving works in the Quinta del Sordo. This lists many of the artist's most personal and enduring images, which became eminently marketable when Javier and Mariano Goya began to sell the family collection. The four panels which are now in the Royal Academy of San Fernando in Madrid appear on Brugada's inventory: the *Burial of the Sardine* (see 177), the *Procession of Flagellants*, the *Inquisition Scene* (see 178) and the late *Madhouse*. These were bought from Javier Goya by the distinguished connoisseur Manuel Garcia de la Prada, whose portrait by

195
Portrait of Juan Bautista, Conde de Muguiro, 1827. Oil on canvas; 102 × 85 cm, 40 1⁄8 × 33 1⁄2 in. Museo del Prado, Madrid

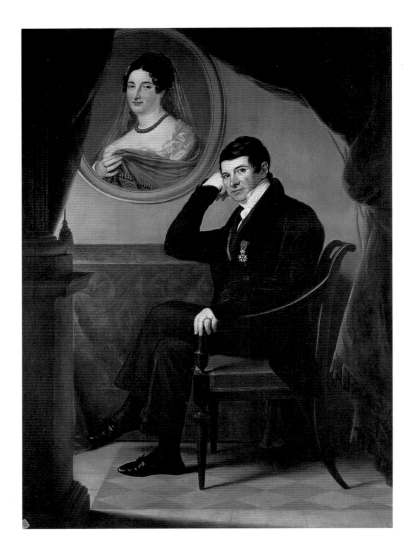

Madrazo (196) demonstrates how far Goya's style had penetrated
Spanish portrait traditions. Goya's influence in Spain was limited,
however, by the small number of his works that were on public view.
Having first opened as a major European museum in 1819, the Prado
in Madrid became a monument to Spanish art, displaying the best of
the royal collection. For most of the nineteenth century only three
paintings by Goya were on view: the two equestrian portraits of
Charles IV and his consort, María Luisa (see 127, 128), and a small
canvas of a mounted picador. And yet inventories of the whole collec-
tion reveal that large numbers of works by Goya were in the reserve

collection. They included historical and religious pictures, the tapestry cartoons, the great group portrait of the family of Charles IV and María Luisa (see 129), and the *Second of May* (see 164) and the *Third of May* (see 165). It was not until the last quarter of the nineteenth century that more of Goya's paintings appeared on view in the Prado.

In the years following the artist's death, his influence continued to grow: through the sale of the family collection and the republication and circulation of his prints. The artist's hoarding of his own works is a comparatively rare but distinct phenomenon in art history; while most artists possess unfinished sketches or private works, it is unusual for a painter to hold in reserve so many of the masterpieces from which his posthumous reputation will grow. During the Romantic period this passion for ownership seems to have been a concomitant to the originality of artistic creation. J M W Turner, for example, was a notorious hoarder of his own paintings and even bought back a formidable public masterpiece, *The Fighting Téméraire*, years after he had first sold it. William Blake possessed much of his own work when he died and so did Théodore Géricault, who, having apparently sold nothing in his lifetime, became the subject of a fantasy portrait by Ary Scheffer (1795–1858) showing him on his deathbed in a room crammed with oil sketches for his most famous picture, *The Raft of the Medusa* (see 143). Goya's obsession with his originality and inventiveness extended to a tenacious ownership of the more extreme examples of his imagination.

When these same works came to light in Antonio Brugada's inventory, the pattern of Goya's collection became clearer. The artist had treasured not only his works of fantasy and imagination, but specific images relating to his private life: a self-portrait, painted in 1783 when the artist would have been thirty-seven, and which was subsequently also bought by the Madrazo family; the full-length portrait of Javier Goya, and studies of Goya's wife and mother. These personal images reveal the extent of the artist's close keeping of his own work over a period of some forty years. Their long preservation shows the strength of Goya's attachment to his family and his concurrent fascination with his own artistic development. The revolutionary images

196
José de
Madrazo
y Agudo,
Portrait of Don Manuel García de la Prada,
1827.
Oil on canvas;
188 × 132 cm,
74 × 52 in.
Royal Academy
of San
Fernando,
Madrid

that were so attractive to later painters and graphic designers, who drew inspiration from Goya's example, were often those same creations which had been executed independently of patronage: the *Caprichos*, *Disparates*, *Disasters of War*, and the 'Black Paintings', as well as easel pictures such as *The Letter* (see 188). These owed their existence to immense personal efforts and little or nothing to the interference of patrons.

Outside Spain, the artist's reputation began to spread. The Goya family shrewdly sold a handful of paintings here and there, often to foreign buyers, and this may have been how Goya himself had envisaged his own bequest to posterity: as a series of commercial transactions with foreign agents attracted by the wealth of the private collection. Foreign interest in Goya focused at first on the *Caprichos*. But the artist's role as a portrayer of the modern Spanish scene also became a selling point. In 1818 the Austrian *chargé d'affaires* in Madrid visited an exhibition and wrote that Goya, 'had the innate ability to be a great painter (especially of scenes of everyday life)'. This opinion reflected the wider European popularity of Spanish themes and images. In France in the 1820s and 1830s, the authors Victor Hugo and Prosper Mérimée and the artist Eugène Delacroix promulgated Spain as a source of exotic idealism. At this time Baron Taylor was commissioned to buy Spanish paintings for the French king, Louis-Philippe (r.1830–48). Taylor approached the Goya family as part of his mission and bought about a dozen of Goya's private works. 'His manner is as eccentric as his temperament', wrote Taylor, setting his aesthetic seal on Goya's posthumous reputation for individuality. And when Louis-Philippe's 'Spanish Gallery' opened at the Louvre in Paris in 1838, among the paintings by Velázquez, Murillo and El Greco hung Goya's scenes of the Spanish everyday life and the labouring poor, such as *The Forge* (197). These works certainly appeared eccentric to the exhibition-going Parisian public. 'Why have paintings by Goya been acquired?' asked the satirical magazine *Le Charivari*. 'Goya may have been a lively caricaturist but he's a very ordinary painter.' The Spanish Gallery remained open for ten years until the 1848 Revolution drove Louis-Philippe into exile, and the pictures were dispersed and sold. By then the enthusiasm of French writers and poets and the

197
The Forge,
c.1812–16.
Oil on canvas;
181·6 × 125 cm,
71½ × 49¼ in.
Frick
Collection,
New York

visual responses of French artists had begun to counter the initial censure of Goya's art. Although not all of the Goyas bought by Taylor were exhibited, the collection included a representative selection of Goya's private subjects, from portraits to fantasies. *The Letter* (see 188) and *The Forge* emerged as classic representations of Goya's late style, with their thick, glistening areas of brushwork and stocky figures.

In the nineteenth century Goya's pictures of the poor must have seemed unique. They attracted European collectors with advanced taste and artists looking for new subjects. Two small paintings which Goya had given to his son in 1812 represent some of the earliest nine-teenth-century icons of peasant imagery: *The Knife-grinder* (198) and *The Water-carrier* (199). Bought from Javier Goya by Alois Wenzel, the Austrian envoy in Madrid, these two canvases reached Vienna by 1820. In 1822 they were acquired by Prince Esterhazy and taken to Budapest. Just as in his middle years Goya had entertained the princes of the Asturias and the dukes of Osuna with his peasant paintings, so, at the end of his life, and as part of the establishment of his post-humous reputation, Goya's low-life subjects appealed to a wider range of European aristocracy.

Such works anticipated those portraits of working-class peasantry which became so dominant in the art of the French painters Jean-François Millet (1814–75), Gustave Courbet (1819–77) and Camille Pissarro (1830–1903), and English painters of the Victorian period. Honoré Daumier, the French painter and graphic designer who worked for *Le Charivari*, made studies of humpbacked and overworked washer-women (200), not unlike those in the background of *The Letter*. Like Goya, he reveals a modern approach to monumentalizing the depic-tion of strength, physical endurance and drudgery, and their effect on the human body. Such pictures exist as memorials to the sturdy virtues of the poor. *The Milkmaid of Bordeaux* (201), one of Goya's very last paintings, reveals more experimental techniques and prefigures the inventions of later artists. Goya apparently painted the *Milkmaid* slowly and was so satisfied with the strength of his achievement that after his death Leocadia Weiss claimed that he had told her not to sell it for less than an ounce of gold. Bought by the artist's last protector,

198
The Knife-grinder,
*c.*1808–12.
Oil on canvas;
68 × 50·5 cm,
26³⁄₄ × 19⁷⁄₈ in.
Museum of
Fine Arts,
Budapest

199
*The Water-
carrier*,
*c.*1808–12.
Oil on canvas;
68 × 52 cm,
26³⁄4 × 20¹⁄2 in.
Museum of Fine
Arts, Budapest

200
**Honoré
Daumier**,
*The Heavy
Burden*,
1855–6.
Oil on canvas;
39·3 × 31·3 cm,
15¹⁄2 × 12³⁄8 in.
Burrell
Collection,
Glasgow

201
*The Milkmaid of
Bordeaux*,
1825–7.
Oil on canvas;
76 × 68 cm,
30 × 26³⁄4 in.
Museo del
Prado, Madrid

202
Camille
Pissarro,
Peasant Woman,
1880.
Oil on canvas;
73·1 × 60 cm,
28³⁄₄ × 23⁵⁄₈ in.
National
Gallery of Art,
Washington, DC

203
Eugène
Delacroix,
Copies after
plates 32
and 37 of
Los Caprichos,
1818–27.
Pen and
brown ink;
15·3 × 20 cm,
6 × 7⁷⁄₈ in.
Musée du
Louvre, Paris

Muguiro, the picture created a revolution in a popular European
subject. While the identification of the figure brings to mind English
and French eighteenth-century picturesque traditions with their
charming characters, no image could be further from the elegant
peasants of Boucher, Nicolas Lancret (1690–1743) or Gainsborough.
The loose brushwork, glowing colours and solid contours of such a
depiction prompted later nineteenth-century critics to claim Goya as
an Impressionist. When Pissarro analysed a similar figure of a peasant
woman (202), he, like Goya, was fascinated with defining the light as it
falls on the head and building up a solid sense of personality.

The role of Goya as someone whose art reflected the world in all
its harsh reality remained an essential part of his international
posthumous fame. But other areas of his conceptual virtuosity were
also absorbed into the consciousness of artists and collectors. His
analysis in paint, chalk and ink of mass disaster and human frailty
pointed to someone obsessed with the chaos of existence, and in the

depiction of lost souls in a social underworld, outcasts and people
subject to aberrant behaviour, he also appealed to later writers and
artists. In 1825 ten of Goya's *Caprichos* were published in Paris. The
artist's peculiar gift of transforming men and women into brutal,
dynamic creatures of the night was copied first by Delacroix, who
seems to have been especially attracted by those compositions show-
ing figures isolated in oppressive darkness. This sense of displace-
ment, which is fundamental to the *Caprichos*, is also present in the
depiction of people alone in sinister interiors. The imprisoned girl
(see 111) drew Delacroix's attention (203) just as, some seventy
years later, Munch painted a similar figure entitled *Puberty* (204).
The disturbing enigma of Goya's vision, the hint of threats from an
unknown source and the conjuring up of indefinable states of mind
made him the inspiration for nineteenth-century masterpieces depict-
ing anxiety and fear. The Spanish master is ranked among the first
major European artists to supply concrete images of such intangible
states, providing an inspiration for a new modern view.

'Goya is always a great artist, frequently he is a terrifying one', wrote the French critic and poet Charles Baudelaire in 1857: 'To the gaiety and joviality of Spanish satire … he adds a more modern attitude, one that has been much sought after in the modern world; a love of the intangible, a feeling for violent contrasts and the terrifying phenomena of nature and strange human physiognomies which in certain circumstances become animalistic.' This interaction between human and animal was used by Goya as a metaphor to express certain conditions of degradation and moral corruption. This technique came to inspire many more of the artist's French admirers. In 1869 one of Goya's very last drawings was sold in Paris. Formerly owned by an

204
Edvard Munch,
Puberty,
1895.
Oil on canvas;
152 × 110 cm,
59⁷⁄₈ × 43³⁄₈ in.
Nasjonal-
galleriet, Oslo

205
Loco Furioso,
1824–8.
Black chalk;
19·3 × 14·5 cm,
7⁵⁄₈ × 5³⁄₄ in.
The Woodner
Collections,
New York

influential French draughtsman, Louis-Léopold Boilly (1761–1845), whose own enthusiasm for caricature and the grotesque had been particularly acclaimed, the sketch is an analysis of an exalted state of human insanity. The chalk drawing of a man in a cage, *Loco Furioso* ('Furious madman'; 205), dates from Goya's years in Bordeaux when he was living among the exiles and still pursuing his interest in alternative states of rationality. Confined to the centre of the composition, the lunatic is cramped within the type of cage often used in nineteenth-century hospitals. Writing about a hospital in Strasbourg, one visitor recorded in 1814: 'For troublesome madmen and those who dirtied themselves, a kind of cage, or wooden closet, which could at

the most contain one man of middle height, had been devised at the end of the great wards.' Goya moves from the realities of such confinement to a grotesque replacement of human with animal: the figure is growing a lion's mane and his face turns into the leonine snout.

This technique of composing an unfixed image from which the spectator can visualize the end result became a new method which artists, moving from Romanticism to Modernism, made their own. In 1885 the French draughtsman and painter Odilon Redon (1840–1916) produced a set of six lithographs. These formed another visual essay on the twin themes of displacement and degradation. Redon admired Goya in particular for those abstract metaphorical qualities which imparted so much strength to the Spaniard's images. Redon entitled his lithographs *Homage to Goya*: the third example (206) is a variation on the subject of insanity entitled *A Madman in a Dismal Landscape*. The figure reveals a leg protruding from its robe, a leg which has a rudimentary hoof-shape growing from the ankle. The caption to this design itemizes a sense of loss, isolation, oppression and desperate searching: 'In OLD AGE | the man was solitary in a NIGHT LANDSCAPE. | The CHIMERA looked at everything with terror. The priestesses were waiting. | And the seeker was engaged in INFINITE SEARCHING.'

206
Odilon Redon,
A Madman in a Dismal Landscape, Homage to Goya, no.3, 1885.
Lithograph; 22·6 × 19·3 cm, 8⁷₈ × 7⁵₈ in

Redon summarizes the mystery of man's sense of loss in a changing world and engages the mystique of the primacy of imaginative creation which Goya too had seen as constantly renewing the originality of all great art. The growing tradition of referring to the art of Goya when depicting the ills of modern societies set a pattern for painters grappling with the darker episodes in the history of the nineteenth and twentieth centuries. In France the shattering political revolutions of 1830 and 1848 were followed by the siege of Paris and the Commune of 1871, which followed the Franco-Prussian War. When Manet produced a watercolour showing the firing squad at work in a Parisian street (207), it is perhaps not surprising that he should have invoked that same image of Goya's *Third of May* (see 165) as he had used in his painting *The Execution of the Emperor Maximilian* (see 170). This time the firing soldiers have been brought right into the modern city, which is now even more vulnerable to aggressors. In England the

imagery of the city was equally dark. In 1872 Gustave Doré (1832–83) and the journalist William Blanchard Jerrold published their huge panoramic book of engraved plates of different areas of the city and vignettes of London life entitled *London: A Pilgrimage*. In this the city emerges as a desolate place with scarcely human figures wandering around in its gloom. Here, too, there is a backward look to Goya's imagery of Madrid, its vaulted arches and darkness, the figures adrift in a confusing world. Having experienced first-hand the tumults of the Spanish Civil War (1936–9) Ernest Hemingway perceived this quality in Madrid and felt that it even went beyond what Goya had portrayed: 'There is a god-damned horribleness about part of Madrid like no other place in the world,' he wrote in 1940, 'Goya never half drew it.'

Spain suffered a particularly savage and brutal history during the nineteenth and twentieth centuries, with a succession of civil wars, revolutions, sudden changes of government and, at times, rigid censorship. Goya's few followers invoked his example of inventing a precise image to express their sense of outrage. Eugenio Lucas Velázquez (1817–70) took that touching composition of the garrotted man, which Goya had etched at the beginning of his career (see 48), and worked it up into a full-blown, monumental painting (208). But it was the 'modernista' movement that appeared in Barcelona at the end of the nineteenth century which supplied Goya's true Spanish inheritors. Although the first major Goya exhibition in Madrid opened only in 1900, his work became well known among this artistic group, whose most famous member was the young Picasso. The Spanish painter Miguel Utrillo (1862–1934) called Picasso 'le petit Goya' ('little Goya'), partly on account of Picasso's early chalk portraits of eccentric bohemian characters, which were shown in Barcelona in February 1900, just three months before Goya's retrospective exhibition opened in Madrid. One critic wrote of Picasso that he had 'an inspired fever reminiscent of the best works of Goya and El Greco, his only indisputable divinities'. It was this same fever which Picasso brought to a re-evaluation of those characters so often depicted by Goya, such as the blind man (209), an image which haunted so much of Goya's work, from the tapestry cartoons to the 'Black Paintings', and which Picasso in 1903 was to invest with similar brutal veracity.

Much post-Freudian art criticism has examined the nightmarish side of the Spaniard's work, particularly his etchings and 'Black Paintings', as a means of analysing the morbid, persuasive and shocking qualities of human emotion, as expressed in art. In the twentieth century the Expressionists and Surrealists claimed Goya as a forerunner to their own imaginative sensibilities, and his work has been scrutinized as a link between the outside world and the artistic subconscious mind. Nevertheless, his art shows him to have been a man of ideas, whose tragic and pessimistic view of life was accompanied by a

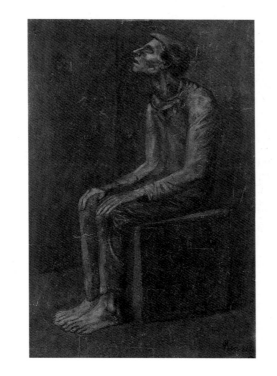

208
Eugenio Lucas Velázquez,
The Garrotted Man,
c.1850–70.
Oil on panel;
51 × 38 cm,
20 × 15 in.
Musée des Beaux-Arts, Agen

209
Pablo Picasso,
The Blind Man,
1903.
Watercolour on paper mounted on canvas;
53·9 × 35·8 cm,
21¼ × 14⅛ in.
Fogg Art Museum, Harvard University Art Museums, Cambridge, Massachusetts

sturdy pragmatism and a sharp eye for the absurdities of existence – absurdities that reside not only in the legendary flavour of his life, but in the final obsequies. When his body was disinterred from the Bordeaux cemetery and returned to Spain in 1901, it was reburied in the little church of San Antonio de la Florida which Goya had decorated in 1798. The magnificence of this public honour was somewhat undermined by the problem of the memorial slab that had marked Goya's French grave, and which was also returned with the artist's

corpse. This hand-carved tablet bore an inscription which inaccurately recorded Goya's age as eighty-five instead of eighty-two and misrecorded the date of his death. Furthermore, at the exhumation it was found that Goya's skull had disappeared. Claims by presumptive owners of Goya's skull are not numerous, but they still occasionally crop up; there is even a painting of it in Saragossa, adding to a macabre mystery which the artist himself might well have enjoyed.

The macabre and the absurd remain among the most enigmatic qualities of Goya's strange art. Those quizzical self-portraits hint at a many-sided personality, and there is in them a meeting place for the diverse affinities and predilections of his style. The sum of contradictions in Goya's life and art appears as an essential ingredient in the posthumous understanding of his images. The self-portraits themselves provided a starting point in this respect. In his own studies of the *Caprichos*, Paul Cézanne was particularly attracted by the famous *Self-Portrait* of the frontispiece (see 90). That beaver-hatted head was copied by Cézanne in 1880, and put next to his own self-image (210). He then went on to caricature Goya's head. Perhaps this was done by Cézanne on the principle that, as a caricaturist himself, Goya was not immune from such compositional distortion of his face. Yet there is also the feeling that this creator of so many eccentric images had offered posterity an unexpected piece of self-scrutiny: the image of the respectable man with the knowing sideways glance. Cézanne makes Goya look cunning; Goya himself was never averse to playing roles, and might well have seen the joke. Cézanne's intuitive understanding of Goya's motives would have appealed to his sense of the ridiculous.

Visions of the underworld and the underdog also seem to have formed cherished artistic heirlooms for Goya's posthumous admirers. And although myth and misunderstanding have clouded some aspects of the artist's long life, his majestic achievement as painter, engraver and social chronicler has now become indisputably valuable for modern art. The curiosity of nineteenth-century Romantics sought out his bold yet mysterious artistic quality and strengthened his posthumous reputation. Academic researches by art historians and critics of

210
Paul Cézanne,
Study 110,
1880–1.
Pencil and
chalk;
49·5 × 30·5 cm,
19½ × 12 in.
The Woodner
Collections,
New York

211
Salvador Dalí,
*Soft
Construction
with Boiled
Beans:
Premonition
of Civil War*,
1936.
Oil on canvas;
100 × 99 cm,
39 3⁄8 × 39 in.
Philadelphia
Museum of Art

212
**Jake and
Dinos
Chapman**,
*Great Deeds
Against the
Dead*,
1994.
Mixed media;
277 × 244 ×
152·5 cm,
109 1⁄8 × 96 1⁄8 ×
60 in.
Saatchi
Collection,
London

213
*Great deeds!
With dead
men!*,
plate 39,
*The Disasters
of War*,
c.1810–15.
Etching and
aquatint;
15·7 × 20·8 cm,
6 1⁄8 × 8 1⁄8 in

the twentieth century have found in his work a multiplicity of ideas to marvel at. His best works have been perceived as possessing the individual power to draw in tradition and transcend it. The way he burrowed into the harsh realities of his own society to create an over-powering, at times horrifying, world, offers us the ingredients we have come to expect from a great artist. His mirroring of war in those macabre designs of dismembered corpses on battlefields may hover like ghosts behind the searing anguish of Salvador Dalí's evocation of yet another major conflict, the Spanish Civil War (211).

Dalí said of Goya that he expressed 'the desires and aspirations of his people'. Many more catastrophic tumults of modern wars and revolutions have also found in Goya a source of metaphor and vision, needed to elucidate the onslaught of a random world upon poetic sensibility. 'I am Goya of the bare field, by the enemy's beak gorged … I am the voice of war' wrote the Russian Andrei Vosnesensky during World War II, in what has since become one of his most memorable poems.

Grande hazaña con muertos.

In this way Goya's art continues to survive as an eternal awareness of universal suffering. And even now, at the end of the twentieth century, this extraordinary man's war pictures can still evoke profound responses from new admirers. The over life-sized sculpture by Jake (b.1966) and Dinos (b.1962) Chapman entitled *Great Deeds Against the Dead* (212), is a three-dimensional reconstruction of one of Goya's most searing compositions from the *Disasters of War* (213). This severe and shocking image of mutilation is still potent enough to inspire young artists and agitate spectators, and demonstrates perhaps more clearly than anything else the enduring value of Goya's vision.

&

Glossary

Academy Originally a term applied to informal meetings of humanist scholars, from the sixteenth century it was used to describe study groups of artists. The foundation of the French Academy in 1648 provided a model for art teaching, both practical and theoretical, which was copied by other European academies founded in the following two centuries.

Academy Figure A drawing or painted sketch of a male nude, used solely for teaching or study purposes. These sketches were a central part of the training at the **Academy**.

Aquatint A printing technique, invented *c.*1770, that achieves an effect resembling a wash drawing. A copper plate is covered with acid-resistant particles such as resin or sugar. Acid is then poured over the plate, biting into the areas between the particles, and leaving a fine 'honeycomb' pattern over the surface.

Baroque A style particularly associated with Italian art of the seventeenth century, which combines dramatic illusionism with bright colours, extreme lighting effects and a deep emotional content. Highly influential throughout Europe and Latin America, it developed into the **Rococo** in the early eighteenth century.

Classic A model of artistic excellence in style and subject matter, mainly derived from antique sources and established in the eighteenth century as a specific demonstration of artistic quality.

Drypoint A printing technique in which a design is scratched on a copper plate with a steel needle. This technique is sometimes used to add details or texture to a basic design already bitten into a plate by acid.

Engraving A general term used to describe a method of printing and reproducing images. **Aquatint**, **drypoint**, **etching** and **mezzotint** are all forms of engraving.

Enlightenment A form of philosophical thought that began in France and England at the start of the eighteenth century, becoming a full-blown movement that dominated Europe and North America and affected political, economic and cultural ideas and developments. The basic principles – a reappraisal of existing institutions, respect for individual freedom, and a rejection of traditional superstitions – turned on a profound belief in Reason. Among its exponents were John Locke, David Hume, Jean-Jacques Rousseau and François Marie Arouet de Voltaire.

Etching A printing technique in which a metal plate is covered with an acid-resistant ground, such as wax, on which the artist draws, exposing the surface underneath.

When the plate is immersed in acid the exposed areas are bitten away. Ink rubbed into the lines prints the design on paper.

Fresco A wall-painting technique in which pigment, mixed with water, is applied to a layer of wet plaster on which a design has been drawn. As it dries, the plaster bonds with the pigment, creating an extremely durable surface. Details added to the dry wall (a technique known as *fresco secco*, literally 'dry fresco') are not so durable.

Lavis From the French for 'wash'. A printing technique in which acid is brushed directly on a copper plate, producing a wash effect.

Lithography A printing technique in which a design is drawn on a stone or metal surface with greasy chalk and then water is poured over the surface. As oil and water do not mix the greasy chalk repels the water. When ink is rolled on the plate it adheres only to the greasy parts of the drawn design, creating the image in reverse, on paper.

Mezzotint This method of engraving was particularly popular in England in the eighteenth century. A copper plate is covered with a network of burred dots made using a toothed tool known as a 'rocker'. Half-tones and areas of highlight are achieved by scraping off the burrs or burnishing the plate so that the ink does not print in those areas. The design appears as a series of white areas on a rich dark ground. Because lines cannot be achieved in mezzotint, this technique is often combined with **etching**.

Neoclassicism Originating among mid-eighteenth century scholars in Rome who encouraged artists to study antique works of art first hand and try to reproduce the artistic ideals of Greece and Rome in their own works, this style consists of cool colours, simple compositions and heroic subjects, usually taken from classical history. It emerged partly as a reaction against the **Baroque** and **Rococo**.

Rococo An eighteenth-century style of painting, architecture and decoration that derives from the French *rocaille* (rock or shell), and is exemplified by ornate decoration and escapist subjects. Originating in France, the style spread throughout France, southern Germany, Italy and Spain.

Romanticism Originating in the late eighteenth century as a literary movement, the term also applies to the art of the early nineteenth century in which striking originality of subject matter and style, and a love of the exotic, are all freely exhibited. Often seen as the antithesis of **Neoclassicism**.

Brief Biographies

María del Pilar Teresa Cayetana de Silva, 13th Duchess of Alba (1762–1802) Spanish noblewoman, second in rank only to the Queen of Spain, who was renowned for her beauty, riches and charm, and her patronage of artists and poets. Goya painted two formal portraits of her as well as a number of more informal images. Although the legend of an affair between Goya and the duchess cannot be verified, their relationship was undeniably close, and she clearly exercised a profound influence on the artist in the 1790s. After her death Goya attempted to design her tomb.

Francisco Bayeu (1734–95) Goya's eldest brother-in-law and principal artistic rival at the Bourbon court. Trained by Goya's teacher, José Luzán y Martínez (1710–85), in Saragossa, he won a painting scholarship to the Royal Academy of San Fernando in Madrid in 1758. Noticed by **Mengs** in 1762, he was invited to work as his principal assistant on the decoration of the new Royal Palace in Madrid. After becoming painter to the court in 1767, he was to help Goya further his career and, in 1773, agreed to the marriage of his sister, Josefa, to the younger artist. In 1780–1 he quarrelled violently with Goya, and the two were never quite reconciled. In 1789 he was refused the post of first court artist by Charles IV, although he received an equivalent salary. Goya painted a portrait of him that was completed a few months after his death in 1795.

Manuel Bayeu (1740–1809) The middle Bayeu brother, he was also taught by José Luzán. He painted religious works, portraits and low-life subjects. At the age of seventeen he became a novice in the Carthusian monastery of the Aula Dei in Saragossa, where Goya was to paint murals in 1774.

Ramón Bayeu (1746–93) The youngest of the three Bayeu brothers. Working principally on tapestry cartoons and religious pictures, he won a gold medal in the student history painting competition at the Royal Academy of San Fernando in 1766. He never achieved a salaried post at court and died in 1793.

Joseph Bonaparte, Joseph I (1768–1844) Brother of Emperor Napoleon I. In 1808 he was made King Joseph I of Spain at the command of his brother. He occupied only a titular position as the Spanish monarch, a position he tried to relinquish before he was driven out in 1812 by the English armies under the **Duke of Wellington**. He was painted several times by Goya (although none of the portraits survive), on whom he conferred the Royal Order of Spain in 1811. He lived in the United States from 1815 to 1841, but he died in Italy.

Francisco Cabarrús (1752–1810) Son of a French merchant, he became an important Spanish financier, founding a trading company with the Philippines and the first national bank in Spain (Banco de San Carlos). Goya invested his savings in the bank and was commissioned to paint portraits of its directors. Cabarrús's portrait forms one of Goya's most advanced images of a man of the **Enlightenment** under the reign of Charles III. He became minister of finance under Napoleon's brother, King **Joseph I** of Spain, a post he occupied until his death.

Juan Agustín Ceán Bermúdez (1749–1829) Spanish art historian and scholar, he trained as a painter in Rome under **Mengs**, producing portraits and decorative works. Having settled in Madrid in 1788 he devoted himself to scholarship, acquiring an extensive private collection and publishing his *Diccionario historico de los más illustres profesores de las Bellas Artes en España* (1800) and *Descripcion artistica de Sevilla* (1804). His profound friendship with Goya influenced the Aragonese artist in a number of ways, and provides a rich source of information about life and art in Spain during this period.

Eugène Delacroix (1798–1863) Major exponent of French **Romanticism**, he made a close study of Spanish art in the 1820s. Through his friendship with the sons of **Ferdinand Guillemardet**, Delacroix came to know Goya's work. He made a series of copies after *Los Caprichos*, and used many of Goya's motifs and images in his own work, notably his lithographic illustrations to Johann Wolfgang von Goethe's *Faust* (1828).

Manuel Godoy (1767–1851) Spanish statesman who began his career as a guards' officer and rose to become the most powerful and hated man in Spain. A favourite of King Charles IV and his consort María Luisa, he was made prime minister in 1792. He was declared Prince of Peace in 1795 after bringing to an end the war with revolutionary France, and he commanded the victorious Spanish army in the War of the Oranges against Portugal in 1801. He headed a corrupt and unpopular government, and his compliance with the French led to their invasion of Spain in 1808. As a patron of the fine arts before the Peninsular War, he was responsible for a number of major works by Goya, notably the *Nude* and *Clothed Majas*, and several fine portraits. Having married the daughter of Charles III's disgraced brother, the Infante Don Luis, Godoy inherited part of his father-in-law's art collection, and continued to buy and commission paintings until his political downfall in 1808.

Javier Goya (1784–1857) Son of Francisco Goya, he was a minor artist and a business man. He promoted and sold his father's remaining pictures during the 1820s and 1830s, and is thought to have helped to paint the 'Black Paintings' on the walls of the Quinta del Sordo.

Ferdinand Guillemardet (1765–1801) French ambassador to Spain from 1798. He was known to have voted for the death of the French king Louis XVI, and was the first foreigner to have his portrait painted by Goya. This outstandingly vivid and colourful portrait, which was taken back to France in 1800, became one of the earliest examples of Goya's work to be known outside Spain; it was later donated by Guillemardet's sons to the Musée du Louvre. Guillemardet also owned a copy of *Los Caprichos*, and it was probably through his enthusiasm for the art of Goya that **Delacroix** came to know the Spanish artist's work.

Gaspar Melchor de Jovellanos (1744–1811) Poet, statesman, leader of the Spanish **Enlightenment**, and influential patron of Goya, whom he probably first met in the 1770s, and who painted his portrait in 1798. His political and philosophical writings are still regarded as the major literary productions of the period before the Peninsular War. An authority on seventeenth-century Spanish literature and art, he praised Goya's work as particularly innovative, and did much to stimulate aesthetic matters in the Royal Academy in Madrid. Jovellanos's poetry provided the inspiration for some of the plates of *Los Caprichos*. After a seven-year term of imprisonment for political reasons (from 1801 to 1808), Jovellanos was freed to join the Central Junta against the French. An active deputy at the Cortes of Cadiz, he wrote *Memoria en la defensa de la Junta Central* in 1810. His diary forms one of the best autobiographical accounts of life, art and letters in late eighteenth-century Spain.

Asensio Juliá (1767–1830) Spanish painter and etcher. Son of a fisherman and nicknamed 'El Pescadoret', he became Goya's pupil and, although little is known of him, he is thought to have assisted his master on the San Antonio de la Florida frescos, made a copy of Goya's *Self-Portrait with Dr Arrieta*, and was painted by Goya in *c*.1798 and 1814.

Vicente López y Portaña (1772–1850) Spanish Neoclassical painter. Vice-Director of Painting at the Academy in Valencia from 1790 to 1814, he returned to Madrid at the request of King Ferdinand VII, whose portrait he painted many times. Renowned for his portraits (including a painting of the aged Goya), he was also, like Goya, one of the earliest Spanish artists to attempt **lithography**.

Eugenio Lucas Velázquez (1817–70) Spanish painter from the generation after Goya. One of the most talented and famous of Goya's disciples and copyists in nineteenth-century Spain, he has yet to be identified as a major Spanish master in his own right. Owing to the similarity in style, a number of his paintings have for long been wrongly attributed to Goya. In 1855 he was asked to value the 'Black Paintings' in the Quinta del Sordo. His enthusiasm for Goya and **Diego Velázquez**, whose works he copied extensively, formed a parallel to his unique repertoire of modern, often violent, contemporary scenes and stormy, atmospheric landscapes. He exhibited in Paris and was said to be a friend of Édouard Manet (1832–83).

José de Madrazo y Agudo (1781–1859) Spanish history painter, portraitist and engraver. In Italy during the Peninsular War, he was subsequently appointed painter to the Spanish court in exile of Charles IV and María Luisa in Rome, where he was briefly imprisoned by the French. Returning to Spain in 1818 he created a sensation with his Neoclassical masterpiece *The Death of Viriathus, Leader of the Lusitanians*, a solemn and majestic painting which reflected the postwar atmosphere of political uncertainty in Madrid, and the futile desire for revenge. Now chiefly remembered as the founding member of an artistic dynasty which dominated Madrid during the nineteenth and early twentieth centuries, he is known to have admired the art of Goya and was profoundly influenced by the Aragonese master's portraits.

Luis Meléndez (1716–89) Son of a miniaturist painter, he left Spain for Italy in 1748, returning in 1753 to become one of the major still-life painters of the era. His *Self-Portrait* of 1746 is one of the most original in the eighteenth century, and prefigures the Romantic self-portraits of Goya in terms of colouring and the brooding quality of characterization.

Juan Meléndez Valdés (1754–1817) Spanish poet who studied Classics and Law. He was a friend of **Jovellanos**, an enthusiast of the fine arts and a patron and friend of Goya. His portrait of 1797 is one of the artist's most sensitive half-lengths.

Anton Raphael Mengs (1728–79) Son of the painter to the court of Dresden, and generally associated with the Neoclassical art theories of the German writer Johann Joachim Winckelmann, he was court artist to August III of Saxony before becoming first court painter to Charles III of Spain. Arriving in Madrid in 1761, he helped reorganize the teaching programme at the Royal Academy of San Fernando and was involved in decorating the new Royal Palace in Madrid. He singled out the most promising Spanish painters of the period, **Francisco Bayeu**, **Luis Paret** and Goya, whom he invited to work on cartoons for the royal tapestry factory.

Leandro Fernández de Moratín (1760–1828) Spanish poet and dramatist whose work was inspired by the plays of Molière. A supporter of **Joseph Bonaparte**, he was forced to flee to France in 1814. His friendship with Goya lasted until old age; the artist joined him in exile in Bordeaux in 1824. Many of the themes examined by Moratín in his plays: bad marriages, church corruption, hypocrisy

and social inequality are analysed in Goya's private drawings and in *Los Caprichos*. Moratín was painted by **Luis Paret** and Goya in two particularly fine portraits.

Duchess of Osuna (María Josefa Alonso Pimentel, formerly Duchess of Benavente) (1752–1834) She married the 9th Duke of Osuna in 1771 and became a leading figure in Spanish **Enlightenment** circles and one of the greatest patronesses of the fine arts of the epoch. Her many interests included education, science, industry and the fine arts, and her broad social tolerance and avant-garde tastes are reflected in the wide range of new and often daring subjects which Goya painted for her.

Luis Paret y Alcázar (1746–99) Goya's most talented contemporary rival, he won a medal in a student history painting competition at the Royal Academy of San Fernando, and travelled to Rome in 1763. He returned to Madrid in 1766 and continued his position as the protégé of King Charles III's younger brother, the Infante Don Luis. His success at the Spanish court came to an end when he was accused of colluding with his patron's indiscretions, and was exiled to Puerto Rico in 1775. In 1778 he returned to Spain, settling in Bilbao; he was eventually pardoned and allowed to return to Madrid in 1787. Once in Madrid, he took up the position of vice-secretary to the Academy. He was renowned for his scenes of contemporary Spanish life, historical, religious and mythological paintings as well as architectural projects, illustrations and decorative works.

Giambattista (Giovanni Battista) Tiepolo (1696–1770) Born in Italy, he rose to become the greatest fresco painter of the eighteenth century. He decorated buildings all over the north of Italy and frescoed the archbishop's palace in Würzburg in 1750. Arriving in Madrid in 1762 he frescoed the throne room of the new Royal Palace. Admired for his elaborate and innovative techniques in engravings, frescos and oil sketches, he was to exercise a profound influence on Goya, especially in the San Antonio de la Florida frescos and the *Caprichos* prints.

Sir Charles Richard Vaughan (1774–1849) British diplomat and academic. Travelled in Spain 1800, 1804–8 (as secretary to the British Embassy), and 1810–19. Subsequently he became British ambassador to Switzerland and the United States. He visited Valencia and was the first recorded British visitor to admire Goya's painting *St Francis Borgia Attending a Dying Impenitent* in the cathedral. He also visited Saragossa during the siege in 1808, where he met General Palafox. His pamphlet, *Narrative of the Siege of Saragossa*, did much to stimulate British support for the Spanish war effort.

Diego Velázquez (1599–1660) The most ambitious, successful and talented of Spanish court artists of the seventeenth century, he was a particular source of inspiration for Goya, who published copies after his paintings in 1778 and regarded himself as the true artistic inheritor of Velázquez's genius. For eighteenth-century Spanish connoisseurs, academics, scholars and painters, he was the true hero of Spanish art, and his magnificent portrait of the family of Philip IV, now known as *Las Meninas*, was valued as the the most precious work in the Royal Collection.

Arthur Wellesley, 1st Duke of Wellington (1769–1852) Educated at Eton and at military college at Angers, he entered the 73rd Highlanders as an ensign in 1787, rose rapidly, and became lieutenant-colonel in 1793. Promoted to a full colonel in 1796, he campaigned extensively in India, was knighted and then elected MP for Rye in 1806. His military campaigns on the Iberian Peninsula (1808–14), where he eventually defeated Napoleon's occupying forces, fully established his immortality in military history, and he received a large number of honours including an earldom and dukedoms in both Spain and Portugal. He was British ambassador in Paris, and dominated postwar Europe as one of the most powerful personalities, crowning his public career by becoming the British prime minister in 1827. The subject of many portraits, Wellington's face and figure were treated by numerous artists in the nineteenth century. While Wellington was in Madrid Goya made at least three major oil paintings and a number of related drawings from one or two sittings, and these rank among the duke's most original and unorthodox images.

Key Dates

Numbers in square brackets refer to illustrations

The Life and Art of Francisco Goya	A Context of Events
1746 Born 30 March in Fuentedetodos, Aragon	**1746** Ferdinand VI becomes King of Spain (to 1759)
	1748 Jacques-Louis David born
1750s Educated by the Piarist Order in Saragossa	**1751** First volume of Denis Diderot's *Encyclopédie* published in France
	1752 Royal Academy of San Fernando founded in Madrid
	1759 Accession of Charles III to the Spanish throne (to 1788)
1760 Studies with José Luzán in Saragossa (to 1763)	**1761** Spain at war with Britain
	1762 Jean-Jacques Rousseau, *The Social Contract*
1763 Unsuccessful in Madrid Academy competition	**1763** Treaty of Paris between Britain, France and Spain ends the Seven Years' War (1756–63)
1766 Again unsuccessful in Madrid Academy competition	**1767** Jesuits driven from Spain and its dominions
	1768 Royal Academy of Arts founded in London
1770 Goes to Italy. In Rome	**1770** Death of Giambattista Tiepolo in Madrid
1771 Wins 'honourable mention' in the Academy competition in Parma with a painting of Hannibal [18]. Returns to Saragossa. Fresco for the 'coreto' in the Cathedral of El Pilar	**1771** Benjamin Franklin, *The Autobiography of Benjamin Franklin*
1773 Marries Josefa Bayeu	**1773** Jesuit order dissolved by Pope Clement XIV under coercion of the Bourbon monarchs
1774 August: Birth of first child	**1774** Accession of Louis XVI to the French throne (to 1792)
1775 January: Leaves Saragossa for Madrid. Completes first cartoons for Royal Tapestry Factory of Santa Bárbara working under the supervision of Mengs and Francisco Bayeu. December: Birth of second child	**1775** Luis Paret forced into exile on the island of Puerto Rico. James Watt constructs first efficient steam-engine
1777 January: Birth of third child	**1776** Declaration of Independence establishes the United States of America
1778 Executes etchings after Velázquez [49, 51]	**1778** Royal Academy opens in Saragossa. Spain at war with Britain
1779 October: Birth of fourth child. New tapestry cartoons including *The Fair in Madrid* [41]	**1779** Anton Raphael Mengs dies in Rome. Death of Thomas Chippendale

The Life and Art of Francisco Goya	A Context of Events
1780 Elected to membership of the Royal Academy in Madrid with *Christ on the Cross* [52]. August: Birth of fifth child. Begins work on frescos in the Cathedral of El Pilar in Saragossa [55]	
1781 Disagreement with Francisco Bayeu over the El Pilar frescos. Returns to Madrid	**1781** Henry Fuseli paints *The Nightmare*
1782 April: Birth of sixth child	
1783 Paints the prime minister, Floridablanca [59]. Visits the king's younger brother, the Infante Don Luis	**1783** Cessation of hostilities between Spain and Britain. Loss of Gibraltar to the British. Treaty of Paris marks the end of the American War of Independence (1775–83) and recognizes the United States of America
1784 December: Birth of seventh child, Javier, his sole offspring to reach maturity	**1784** Birth of the future king of Spain, Ferdinand VII
1785 Appointed Assistant Director of Painting to the Royal Academy of San Fernando in Madrid	**1785** First Channel crossing by hot air balloon
1786 Appointed Painter to the King	**1786** Mozart, *Marriage of Figaro*
1788 Duke and Duchess of Osuna commission two paintings of St Francis Borgia for their chapel in Valencia Cathedral which inspire the first 'monster' painting [56, 57]	**1788** December: Death of Charles III of Spain, accession of Charles IV and María Luisa. Death of Thomas Gainsborough
1789 Promoted to the position of Court Painter. Last set of tapestry cartoons commissioned including *The Little Giants* [94]. Paints first royal portraits [77, 78]	**1789** Coronation of Charles IV. Charles IV grants new powers to the Spanish Inquisition in order to censor the circulation of revolutionary material from France. July: Storming of the Bastille signals the beginning of the French Revolution
	1790 Edmund Burke, *Reflections on the Revolution in France*
1791 Completes inventory of Royal Collection	**1791** Manuel Godoy created Duke of Alcudia and Protector of the Royal Academy of San Fernando
1792 Reports to the Academy on the training of Spanish art students. Becomes seriously ill	**1792** Godoy becomes Captain-General of the Spanish army. French Republic proclaimed
1793 January: Is allowed to travel and is taken ill in Seville. March: In Cadiz under the care of Sebastián Martínez. July: Returns to Madrid	**1793** January: Execution of Louis XVI of France. March: France declares war on Spain
1794 January: Eleven cabinet pictures painted during his period of convalescence exhibited in Madrid to members of the Royal Academy	**1794** Maximilien Robespierre executed
1795 Appointed Director of Painting at the Royal Academy of San Fernando	**1795** Death of Francisco Bayeu. July: Peace between Spain and France
1796 Visits the Duchess of Alba on her estate at Sanlúcar de Barrameda. Completes the Sanlúcar Album of drawings [97, 98]	**1796** Spain declares war on Britain. Napoleon's Italian campaign. Lithography invented by Aloys Senefelder
1797 Works on 'Sueños' prints and drawings which will eventually become *Los Caprichos*	**1797** Godoy appoints a liberal government that includes Jovellanos
1798 Six witchcraft paintings sold to the Duke of Osuna. Commission for fresco decoration of San Antonio de la Florida, Madrid [120, 121]	**1798** Jovellanos ousted from the government. French expedition to Egypt. French occupation of Egypt (to 1801). July: Battle of the Pyramids. August: Nelson destroys French fleet at Aboukir

The Life and Art of Francisco Goya	A Context of Events
1799 Publication of *Los Caprichos*. Appointed first Court Painter. Begins equestrian portrait of the Spanish queen María Luisa [128]	**1799** February: Death of Luis Paret. November: Coup d'Etat of 18 Brumaire establishes the Consulate under Napoleon
1800 Paints equestrian portrait of the Spanish king Charles IV [127] and begins *The Family of Charles IV* [129]	**1800** Godoy retakes power. Beethoven, *First Symphony*
1801 Paints portrait of Generalisimo Godoy	**1801** War of the Oranges between Spain and Portugal
	1802 Death of the Duchess of Alba. Treaty of Amiens marks the end of the French Revolutionary Wars and sets the stage for the Napoleonic Wars
1803 Presents copper plates and 240 unsold sets of *Los Caprichos* to the king in exchange for a pension for Javier	**1803** Britain declares war on France. Robert Fulton experiments with steamboats on the Seine in Paris
	1804 Napoleon crowned Emperor
1805 Javier Goya marries Gumersinda Goicoechea [144, 145]	**1805** British victory at the Battle of Trafalgar. David paints *The Coronation of the Emperor and Empress* [123]
1806 Birth of Mariano, his only grandchild	**1806** Joseph Bonaparte crowned King of Naples
	1807 Napoleon gives orders for the military occupation of Spain
1808 The *Nude* and *Clothed Majas* [132, 133] listed in the inventory of Godoy's collection. Commissioned by Royal Academy to paint a portrait of Ferdinand VII. General Palafox invites him to view the siege of Saragossa; probably visits home village of Fuendetodos	**1808** Charles IV abdicates in favour of his son. Accession of Ferdinand VII (king until 1833). March: French army enters Madrid. 2 May: Madrid uprisings against the French followed by executions of 3 May. 5 May: Spanish royal family in Bayonne, cede Spanish crown to Napoleon. Start of the Peninsular War or War of Independence (to 1814). June: Joseph Bonaparte made King of Spain. December: Madrid surrenders to the French
1809 Back in Madrid	**1809** Arthur Wellesley sent in command of a force to defend Portugal, enters Spain in July. Battle of Talavera: Wellesley defeats the French under Joseph Bonaparte and is made Viscount Wellington
1810 Begins *The Disasters of War* and executes paintings such as *Allegory of the City of Madrid* [148] for Joseph Bonaparte	**1810** Napoleon marries Marie-Louise of Austria. Johann Wolfgang von Goethe, *Theory of Colours*
1811 Paints portraits of Joseph Bonaparte and is awarded Royal Order of Spain. Leocadia Weiss's marriage breaks down	**1811** Death of Jovellanos. French armies defeated at Portuguese border town of Almeida and retreat into Spain. Wellington is promoted to General
1812 Death of his wife, Josefa. Property divided between father and son. Inventory made of contents of house. Paints and sketches several portraits of the Duke of Wellington [158–160]	**1812** Wellington created Earl of Wellington and Grandee of Spain. March: Cortes of Cadiz adopt new liberal constitution. August: Wellington enters Madrid and is created Marquess of Wellington and Generalisimo of the Spanish armies. Lord Byron, *Childe Harold's Pilgrimage* (to 1818)

The Life and Art of Francisco Goya	A Context of Events
	1813 Abdication of King Joseph. French withdraw from Spain. Napoleon defeated at the Battle of Leipzig. Ferdinand VII returns to Spain
1814 Petitions Regency for a grant to paint *The Second of May 1808* [164] and *The Third of May 1808* [165]. Birth of Maria del Rosario Weiss. The *Nude* and *Clothed Majas* denounced to the Inquisition as obscene. November: Serna's report on Goya's conduct during the French occupation	**1814** Allied forces enter Paris. Napoleon abdicates and Louis XVIII returns. Ferdinand VII enters Madrid. Abolition of liberal constitution. Inquisition re-established in Spain. Napoleon given the sovereignty of Elba. Treaty of Paris concluded after the abdication of Napoleon
1815 March: Forced to appear before the Inquisition. Begins the *Tauromaquia* prints [179, 180]	**1815** March: Napoleon returns to France, Louis XVIII flees. June: Napoleon defeated at the Battle of Waterloo and subsequently abdicates. July: Allies enter Paris, Louis XVIII returns
1816 Advertises the *Tauromaquia* prints for sale	**1816** Jane Austen, *Emma*
1817 Visits Seville and completes very successful religious work for Cathedral. Probably begins work on the *Disparates* prints [1, 182]	**1817** Death of Juan Meléndez Valdés. John Constable exhibits his first landscapes
1818 Contract drawn up for purchase of the Quinta del Sordo [184]	**1818** Mary Wollstonecraft Shelley, *Frankenstein*
1819 February: Buys the Quinta del Sordo and moves in. Executes first lithographs [183]. Becomes seriously ill	**1819** Charles IV and María Luisa die in exile in Rome. Opening of the Museo del Prado in Madrid. Théodore Géricault exhibits *The Raft of the Medusa* in Paris
1820 Paints *Self-Portrait with Dr Arrieta* [185]. Begins work on the 'Black Paintings' [186–189]. Last visit to the Royal Academy of San Fernando in Madrid to swear allegiance to the constitution	**1820** Rafael del Riego y Nuñez leads a successful liberal coup against Ferdinand VII who is forced to accept the constitution. Inquisition abolished
	1822 Congress of Verona discusses the revolution against Ferdinand VII, decides that French troops should suppress the uprising
1823 Draws up Deed of Gift making the Quinta del Sordo over to his grandson, Mariano Goya	**1823** April: War between France and Spain. August: French capture Fort of Trocadero and restore Ferdinand VII to full power
1824 Goes into hiding. Probably etches the *Disparates* prints [1, 182]. During amnesty requests permission to visit France. Visits Paris. Settles in Bordeaux with Leocadia Weiss	**1824** May: General amnesty granted in Spain. Simón Bolívar frees Peru from Spanish domination. National Gallery founded in London
1825 January: Ten *Caprichos* prints produced in Paris and advertised for sale in the *Bibliographie de la France*. First renewal of leave of absence. Becomes seriously ill. July: Second renewal of leave of absence. Produces lithographs	**1825** Death of Jacques-Louis David in Brussels. End of Spanish colonial rule in South America. John Nash, Buckingham Palace. Aleksandr Pushkin, *Boris Godunov*
1826 Visits Madrid and is granted retirement on full pay as Court Painter	**1826** James Fenimore Cooper, *The Last of the Mohicans*
1828 Dies on 16 April, buried in Bordeaux. Inventory of surviving works in the Quinta del Sordo completed by Antonio Brugada	**1828** First catalogue of the Museo del Prado includes an autobiographical note by Goya
1901 Body disinterred from Bordeaux cemetery and returned to Spain	**1901** Death of Queen Victoria. Gugliemo Marconi's first radio transmission

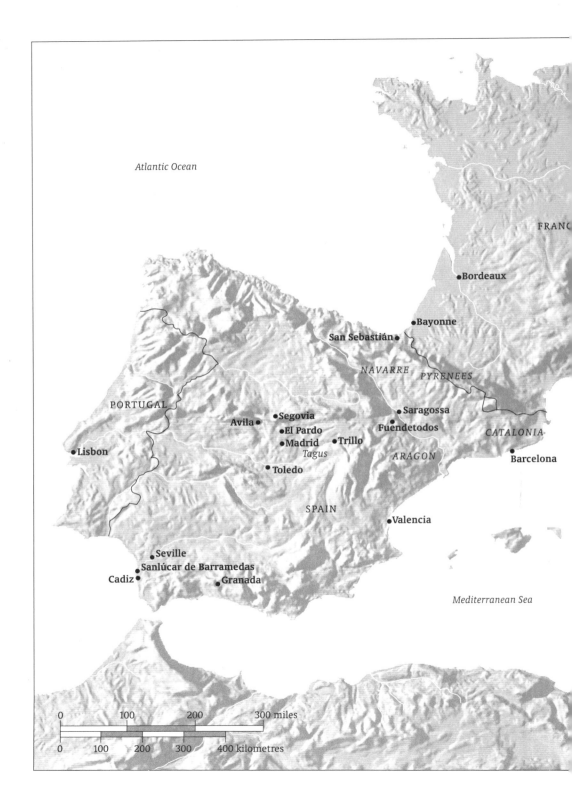

Atlantic Ocean

FRANC

●Bordeaux

●Bayonne

San Sebastián●

NAVARRE *PYRENEES*

PORTUGAL

●Saragossa

Avila ● ●Segovia Fuendetodos●

●El Pardo

●Lisbon ●Madrid ●Trillo *CATALONIA*

Tagus ●Barcelona

●Toledo *ARAGON*

SPAIN

●Valencia

●Seville

Sanlúcar de Barramedas

Cadiz ● ●Granada

Mediterranean Sea

0 100 200 300 miles

0 100 200 300 400 kilometres

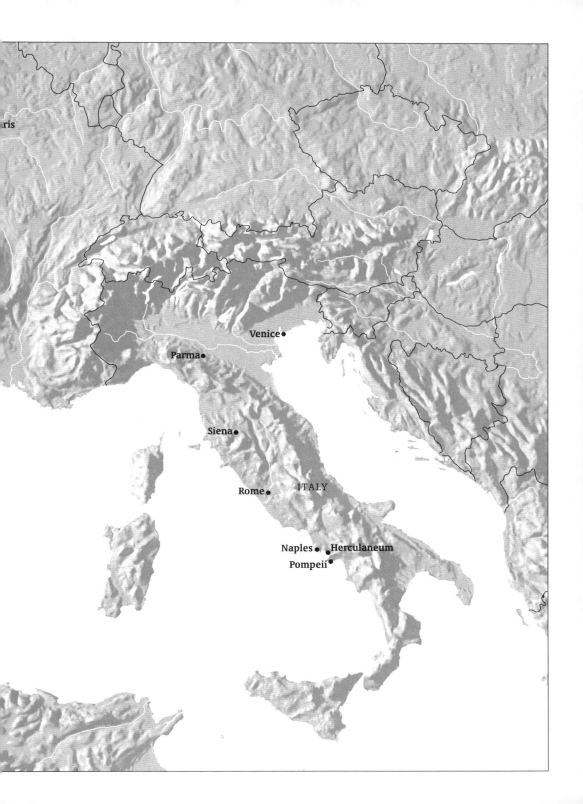

Further Reading

Works on Goya

There are several catalogue raisonnés of Goya's work. Although some of the works have now changed hands and are no longer in the collections listed, the most accessible and reliable is that by Gassier, Wilson and Lachenal. A huge number of biographical works are now in print, written in many different languages. Some date from the last century, others have created major new sources of information and scholarship for Goya enthusiasts. I list here some of the most original and useful, and some of the most up-to-date and accessible.

Pierre Gassier, *Francisco Goya: Drawings: The Complete Albums* (New York, 1973)

—, *The Drawings of Goya: The Sketches, Studies and Individual Drawings* (New York, 1975)

Pierre Gassier, Juliet Wilson and François Lachenal, *Goya Life and Work* (Paris, 1971, repr. Cologne, 1994)

Nigel Glendinning, *Goya and his Critics* (New Haven and London, 1977)

—, 'Goya on Women in the Caprichos: The Case of Castillo's Wife', *Apollo*, 107 (1978), pp.130–4

—, 'Goya's Patrons', *Apollo*, 114 (1981), pp.236–47

Fred Licht, *Goya and the Modern Temper in Art* (New York, 1978)

Folke Nordstrom, *Goya, Saturn and Melancholy, Studies in the Art of Goya* (Stockholm, Göteborg, Uppsala, Almquist and Wiksell, 1962)

Alfonso E Péréz Sanchez and Julián Gállego, *Goya, The Complete Etchings and Lithographs*, trans. by David Robinson Edwards and Jenifer Wakelyn (Munich and New York, 1995)

Sarah Symmons, *Goya* (London, 1977)

—, *Goya: In Pursuit of Patronage* (London, 1988)

Janis Tomlinson, *Goya in the Twilight of Enlightenment* (New Haven and London, 1992)

—, *Francisco Goya y Lucientes 1746–1828* (London, 1994)

Jesusa Vega, 'The Dating and Interpretation of Goya's Disasters of War', *Print Quarterly*, 11:1 (1994), pp.3–17

—, 'Goya's Etching after Velázquez', *Print Quarterly*, 12:2 (1995), pp.145–63

Gwyn A Williams, *Goya and the Impossible Revolution* (New York, 1976)

Exhibition Catalogues

There have been a number of significant exhibitions on Goya, his contemporaries, and the epoch in which they lived and worked. Catalogues from these exhibitions can still be obtained and provide an invaluable source of Goya material.

Jeannine Baticle, *L'Art européen à la cour d'Espagne au XVIIIe siècle* (Galeries des Beaux-Arts, Bordeaux; Galerie Nationales d'Exposition du Grand-Palais, Paris; Museo del Prado, Madrid, 1979–80)

David Bindman, *The Shadow of the Guillotine, Britain and the French Revolution* (British Museum, London, 1989)

Carlos III y La Ilustración, 2 vols (Palacio de Velázquez, Madrid, 1988–9)

Goya and his Times (Royal Academy of Arts, London, 1963–4)

Goya and the Spirit of the Enlightenment (Museo del Prado, Madrid; Museum of Fine Arts, Boston; Metropolitan Museum of Art, New York, 1988–9)

Goya, Truth and Fantasy, The Small Paintings (Museo del Prado, Madrid; Royal Academy of Arts, London; The Art Institute of Chicago, 1993–4)

Werner Hofmann (ed.), *Goya: Das Zeitalter der Revolutionen 1789–1830* (Hamburger Kunsthalle, 1980)

William B Jordan and Peter Cherry, *Spanish Still Life from Velázquez to Goya* (National Gallery, London, 1995)

Roger Malbert, *Goya, The Disparates* (Hayward Gallery, London, 1997)

Painting in Spain During the Later Eighteenth Century (National Gallery, London, 1989)

Painting in Spain in the Age of Enlightenment: Goya and his Contemporaries (Spanish Institute, New York; Indianapolis Museum of Art, 1997)

Le Siècle d'Or des Estampes Tauromachiques 1750–1868 (Royal Academy of San Fernando, Madrid, 1989)

Juliet Wilson Bareau, *Goya's Prints: The Tomás Harris Collection in the British Museum* (British Museum, London, 1981)

Reva Wolf, *Goya and the Satirical Print in England and on the Continent, 1730–1830* (Boston College Museum, 1991)

Historical and Cultural Background

Angel Alcalá (ed.), *The Spanish Inquisition and the Inquisitional Mind* (Boulder, 1987)

Raymond Carr, *Spain 1808–1975* (Oxford, 1966, 2nd edn, 1982)

David Francis, *The First Peninsular War, 1702–13* (London, 1975)

Nigel Glendinning, *A Literary History of Spain: The Eighteenth Century* (London, 1972)

W N Hargreaves-Mawdsley, *Eighteenth-Century Spain, 1700–1788: A Political, Diplomatic and Institutional History* (London, 1979)

—, *Spain Under the Bourbons, 1700–1833: A Collection of Documents* (London, 1973)

Richard Herr, *The Eighteenth-Century Revolution in Spain* (Princeton, 1958)

Henry Kamen, *The War of Succession in Spain, 1700–15* (London, 1969)

—, *Inquisition and Society in Spain in the Sixteenth and Seventeenth Centuries* (London, 1985)

George Kubler, *Art and Architecture in Spain, Portugal and their American Dominions, 1500–1800* (London, 1962)

Geoffrey J Walker, *Spanish Politics and Imperial Trade, 1700–1789* (London, 1979)

Contemporary Sources

Charles Baudelaire, *The Painter of Modern Life and Other Essays*, ed. and trans. by Jonathan Mayne (London, 1995)

Alexander Boyd (ed.), *The Journal of William Beckford in Portugal and Spain 1787–1788* (London, 1954)

J A Ceán Bermúdez, *Diccionario historico de los más ilustres profesores de las Bellas Artes en España*, 6 vols (Madrid, 1800, repr. 1965)

Edmund Burke, *A Philosophical Enquiry into the Origin of Our Ideas of the Sublime and Beautiful*, ed. James T Boulton (London, 1958)

Richard Cumberland, *Anecdotes of Eminent Painters in Spain* (London, 1787)

Diderot on Art – I: The Salon of 1765 and Notes on Painting, trans. by John Goodman, introduction by Thomas Crow (New Haven and London, 1995)

William Hogarth, *Analysis of Beauty* (London, 1753)

Dionysius Longinus, *Longinus on the Sublime*, trans. by William Smith (London, 1819)

William Napier, *History of the Peninsular War* (London, 1828–40)

Antonio Palomino, *El Museo Pictórico y Escala Óptica* (Madrid, 1715–24, repr. 1795–7), trans. by Nina Ayala Mallory: Antonio Palomino, *Lives of the Eminent Spanish Painters and Sculptors* (Cambridge, 1987)

Vol. 1: *Teoría de la Pintura*

Vol. 2: *Práctica de la Pintura*

Vol. 3: *El Parnaso español pintoresco laureado*

Antonio Ponz, *Viaje de España*, 18 vols (Madrid, 1772–94)

Sir Joshua Reynolds, *Discourses on Art*, ed. Robert R Wark (New Haven and London, 1975)

Charles Vaughan, *Narrative of the Siege of Saragossa* (London, 1809)

Books about Goya's Contemporaries and Posthumous Admirers

Jonathan Brown (ed.), *Picasso and the Spanish Tradition* (New Haven and London, 1996)

Douglas Druick, Fred Leeman and Mary Anne Stevens, *Odilon Redon 1840–1916* (London, 1995)

Ian Gibson, *The Shameful Life of Salvador Dalí* (London, 1997)

Sensation: Young British Artists from the Saatchi Collection (exh. cat., Royal Academy of Arts, London, 1997)

Eleanor M Tufts, *Luis Meléndez: Eighteenth-Century Master of the Spanish Still Life: With a Catalogue Raisonné* (Columbia, MO, 1985)

Catherine Whistler, 'G B Tiepolo at the Court of Charles III', *Burlington Magazine*, 128 (1986), pp.198–205

Index

Numbers in **bold** refer to illustrations

Acknowledgements

I owe a special debt to Jesusa Vega who has influenced my view of Goya, kindly read this book in manuscript, and made many valuable comments. I have also benefited greatly from conversations about Goya and his times with a number of people, particularly Valeriano Bozal, Juan Carrete, John Gage, Nigel Glendenning, Xavier Portús and Aileen Ribeiro. Juliet Wilson Bareau's 'Study Day' at the Royal Academy in London in June 1994, in connection with the exhibition *Goya: Truth and Fantasy, The Small Paintings*, provided a valuable opportunity to exchange information with many scholars who have also influenced my interpretation of Goya's art. Thanks must also go to my students, to my editors at Phaidon Press and, particularly, to the British Academy for a generous research grant while I was working on this book.

S S

Photographic Credits

AKG, London: 204; Biblioteca Nacional, Madrid: 45, 97, 98, 183; The Bowes Museum, Barnard Castle, County Durham: 63; British Museum, London: 46, 47, 51, 89, 95, 126, 151, 152, 154, 174, 179, 180, 182, 191, 206, 213; Courtauld Institute, London: 138; Fitzwilliam Museum, University of Cambridge: 90, 104, 106, 108, 109, 110, 111, 113, 114, 116, 117; Fondación Thyssen-Bornemisza, Madrid: 122; Fondazione Magnani-Rocca, Parma: 66; Frick Collection, New York: 198; Gallery Cramer, The Hague: 75; Giraudon, Paris: 125; Glasgow Museums, Burrell Collection: 200; Hamburger Kunsthalle: photo Elke Walford 101, 107, 161; photo by John Hammond, London: 156; Harvard University Art Museums, Cambridge, Massachusetts: 209; The Hispanic Society of America, New York: 119, 176; Index, Barcelona: 40, 121, 163, 172; Institut Amatller d'Art Hispànic, Barcelona: 2, 3, 6, 19, 20, 28, 44, 53, 55, 56, 57, 59, 65, 69, 70, 72, 77, 78, 120, 146, 167; Anthony King/Medimage: 13; Kunsthalle, Mannheim: 170; Metropolitan Museum of Art, New York: Rogers Fund (1906) 74, Jules Bache Collection (1949) 76, Harris Brisbane Dick Fund (1935) 88, bequest of Walter C Baker (1971) 103; Mountain High Maps, copyright © 1995 Digital Wisdom Inc: p.342–3; Musée des Beaux-Arts, Agen: photo Gilles Salles 208; Musée des Beaux-Arts, Besançon: 141, 142; Musée Goya, Castres: 87; Museo Municipal, Madrid: 29, 118, 157, 166, 168; Museo del Prado, Madrid: 15, 16, 17, 18, 21, 22, 24, 26, 27, 33, 34, 35, 36, 37, 38, 41, 42, 43, 49, 50, 52, 58, 61, 62, 68, 79, 91, 92, 93, 94, 105, 112, 127, 128, 129, 130, 131, 132, 133, 134, 135, 136, 139, 149, 160, 162, 164, 165, 171, 181, 186, 187, 189, 192, 194, 195, 201; Museum of Fine Arts, Boston: bequest of Charles Hitchcock Taylor (1933) 32, Zoe Oliver Sherman Collection, given in memory of Lillie Oliver Poor 83; National Army Museum, London: 153; National Gallery, London: 7, 30, 80, 159; National Gallery of Art, Washington, DC: Samuel H Kress Collection 12, Andrew W Mellon Collection 71, Chester Dale Collection 202; Philadelphia Museum of Art: the Louise and Walter Arensberg Collection 211; RMN, Paris: 8, 86, 123, 124, 137, 143, 169, 203; Royal Academy of San Fernando, Madrid: 9, 11, 12, 64, 73, 82, 115, 177, 178, 193, 196; Royal Collection, © Her Majesty Queen Elizabeth II: 85; Royal Palace, Madrid: 5, 25, 31; Szépmüvészeti Múzeum, Budapest: 207; Tate Gallery, London: 81, 140; courtesy of the Trustees of the Victoria and Albert Museum, London: photo Daniel McGrath 158; Victoria Miro Gallery, London: 212; Virginia Museum of Fine Arts, Richmond: 150; Board of Trustees of the National Museums and Galleries on Merseyside: Walker Art Gallery, Liverpool 10; Woodner Collections, New York: 205, photo Jim Strong 210

Phaidon Press Limited
Regent's Wharf
All Saints Street
London N1 9PA

First published 1998
© 1998 Phaidon Press Limited

ISBN 0 7148 3751 2

A CIP catalogue record for this book is available
from the British Library.

Text typeset in Oranda, chapter numbers in
Latin Bold

Printed in Singapore

Cover illustration Detail from *The Picnic*, 1776
(see p.54)